Mikhail Larionov
and the Russian Avant-Garde

Mikhail Larionov
and the Russian Avant-Garde

ANTHONY PARTON

PRINCETON UNIVERSITY PRESS

Copyright © 1993 by Princeton University Press
Published by Princeton University Press, 41 William Street,
Princeton, New Jersey 08540
In the United Kingdom: Princeton University Press, Oxford

Library of Congress Cataloging-in-Publication Data

Parton, Anthony.
Mikhail Larionov and the Russian avant-garde / Anthony Parton.
 p. cm.
Includes bibliographical references and index.
ISBN 0-691-03603-9
1. Larionov, Mikhail Fedorovich, 1881–1964—Criticism and
interpretation. 2. Avant-garde (Aesthetics)—Russia (Federation)—
History—20th century. I. Title.
NX556.Z9L376 1993
700'.92—dc20 92-20814

This book has been composed in Trump and Gill Sans by
The Composing Room of Michigan, Inc.

Princeton University Press books are printed on acid-free paper, and meet
the guidelines for permanence and durability of the Committee on Production
Guidelines for Book Longevity of the Council on Library Resources

Printed in Singapore

10 9 8 7 6 5 4 3 2 1

10 9 8 7 6 5 4 3 2 1

Designed by Laury A. Egan

FOR JANICE

CONTENTS

LIST OF ILLUSTRATIONS

Color Plates
(after p. 56)

Black and White Illustrations

For help with photographic material I am grateful to the following individuals: Gavin Bryars, London; Fulvia Casella Nicolodi, Lausanne; Mary Chamot, London; Jean Chauvelin, Paris; Evelyn Cournand, Paris; Mariya Gimbutas, California; Ben Hellman, Helsinki; Collection Krotoschin, Berlin; Mr. Lobanov-Rostovsky, London; Tatiana Loguine, Paris; Mr. and Mrs. Donald B. Marron, New York; Robin Milner-Gulland, Sussex; Yvette Moch, Paris; Kirill Sokolov, Durham; Archives Théodore Stravinsky, Geneva; John Stuart, London; Sergei Tartakovsky, Moscow; Thysen-Bornemisza Collection, Lugano; Robert L. Tobin, San Antonio, Texas; Pierre Vorms, Belvès, France; and Hélène Zdanevich, Paris.

I would also like to acknowledge the following galleries and institutions: Albright-Knox Art Gallery, Buffalo; Annely Juda Fine Art, London; Bashkirian Museum of Fine Arts, Ufa; Bauhaus-Archiv, Berlin; Galerie Beyeler, Bâle; University of Birmingham; British Library, London; Cambridge University Library; Chadwyck-Healey Ltd., Cambridge; Chatto & Windus, London; J. & W. Chester, London; Dansmuseet, Stockholm; Max Eschig, Paris; Ex Libris, New York; Galleria Fonte d'Abisso Arte, Modena; Barry Friedman Ltd., New York; State Art Museum, Georgia; Gilchrist Photo Service, Leeds; Gimpel Fils, London; Gorky Art Museum; Solomon R. Guggenheim Museum, New York; Harrap Publishing Group; State Hermitage Museum, St. Petersburg; Hoover Institution Archives, Stanford; Leonard Hutton Galleries, New York; Kazan Art Museum; Galeria del Levante, Milan; Museum Ludwig, Cologne; Methuen Publishers Ltd.; Metropolitan Museum of Art, New York; Moderna Museet, Stockholm; Municipal Museum, St. Petersburg; Musée National d'Art Moderne, Centre Georges Pompidou, Paris; Museo d'Arte Moderna e Contemporanea, Trento e Rovereto, Italy; Museum of Fine Arts, Houston; Museum of Modern Art, New York; Museum moderna Kunst, Vienna; Omsk State Museum of Fine Arts; Pitt Rivers Museum, University of Oxford; Popoff and Co., Paris; Marion Richardson Archive, City of Birmingham Polytechnic; Royal Opera House, London; State Russian Museum, St. Petersburg; Saltykov-Shchedrin State Public Library, St. Petersburg; School of Slavonic and East European Studies, London University; Science Museum, London; Serpukhov Historical Artistic Museum; Sotheby's, London; Sverdlovsk State Art Gallery; Tate Gallery, London; Thames and Hudson, London; State Tretyakov Gallery, Moscow; Ulyanovsk Regional Art Museum; Victoria & Albert Museum, London; Wadsworth Atheneum, Hartford; Yale University Art Gallery.

	Biography	Artistic Career	Exhibitions
1881	Born in Tiraspol		
1898		Joins Moscow School of Painting	
1900	Meets Goncharova	Executes urban sketches	
1903	Meets Diaghilev	Impressionist style: *Roses*	
1906	Visits Paris with Bakst, Diaghilev, and Kuznetsov	First criticism of exhibited work. Joins *Soyuz russkikh khudozhnikov*	*Mir iskusstva*, St. Petersburg *Salon d'Automne*, Paris
1907	Close to symbolism	*Rain*	*Stefanos*, Moscow
1908	Friendly with Ryabushinsky	Inspired by Denis, Cézanne, Gauguin, and the Fauves	*Zolotoe runo*, Moscow *Zveno*, Kiev
1909		Paints *genre* works: *Walk in a Provincial Town*. Interested in the *lubok* tradition	*Zolotoe runo*, Moscow Izdebsky's *Salon*, Odessa, Kiev, St. Petersburg, Riga
1910	Expelled from Moscow School. Begins military service	(1910–1912) Executes soldier and low-life paintings: *Street in a Province* and *Circus Dancer*	Founds *Bubnovy valet*, Moscow *Soyuz molodezhi*, St. Petersburg Izdebsky's *Salon 2*, Odessa
1911	Meets Matisse	Turkish paintings	First one-man exhibition
1912	Friendly with futurist poets. Illustrates work by Kruchenykh and Khlebnikov	Develops rayist and neo-primitive styles: *Glass, Rayist Sausage and Mackerel, Venus* and *Seasons* paintings	Founds *Osliny khvost* Second Post-Impressionist Exhibition, London Soyuz molodezhi, St. Petersburg
1913	Becomes a Russian futurist. Paints face, participates in cabaret, film, and theatre. Illustrates futurist verse. Eganbyuri's monograph	Executes cubo-futurist works: *Boulevard Venus*; pneumo-rayist paintings: *Sea Beach and Woman*. Publishes *Osliny khvost i mishen'*. Writes on rayism and face painting	Founds *Mishen'* Organizes Exhibition of Icons and *Lubki* Exhibits at *Der Sturm*, Berlin Goncharova exhibition, Moscow
1914	Visits Paris with Goncharova. Friendship with Apollinaire. Wounded in war	Non-objective works: *Sunny Day*. Works with Goncharova on *Le Coq d'Or*. Writes *Rayonnisme Pictural*	Organizes *Vystavka kartin No. 4*, Moscow Galerie Paul Guillaume, Paris
1915	Leaves Russia with Goncharova. Joins Diaghilev and Stravinsky in Switzerland	Designs for *Soleil de Nuit*. Works with Massine on the choreography	Participates in *Vystavka zhivopisi 1915 god*, Moscow
1916	Paris, Spain, and Rome	Designs for *Kikimora*	
1917	In Rome with Picasso, Cocteau, Balla, and Bakst. Meets Gumilev on return to Paris	Designs for *Contes Russes*. Begins work on *Histoires Naturelles*. Interest in shadow theatre	
1918			Galerie Sauvage, Paris
1919	Settles in Rue de Seine, Paris. Organizes soirées and participates in café culture	*Contes Russes* acclaimed in London. Publishes *L'Art Décoratif Théâtral Moderne*	Omega Workshops, London Theatrical work at Galerie Barbazanges, Paris
1920		Illustrates Blok's *Dvenadtsat'*	

	Biography	**Artistic Career**	**Exhibitions**
1921	Visits Spain and London	Designs for Prokofiev's ballet *Chout*	Whitechapel Gallery, London
1922	Visits Berlin	Designs for Stravinsky's *Le Renard*	Kingore Galleries, New York, and Theatre Exhibition, Amsterdam
1923	Organizes *Bal Travesti*	Illustrates Mayakovsky's *Solntse*	Galerie Shiseido, Toyko
1924	Organizes *Bal Banal*	Designs puppet ballet *Karagueuz*	
1928		Publishes *Voyage en Turquie*	Organizes *Vystavka sovremennogo frantsuzskogo iskusstva,* Moscow
1929	Diaghilev dies, Venice	New designs for *Le Renard*	
1932		Designs for *Sur le Borysthène*	
1935		Designs for *Port Saïd*	Exhibits in Prague
1936	Corresponds with Alfred Barr on rayism		Rayist work shown in *Cubism and Abstract Art,* New York
1938	Becomes French citizen		
1948		Seuphor "rediscovers" rayism	Rayist works shown in Paris
1955	Marries Goncharova	Writes *Les Ballets Russes* with Goncharova and Vorms	
1961	Sells his library		Retrospective in London
1962	Goncharova dies, Paris		
1963	Marries Tomilina		Retrospective in Paris
1964	Larionov dies, Paris		

ACKNOWLEDGMENTS

The conception of this book is due to my doctoral tutor, John Milner, who encouraged me to begin research on Larionov. I also wish to express deep thanks to my friend Mary Chamot, who has shared both her memories and her rich archive with me. She was the first to communicate to me the atmosphere of Larionov's world, which was an inspiration and a privilege. Her example has served as a beacon throughout my research.

Of Larionov's friends, Michel Seuphor illuminated Larionov's personality. Marcel Mihalovici discussed his relationship with Larionov. Tatiana Loguine guided by footsteps through the School of Paris, from grand houses to garret studios, in search of those who had known Larionov. Hélène Zdanevich allowed access to her archives. Frédéric Pottecher reenacted his meetings with Larionov. Lina Prokofieff recounted her reminiscences. Giuseppe Sprovieri recalled Larionov's visits to Rome and Florence. And I am grateful to Joan Osiakovski for her memories of Larionov.

Several acquaintances of Larionov spurred me on by their enthusiasm. Mme. Tikanova and Hélène Poluchine undertook research on my behalf. The Casella family opened their archives. Mr. and Mrs. John Carr-Doughty introduced me to their wonderful collection and Christine Gautier informed me about Larionov's time at "La Provençale." Collectors such as Yvette Moch have been generous in their response to my requests.

Scholars and artists have also played an important role. Avril Pyman and Kirill Sokolov have inspired me with their rich insights into Larionov's Russian context. Susan Compton gave me the benefit of her own research. Gavin Bryars was helpful. Andrei Boris Nakov supplied essential information and John Bowlt has kept me in touch with recent Larionov scholarship. I also owe a debt of thanks to my two friends Charlotte Humphreys and Jeremy Howard for sharing their own research on the Russian avant-garde. Although most of the translations from French and Russian, unless otherwise indicated, are by myself, I wish to thank Avril Pyman and Kirill Sokolov for rendering some of Larionov's more obscure phrases and Pamela Gregg for translations from Italian. Stephanie Brown deserves my thanks for her help in editing the text.

The most important debt of thanks is to my parents, Margaret and John Parton, without whose financial support the research needed for this book could never have been carried out, and to my wife, Janice Wailes, who has supported the project throughout.

Finally, the late Pierre Vorms played a crucial role in my work. He was delighted to communicate his memories of Larionov, portions of his archive, and an important tape-recorded interview about Larionov made with Serge Fotinsky in the late 1960s. My only regret is that he was unable to see the realization of this book, which he was so looking forward to.

Mikhail Larionov is not only one of the most important figures in twentieth-century Russian art but was also one of the outstanding artistic personalities of his age. His work was crucial to the development of the Russian avant-garde before the First World War, after which he became a celebrity in the west through his stage designs for Diaghilev's *Ballets Russes.* During the 1920s Larionov played a significant role in the School of Paris and continued to live and work in France until his death in 1964. His lifelong association with the artist Nataliya Goncharova proved mutually inspirational and together they made impressive contributions in the fields of painting, graphic art, and theatrical design.

As a painter Larionov pioneered the neo-primitive and rayist styles in modern art. Neo-primitivism represented an attempt to subvert the "western" fine art tradition and to reinvigorate painting by returning to the stylistic principles of native Russian art forms and the pictorial conventions of naive artists and peasant craftspeople. Larionov later applied neo-primitivism to his stage designs for the *Ballets Russes* and, as an artist in the Diaghilev troupe, was successful in communicating Russian visual traditions to the western audience. Larionov's rayism, on the other hand, was an abstract and nonobjective style of painting.[1] The first rayist canvases depict rays of light reflected from everyday objects which shatter the picture space while subsequent works represent only the rays themselves which intersect to create dynamic planes of color. Larionov thus became the first nonobjective artist in Russia, and although rayism attracted few followers at the time, the style had repercussions on the development of constructivism.

The significance of Larionov's art is now recognized and his paintings and theatre designs feature in the collections of major Russian and western galleries. However, his work raises complex art-historical issues. The chronology of Larionov's stylistic development, the biographical details of the artist's career, and the question of meaning in his work have been subjects of debate for many years and it is these issues that this monograph addresses.

The chronology of Larionov's and Goncharova's work is obscured primarily by the fact that they seldom dated their paintings on execution and in later years consistently pre-dated their early works, sometimes by more than a decade. Inaccurate memory undoubtedly played its part, but Larionov was a shrewd propagandist of their historic role as painters. Following World War II, when the early twentieth-century avant-garde were being reevaluated, Larionov was one of several who rewrote the history of their artistic development. The pre-dating of neo-primitive and rayist canvases to the early years of the century seemed to establish Larionov and Goncharova's claim to be the first "abstract" painters in Europe. Larionov also pre-dated his experimental stage designs. His cubist and futurist designs for the ballet *Histoires Naturelles* (pls. 19–20) were conceived in 1917 but were later pre-dated by him to 1911 thus preempting Picasso's application of cubism in the ballet *Parade* by six years.[2]

Larionov and Goncharova also invented corroborative evidence to support the early dates they ascribed to their paintings. Larionov claimed to have exhibited his rayist painting *Glass* (fig. 44) at a one-day exhibition held at the Society of Free Aesthetics in Moscow in 1909 and to have published an essay on rayism in the newspaper *Utro Rossii* as early as January 1910. However, the Society of Free Aesthetics only began to hold their one-day exhibitions in 1911 and when Larionov did show with them in that year, *Glass* was not among his exhibits. His citation of an essay in *Utro Rossii* is also spurious. Documentary evidence in Larionov's library has been extensively revised in his own hand. A copy of his manifesto *Luchizm (Rayism)* of 1913 has had the dated flyleaf torn out and is inscribed "second revised edition 1911." Similarly, Larionov's book of neo-primitive drawings, *Poluzhivoi (Half-Alive),* also of 1913, is inscribed "Half-Alive, Drawings by Mikhail Larionov 1907." Larionov also "amended" a chronological list of his paintings published in Eganbyuri's monograph of 1913 by altering the published dates of his works and pre-dating them in ink. As Peter Vergo concluded, "Larionov had managed to convince himself, and others, that his own *efforts créateurs* had occurred considerably earlier than the catalogue compiled by Eganbyuri indicates."[3]

Eganbyuri's monograph, however, is not without problems. Dates accompanying reproductions of Larionov's paintings differ from those cited in the catalogue, and Eganbyuri himself admitted that his monograph was unreliable. Printing errors in other sources add to the confusion. The painting *Rayist Sausage and Mackerel* (fig. 45) of late 1912 was for many years assumed to have been painted and exhib-

ited a full year earlier due to a misprint on the cover of the Union of Youth exhibition catalogue reading "December–January 1912". Further complicating the chronology of Larionov's stylistic development is the fact that he later overpainted several of his early masterpieces such as *Soldiers* (fig. 31), *Bread* (fig. 88), and *Portrait of a Fool* (fig. 42).

In addressing these chronological issues this monograph gives no credence to dates inscribed on paintings or published at any time by Larionov. Instead a new chronology is proposed based principally upon factual evidence. Larionov frequently exhibited his paintings, and it is possible to reconstruct his stylistic development by studying the sequence of works shown at exhibitions from 1906 onwards. This development may be corroborated by exhibition reviews, reproductions of paintings in the art press, and illustrations in Russian futurist books which may be accurately dated according to the publication in which they appear. As regards overpainting, photographs of works in their original form have been reproduced wherever possible.

Biographical lacunae also impinge upon these chronological concerns. The correct dating of Larionov's military service has long been a subject of debate since it provides a *terminus post quem* for his series of soldier paintings. As no reliable monograph exists, biographical details are again drawn from documentary evidence to provide a comprehensive biography of the artist, his activities and relationships. Having established a working chronology and biography, discussion focuses on the paintings themselves. This is based on Larionov's theoretical writings as well as research into his personal library now located in the National Art Library of the Victoria & Albert Museum in London. The contents of Larionov's library reveal his interest in contemporary science, comparative religion, and archaeological discoveries, all of which were pertinent to his art. His library assists in constructing a meaningful interpretation of his work. Such an approach elucidates Larionov's aesthetic ideology and reveals the importance of his contribution to the development of twentieth-century art.

Mikhail Larionov
and the Russian Avant-Garde

Tiraspol to Myasnitskaya Ulitsa

1881–1908

◼

Mikhail Fedorovich Larionov was born in the home of his maternal grandparents near Tiraspol on 22 May 1881.[1] He was the son of Fedor Mikhailovich Larionov, a doctor and pharmacist at the Tiraspol Military Hospital, and Aleksandra Fedorovna Petrovskaya, the daughter of a local farmer. Larionov's parents were members of the Russian Orthodox Church and on 30 June 1881 he was baptized in the Church of St. Andrew the Apostle by the priest Vasily Vinogradov in the presence of the family and two godparents: Pavel Fedorovich Zmeitzin, administrator of the dispensary of the Military Hospital, and Evdokia Timofeevna Vladimirovna, wife of the accountant of the Tiraspol Tax Office.[2]

Larionov spent his childhood with his grandparents at Tiraspol, a town rich in meadows and gardens. As a young child he grew to love not only the town but also the beautiful beaches along the Dnestr and the surrounding steppe landscape of Kherson province, which he returned to paint again and again.

At the age of twelve Larionov left Tiraspol to begin his secondary education at the Voskresensky Technical High School in Moscow. There he studied the general science curriculum and on leaving at the age of fourteen in 1895 he was awarded his diploma. In July 1898, Larionov enrolled as a student at the Moscow School of Painting, Sculpture, and Architecture on Myasnitskaya Ulitsa. The Moscow School was then directed by Prince Lvov who headed a distinguished staff including Leonid Pasternak and Pavel Trubetskoy. Initially Larionov entered the preparatory classes of the School, where he studied under the landscapist Isaak Levitan (1860–1900), and exhibited his first student works with the Society for the Encouragement of the Arts.[3] In 1902 he passed into the painting classes and during the following eight years was taught by Vasily Baksheev (1862–1958), Valentin Serov (1865–1911), and Konstantin Korovin (1861–1939).

In these early years Larionov befriended Nataliya Sergeevna Goncharova, a fellow student who had recently entered the School. Goncharova was born in the village of Negaevo in Tula province on 4 June 1881 and spent her childhood with her grandmother on the family estate of *Ladyzhino*. Goncharova came from a more intellectual and cultured background than Larionov. Her father was an architect and the owner of a linen factory near Kaluga; her mother was related to the musicologist Belyaev and her maternal grandfather taught in the Theological Academy in Moscow. Goncharova underwent her secondary education in Moscow before joining the sculpture classes at the Moscow School in 1901. The two artists became lifelong companions and colleagues, and it was on Larionov's advice that Goncharova renounced sculpture and turned to painting.

Larionov and Goncharova's closest friends at this time included fellow students Dmitry Mitrokhin, Artur Fon Vizen, and Léopold Survage (Shtyurtsvage).[4] At this time Larionov rented a studio in the Zamoskvoreche district of the city, but during the summer months Larionov returned to Tiraspol where he relaxed and painted.

In 1902 the painter Konstantin Korovin was appointed to the staff of the Moscow School. Larionov became particularly friendly with Korovin and captured the artist in a series of informal sketches (fig. 3). Korovin had studied in Paris with the impressionists in 1885 and, like his friend Serov, was interested not only in painting but also in theatrical design. Both Serov and Korovin were members of the World of Art, the leading St. Petersburg art society, led by Serge Diaghilev, and both had worked extensively with the Abramtsevo arts and crafts colony founded by the railway magnate Savva Mamontov. Although Larionov admired Serov for his manipulation of different media and high standards of technical discipline, he was closer to Korovin. Jotterand, in an inter-

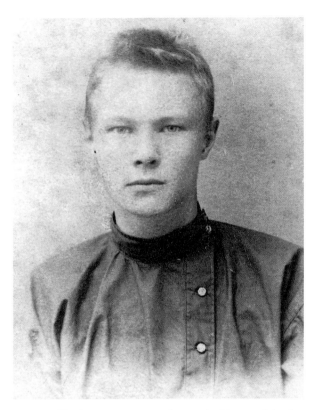

Fig. 1. Mikhail Larionov as a student at the Moscow School of Painting, c. 1898

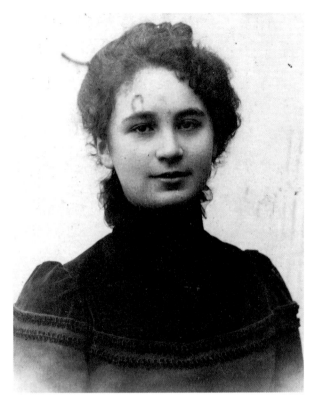

Fig. 2. Nataliya Goncharova as a student at the Moscow School of Painting, c. 1901

view with Larionov, recalled, "At this name Larionov smiled with joy. 'Korovin, but he was my teacher!' said Larionov. 'He launched the first modern painting in Russia . . . it was thanks to painters like Korovin that Russian art began to discover its own path by the end of the Nineteenth Century!'"[5]

During 1902 Larionov's behavior resulted in his expulsion from the School. Larionov himself claimed that he disrupted the student exhibition by hanging one hundred fifty of his own works and taking up all the available wall space! According to Larionov, both staff and students begged him to remove his works but to no avail. Finally Prince Lvov himself ordered Larionov to remove the paintings and when the latter still refused he was expelled.[6] Sadly this scenario seems to be apocryphal. Several such anecdotes were published by Eganbyuri in 1913 as futurist propaganda to portray Larionov as a nonconformist and futurist bully *avant la lettre*. The archives of the Moscow School record that Larionov was actually expelled for failing to complete the drawing, painting, and composition courses which he was required to attend.[7] A year later, however, Larionov was readmitted to the painting classes of the School.

One of the most important meetings of Larionov's

career took place during the winter of 1902–1903 when he visited the Charles Rennie Mackintosh exhibition at the Moscow Society of Architects. Here, Larionov was introduced to Serge Pavlovich Diaghilev (1872–1929) who was reviewing the exhibition for the magazine *Mir iskusstva* (*The World of Art*). Diaghilev invited Larionov for lunch: "Our conversation flowed quickly and fascinatingly. Diaghilev broached the topics of most relevance to me: painting, artists, and the theatre. The meal ended only too quickly. . . . We left together and since he didn't say good-bye I took the opportunity to accompany him to his hotel."[8] Subsequently a close personal and creative relationship developed between Larionov and Diaghilev which, although it occasionally lapsed, was renewed again and again until Diaghilev's death in 1929.

It is difficult to be precise about Larionov's artistic output in these early years. Although Eganbyuri's listing of Larionov's work is chronologically unreliable, it does provide a rough guide to the sequence of subjects and media that he adopted and sheds some light on his first years as an artist.[9] Eganbyuri indicates that from 1898 to about 1903 Larionov produced mainly sketches and studies and very few full-

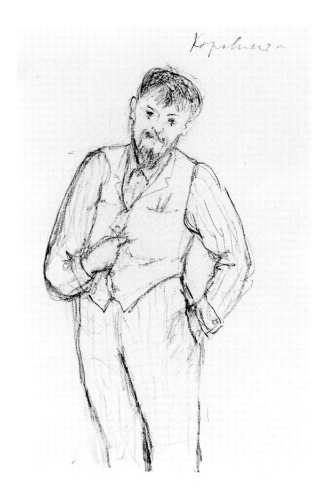

Fig. 3. Mikhail Larionov, *Konstantin Korovin*

atory course at the Moscow School. However, when Larionov was elevated to the painting classes, the emphasis changed to oils, and painting became his passion.

During the summer of 1903 Larionov and Goncharova toured the Crimea but in the following two summers Eganbyuri records that Larionov returned to Tiraspol where he painted in his grandparents' garden. To these years belong a fine series of canvases entitled *The Garden* and *The Coal Shed* of which *Lilac Bush in Flower* (pl. 1) is an example. Larionov also executed a series depicting roses as well as a series devoted to bathers and the Black Sea. As these themes preoccupied Larionov for several years it is difficult to establish the dating of individual paintings. However, contemporary commentators and the earliest reproductions of his work in 1906 indicate that they were impressionist in style, and they should not be confused with later works on similar themes but in bolder styles, which have been wrongly attributed to this period.

By 1904 Larionov's reputation at the Moscow School, his friendship with Diaghilev, Korovin, and Serov, and his regular participation in exhibitions brought him to the attention of collectors and critics such as Igor Grabar:

> I set off to find Larionov, having seen his pastels at the Student Exhibition in 1904. At that time he lived in a small room in the Zamoskvoreche district. On my arrival at 11 o'clock in the morning he was still in bed. All the walls were covered with pastels and oil sketches. That same day I. I. Troyanovsky bought about ten pastels from him. At this time Larionov was still very restrained, standing almost entirely on the platform of impressionism.[10]

Grabar's description is interesting for two reasons. First, it indicates that in 1904 Larionov was working in an impressionist style and, second, that he had attracted the attention of the collector Troyanovsky, who became Larionov's first patron. During the next five years Troyanovsky purchased over forty canvases, mostly from the *Coal Shed* and *Black Sea* series, though he also bought the illustrations for *The Arabian Nights* and numerous pastels and paintings of landscapes and still lifes.

During the following decade Larionov sold over one hundred paintings to more than thirty buyers. These included not only museums such as the Tretyakov Gallery and the Vyatsk (now Kirov) Museum, but also collectors such as Ivan Morozov, Nikolai Ryabushinsky, and Sergei Polyakov, the editor of the

scale oil paintings. His work comprised a series of watercolor illustrations for *The Arabian Nights*, several history drawings, over four hundred street sketches, and five hundred miscellaneous sketches, pastels, watercolors, tempera, and decorative boards, as well as a series of sculptures.

Characteristic of this period are naturalistic figure drawings, such as *Seated Woman* and *Seated Woman with Hat* (figs. 4 and 5), based upon direct observation in the Moscow streets. These young girls and city prostitutes recall the modern social types found in the work of Degas and Lautrec. Larionov's rapid use of white pastel on cardboard, the "unfinished" appearance, and the presentation of the subject against a plain ground particularly resemble the brief notations of Lautrec. Nonetheless, these drawings are restrained, lacking the intensity of color, artistic artifice, and shrewd observations of French modernism. Larionov's passion for sketching in these early years was fostered by his teachers in the prep-

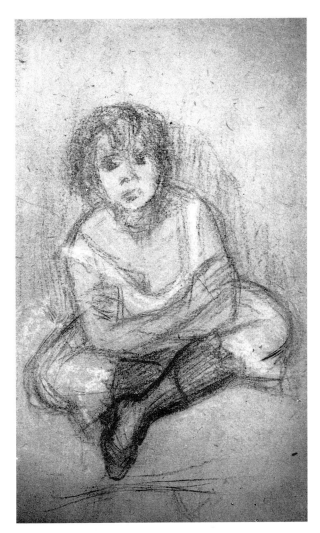

Fig. 4. Mikhail Larionov, *Seated Woman*, c. 1900

ety, where he showed mostly his earlier work from the collection of Troyanovsky. In this last instance, he was described as one of several young artists whose work shone out in an exhibition otherwise lacking in artistic quality.[13]

Through his friendship with Diaghilev, Larionov was also invited to participate in the World of Art exhibition in St. Petersburg in February 1906. He contributed six works including *Garden*, later reproduced in the *Salon d'Automne* catalogue of October 1906, and *Roses* (fig. 6), selected for reproduction in the May edition of the luxurious art magazine *Zolotoe runo* (*The Golden Fleece*). These reproductions not only show the impressionist style in which Larionov had been working during the summers of 1904 and 1905 but also enable us to attribute other works such as *Lilac Bush in Flower* (pl. 1) to this period. These paintings are characterized by their naturalistic coloring and unusual composition in which the viewer is brought up sharply against tree boughs and branches without any pictorial space within which to view the landscape.

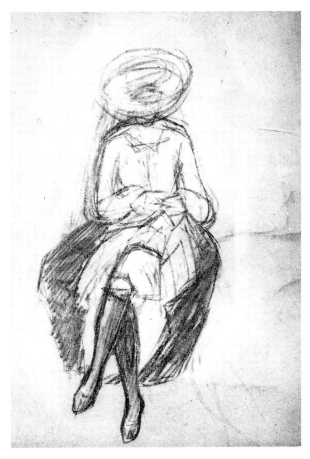

Fig. 5. Mikhail Larionov, *Seated Woman with Hat*, c. 1900

literary magazine *Vesy* (*The Scales*). He also sold his work to colleagues and friends such as the fashion designer N. P. Lamanova, the painters Konstantin Korovin, Nikolai Mescherin, Vasily Milioti, Vasily Baksheev, Aleksandra Exter, and David Burlyuk, as well as many literary personalities of the day.[11]

At the start of 1906 Larionov began to exhibit widely and actively to promote his career as an artist. He showed several landscapes at the Exhibition of Paintings by the Moscow Association of Artists but these were not well received: "Larionov's flowering trees are certainly beautiful but their beauty does not move you; one senses something feigned, superficial, and cold."[12] Larionov's works could also be seen at the Periodical Exhibition of the Society of Art Connoisseurs at the Historical Museum, as well as at the Exhibition of Watercolors, Pastels, Tempera, and Drawings at the Moscow Literary and Artistic Soci-

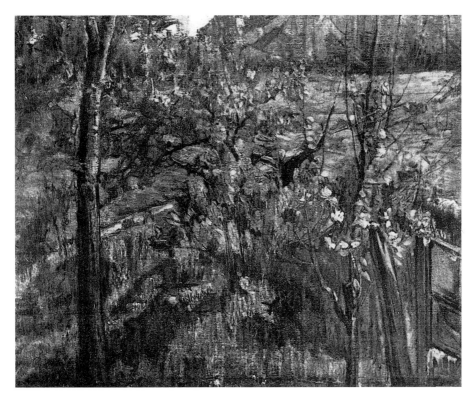

Fig. 6. Mikhail Larionov, *Roses*, 1905

Although contemporary critics were dismissive of Larionov's early impressionist paintings, fellow artists such as Mitrokhin were fascinated by "their fidelity to nature and poetic quality," and in the late 1920s Nikolai Punin, the leading art critic of the day, described Larionov's impressionist work as an important contribution to the development of Russian modernism.[14] Punin cites various influences upon Larionov at this time such as reproductions of French impressionist paintings in *Mir iskusstva*, the exhibition of impressionist works in Russia by the World of Art in their International Exhibition of 1899 and the exhibition of French art organized by the Society for the Encouragement of the Arts in St. Petersburg in 1900.[15] More importantly Punin refers to the influence of the collection of Sergei Shchukin who brought the first Monet to Russia in 1897.

These events undoubtedly aroused Larionov's interest in impressionism but so too did his contemporaries, such as Korovin and Grabar who were painting exciting impressionist works in this period. Larionov's own approach owes a debt to them. For example, Larionov's painting *Roses* (fig. 6) recalls works by Grabar such as *Spring Current* 1904 (Russian Museum, St. Petersburg) both in the omission of sentimental or picturesque detail and in the unusual view-point and composition, in which the foreground trees extend from top to bottom of the canvas, thus flattening the picture space. The influence of Igor Grabar upon Larionov's early work was clearly important and Larionov openly acknowledged this.[16]

Spring Garden 1907 (pl. 2) and *Rose Bush* 1906 (fig. 7), however, mark a difference from Larionov's earlier impressionist work. In *Spring Garden* the painted surface displays a unifying pattern of directional brushstrokes and in *Rose Bush* this process is more advanced. The generalized approach to landscape and Larionov's emphasis on the integrated surface of the painting, achieved through the rhythmical effect of the directional brushstrokes, reveal a growing interest in purely painterly concerns which sets these paintings apart from the arbitrary composition and free execution of earlier canvases. This development betrays the influence of Viktor Borisov-Musatov (1870–1905) whose landscapes had been posthumously exhibited at the 1906 World of Art Exhibition in St. Petersburg. Borisov-Musatov had made his name as an impressionist painter but had increasingly adopted decorative characteristics in his work, somewhat in the manner of the Nabis. In *Spring* 1898–1901 (fig. 8), for example, the delicate tonalities and handling of brushwork are impressionist while

Fig. 7. Mikhail Larionov, *Rose Bush*, 1906

the balanced color planes and subtle linear design of the flowering branches reflect decorative concerns. The branches straying across the picture plane and the pretty effect of the dandelion clocks in *Spring* both find an echo in Larionov's *Rose Bush* where red blooms of paint act as a decorative counterpoint to the directional brushstrokes that bind the painted surface into an overall rhythm. It was these decorative and poetic qualities that Larionov now adopted in his work.

Rose Bush was later acquired by Korovin who recognized it as one of Larionov's early masterpieces. The painting exemplifies two stylistic features which Punin associates with Larionov's finest impressionist work: first, the emphasis on the overall unity of the picture surface, achieved atmospherically by bathing the scene in a delicate light, as well as structurally by the directional brushstrokes, second, Larionov's vivid representation of nature, derived, Punin is at pains to point out, from a spontaneity of perception unique in Russia. Because Larionov "sees impressionistically" he is able to imbue his landscapes

with the flicker and glint of real life, whereas, for Punin, other practitioners merely copy the stylistic mannerisms of impressionism. However, Larionov shares this characteristic at least with Igor Grabar and Borisov-Musatov, whose impressionist works, though different in spirit, are handled in an equally vivacious way.

Contemporary critics, however, were unimpressed by Larionov's impressionist paintings. Tarovaty remarked, "The works of Larionov are good and successfully executed student pieces. One can't deny him a certain talent, but its too soon for him to be in such a hurry to appear in all the exhibitions simultaneously."[17] Indeed, shortly after this review Larionov contributed to yet another exhibition, that of the influential Union of Russian Artists. In Russia after the turn of the century, the way ahead for young artists was to attach themselves to an exhibiting group of established painters, and many *obshchestva* (societies), *tovarishchestva* (associations), and *soyuzy* (unions) exhibited, of which the Union of Russian Artists was the most important, following the demise

of the World of Art. The Union included the painters Benois, Bakst, Bilibin, Grabar, Dobuzhinsky, Korovin, Serov, and Somov, and it was among such company that Larionov again exhibited his impressionist landscapes in April 1906.

During the summer of 1906 Larionov returned to his grandparents' home in Tiraspol where each morning, using an old wooden door as an easel, he painted in the garden. On such a summer's morning Larionov received Diaghilev's letter inviting him to exhibit at the *Salon d'Automne* in Paris. Diaghilev was planning an exhibition of historical and contemporary Russian art and he asked Larionov to help organize the exhibition at the Grand Palais and be present at the opening on October 6. Larionov seized the opportunity and travelled to Paris with Diaghilev, Bakst, and Pavel Kuznetsov. Goncharova did not accompany them.

The Exhibition of Russian Art at the *Salon d'Automne* presented the development of Russian paint-

ing from the fifteenth century to the present day. It included icon paintings as well as the work of Nikitin and Matveev, who were among the first secular painters to reject such traditional canons in favor of the western tradition of easel painting. The portrait painters who flourished under Elizabeth and Catherine II were represented by Levitsky, Borovikovsky, and Rokotov, and works by Kiprensky, Venetsianov, and Bryullov exemplified Russian romanticism.

The only significant omissions from the exhibition included neoclassical works that were too large to be transported and works by the nineteenth-century realist painters known as the Wanderers (*Peredvizhniki*), although some work by Repin was shown. The World of Art had developed as a reaction against the realist aesthetics of the Wanderers and their ideas about the didactic role of art, so their omission was to be expected. The World of Art members were there in force—Benois, Bakst, Dobuzhinsky, Lanceray, Malyutin, Ryurikh, and Somov. As representative of the

Fig. 8. Viktor Borisov-Musatov, *Spring*, 1898–1901

Russian arts and crafts movement, works by Golovin and Vrubel from the Abramtsevo colony and ceramics from the colony at Talashkino were exhibited. The youngest Russian artists in the exhibition were Larionov and Goncharova and a loose affiliation of painters that included the Milioti brothers, Pavel Kuznetsov, Sergei Sudeikin, and Petr Utkin, who, shortly after, founded a symbolist group entitled the Blue Rose (*Golubaya roza*).

Larionov exhibited six landscapes in Paris of which only three are identifiable: *Roses* (fig. 6), *Garden*, which had already featured in the February World of Art exhibition, and *Flowering Acacias* (fig. 9). We know, however, that all Larionov's exhibits were considered impressionist in style since Shervashidze, in his review of the exhibition, identified Larionov along with Grabar, Lokkenberg, Meshcherin, Tarkhov, and Yuon as a group of impressionists who were exhibiting together in Room Seven.[18] All these painters were members of the Union of Russian Artists and they had evidently formed a group based upon their common adoption of an impressionist style.

Flowering Acacias was shown for the first time in Paris and then exhibited constantly, until it was bought by Nikolai Ryabushinsky in 1908, and reproduced in *Zolotoe runo*. *Spring* (fig. 10), bought by Ivan Morozov and later exhibited and reproduced in *Zolotoe runo* of 1908, is another impressionist work of this period that owes a debt to Grabar. The unusual viewpoint and use of boughs and branches to form a skeletal structure within which to display the dappled effects of foliage and sky recall Grabar's painting *February Azure* of 1904 (Tretyakov Gallery, Moscow).

The *Salon d'Automne* provided Larionov with valuable experience in organizing a large-scale exhibition. Furthermore, it was the first time that his works had appeared in an historical context where he and his contemporaries could be seen as heirs to five centuries of Russian cultural tradition. This focused his attention on the relationship between his own art and that of the past and was to be an important consideration when he later developed his neo-primitive style, based upon the traditions of the icon, *lubok* (Russian popular print), and nineteenth-century Russian *genre* painting. Finally, Larionov saw the large Cézanne and Gauguin retrospectives in the *Salon d'Automne* as well as the work of the Nabis, symbolists, and Fauves.

On his return to Russia, after a month spent in Paris, Larionov contributed to the fourth exhibition by the Union of Russian Artists held in St. Petersburg and Moscow during December 1906 and February

Fig. 9. Mikhail Larionov, *Flowering Acacias*, 1906

1907, respectively. At the Moscow venue Larionov exhibited a series of *Peacock* paintings as well as an impressionist canvas entitled *Spring Landscape*. The critics continued to acclaim Larionov's abilities but remained ambivalent about his use of them: "Larionov is a young and not ungifted artist but he provokes disappointment. His present path is that of impressionism or 'scientific painting' yet he stubbornly seeks the decorative. However, in decorative painting good style is the one and only condition. . . . All these peacocks of his are quite unsuccessful, and if the artist himself can't see it, then he doesn't possess the least artistic discrimination."[19] This reference to the decorative qualities of Larionov's painting is interesting as the first critical indication of his shift of sensibility from impressionism to symbolism. *Spring Landscape*, on the other hand, described by Grabar as an impressionist canvas, fared better in critical circles. Following the exhibition, the painting was purchased by the Tretyakov Gallery and

Fig. 10. Mikhail Larionov, *Spring*, 1906

this increased Larionov's standing among his contemporaries.[20]

Larionov also remained a member of the Moscow Association of Artists and in April 1907 contributed to their exhibition in the Historical Museum in Moscow. The critics again discussed the decorative qualities of Larionov's work. A painting of roses with large flaming petals now called forth admiration and the young artists were praised for their "new approach and youthful enthusiasm."[21] It was an interesting exhibition, bringing together a number of personalities including Vladimir Burlyuk, Vasily Kandinsky, Kazimir Malevich, Aleksei Morgunov, Aleksandr Shevchenko, and Georgy Yakulov, with whom Larionov later associated.

Initially Larionov befriended Malevich (1878–1935) and he later described how on their first meeting they sat all night, deep in discussion, opposite the Pushkin Monument on Tverskoi Boulevard.[22] Larionov found Malevich lacking in general culture and his theoretical work to be purely instinctive; nonetheless Malevich was passionately fond of painting and worked unstintingly, and this rendered them al-

lies for several years. Malevich thus became an important member of the successive avant-garde groups that Larionov led.

Larionov also met and shared a fruitful relationship with the Burlyuk brothers at this time. David Burlyuk (1882–1967) and Vladimir Burlyuk (1887–1917) lived at Chernyanka in the Crimea, but since the turn of the century had studied painting in Kazan, Paris, and Munich, where they had met Kandinsky, Yavlensky, and Verefkina. In the autumn of 1907 the Burlyuks arrived at the Moscow School of Painting and met Larionov and Goncharova. Almost immediately they planned an exhibition together entitled *Stefanos* (wreath) for, as Larionov later explained, each painting was to represent a flower and the ensemble a pictorial garland.[23]

The title, however, possessed more specific connotations. It referred to the cycle of symbolist poems entitled *Stefanos*, published by Valery Bryusov in 1906, and more generally to the widespread interest among the symbolist poets and painters in both flower symbolism and the mythology of ancient Greece. These preoccupations were chiefly reflected

through the pages of *Zolotoe runo* which entertained a decisively symbolist orientation since its editor, the wealthy Moscow banker Nikolai Ryabushinsky (1876–1951), was a member of the Blue Rose group.

It was no coincidence that Larionov, Goncharova, and the Burlyuks referred to these symbolist themes in the title of their exhibition, since a third of the contributors were members of the Blue Rose who had exhibited together in March 1907. This esoteric group of young symbolist painters believed that it was the function of art to transcend reality and communicate with the beyond. To this end they adopted a communal symbolism in their painting and a common stylistic approach. Their subject matter included pregnancy, fetal life, and flowing water painted in cool blue, grey, and green tones, which convey a melancholy impression. In this respect the work of Borisov-Musatov was important.

The inclusion of Blue Rose artists in the *Stefanos* exhibition marked a new direction for Larionov. He turned away from impressionism to embrace symbolism. However, it was neither the morbid symbolism of the Blue Rose, nor the occult symbolism of artists such as Vrubel and Beardsley, but rather the gentle symbolism of Borisov-Musatov and the evocative atmosphere of his landscapes to which Larionov was attracted.

Larionov's *Garden* (fig. 11), exhibited at *Stefanos* and later reproduced in *Zolotoe runo*, exemplifies this shift of sensibility. The shapes of trees, bushes, and foliage are now indistinct and merge together while sunbeams cutting through the foliage create alternating shafts of light and shade that add to the suggestive atmosphere of the landscape. Larionov's style here recalls that of Borisov-Musatov whose later works, such as *Hazel Bush* of 1905 (Tretyakov Gallery, Moscow), are vague and misty with soft-edged forms blurring into one another. Larionov's use of clusters of vertical lines to represent the grasses and the generalized shapes of leaves hanging from shrubbery are all features that occur in Borisov-Musatov's art.

The opening of *Stefanos* in the Stroganov School in Moscow in December 1907 was concurrent with the opening of the fifth exhibition by the Union of Russian Artists in adjacent premises. The Union had achieved a reputation among the Russian public and this exhibition was enormously successful, attracting over ten thousand visitors, though Larionov's work received a mixed reception in critical circles.[24]

In January 1908 Larionov joined *Zolotoe runo* as a coeditor of the art section and remained with the magazine until it ceased publication in 1910. Nikolai Ryabushinksy, the editor, was also an influential col-

Fig. 11. Mikhail Larionov, *Garden*, 1907

lector of contemporary painting and had already purchased three of Larionov's *Acacia* paintings. Sergei Polyakov, editor of the literary magazine *Vesy*, was an equally enthusiastic collector of Larionov's works at this time. Polyakov had purchased Larionov's painting *The Water Seller* on behalf of the magazine in early 1908, and by the end of 1909 he had bought five paintings by the artist.[25] The patronage of Ryabushinsky and Polyakov, and Larionov's post as coeditor of *Zolotoe runo*, opened a new range of contacts for him among Russian symbolist writers and intellectuals. A. K. Toporkov, who wrote for *Zolotoe runo*, the French poet René Ghil, who was a "foreign correspondent" for *Vesy*, and the writer Poznyakov all became his friends and patrons.[26]

Larionov's introduction into symbolist circles confirmed his allegiance to the "decorative" qualities of his art, which had been increasingly noted by the critics, as well as to the subject matter of lilacs and peacocks with which he had been experimenting. It was no coincidence that René Ghil purchased Larionov's painting *Lilac in Front of the Setting Sun*, since the lilac, with its pungent perfume and opulent blooms, was an evocative image for the symbolists.

Similarly, the peacock had become a leitmotif of European symbolism during the 1890s. The sinuous curves and mystique of its ornate plumage attracted artists such as Aman-Jean, Degouve de Nunques, and Edgar Maxence. Peacock imagery was also employed by contemporary designers in Art Nouveau vases, jewelry, and posters. In Russia the writer Miré published a story entitled "The Peacocks" in *Zolotoe runo* in 1906, and Larionov had adopted the subject at about the same time for those works criticized as "decorative" and "unsuccessful" at the fourth exhibition of the Union of Russian Artists. Another, more recent work, *White Peacock*, was exhibited in March 1908 in the Wreath exhibition in St. Petersburg.

The Wreath exhibition of 1908 (*Vystavka kartin "Venok"*) was organized by Sergei Makovsky and Aleksandr Gaush, and although Larionov contributed to this new exhibition, he had no hand in its organization. Several artists participated, including members of the Blue Rose, Ryurikh and Tarkhov from the Union of Russian Artists, and Yavlensky from Munich. The exhibition was once again symbolist in content. The critics characterized the paintings on show as "hymns" to the sun and air and as an "expression through color-symphonies of one's inner experience."[27] Of Larionov's exhibited work his painting *Garden in the Morning* may have exemplified the latter trend, while his *White Peacock* drew on symbolist iconography. His *Water Seller* was also exhibited.

During late 1907 and early 1908 Larionov executed several other works which are noteworthy. *Rain* (fig. 12) was clearly inspired by his collaboration with Blue Rose artists and is comparable to Pavel Kuznetsov's *Blue Fountain* of 1905 (Tretyakov Gallery, Moscow). Both paintings picture falling water and are executed in a palette of blues and greys. In addition, the vertical brushwork in Larionov's painting which contributes to the effect of pouring rain is not unlike the vivid pattern of strokes employed by Kuznetsov.

Larionov's series of *Bathers* (see fig. 13) were also begun at this time but these represent a new stylistic approach. Here the figures are crudely articulated and unevenly modelled, the density of paint varies from impasto to bare canvas, the bathers occupy awkward postures in unconventional compositions, and the texture of the paint is now autonomous, making it difficult to read the large green strokes of paint as hanging foliage. This again relates to Blue Rose practice and specifically to their cruel figurative distortions, though Larionov does not use these devices for psychological ends. *Bathers* is a transitional painting which represents the first investigation of stylistic principles and devices that Larionov elaborated in his figure painting of 1909 and that later informed his neo-primitive practice.

Larionov exhibited both *Rain* and *Bathers* at the Salon of the Golden Fleece held in Moscow during April–May 1908. The Salon was financed by *Zolotoe runo* and included a wide range of modern and contemporary French painting as well as contemporary Russian art. Nikolai Ryabushinsky enlisted the help of the French art critic Alexandre Mercereau to choose the French exhibits, and Larionov was delegated to approach the two collectors Ivan Morozov and Sergei Shchukin.[28] Morozov would lend only Russian paintings to the exhibition, such as Larionov's *Spring* (fig. 10), which he had recently purchased, and Shchukin refused to lend at all, claiming that he was about to exhibit the paintings himself.

The Russian section of the exhibition included the work of Larionov, Goncharova, and Blue Rose artists such as Fon Vizen, Kuznetsov, Matveev, Vasily Milioti, Ryabushinsky, Saryan, and Utkin. Larionov dominated the section with thirteen paintings which included works from the *Garden*, *Roses*, and *Lilacs* series, and more recent canvases such as *Rain* (fig. 12) and *Bathers* (fig. 13). This was the first exhibition in which Larionov had shown *Rain*, which, together with his symbolist contacts at the time, suggests a date in late 1907 or early 1908 for its execution. In addition, the reproduction of *Bathers*, with its restrained color range, in *Zolotoe runo* of October 1908,

Fig. 12. Mikhail Larionov,
Rain, 1907–1908

indicates that a second series of *Bathers* by Larionov, executed in a cruder style and painted in red, white, and green, belong to a later period and should not be confused with this first series. Finally, Larionov's paintings, *Roses* (fig. 6), *Flowering Acacias* (fig. 9), and *Spring* (fig. 10) may all be identified in the installation photograph of the exhibition (fig. 14) alongside other works by the artist. Given that he would likely show his most recent work as well as his earlier at this exhibition, it is clear from this photograph that by March 1908 Larionov had not progressed beyond impressionism and symbolism.

Modern and contemporary French painting was given a broad representation at the exhibition. The later work of artists such as Renoir, Van Gogh, Gauguin, Cézanne, Pissarro, Signac, Cross, and Toulouse-Lautrec was shown. There was also a large body of

symbolist work by Bourdelle, Carrière, Desvallières, Redon, Rodin, and Rosso, among others, and paintings by members of the Nabis such as Maurice Denis, Bonnard, Vuillard, Sérusier, Vallotton, and Roussel. The Fauve group were also represented, with paintings by Derain, Friesz, Marquet, Matisse, Puy, Rouault, Valtat, and Van Dongen.

The exhibition attracted an audience of over six thousand and aroused considerable interest.[29] It was the first time that work by many of these painters had been exhibited in Russia and the quality and diversity of their work had a profound effect on the younger generation of Russian artists. Aleksandr Kuprin, a close friend of Larionov at the time, later recalled:

Times had changed and a new orientation had been initiated—an orientation towards the French. Dur-

Fig. 13. Mikhail Larionov, *Bathers*, 1907–1908

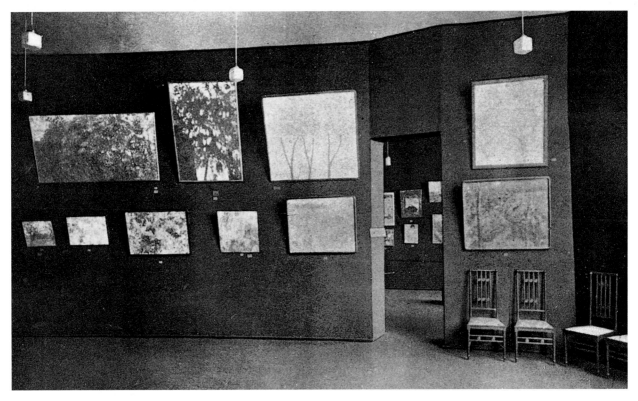

Fig. 14. The Salon of the Golden Fleece, 1908

ing the summer I was in a life drawing class. I drew life studies, male and female, in clear imitation of Cézanne, Van Gogh, Manet, Derain and others. Even my palette had been altered. Derain, Cézanne, Matisse and Van Gogh had turned all my conceptions about color upside down and completely transformed them. . . . This was a mutiny. The old art that had turned sour on us was radically rejected.[30]

Following the closure of the exhibition in June 1908, *Zolotoe runo* played an important role in promoting the aesthetics and ideology of French modernism.[31] Both Maurice Denis and Rodin became co-editors of the magazine and the July–September volume included no less than ninety-four reproductions of French paintings that had been on exhibition. The magazine also published scholarly articles and artists' texts, among them the essay by Tasteven, "Impressionism and New Trends," an essay by Maksimilian Voloshin, "The New Orientation in French Painting," one by Charles Morice, "The New Tendencies of French Art," and a translation of several of Van Gogh's letters.[32]

Larionov's initial response to the French exhibits

in the Salon of the Golden Fleece was to brighten his palette and move away from the opulent tones of the symbolists. In a series of paintings entitled *Fishes* (fig. 15), executed during the summer of 1908, Larionov employed bright reds, yellows, peaches, and oranges in some of the fish scales to contrast with the cooler range of whites and greys in others. These paintings are notable for their light brushwork and the harmony of their coloring. Larionov exhibited three of them at the Link exhibition in Kiev in November 1908. The exhibition was arranged primarily by Aleksandra Exter and the Burlyuk brothers who invited Larionov, Goncharova, Baranov-Rossiné, Aleksandr Bogomazov, Fon Vizen, Lentulov, Matveev, and a number of local artists to participate. The Link was notable in that it displayed the first works to have been influenced by the French section of the Salon of the Golden Fleece, the first fruits of the young Russians' dialogue with French modernism, a dialogue that continued until 1914. Furthermore, the Link may be considered the first exhibition of a self-conscious avant-garde group in Russia: the exhibitors distributed a provocative manifesto which decried the art of the past; the Wanderers were described as "hooligans of the palette"; "the chaff-like ghost of

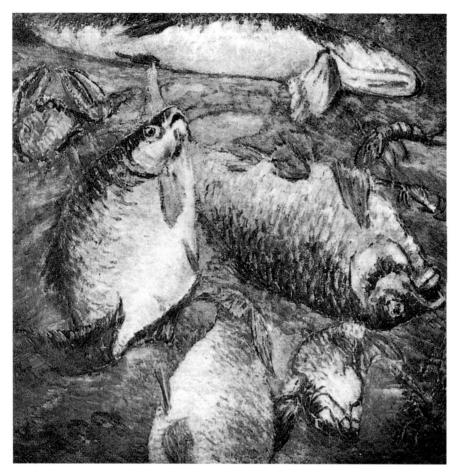

Fig. 15. Mikhail Larionov, *Fishes*, 1908

Repin" was being blown away and the "bast shoe" of oppression was described as losing its grip. The artists of the Link agreed, however, to tolerate Serov, Levitan, Vrubel, and "the literary Diaghilevians." The group identified their chief source as "western models . . . Gauguin, Van Gogh, Cézanne (a synthesis of French pictorial trends)" and concluded that only in their own art lay "the hopes of a renaissance of Russian painting."[33]

Both the exhibition and manifesto aroused hostility among the reviewers, and the artists were most commonly criticized as being weak practitioners of the styles they sought to emulate. The most biting critic was Chuzhanov who argued that the artists of the Link had little in common with the aesthetic principles elaborated by Cézanne, Van Gogh, and Gauguin and concluded: "The majority are simply not able to paint. . . . You may ask: 'Surely, isn't there one work at the exhibition that deserves serious attention?' I reply: 'There are some, but so insignifi-cantly few that they are literally buried in a sea of faded bluish rags.'"[34]

In their comments on the manifesto the critics became hysterical. One, referring to a fable by Krylov, likened it to "the discordant brayings of that same foolish donkey that finished off an old sick lion in a cave," the point being that any ass (the Link) could dispense with a dying lion (the Wanderers).[35] Chuzhanov on the other hand simply declared the manifesto "illiterate." These reviews represented a reaction to two new trends established by the Link, which were seen as a dangerous threat to the Russian art establishment: the development on Russian soil of that "extreme modernism" associated with contemporary French art, and the ability of this young generation of painters to propagandize and fight for their own point of view. And indeed the Link was crucial in the future development of the avant-garde in Russia.

The Golden Fleece

1908–1910

■

The two years that elapsed following the Link exhibition were decisive in Larionov's career. During this period his aesthetic ideology was turned upside down by the revelation of French modernism at the Salon of the Golden Fleece. Having tested the possibilities of Cézanne, Van Gogh, Gauguin, and Denis, he quickly assimilated a Fauve barbarity of style into a personal mode of pictorial expression. Larionov's fortunes were bound up with the success of the Golden Fleece enterprise. Through the magazine, the exhibitions it promoted, and especially through his friendship with Nikolai Ryabushinksy, Larionov established his reputation as one of the leading members of the young avant-garde. His public misbehavior undoubtedly contributed to his reputation, especially when he was expelled from the Moscow School in 1910 for leading a student demonstration and was forced to enter the army, marking a new period in his life and creativity.

The Golden Fleece exhibition of 1908 had opened up wide-ranging critical debates in Russia about the nature of modern French art. During the winter of that year and the following spring Larionov, in common with many young painters of his generation, continued to respond to French modernism and to evaluate its achievements in the context of his own work. Larionov's investigations, however, were neither consistent nor coherent at this time. It was not easy for the Russians to interpret twenty years of French modernism in the wake of the Golden Fleece exhibition, and the stylistic diversity evident in Larionov's paintings of this period reflect his attempt to come to terms with the complexity of French developments.

Cézanne was increasingly admired by both Russian and western critics and several of Larionov's works reflect the impact of Cézanne's still lifes. In Larionov's painting *Pears* (fig. 16) the floral wallpaper and use of a cloth to provide a bright counterpoint to the composition specifically allude to Cézanne's canvas *Fruit* c. 1880 (Hermitage, St. Petersburg), which then formed part of the Shchukin Collection. Although

the density of paint and color modulation in the Cézanne evoke a sense of form and tangibility that is lacking in the Larionov, *Pears* nonetheless recalls the flattened forms, lack of recession, perspectival distortion, and interest in modelling through tonal gradation that are found in Cézanne's later works. Larionov himself esteemed Cézanne highly and later reexamined Cézanne's technique in works such as *The Camp* of 1911 (Tretyakov Gallery) which displays the same integrated patchwork of colors to be found in Cézanne's *Mont Sainte-Victoire* of 1905 (Pushkin Museum), then in the Shchukin Collection.

The impact of Gauguin and Fauve painting may also be traced at this time in Larionov's painting *Heads of Bathers (Study)* (fig. 17). Here the posture of the bather with her arm raised behind her head copies that of the Tahitian girl in one of Gauguin's carved panels for the *Soyez Mystérieuses* series which was illustrated in *Zolotoe runo* in January 1909.[1] In style, however, Larionov emulates the aggressive brushwork of the Fauves, the violent contrast of their colors, their crude figure-drawing, and the masklike features employed in their depiction of the human face. Larionov also quotes motifs from Gauguin's work. The figure of the fisherman that appears in *Bathers* (fig. 18) and in a later etching by Larionov (fig. 19) is borrowed directly from Gauguin's *Green Christ* 1889 (Musée des Beaux Arts, Brussels). *Bathers* is also indebted to Gauguin's painting *The Red Beach* and Fauve paintings of bathers such as *The Pastime of the Gods* by Jean Puy, both exhibited in the Salon of the Golden Fleece.

Through the Nets (pl. 3) is related to *Bathers* but is a more unusual and advanced composition. The coarse brushwork makes a variety of pleasing textures against the weave of the canvas. Outlines are only vaguely indicated and shapes and forms generalized until they are almost unrecognizable. The rocks in the sea, the bathers on the shore, and the fish on the sand are illusive images. The high viewpoint which flattens the picture space and the thin webbing of the

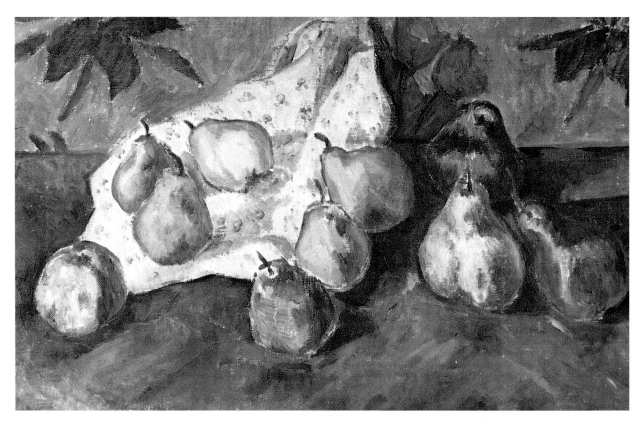

Fig. 16. Mikhail Larionov, *Pears,* 1908

fishing nets supported on a pole reveal an interest in the decorative patterning of the flat painted surface and recall the formalist position expressed by Maurice Denis that "a picture . . . is essentially a plane surface covered with colours assembled in a certain order."[2] The sensuous blues and greens and the lemon yellows of Larionov's palette recall the evocative approach to color used by the Nabis. The influence of Denis waxed strong in Russia at this time because of the invitation to join *Zolotoe runo* as a guest editor and due to the fact that he visited Moscow in January 1909.

Restaurant on the Sea-Shore (Denisov Collection, Moscow), however, is more indebted to Seurat with its modern-life subject matter and the disposition of the figures modelled upon Seurat's *Grande Jatte* of 1883–1885 (Art Institute of Chicago). This correspondence with Seurat's work is particularly interesting as up to the end of 1908, when a drawing was reproduced in *Zolotoe runo,* Seurat was practically unknown in Russia. He was one of the few artists who was not shown at the Golden Fleece, and none of his paintings existed in any of the major public or private collections in Russia. Only in July 1911, when Sher-

vashidze published an article on the artist in *Apollon,* was Seurat acknowledged.[3]

Apart from the static and posed attitudes of the figures, the style of *Restaurant on the Sea-Shore* is unlike Seurat's neo-impressionist technique. Larionov's figures are flat, monochrome, schematized shapes outlined in black. These devices were derived from the *lubok* (Russian popular print), which exerted an increasing influence upon Larionov's work, and the fact that western artists such as Van Gogh had already appreciated the stylistic qualities of old prints and incorporated such devices into their own work can only have strengthened Larionov's interest in their qualities.

While painting these works during the winter of 1908 Larionov collaborated on a second Franco-Russian exhibition, again organized by the magazine *Zolotoe runo.* When the exhibition opened in January 1909 it was half the size of the first Salon and now more Russian artists than French had been invited to participate. The Russian contingent included, among others, Larionov, Goncharova, Kuznetsov, and Kuzma Petrov-Vodkin, while the French section comprised only artists associated with the Fauves in Paris,

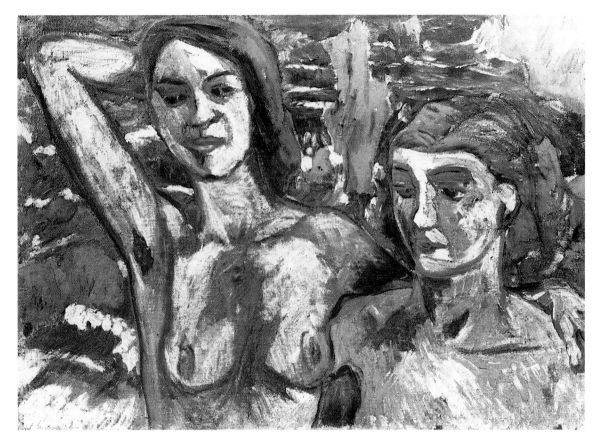

Fig. 17. Mikhail Larionov, *Heads of Bathers (Study),* 1908

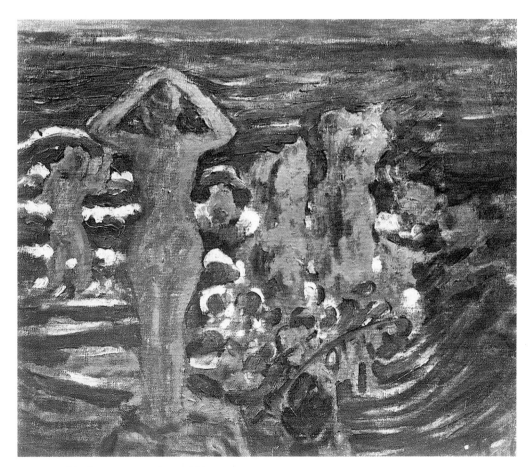

Fig. 18. Mikhail Larionov, *Bathers,* 1908

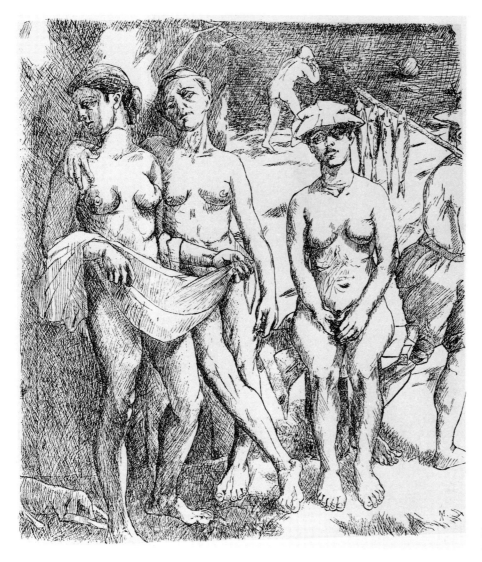

Fig. 19. Mikhail Larionov, *Bathers*, 1909

painters such as Braque, Derain Vlaminck, Friesz, Marquet, Matisse, Rouault, and Van Dongen. From this point of view, however, the exhibition was notable as it included Braque's canvas *Le Grand Nu* as well as an early cubist still life by him.

Having survived the hail of criticism occasioned by the Link and given the context of French Fauvism, Larionov submitted his most recent works to this second Golden Fleece exhibition. He showed *Fishes* (fig. 15), *Pears* (fig. 16), *Heads of Bathers (Study)* (fig. 17), *Through the Nets* (pl. 3), *Restaurant on the Sea-Shore* and the latest in his series of *Peacock* paintings (fig. 20). Goncharova's work was equally radical for she too had been influenced by the Salon of the Golden Fleece the year before. Generally the second Golden Fleece exhibition was welcomed with enthusiasm, and by the time the exhibition closed in February, more than eight thousand visitors had passed

through its doors.[4] In addition, Larionov made some prestigious sales. Troyanovsky bought *Pears*, Sergei Polyakov purchased *Restaurant on the Sea-Shore* on behalf of *Vesy*, and the English Club in St. Petersburg acquired *Peacock*. However, the exhibition did not meet with critical success. Grabar wrote:

Larionov's works . . . are more serious and almost devoid of that veneer of "slickness" and cheap tomfoolery that has so far spoiled his most talented pieces. A most successful still life, representing pears on a light-green ground with pink pieces of cloth thrown down by their side, is better than the rest. He is much weaker when not painting from life. His *Peacock* is devoid of any sense of rhythm. Looking at it, one must advise Larionov to avoid the horns of a dilemma: he apparently wants to reject naturalism here but has not embraced "the

Fig. 20. Mikhail Larionov, *Peacock,* 1908

decorative"; the result is frigid, dull, and unnecessary. One looks at the whole wall of Larionov's paintings with pleasure and is glad that the work of this "Frenchman" is no worse than the row of exhibits by little Matisses.[5]

Grabar's description of Larionov as a "Frenchman" is particularly interesting as it demonstrates a contemporary awareness of the degree to which Larionov's painting was indebted to French example.

An important event in this respect was the visit of Maurice Denis to Russia in January 1909 to endorse the hanging of his five *Psyche* panels in the home of Ivan Morozov. It is by no means certain that Larionov met Denis at this time but we know that Denis was entertained by, among others, Ryabushinsky who gave him tea at the offices of *Zolotoe runo* before introducing the artist to his collection of Russian "Fauve" paintings.[6] *Zolotoe runo* continued to publi-

cize French Art and in its May and June issues serialized the recent essay by Maurice Denis entitled "From Van Gogh and Gauguin to Classicism."[7]

Exposure to the art and ideology of French modernism necessarily provoked a strong response among the Russians, and several striking developments took place in Larionov's art during the summer and autumn of 1909. In figurative paintings such as *Woman Passing By* (pl. 4) and *The Gypsy* (fig. 21) Larionov took as his subject the peasant women he observed in and around Tiraspol. These were his first direct portrayals of peasants and he depicted them in monumental terms. Their figures fill the canvas and are characterized by strong contours and a bold approach to modelling. These works represented a radical departure from previous paintings in both the choice of subject and the rejection of the stylistic conventions of *Bathers* (fig. 13), in which the figures are modified by dappled light and foliage, and of *Through the Nets,*

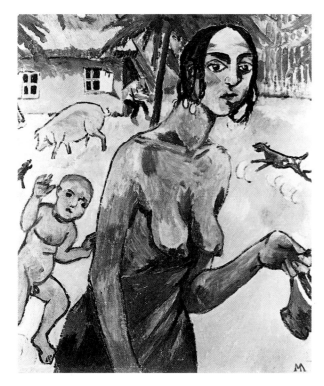

Fig. 21. Mikhail Larionov, *The Gypsy*, 1909

Larionov's new responsiveness to clarity of line and solidity of form may also be seen in the wider context of what Denis called a return to "classicism" among the French avant-garde. In the summer of 1909 Larionov read the essay "From Van Gogh and Gauguin to Classicism" in which Denis described a revival of classicism in the arts stemming from Van Gogh and Gauguin and characterized by a return to order and tradition. Denis himself responded to this prevailing trend in his paintings for Morozov, such as the *Psyche* panels and *Polyphemus* (Pushkin Museum, Moscow), which depicted classical themes in a style that recalled the work of Puvis de Chavannes and the quattrocento. The impact of this return to "classicism" may also be observed in the work of Petrov-Vodkin, who had studied in Paris during 1906–1908. In the second Golden Fleece exhibition Petrov-Vodkin showed his painting *The Shore* (Russian Museum, St. Petersburg) which, in its somber range of colors and the modelling of the figures, recalls Puvis de Chavannes but, in its subject of classical muses and bathers on the seashore, clearly evoked the work of Denis.

Larionov also tried this *genre* of classical beach scene, which Denis had popularized, in an etching published in the August number of *Vesy* (fig. 19). The print is similar in spirit to Denis' painting *Polyphemus* though Larionov repudiates the linear decorative style of Denis in favor of the well-modelled figures with firm contours that were characteristic of his easel painting at this time. Larionov even emulates Denis' monogram by arranging his own initials in a similar pattern. The use of the same monogram in the paintings *Spiders Web* and *Bare Feet with Foliage* (*Ex* Tomilina-Larionova Coll.) indicates that these works too were executed during 1909.

Larionov did not wholly commit himself either to the theoretical approach elaborated by Denis or to his view of French modernism. In his essay Denis warns against the unchecked influence of Van Gogh whose "subjective deformations" could cause young artists to lapse into romanticism. Larionov admired Van Gogh's work, and his painting *The Soldier's Tavern* (fig. 22), for example, is a reinterpretation of Van Gogh's *Night Café* (fig. 23), which was exhibited at the Salon of the Golden Fleece in 1908 and reproduced in color in *Zolotoe runo* (1908, nos. 7–9, pp. 58–59). Larionov's composition and viewpoint resemble those of the *Night Café* as do devices such as the ceiling light emitting bold yellow rays and the vacated table littered with empty bottles. Larionov also imitates the disposition of the two couples who are pressed against the walls of the *Night Café*. His

in which the figures are ill-defined and integrated with their context.

The reasons for this new concentration on monumental figures of peasant types are complex and difficult to reconstruct. The influence of Gauguin was certainly crucial and in *Heads of Bathers* Larionov had already investigated his approach to figure painting. Marianne Daulte has discussed the relationship between Gauguin's *Ea Haere Ia Oe* (1893, Hermitage, St. Petersburg) which had been acquired by Morozov in 1908 and Larionov's *Gypsy* (fig. 21). In particular she notes the similarity of subject, the same palette of colors, and an attempt to imitate the sculptural aspect of Gauguin's figure painting.[8]

In *Woman Passing By*, however, the linear treatment of the figure and the emphasis on the geometrical volumes of the face suggest the influence of monumental figure paintings by Picasso, such as *Dryad* and *Standing Woman* (1908, Hermitage, St. Petersburg), both acquired by Shchukin shortly after their execution. Goncharova's painting at this time passed through a similar phase and in an interview in April 1910 she explained, "I, like the latest Frenchmen (Le Fauconnier, Braque, Picasso), seek to achieve solid form, sculptural distinctiveness, and simplification of drawing."[9]

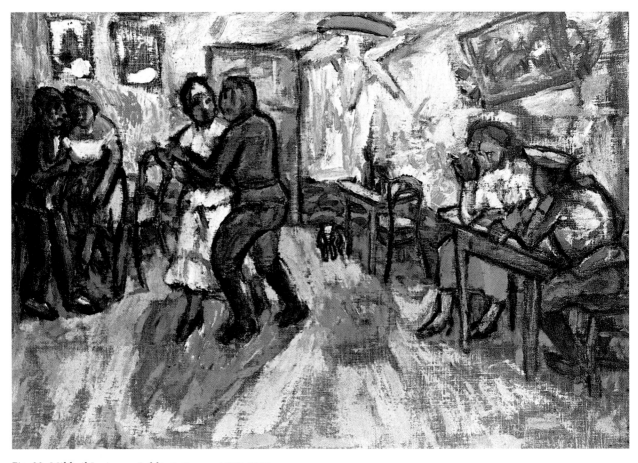

Fig. 22. Mikhail Larionov, *Soldier's Tavern*, 1909–1910

two significant departures are the substitution of dancers for the billiard table and the use of a different palette of colors. Nonetheless, the garish purple and yellow color scheme of *The Soldier's Tavern* and the vivid contrast of cobalt, white, and viridian clothes against scarlet shadows and reflections, certainly evoke the atmosphere of Van Gogh's interior where "one can ruin oneself, go mad or commit a crime."[10]

Larionov's move towards vivid coloring and his use of crude and aggressive brushwork also indicate his interest in Fauve theory and practice. The translation of Matisse's essay "Notes of a Painter" had recently been published in *Zolotoe runo* and Larionov applied the principles outlined by Matisse in a large group of works painted during the summer and autumn of 1909. In his essay Matisse argued that art served an expressive function and that there were various means by which the artist might express his feeling for life. These included the use of a decorative and expressive composition, the renunciation of super-

fluous detail, and the depiction of subjects in a deliberately crude manner. Matisse also advocated a purely instinctive use of color, without reference to scientific theory, and suggested simplicity as the best path for artists to follow.[11]

In a major canvas of this period entitled *Evening after the Rain* (pl. 5) Larionov follows Matisse's prescriptions exactly.[12] The painting is executed in a coarse and ungainly manner without the rhythm of brushstrokes that is found in Larionov's earlier work. The scene is depicted with a strict simplicity in which the branches and foliage of the trees in the foreground are reduced to their bare essentials. The exaggerated palette of colors is also striking and makes a mockery of what had once been called his "scientific impressionism," as indeed Matisse suggests it should. The result is bold and expressive. Another painting of this series is *The Blue Pig* (fig. 24), in which Larionov applies the same stylistic principles and again takes liberties with the color scheme. In this unusual landscape trees sprout huge red and

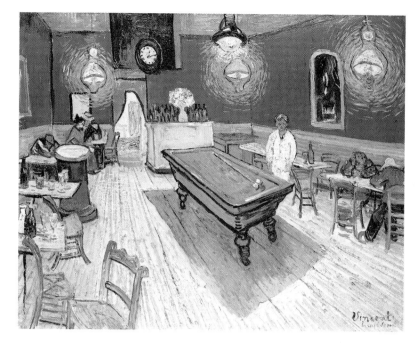

Fig. 23. Vincent Van Gogh, *The Night Café*, 1888

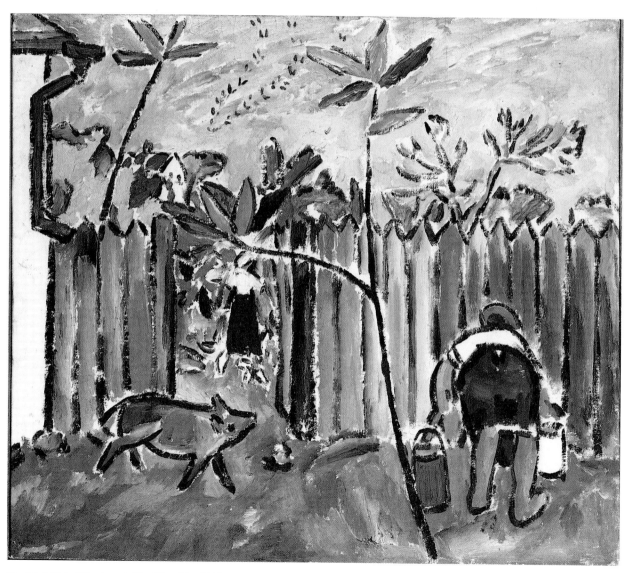

Fig. 24. Mikhail Larionov, *The Blue Pig*, 1909

black leaves and an ultramarine pig enjoys its morning stroll. Here, though, the crude style is echoed by a coarse sense of humor, and the spectator is affronted by a peasant's backside.

Both Matisse and Denis had discussed the use of "primitive" art forms in their respective essays. Matisse had cited the example of Egyptian statuary while Denis had drawn attention to the Tahitian idols, Breton calvaries, Japanese prints, and old *Épinal* woodcuts used by French artists from Van Gogh and Gauguin onwards. Both the French and German avant-garde invoked the characteristics of such art forms in their work and so it appeared that the question of "primitivism" was one that modern artists should address. Consequently Larionov and Goncharova turned their attention to indigenous Russian art forms such as the Russian icon, stone *baba,* and especially the *lubok.* In *Landscape after the Rain* and *The Blue Pig* the rejection of superfluous detail in favor of a simple and bold composition, the reduction of figures to a basic schema with stiff yet vivacious qualities, an instinctive use of color, and a general simplicity of means, while characteristic of Fauve painting and theory, were also features of the *lubok.* Larionov's development at this time was, therefore, clearly inspired by Fauvism, yet the insistence by the western avant-garde on "primitive" art forms also drew Larionov's attention towards purely Russian sources such as the *lubok.*

In other paintings from this period Larionov was inspired by the naive qualities of nineteenth-century Russian *genre* painting and particularly by works of the Venetsianov school, which was made up of self-taught artists who worked outside the academic system. The painting *Walk in a Provincial Town* (pl. 6), for example, is indebted to the work of Evgraf Krendovsky (1810–1853?) who is noted for his *Aleksandrovskaya Square in Poltava* (fig. 25), a panorama of provincial life painted in the early 1850s and acquired by the Tretyakov Gallery in 1908. Executed in a somewhat naive fashion, *Aleksandrovskaya Square,* like the paintings of modern life by the English artist W. P. Frith, depicts the "types" of Russian provincial society: the banker converses with a client, army officers mingle with townspeople, the young dandy cuts a dash with his top hat and cane, the middle classes take their promenade, the *kulak* rides into town, and the peasants go about their daily business, carrying buckets and gathering fagots.

Larionov, like Krendovsky, adopts a flattened and uncluttered picture space as well as a long, horizontal format in which to display the "types" he wishes to satirize. Although *Walk in a Provincial Town* is a less complex and more modern equivalent of *Aleksandrovskaya Square,* Larionov adopts some of the types Krendovsky observes, in particular, the dandy and the banker, though their dress is now reversed. The banker looks imperious in top hat, blue frock coat, pinstripe trousers, with gloves, tie pin, and cane, while the dandy sports a trilby hat and grey morning-coat. In the provincial society that Larionov paints, women have left their homes and families to

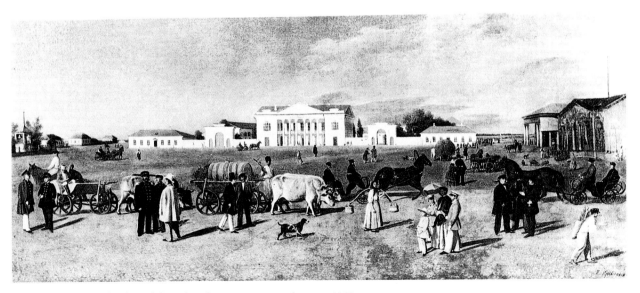

Fig. 25. Evgraf Krendovsky, *Aleksandrovskaya Square in Poltava,* c. 1850

show off the latest fashions down the high-street. The coquette wears a beret and *zouave,* while the rich lady, a masterpiece of Larionov's caricatural abilities, wears high heels for elevation and, modelling a fashionable pink dress and fluttering her fan in an ostentatious manner, proudly struts along.

In this canvas, Larionov singles out the trivial world of fashion, display, and affectation exemplified by the middle classes in Russian provincial society. Krendovsky had included dogs, pigs, and other farm animals in *Aleksandrovskaya Square* to form part of the picturesque local context. In *Walk in a Provincial Town,* however, the pig, which strolls up the street mingling with middle-class society, is a satirical device. It provides a witty and pointed contrast to these provincial "peacocks" and punctures the pretentious facade they present.

Although *Walk in a Provincial Town* was modelled on *Aleksandrovskaya Square,* the style of both the painting and the preparatory studies for it are quite different from that of Krendovsky's painting. The human figures are reduced to simple schemas in the manner of the eighteenth-century *lubok* and are presented as paper-thin "cut-outs" in frozen postures, with their constituent parts outlined in black. On the one hand this approach to figure painting exemplifies Matisse's reference to the static yet animated qualities of primitive art forms, while on the other, the linear simplicity of the painting acts as an expressive vehicle for Larionov's shrewd observation and witty analysis of the social behavior and class characteristics of the provincial bourgeoisie.

The same process may be noted in other figure paintings of the period, such as *Hairdresser* (fig. 26) in which the figures are drawn with a brief yet bold delineation, the faces are stylized, the figures adopt difficult poses, and the ill-proportioned limbs fail to relate in a naturalistic manner. Such devices firmly rejected the academic conventions of figure painting in favor of expressive needs.

In *Dancing* (fig. 27) the overall effect is more dramatic and the process of abstraction more advanced. The thrusting and intersecting diagonals of arms, legs, dresses, and jacket tails and the brisk texture of paint possess an expressive quality that is emphasized by the flat treatment of the figures. The color scheme is strong and vivid, executed in browns, yellows, orange, dark green, and dark blue with the faces modelled in orange and flesh pink. The subject of the dance had once been an important theme for symbolist painters such as Edvard Munch, and a year before, Larionov may well have been tempted by the symbolic content of such a theme. Here, however, there

are none of the sinuous curves and emotive color harmonies that typify symbolist treatments of the dance.

In works such as *Tavern Still Life* (fig. 28), objects undergo the same treatment as people. Here the *samovar* is depicted as a two-dimensional shape outlined in black and other objects are executed in a crude and hasty way. Furthermore Larionov does not attempt to convey any idea of form or volume as in earlier still lifes such as *Pears.* The plate, for example, is simply a maroon oval of paint. An interesting feature of the painting in this respect is its spatial ambiguity, with objects observed from conflicting points of view against the background of the table top so that they appear to float in space. Ambiguities such as these, combined with a lack of recession and shadow, are typical of the *lubok* tradition but may also be found in Fauve painting. Moreover, although the dazzling color scheme and bold wallpaper design may have been inspired by the decorative backgrounds of Fauve works, they are entirely Russian and entirely Larionov's.

The question of the extent to which Larionov responded to French Fauvism or indigenous Russian art forms at this time is complex. It has often been suggested that the *lubok* was an overriding factor in the choice of subject matter and style adopted by Larionov in the *Hairdresser* series. However, it may be argued that the figurative distortion, simplicity of contour, and flattening of form, as well as the subject of hairdressers, were to a certain extent shaped by the Fauves.[13] At the very least Fauve example and theory represented a crucial confirmation of the new path that Larionov was treading.

In a wider context, Larionov's adoption of a new approach to painting, emphasizing expressiveness in style and contemporary subject matter, may be seen as one aspect of a general reaction against symbolism that was taking place throughout the arts in Russia. Toporkov captured the atmosphere well: "The confines of subjectivity must be broken, a cognition and feeling for things must appear, people want to touch reality."[14]

Larionov's recent works fitted the bill admirably. Devoid of suggestive color harmonies, evocative atmospheres, and soft contours, these brightly colored paintings which treated everyday people and objects in a direct and witty way were the antithesis of the symbolist aesthetic. And, although Larionov would have never admitted it, one may even see a trace of the Wanderers in several of his paintings from 1908 to 1912 as well as in his aesthetic ideology during this period. Indeed, reviews of Larionov's work at the time

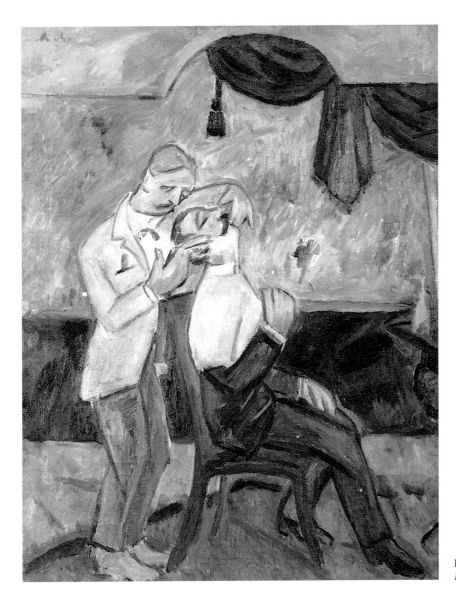

Fig. 26. Mikhail Larionov,
Hairdresser, 1909

identify him as no longer an impressionist but "a talented and innate realist" who stubbornly refuses "to proceed on his own two feet without first walking on his hands or crawling on all fours and then standing on his head"![15]

Larionov exhibited the majority of his recent works at the third and final exhibition by the Golden Fleece which opened at the end of December 1909 and closed at the end of January 1910. This time, however, French artists were not invited to participate and the exhibition featured only the work of Russian artists, including Larionov, Goncharova, Konchalovsky, Kuznetsov, Kuprin, Mashkov, Ryabushinsky, Saryan, Tarkhov, Ulyanov, Utkin, Falk, and Chekhonin. Among Larionov's exhibits here were *Woman Pass-*

ing By, The Gypsy, Walk in a Provincial Town, and its two studies *Portrait of a Provincial Coquette* and *Provincial Dandy*, as well as *Dough Kneaders, Dancing*, two versions of *Tavern Still Life, Evening after the Rain*, and *Hairdresser*. In the brief month that the exhibition was open, it was visited by over five thousand visitors. Generally Larionov's paintings were well received and by the end of the exhibition he had sold *Walk in a Provincial Town* to S. I. Kurlyand and *Evening after the Rain* to Sergei Polyakov.

Larionov also exhibited two sculptures at this Golden Fleece exhibition and these represented an important aspect of his artistic activity during 1909. Both Larionov and Goncharova were inspired by Gauguin's wooden idols which had been reproduced

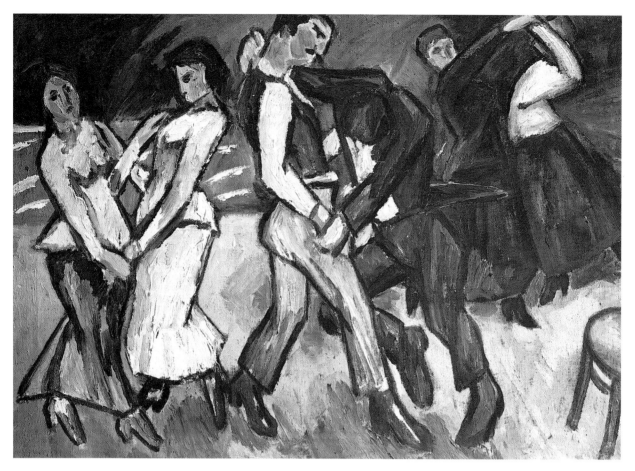

Fig. 27. Mikhail Larionov, *Dancing*, 1909

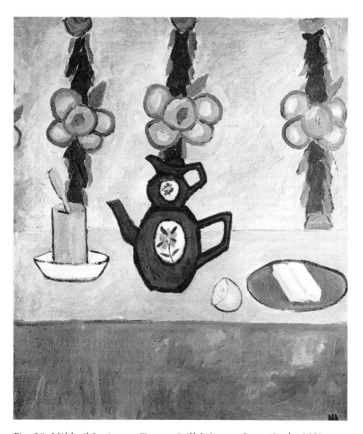

Fig. 28. Mikhail Larionov, *Tavern Still Life on a Large Scale*, 1909

in *Zolotoe runo*, as well as by an essay on Gauguin as a sculptor.[16] In addition, both artists were impressed by the "solid form" and "sculptural distinctiveness," as Goncharova put it, of the monumental figurative works of early cubism in the Shchukin collection. Larionov and Goncharova's attention had already been attracted to the medieval stone figures known as stone *babas* (see fig. 94), which littered the southern Russian steppe. Goncharova used such stone idols as the basis for her painting *God* of 1909 and exhibition reviews suggest that Larionov's sculptures of this period were concerned with the same theme. One critic, for example, referred to Larionov's wooden sculpture at the Russian Secession exhibition of summer 1910 as being "a stone *baba* of an antediluvian man."[17]

During the first half of 1910 Larionov made preparations for several exhibitions. The first was the immense International Exhibition of Paintings, Sculptures, Prints, and Drawings organized by Vladimir Izdebsky in Kiev. Izdebsky was a sculptor with an extensive range of contacts in both France and Germany. Consequently the exhibition included works by leading avant-garde groups such as the Nabis, the symbolists, the Fauves, representatives of early cubism, the Munich *Neue Künstlervereinigung*, and Russians from home and abroad. Izdebsky was one of the first to recognize the artistic importance of children's drawings, and four of these were exhibited as a finale to the exhibition.

Larionov also contributed to the seventh exhibition by the Union of Russian Artists held during February and March 1910 in St. Petersburg. The Union had become extremely successful and was attracting over sixteen thousand people to each exhibition, yet Larionov felt increasingly uneasy with what was basically a conservative organization, for he contributed only *Evening after the Rain* and a still life to the exhibition. This, in fact, was the last time that Larionov exhibited with the Union of Russian Artists. Aleksandr Kuprin later recalled, "Larionov used to say: 'One should plough up virgin soil and not ruminate over the deceased.' He was a very interesting character. He impressed us with his questing spirit."[18] Given the radical new developments in his art, Larionov evidently felt his relationship with the Union was now inappropriate; it was time to move on.

This change of direction was symbolized not only by Larionov's withdrawal from the Union of Russian Artists but by his larger contribution, and hence transfer of allegiance, to the exhibition of another union of painters, the Union of Youth (*Soyuz mo-lodezhi*), a recently formed confederation of avant-garde painters and poets comprising, among others, Pavel Filonov, Petrov-Vodkin, Olga Rozanova, Iosif Shkolnik, Eduard Spandikov, the painter and art critic Vladimir Markov (pseudonym of Waldemar Matvejs), and Zheverzheev, a rich patron who became the secretary of the Union. During the next four years the Union of Youth became the leading Russian avant-garde group in St. Petersburg, attracting the participation of Natan Altman, Ivan Klyun, Mikhail Matyushin, and Ivan Puni.

The Union functioned principally as an exhibiting society and developed as a reaction against conservative societies such as the Union of Russian Artists. Members of the Union of Youth entertained a free aesthetic ideology, painting in a variety of styles, and were keen to associate with other groups. Consequently they invited Muscovite painters, including Larionov, Goncharova, and Mashkov, to participate in their first exhibition in March 1910 and this marked the beginning of a fruitful collaboration between the progressive artists in St. Petersburg and Moscow.

It was Vladimir Markov who visited Larionov's studio in early 1910 to select works for the first Union of Youth exhibition to be held in St. Petersburg in March and for a second exhibition to be held in Riga during the summer under the title of the Russian Secession. The task was not easy. Markov complained that Larionov refused to loan him the paintings he wanted, preferring to impose his own choice. However, Markov noted: "I have taken two small but interesting works," one of which was the stone *baba* executed in 1909.[19] In addition to these, Larionov's exhibits at the Union of Youth included the paintings *Woman Passing By* and *Hairdresser* which had already been shown at the Golden Fleece exhibition. However, Larionov also exhibited previously unshown works from the same period—*The Waterseller* (*Ex* Tomilina-Larionova Collection), for example, another subject based on Russian life in which the figures were again executed schematically.

The Union of Youth exhibition attracted some harsh criticism. In Larionov's paintings Breshko-Breshkovsky observed only "misshapen figures" deformed "by some kind of malignant boils with loose-hanging stomachs and breasts."[20] The attitude of *Zolotoe runo*, on the other hand, was ambivalent; they wished to publish a biting review of the exhibition but were deterred by the fact that Larionov and Goncharova were exhibiting works that had already been shown in the last Golden Fleece exhibition:

The exhibition creates an extremely slovenly impression. Of its exhibitors, Goncharova, Larionov, and Mashkov are showing items which were in the Golden Fleece and some others, one of which is *Headache* (Goncharova) and the other *Water Seller* (Larionov). These three are the center of the exhibition. The works of the rest of the exhibitors bear the stamp of either a hopeless amateurism (Evseev, Matvei, Spandikov, Shkolnik, Filonov) or of cunning tricks, as with Bystrenin. They are neither works of sincerity of impulse nor of studiousness.[21]

The vehemence of the review by *Zolotoe runo* was not mitigated by the fact that the magazine was in its death throes. During 1909 publication of various numbers had been badly delayed and the last issue for November and December 1909 was not published until April 1910. This proved a fortunate turn of events for Larionov and Goncharova had become embroiled in a lawsuit with the press and he was able to publish in it an article in her defense entitled "Newspaper Critics in the Role of Morality Police."

The article explained that Goncharova had been invited by the Society of Free Aesthetics (*Obshchestvo svobodnoe estetiki*) to exhibit her work in association with a conference on their premises from 24 March 1910 onwards. A reporter from *Golos Moskvy* (*Voice of Moscow*) attending the opening of the conference was appalled by Goncharova's paintings and wrote a scurrilous review. The review caused a furor since it described Goncharova's work as "completely decadent and indecent," "exceeding all the pornography of dirty postcards," and claimed that young people were being exposed to "the most loathsome of paintings." The entire exhibition was subsequently sequestered by the police, three of the paintings were confiscated and Goncharova was charged with "an offence against public morality."[22]

Larionov, in his published defense of Goncharova, pointed out that the public had not been admitted into the conference hall and that the "pornographic" works were merely paintings of nude models representing heathen gods. The entire affair, however, was taken to the law courts, with Goncharova's case conducted by the renowned lawyer Mikhail Khodasevich. Khodasevich was a personal friend as well as an enthusiastic collector of Larionov's and Goncharova's work; he proved a staunch supporter of Goncharova's cause and in January 1911 won her case.[23]

By June 1910 Larionov and the Burlyuk brothers had again become friendly. They had last collaborated on the Link exhibition in November 1908 and since then there had been a lapse in communication between them. Larionov had increasingly associated himself with *Zolotoe runo* and with the Union of Russian Artists, interests not shared by the Burlyuks, who never identified or collaborated with the former and who ceased exhibiting with the latter in January 1907. By the summer of 1910, however, *Zolotoe runo* had foundered and Larionov had forsaken the Union of Russian Artists. Moreover, the paintings of both Larionov and the Burlyuks had recently been shown together at exhibitions such as Izdebsky's Salon and the Russian Secession organized by the Union of Youth in Riga.

This renewed contact led Larionov to accept an invitation by the Burlyuks to spend the summer at their home in Chernyanka, in the Crimea.[24] Larionov arrived at the end of May and during the summer painted portraits of both Vladimir Burlyuk and Velimir Khlebnikov (fig. 29), who was also a guest of the Burlyuks at the time. Khlebnikov (1885–1922) was an erudite and intellectual young poet from the province of Astrakhan who became a major cultural figure of the period. In 1908 he entered St. Petersburg University where he associated with the literary group around Vyacheslav Ivanov and Mikhail Kuzmin. He published a poem in Vasily Kamensky's journal *Vesna* (*Spring*), and a year later Kamensky introduced him to David Burlyuk and to the circle of the Union of Youth including Guro and Matyushin. In April 1910 the group published the almanac *Sadok sudei* (*Hatchery of Judges*) which included poetry by Khlebnikov.[25]

Larionov's portrait shows Khlebnikov at Chernyanka at the beginning of his career and captures the distinctive features of the poet as he concentrates on his book. But more than this, the aggressive brushwork of the painting, the dynamism of its lines, and the garish coloring of the bright orange hands and face against the white shirt act as a visual metaphor for the activity of Khlebnikov's fertile brain. This is the most Fauve of Larionov's works especially in the brisk treatment of the canvas around the figure—everything has an expressive force. The color, line, composition, and brushwork evoke the character of Khlebnikov himself, recalling Matisse's advice on expression and portraiture in "Notes of a Painter": "A work of art must carry in itself its complete significance and impose it upon the beholder even before he can identify the subject matter. . . . I perceive instantly the sentiment which radiates from it and which is instinct in the composition in every line and colour. The title will only serve to confirm my impression."[26]

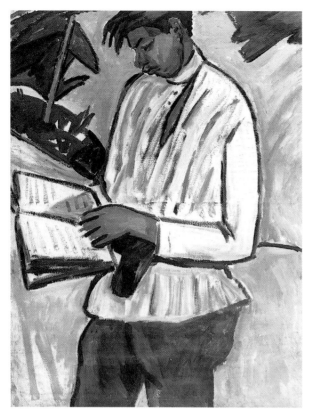

Fig. 29. Mikhail Larionov, *Portrait of Khlebnikov,* 1910

Following the summer with the Burlyuks and Khlebnikov, Larionov returned to the Moscow School of Painting. The School was undergoing a transformation which the students deplored. Aleksandr Kuprin was among the first to complain that the previously liberal School was becoming a conservative academy.[27] In a bid to halt this process Larionov led fifty students in a demonstration against the existing system of teaching and rules of behavior. Many of those taking part were expelled for a term or a year but, as Larionov had already been expelled once before and was considered a ringleader, the Council of the Moscow School expelled him without any possibility of future reinstatement.

On 24 September 1910 Larionov was awarded the diploma of painter, second class, and this officially terminated his education.[28] The Moscow School had now taken revenge, since without the exemption of a first-class diploma, Larionov was eligible for military service. Two options lay ahead: Larionov could volunteer for a year's service, or remain a civilian and subject to involuntary conscription with a longer term of service. With his twelve years as a student at the Moscow School at an end, Larionov volunteered.

CHAPTER THREE

The Jack of Diamonds and Donkey's Tail

1910–1912

■

The date of Larionov's military service has been the subject of much debate since the *terminus post-quem* of his soldier paintings rests upon it. Peter Vergo noted that Larionov's service might date either from autumn 1909 (as Isarlov stated) to summer 1910, when Larionov stayed with the Burlyuks at Chernyanka, or from 1910 (as Eganbyuri stated), perhaps in the autumn, after he received his diploma from the School, to the late summer of 1911. Vergo concluded that by either account Larionov's soldier paintings were not executed before 1909–1910, contrary to the dates later ascribed to them by the artist and subsequently accepted by art historians.[1]

John Bowlt, in reply, noted that the graffiti in Larionov's *Resting Soldier* (fig. 33) reads: "srok sluzhby [period of service], 1910, 1911, 1909, M.L.," and that as overpainting in this instance could be ruled out, the dates 1909–1911 should be accepted. However this solution is complicated by at least one contemporary drawing, which bears the inscription "srok sluzhby 1913 M.L."[2] According to the Soviet art historian Khardzhiev, Larionov was conscripted following his expulsion from the Moscow School and was required to complete eleven months of military service as well as an additional three months every summer for three years.[3]

Apart from the essay by Isarlov, which is factually unreliable, the only evidence supporting a date of 1909 is a document from the Office of Russian Refugees in Paris, submitted by Larionov in support of his application for French nationality in 1938.[4] This document states that Larionov had fulfilled his military obligations to the Russian army and cites the dates of his service as 1909–1910. It is unlikely, however, that Larionov would have begun service while still a student at the Moscow School. Moreover, this document was based on Larionov's own testimonial, which after twenty years may have been inaccurate.

Indeed, other dates in the document, such as that of his father's death, given as 1904–1905, appear to be approximate.

Given that Larionov was expelled from the School in September 1910 and awarded a second-class diploma, it seems logical to agree with Eganbyuri that Larionov's service began in this year, and with Khardzhiev, that it continued into 1911. In fact the archives of the Moscow School cite these dates as those of Larionov's military service and Pospelov has since confirmed them through his own research.[5] As to the length of service, we know from the memoirs of Livshits and the logbook of Kirill Zdanevich that volunteers served for one year and that their term began in October.[6]

Larionov's application for service was accepted by the First Ekaterinoslavsky Life Grenadier Regiment of Aleksandr II. The Regiment was based in Moscow and Larionov spent the winter serving in the Kremlin and the summer in a tent camp on the outskirts of Moscow. As a volunteer Larionov was treated better than those recruited forcibly. He continued to live in private accommodation and, if his service was like that of Livshits, he joined his company at 8 a.m., thus missing the early morning drill. Larionov's friendship with the platoon commander is revealed in two double portraits by Goncharova (fig. 30). According to Eugene Mollo, Larionov made known he was an artist and was commissioned to paint a mural in the mess. The painting, executed in minute detail "in the style of Vereshchagin," represented a realistic battle scene depicting the exploits of the regiment during the Russo-Japanese war.[7] Larionov's uncharacteristically detailed approach may have been dictated either by the tastes of his platoon commander or by his own desire to spin the work out and obtain time off from routine duties.

During the course of his service Larionov kept up

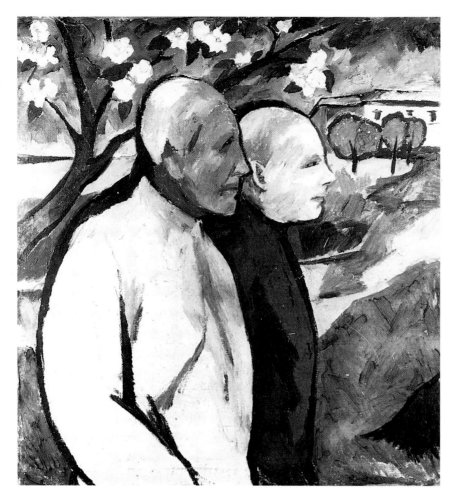

Fig. 30. Nataliya Goncharova, *Larionov and His Platoon Commander*, 1911

with artistic events and in late 1910 became a founder member of the Jack of Diamonds group. It was the painter Aristarkh Lentulov who first proposed the idea of an alternative exhibition society for young artists who objected to the policies of the established groups. Lentulov enlisted the support of Larionov, Goncharova, the Burlyuk brothers, Konchalovsky, Mashkov, Falk, and Kuprin, and Larionov's first contribution was to name the society. Although Larionov claimed he chose the name "Jack of Diamonds" (*Bubnovy valet*) because he liked the sound of the words, it had other significance. Pospelov (1980) contends that the name was a contemporary sobriquet for prisoners, and that the group adopted it to suggest their role as social outcasts. However, the name also referred to playing cards, which Larionov and his colleagues collected along with Russian *lubki*, Chinese and Japanese prints, and French Épinal woodcuts, all of which could be bought cheaply in the Moscow flea markets.

Russian painters in Germany, such as Kandinsky, Verefkina, and Yavlensky, who led the *Neue Künstlervereinigung* in Munich, were also interested in these objects. In fact, the Burlyuk brothers were in contact with this group and contributed to the second exhibition of the *N.K.V.* in September 1910. As a reciprocal gesture the Burlyuk brothers invited the leaders of the *N.K.V.* to exhibit at the Jack of Diamonds exhibition when it opened just two months later in December 1910 on Bolshaya Dmitrovka in Moscow. Of the German group, Bekhteev, Erbslöh, Kandinsky, Kanoldt, Münter, Verefkina, and Yavlensky all contributed to the Jack of Diamonds, as did the French artists Le Fauconnier and Gleizes whom Lentulov had befriended on a recent visit to France.

Prominent in the Russian section of the exhibition were Lentulov, Larionov, Goncharova, the Burlyuks, Falk, Konchalovsky, and Mashkov, as well as Exter, Malevich, and Morgunov. Larionov contributed recent paintings such as *Soldiers* (fig. 31) and *Street in a*

Province (pl. 9), based on his experience of military service and provincial life. *Soldiers* was deliberately crude in both subject and style.[8] The painting depicts a drunken soldier playing his accordion and singing a bawdy song while his companions curse and swear as they play cards. The soldiers are grotesquely deformed, objects are reduced to flat shapes without distinguishing features, and Larionov rejects a credible depth for ambiguous spatial relationships in which the soldiers and their accoutrements float against the ill-defined background of the mess.

The painting was inspired not only by the miserable life of the soldiers in the barracks but also by the *lubok* and the aspiration towards "primitivism" common among so many European artists of the early twentieth century. However, although Larionov's mode of aesthetic expression at this time ran parallel to that of the Fauves and the expressionists, it was not entirely dependent upon them as models, for his painting of this period is the most outrageous of all. No other artist of Larionov's generation scandalized their audience by scribbling vulgar graffiti verbatim across the canvas.

Street in a Province (pl. 9), on the other hand, is notable for its spontaneity of execution and expressive line—witness the easy schema for the dog which conveys its energy and movement. The coarse and emphatic brushwork, the use of bare canvas, the crudely attenuated shapes, and the flattened picture space are all reminiscent of Fauvism or expressionism, yet Larionov's paintings are quite original and these humble scenes of everyday life are filled with local color. Through shrewd observation and a vivacious handling of paint, the artist conveys his joy in the ordinary life of the Russian people and the landscape they inhabit. Scenes such as these are lifted above the banal and are invested with a grandeur all their own.

Works such as *Soldiers* and *Street in a Province* indicate that during the summer and autumn of 1910 Larionov continued to develop a more direct approach to representation. He had initially been inspired by the *lubok* but now other forms of graphic art, such as newspaper advertisements, attracted his attention. In later years the artist assembled an extensive collection of newspaper graphics and typography, but their influence may first be traced in his painting *Woman in a Blue Corset (Newspaper Advertisement)* also shown at the Jack of Diamonds.[9]

Paintings by Larionov's colleagues in the Jack of Diamonds, such as Mashkov's *Portrait of Vinogradova* (fig. 32), were equally forthright but were

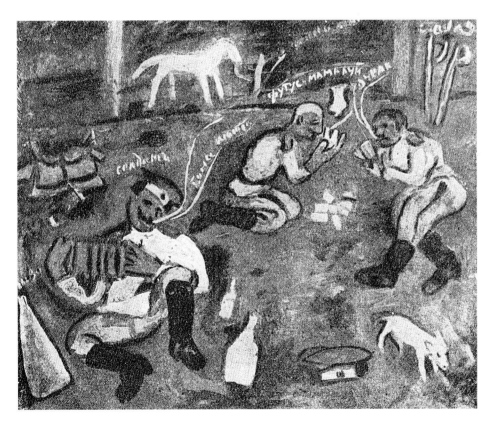

Fig. 31. Mikhail Larionov,
Soldiers, 1910

35

Fig. 32. Ilya Mashkov, *Portrait of Mme. Vinogradova*

inspired more by contemporary French example than by Russian sources. The simplified figure drawing and startling color combinations owe a debt to Fauvism while the exotic arabesques recall the decorative patterns used by Matisse in *The Red Room* of 1908–1909 (Hermitage, St. Petersburg), then in the Shchukin Collection.

The Jack of Diamonds thus provided a favorable context for Larionov's artistic development, in which he met artists whose aesthetic ideology and painterly practice, although more directly indebted to western example, was nonetheless akin to his own. Paintings such as those by Larionov and Mashkov were guaranteed to shock and scandalize the Russian public. The exhibition had been advertised in the press and on the opening day crowds of visitors flocked through the halls. However, as Lentulov recalled:

The public's conduct was extremely strained. Worthy people evaluated the exhibition with extreme disgust and indignation and attempted to leave quickly. . . . Critics and connoisseurs were bitterly quarrelling. One could see here or there a group of people heatedly arguing, or surrounding an artist with clever questions and derisive remarks: "Even I could have painted that," "This is a child's drawing," "This sketch is crudely done," and so on, and so forth.[10]

The reviews in the daily press did nothing to lessen the furor that the exhibition aroused.[11]

At this stage though, the Jack of Diamonds did not intend to provoke the audience. Konchalovsky later remembered that the group thought of nothing but painting and the resolution of artistic problems, but certain divisions were already apparent:

> . . . during the very founding of the Jack of Diamonds we didn't all relate to art in the same way. The dazzling painterly skills of Larionov and Goncharova, naturally rendered them our allies, but there was a big difference in our attitude to art. Mashkov, Kuprin, Lentulov, and myself—we looked at painting with some sort of blind, youthful passion, and we were not at all interested in the materialistic aspect of painting. But even at that early stage, Larionov's group dreamed of glory and fame and provoked all sorts of bally-hoos and scandals.[12]

Konchalovsky evidently had Goncharova's court case in mind which had been pending since her exhibition at the Society of Free Aesthetics. For the more conservative members of the Jack of Diamonds this proved embarrassing, especially as they were summoned to appear as witnesses to Goncharova's character. Although the "Queen of Diamonds," as she was named in the press, was finally acquitted, the group resented the fact that immediately afterwards Goncharova stated her intention to exhibit the offending works at Izdebsky's Salon 2 in Odessa, thus reopening the scandal.

Izdebsky's Salon 2, which also opened in December 1910, attracted the participation of Larionov, Goncharova, and several members of the Jack of Diamonds. Here Larionov showed paintings dating from 1909 such as *Tavern Still Life* (pl. 8) and *Provincial Coquette* (pl. 7), and recent works such as *Soldiers in a Café*. The exhibition was dominated by Kandinsky who exhibited many of his *Improvisations* and his first three *Compositions*. He also published his essay "Content and Form" along with his annotated translation of Schoenberg's essay "On Parallel Octaves and

Fifths" in the catalogue, which included three other essays emphasizing the relationship between painting and music and advocating a "synthetic" approach to the arts. Similar ideas were later important in the theoretical development of rayism where Larionov states an equivalence between color and sound.

During 1911 Larionov's military duties prevented him from participating in further exhibitions. However, five of his paintings were shown in the Union of Youth exhibition that spring in St. Petersburg as part of a special Jack of Diamonds section. Beyond this we know little of his activity until his military service terminated in the autumn of 1911.

Larionov's reemergence in the Muscovite art world coincided with the arrival of Henri Matisse in Moscow during October 1911 to inspect the installation of his two large panels, *Music* and *Dance*, executed for Shchukin. Larionov met Matisse during his visit at a reception organized in his honor at which Matisse was reported to have talked a great deal with the artists of the Jack of Diamonds who "listened reverently to their *maitre*."[13]

Matisse was enthusiastic about the icons he saw in the private collections and museums to which Ilya Ostroukhov took him, and his comments were reported in the daily press. One newspaper recorded Matisse as saying: "This is primitive art. This is authentic popular art. Here is the primary source of all artistic endeavor. The modern artist should derive inspiration from these primitives."[14] Larionov had appreciated the artistic qualities of icons long before Matisse and had already begun his own impressive collection. However, for Matisse to substantiate the view that icons were inherently beautiful and should "inspire" the "modern artist" would have confirmed the course of Larionov's aesthetic ideology.

Following his release from service Larionov once again exhibited regularly. In particular he held a retrospective exhibition at the Society of Free Aesthetics in Moscow on 8 December 1911. Although a large show it lasted only one day and was among the first of a series of such events planned by the Society.[15] This famous "one day" exhibition featured over a hundred works in different media and was hung in a chronological order. The first fifty paintings represented his impressionist and symbolist periods. Then followed works from 1909 such as *Provincial Dandy* (fig. 77), *Woman Passing By* (pl. 4), and the *Tavern Still Life* series, works of 1910 such as *Bread* (fig. 88), and soldier paintings such as *Salvo* and *Bathing Soldiers* (Tretyakov Gallery, Moscow). *Resting Soldier* (fig. 33), exhibited here for the first time, is an important painting in this series; the distorted posture of the soldier and the ambiguous interrelationship of his

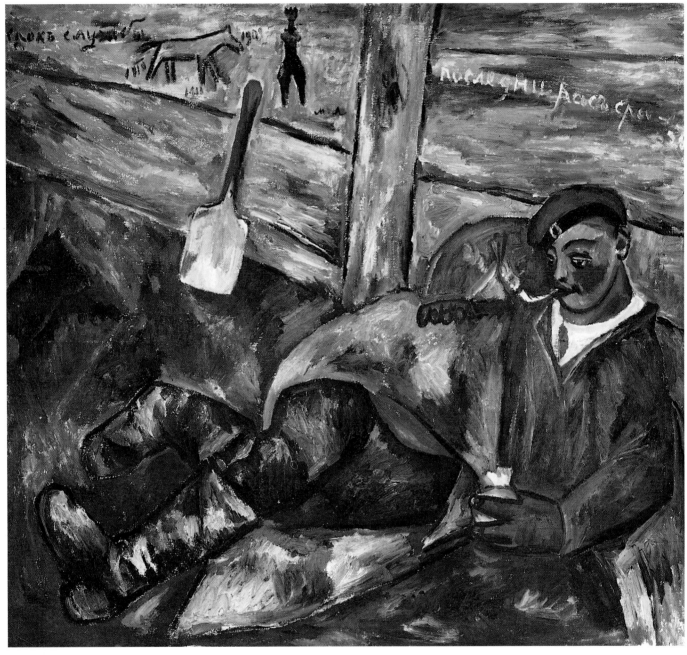

Fig. 33. Mikhail Larionov, *Resting Soldier*, 1911

limbs, similar to the work of Chagall at this time, represent Larionov's most daring work up to this point. However, the critics declared that the artist had betrayed his talent:

> Larionov began his artistic career with delicate and at times moving colorful studies. They may not have been original but did reflect fresh and reasonable influences. They revealed an unquestionable sense of paint and color. . . . But too soon, Larionov abandoned any concern with draftsmanship and betrayed the directly perceived colors of nature. He chose instead the turbulent path of innovation which came to us from the west and became a "Matisse."[16]

Towards the end of the year the artistic atmosphere in Moscow became tense. The press reported that Larionov had acrimoniously broken with the Jack of Diamonds and formed a rival group called the Donkey's Tail (*Osliny khvost*).[17] The storm broke when Larionov and Goncharova refused to participate in a second Jack of Diamonds exhibition which was to open on 25 January 1912. This exhibition was organized by Lentulov, Mashkov, Konchalovsky, Falk, and Kuprin, who remained at the core of the Jack of Dia-

monds for a number of years. Kandinsky, Kirchner, Marc, and Münter, however, were also taking part as were French artists, including Gleizes, Van Dongen, Léger, Delaunay, Matisse, Picasso, and Le Fauconnier.

Larionov and Goncharova had now distanced themselves from the pervasive influence of western modernism on the grounds that Russian art proceeded from a different cultural basis. They believed that a modern Russian art should address the question of national artistic traditions and therefore they disassociated themselves from the Jack of Diamonds on the grounds that Burlyuk was a "decadent Munich follower" while the others, known as Cézanne-ists, were conservative and eclectic. Larionov and Goncharova called for an independent Russian school, and although their stance was largely polemical, it was nonetheless historic in that they were the first to insist that Russian art was essentially different from that of western European countries and that its development should be informed by reference to indigenous cultural conventions.

The origins of Larionov's new group actually dated back to April 1911 when the press first reported that artists from the Moscow Salon society had decided to organize a separate exhibition under the name of the Donkey's Tail.[18] Initially the group must have included participants in the Moscow Salon exhibition such as Larionov, Goncharova, Malevich, and Shevchenko. The poet Sergei Bobrov had joined the Donkey's Tail by the end of the year, and Viktor Bart, Morgunov, Rogovin, and Skuie later resigned from the Jack of Diamonds to join the group. The Donkey's Tail also included Ivan Larionov, the artist and critic Vladimir Markov, and several students from the Moscow School of Painting and the Academy of Fine Arts in St. Petersburg, such as Mikhail Le-Dantyu, Vladimir Tatlin, and Kirill Zdanevich.

The Donkey's Tail first exhibited with the Union of Youth in St. Petersburg during January–February 1912, though the two exhibitions remained distinct, and separate catalogues were published for each. Afterwards, they opened their own exhibition in Moscow, following the closure of the second Jack of Diamonds show. In addition, Larionov "poached" Artur Fon Vizen from the Jack of Diamonds by hanging his paintings, without the artist's knowledge, in the exhibition. Naturally, Fon Vizen, vehemently disassociated himself from this forced cooption into the Donkey's Tail.[19]

A showdown between the Donkey's Tail and the Jack of Diamonds was inevitable and it took place during the Jack of Diamonds conference held in the Museum of the Polytechnic School of Moscow on 12

February 1912. At the conference Nikolai Kulbin read his essay "The New Art as the Basis of Life" and spoke about Kandinsky while David Burlyuk gave an illustrated lecture, "On Cubism and Other Directions in Painting," in which he showed lantern slides of paintings by artists of the Jack of Diamonds, including two by Goncharova. At the end of the evening Goncharova accused Burlyuk of distorting the facts since she was no longer a member of the Jack of Diamonds but belonged to the Donkey's Tail. Livshits recalled that these words provoked indescribable laughter from all quarters of the auditorium but that Goncharova mastered the situation and continued:

> "Cubism" is a positive phenomenon, but it is not altogether a new one. The Scythian stone images, the painted wooden dolls sold at fairs are Cubist works. True they are sculpture and not painting, but in France too, in the home of Cubism, it was sculpture—Gothic sculpture—which served as the point of departure for the movement. For a long time I have been working in the Cubist manner, but I condemn the position of the Knave of Diamonds without hesitation. It has replaced creative activity by theorizing. . . .
>
> After Goncharova, Larionov commenced with a dithyramb to The Donkey's Tail, but the audience refused to listen. Through the noise, the whistles and the shouts of "Get outta here!" he yelled out incoherent phrases about the conservatism of The Knave of Diamonds about the originality of the French artists and about the robbery of Donkey's Tail members by The Knave of Diamonds. In exasperation he banged his fist on the lectern and left the stage to the howls and whoops of the entire hall.[20]

In a letter to the press published after the debate Goncharova again proclaimed her allegiance to the Donkey's Tail and disassociated herself from what she called "the half-baked non-Cubism" of the Jack of Diamonds.[21]

The name "The Donkey's Tail" derived from a famous Parisian hoax in which the art critic Roland Dorgelès and Frédéric Gérard, proprietor of the Montmartre café *Le Lapin Agile,* had painted a lurid red and blue seascape by tying a paintbrush to a donkey's tail. The work was exhibited as *Sunset over the Adriatic* under the name of Joachim Raphael Baronali at the *Salon des Indépendants* of 1905 apparently without comment![22] In 1910 Ilya Repin recounted the incident of the donkey's tail in his review of Izdebsky's International Exhibition and used the term as a critical epithet for the modernist work on

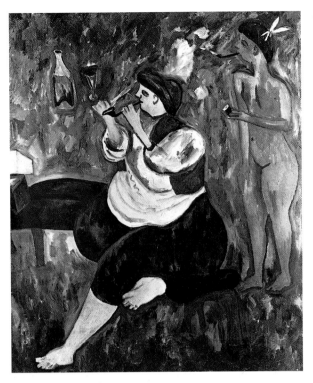

Fig. 34. Mikhail Larionov, *Mistress and Maidservant* (from *An Imaginary Voyage to Turkey*), 1911–1912

Fig. 35. Mikhail Larionov, *Mistress and Maidservant* (from *An Imaginary Voyage to Turkey*), 1911

show.[23] Shortly afterwards, the Russian press satirized the Jack of Diamonds exhibition by publishing a cartoon of a donkey painting with its tail, with the cynical caption: "Off home already after looking round just one hall? Don't be shy. Get your sixty kopeks worth and next year come again. Then we will change the name and under the sign of 'the Donkey's Tail' we will show you the way we paint our pictures."[24] In adopting this name for his group Larionov beat the critics with their own stick.

The Donkey's Tail exhibition opened on 11 March 1912 in the Stroganov School in Moscow and eclipsed the Jack of Diamonds in both size and scandal. Over three hundred works were exhibited of which fifty-eight were by Larionov. He showed many recent soldier paintings as well as impressive works on low-life themes such as *Baker* (Thyssen-Bornemisza Collection), *The Waitress* (Tretyakov Gallery), and *Circus Dancer before Her Entrance* (pl. 10). The *Circus Dancer* was typical of these works in its simplistic and monumental approach to the figure painting. Attention is focused on the dancer, smoking before her cue, with only a curtain in the background to provide a clue to her raunchy performance.

Larionov's paintings entitled *An Imaginary Voyage to Turkey* are from the same period and are executed in a similar style. The artist later recalled that while at the Moscow School he won a grant to travel to Turkey but kept the money and went to Tiraspol instead. There he painted works on Turkish themes to convince the authorities he had been abroad.[25] It is more likely, though, that Larionov's choice of Turkey as an exotic subject was motivated by Matisse's Moroccan interests. *Mistress and Maidservant* (fig. 34) was one of the two paintings from this series that Larionov exhibited at the Donkey's Tail. The painting owes a debt to Fauvism and expressionism with its exaggerated color scheme, bold brushwork, crude distortion of human forms, flattened picture space, and arbitrary location of objects. The painting may be a gentle parody of *Music* by Matisse which was on view in Shchukin's collection during 1911. The odalisque occupies the same awkward posture as the flute player in *Music* while the naked maidservant imitates the female fiddler. A preliminary drawing for the painting (fig. 35) was also exhibited at the Donkey's Tail though here the figure drawing is cruder. The elongated arms of the mistress and the distorted form of her maidservant became leitmotifs in Larionov's oeuvre and recur until the late 1920s (cf. fig. 201).

Other paintings in the exhibition—as, for example, *Photographic Study from Nature of a City Street, In-*

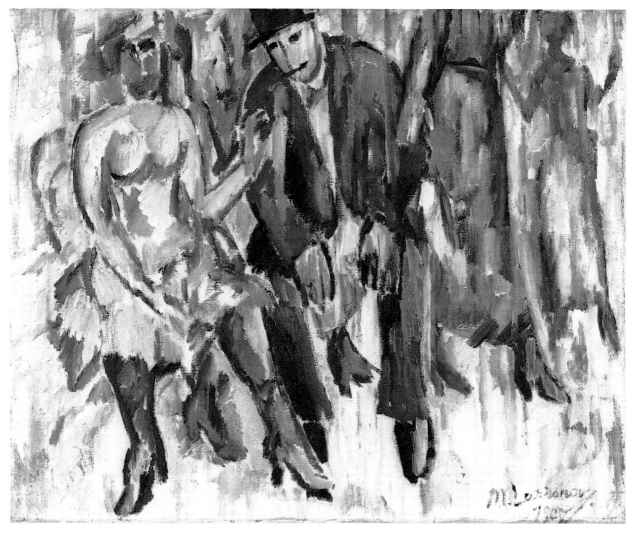

Fig. 36. Mikhail Larionov, *Scene – The Cinema*, 1912

stantaneous Photograph, and *Photographic Study of Spring Snow Melt*—indicated Larionov's interest in contemporary photography and the relationship between the visual qualities of the photographic image and its artistic application. The painting *Scene – The Cinema* (fig. 36), also shown in the exhibition, points to a keen interest in cinematography. Painted in shades of gray on a bare canvas it captures the effect of the flickering and transient images of the early cinema.

Finally, *Study of a Woman* (fig. 37) and *Head of a Soldier* (fig. 120), in which lines delineate the head and create ambiguous planes around it, represented Larionov's tentative steps towards rayism. In this respect both works acted as preparatory studies for Larionov's rayist painting *Portrait of a Fool* and may be regarded as his first response to the painterly trends initiated by cubism.

Unfortunately, the exhibition had an inauspicious start. The Public Censor took the "tail" of the donkey to be an allusion to another part of its anatomy and advised the police to confiscate a row of religious paintings by Goncharova on the grounds that to show them in an exhibition with such a title was blasphemous. Then, on the opening day, a fire in the exhibition premises damaged many of the exhibits, especially the watercolors, and this afforded the hostile reviewers unique ammunition with which to attack the group.[26] In *Utro Rossii* it was suggested that the fire began when the walls turned red with shame because of the paintings hanging on them. Their blushes turned to a raging fire and the walls burst into

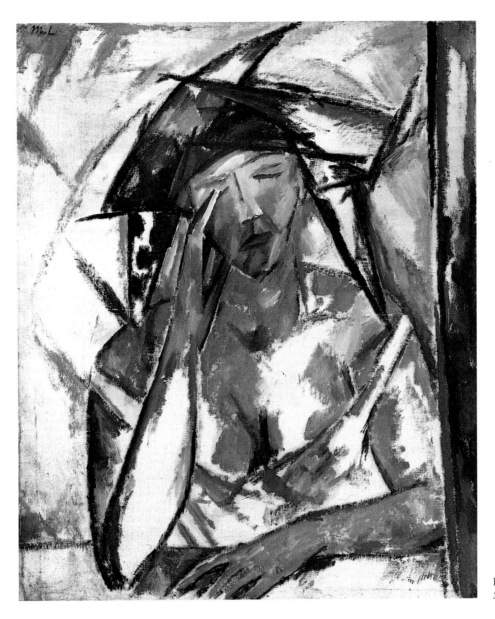

Fig. 37. Mikhail Larionov,
Study of a Woman, 1912

flames out of confusion! The fire, however, improved the paintings at the exhibition by covering them with soot! In comparison, the Jack of Diamonds was declared second rate because the work of Larionov's group was "a new art born of fire and soot!"[27]

The newspapers were unmerciful. Larionov was widely caricatured in the press and the "leftist" art of the Donkey's Tail held up for public scorn. Perhaps the only objective critic was Maksimilian Voloshin who wrote an entertaining appraisal which stands out by its informative and fair criticism. Voloshin noted with interest the paintings from popular Russian life featuring hairdressers, prostitutes, soldiers, and chiropodists. However, he found the titles of the exhibits more interesting than the paintings themselves which, although they indicated talent, he described as "tendentiously untidy" and deliberately provocative. Beyond this, Voloshin praised the experimental approach of the group and singled out Larionov's paintings *Sonya the Camp Follower* and *Bathing Soldiers* as two of the most "expressive" compositions in the show.[28] The Donkey's Tail closed on April 8 after ten thousand visitors had viewed the exhibition.[29]

Despite Larionov's outcry against "Munich decadence" and his refusal to admit artists working

abroad, with the exception of Chagall, to the Donkey's Tail, both he and Goncharova exhibited their work in Munich in February 1912 at the second *Blaue Reiter* exhibition and later in the year in Fauve company in Roger Fry's Second Post-Impressionist Exhibition in London. Larionov also maintained a close relationship with the Union of Youth. Shortly after the Donkey's Tail exhibition had opened in conjunction with a Union of Youth exhibition in the same premises, the Union published an almanac edited by Vladimir Markov, devoted to eastern art forms and contemporary Russian painting. It included articles on Chinese poetry, Persian art, and the first part of an essay by Markov entitled "The Principles of the New Art" in which he advocated "the principle of free creation"—the artist's right to paint intuitively according to inner impulses as opposed to stylistic conventions. The final part of Markov's essay with reproductions of paintings by the Union of Youth was published in June in a second almanac devoted to western European art, with an article on Kees van Dongen, a text by Le Fauconnier, and translations of two Italian futurist manifestos.[30]

The Union of Youth almanacs were not a new kind of activity. Already in 1910 Nikolai Kulbin had published a volume of poetry by David Burlyuk and Khlebnikov entitled *Studiya impressionistov* (*The Impressionists' Studio*) which also contained Kulbin's essay "Free Art as the Basis of Life," a monodrama by the theatrical writer and director Evreinov, and an article on Javanese puppets. Shortly afterwards in May 1910, David Burlyuk, Khlebnikov, Guro, and Kamensky published their poems with illustrations by Vladimir Burlyuk in a volume entitled *Sadok sudei* (*Hatchery of Judges*). These collections were the precursors of a large corpus of publications known as Russian futurist books, and during 1912–1913 Larionov played an important role in their illustration and production. Moreover, as each book was listed in the fortnightly review *Knizhnaya letopis'* (*Book Chronicle*) before release to the market, we have accurate dates for Larionov's stylistic development at this time.

Larionov collaborated with the poet Aleksei Kruchenykh (fig. 38) who was a central figure among the Russian avant-garde. Kruchenykh associated closely with Khlebnikov at this time, with whom he developed "trans-rational" or *zaum* poetry, a kind of sound poetry that was "broader than sense" and defied conventional meaning by employing only vowels, consonants, and syllables. Kruchenykh was also an avid publisher and during 1912–1913 he commissioned Larionov and Goncharova to illustrate several of his

books. Larionov's portrait of the poet reveals a disheveled, almost rakish, figure who, in the manner of Van Gogh's *Eugène Boch*, is elevated by the "mysterious effect" of "a star in the depths of an azure sky."[31]

The portrait was reproduced in a series of Donkey's Tail postcards published by Kruchenykh in summer 1912. Several artists participated in this venture including Goncharova, Ivan Larionov, Shevchenko, and Tatlin. Larionov himself supplied over a dozen drawings for reproduction, mostly based on his recent paintings.[32] Treated as graphics the designs were more simple and direct than the original oils, with little attention to detail and the surroundings shaded with hurried gestural marks. *Sonya the Whore* (fig. 39), for example, displays disproportionate limbs outlined in bold contours and dislocated both from each other and from the torso. The composition is completed by ugly striations and the inclusion of graffiti that spells out *Sonya kur[tizanka]* (Sonya the Pros[titute]). Such tasteless references appear frequently in Larionov's work at this time and are used here to specify and complement the pornographic image of the prostitute and the lecherous voyeurism of her client.

The Street and *The City* (fig. 40), however, are more akin to the work of Delaunay and Boccioni. Delaunay's work had been on view at the Jack of Diamonds exhibition of 1912 and Italian futurism was accessible through translations of manifestos and international exhibitions which were accompanied by illustrated catalogues. *The City* represents Larionov's first response to Italian futurism. It portrays a busy street in which tramcars and horse-drawn cabs hurtle by and evokes the futurist sense of dynamism by the use of rapid diagonals and the fleeting images of buildings and windows.

In October 1912 Kruchenykh published two books of verse with designs by Larionov and Goncharova. Goncharova illustrated the volume *Igra v adu* (*Game in Hell*) by Khlebnikov and Kruchenykh which told the story of a card game between sinners and devils. The printed text of the poem imitated slavonic lettering in Russian orthodox liturgical books and Goncharova's illustrations appropriately drew on the traditional rendering of infernal imagery found in icons, church frescoes, and eighteenth-century *lubki*. Larionov, on the other hand, illustrated a cycle of poems by Kruchenykh entitled *Starinnaya lyubov'* (*Old Time Love*), which parodied nineteenth-century romantic and provincial love poetry. Larionov's work for *Starinnaya lyubov'* was particularly notable since several of his illustrations were executed in his new rayist style.

Fig. 38. Mikhail Larionov, *Aleksei Kruchenykh*, 1912

Fig. 39. Mikhail Larionov, *Sonya the Whore*, 1912

Fig. 40. Mikhail Larionov, *The City*, 1912

Although Larionov first proclaimed his theory of rayism in a letter of 20 September 1912 to Zheverzheev in St. Petersburg, it was Pavel Ivanov, writing under the pseudonym of V. Mak, who first publicized it in an article of October 1912 for the newspaper *Golos Moskvy*. The article proclaimed that Larionov had founded a new artistic movement called rayism which, in contrast to cubism and futurism, was an entirely Russian creation. In the article both cubism and futurism are described as fracturing the surface plane of the painting while rayism aims "to summarize everything on the one surface." Rayism, the author states, represents a completely new technical method in which objects are treated as a play of lines from which forms gradually arise. The article then describes the first rayist landscape paintings: "trees reach to the sun and the sun to them, sprays of light spring from the roofs of houses, the tops of bushes sparkle like torches, everything shines and glitters in a play of light" (Mak 1912).

Mak also discusses a rayist triptych entitled *The Farm* (figs. 41–43). The first painting of this series was the grotesque *Head of a Bull*, innocuously described as "a thoughtful chap with yellow face and whiskers." Yet this is a peculiar and powerful painting, a hybrid of rayist and neo-primitive styles, in which the leering head sprouts not only horns but ungainly bunches of rays. The directness with which the bull confronts the viewer, the mawkish palette of colors, the sagging jaw, and the vacant eyes create a

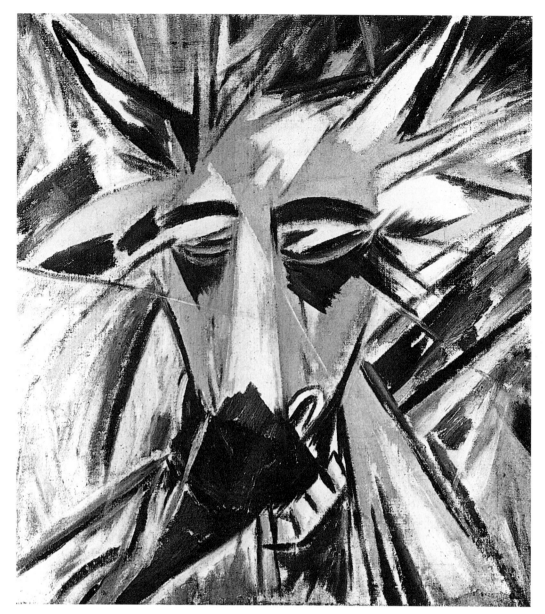

Fig. 41. Mikhail Larionov, *The Farm: Head of a Bull*, 1912

disturbing effect. The painting would be almost farcical if it were not for its unsavory cadaverous qualities.

The second painting of the triptych was *Portrait of a Fool* in which Mak failed to discover any recognizable features whatever despite the artist's elucidation. However, *Cockerel and Hen*, the final work of the triptych, particularly impressed the critic: "you see the fantastic apparition of a gigantic glittering bird which arises, as if from a luminous mist of crossing lines, on the radiant surface of the canvas" (Ibid.). Larionov transforms the cockerel into a firebird of brilliant red, yellow, and orange streaks set off against

the facets of a green and violet ground. The astonishing use of color, combined with the vortex of movement and the dynamism of the needle-sharp rays, make this one of the finest examples of rayism in Larionov's oeuvre.

Rayism was based on a theory of perception that Larionov elaborated principally between 1912 and 1914. His theory stated that reflected rays of light from everyday objects intersect each other to create what he calls "immaterial objects" and "intangible spatial forms" which it is possible for the artist to paint: "The sum of rays from object A intersects the

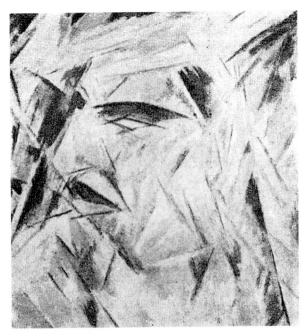

Fig. 42. Mikhail Larionov, *The Farm: Portrait of a Fool*, 1912

sum of rays from object B; in the space between them a certain form appears, isolated by the artist's will. This can be applied in relation to several objects, for example, the form constructed from scissors, a nose, and a bottle, etcetera."[33]

Larionov's first rayist works took the form of "realistic" rayism (*realistichesky luchizm*) in which the artist depicted both objects and the rays of light reflected from them. In *Glass* (fig. 44), for example, a wine glass, tumblers, bottles, and even the table top reflect clusters of rays that create perceptual illusions—the shattered wine glass and green bottle—and secondary images, those "immaterial objects," such as the double neck of the brown bottle. In *Rayist Sausage and Mackerel* (fig. 45) clusters of rays spring from the ends of sausages, from the corners of the fish tray, and from nearby objects. In their intersection the rays create ambiguous planes which themselves intersect and slide across the surface of the painting, thereby creating those "intangible spatial forms" of which Larionov speaks. These are more pronounced in *Portrait of a Fool* (fig. 42) in which the rays fracture the contours of the portrait and reduce it to a series of shifting planes that are integrated with the immediate surroundings. In this respect the painting represents a development of the principles established in *Study of a Woman* (fig. 37) and *Head of a Soldier* (fig. 120) in which the integration of the head with its context is achieved by extended lines.

In developing his theory of rayism Larionov was inspired principally by nineteenth-century color the-

ories which encouraged artists to think of color as reflected light. To give credibility to the scientific basis of his new art Larionov also referred to contemporary scientific developments, and both rayist painting and theory reveal his study of X-rays, radiation, and cloud-chamber experiments. There was also a metaphysical aspect which appeared in Larionov's rayist manifestos under the guise of "the fourth dimension," and which had considerable impact on the development of the style.

The example of Leonardo da Vinci as an artist whose painterly practice was informed by his scientific investigations was important to Larionov in formulating rayism, despite the fact that Larionov later repudiated the suggestion.[34] Leonardo had suggested a viewpoint similar to that which Larionov espoused in his manifestos: "The air is filled with an infinite number of straight and radiating lines, crossed and intercrossed, and never one of them coinciding with another, and for each object they represent the true form of their own reason."[35] In fact Paul Valéry, in his essay of 1895 on Leonardo, had singled out this particular sentence from Leonardo's writings as being of fundamental relevance to our modern knowledge of the world and the origin of the theory of luminous waves.

Rayism was also indebted to the theory and practice of more modern and contemporary painters. The Italian futurists exerted a strong influence on the formation of the style as, to a certain extent, did the cubists. It may be that Oskar Kokoshka's graphic work for *Der Sturm* at this time was also influential.[36] The Russian symbolist painter Mikhail Vrubel had made headway along a similar path when he declared, "The contours with which artists normally delineate the confines of a form in actual fact do not exist—they are merely an optical illusion that occurs from the interaction of rays falling onto the object and reflected from its surface at different angles."[37] A drawing by Vrubel (fig. 46) reproduced in *Zolotoe runo* in 1909 exemplifies his theory. Here the contours that delineate the image of the woman are shattered by rays. Short rays break up the surface of the dress, long narrow rays project from the right-hand edge, bold rays fall across the woman's shoulder, and the reflected rays around her hat fracture the picture space to create nonobjective planes. In fact this drawing by Vrubel is not dissimilar to either *Study of a Woman* (fig. 37), or *Portrait of a Fool* (fig. 42) in which an intersection of rays and planes around the subject's head fragments the picture space.

Larionov exhibited his rayist paintings for the first time in December 1912. *Glass* was shown at the Moscow World of Art exhibition, which in early 1913

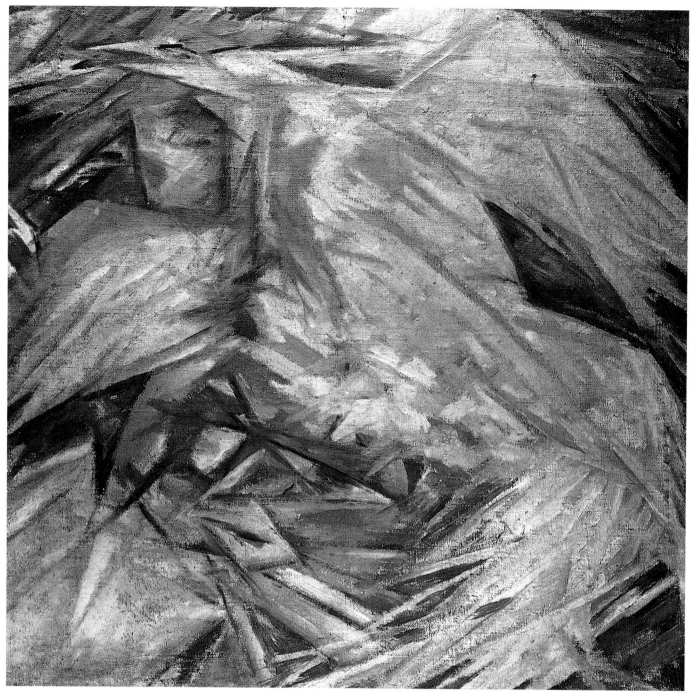

Fig. 43. Mikhail Larionov, *The Farm: Cockerel and Hen*, 1912

toured to St. Petersburg and Kiev, while *Rayist Sausage and Mackerel* and *Portrait of a Fool* were both exhibited in the St. Petersburg Union of Youth show. The critical response to these rayist paintings was mixed. Sergei Makovsky claimed that it was ridiculous for the World of Art, which stood for "the creed of high artistic culture," to exhibit with representatives of "new trends in art." Makovsky even suggested that "the World of Art should have been much stricter in drawing the line and should not have allowed paintings in their exhibition such as *Glass* by

M. Larionov (technique of rayism [?]). It is quite unnecessary to flirt with the cubists."[38] Benois, however, in his review of the Union of Youth exhibition, was at greater pains to point out the "nonsense" of works by Malevich and Burlyuk than the folly of rayism. When he did turn his attention to Larionov he found *Rayist Sausage and Mackerel* "frankly modest" and the title *Portrait of a Fool* to be more exciting than the painting itself.[39]

Larionov later claimed to have executed and exhibited his rayist paintings some years earlier. He

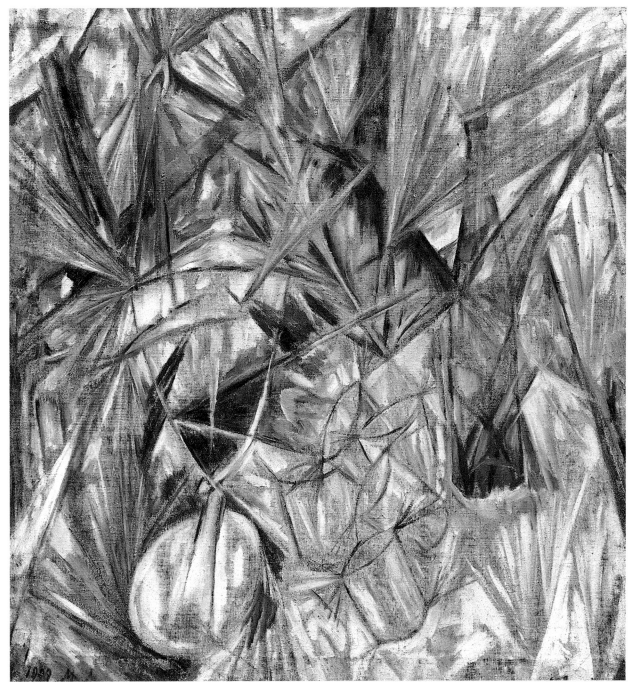

Fig. 44. Mikhail Larionov, *Glass*, 1912

maintained that *Glass* had been executed in 1909 and exhibited in that year in his One Day Exhibition (*Odnodnevnaya vystavka proizvedenny M. F. Larionova*) at the Society of Free Aesthetics. However, this exhibition took place in December 1911 and no previous exhibition of Larionov's work at the Society of Free Aesthetics is known. Even then a painting by this title was neither recorded in the catalogue nor described in reviews. This evidence points to a date of 1912 for the execution and exhibition of *Glass* and Larionov's claim to the contrary must be regarded

with doubt unless corroborative evidence is found. Larionov also asserted that he had published an article on rayism as early as January 1910 in the newspaper *Utro Rossii*[40] but scrutiny of the paper reveals no such article. The claim that Larionov lectured on rayism during 1910 in the studio of the sculptor Krakht in the Presnya district of Moscow is likewise doubtful given that there is no evidence to substantiate it.[41]

Documentary evidence indicates that Larionov began to work in his rayist style substantially later. The

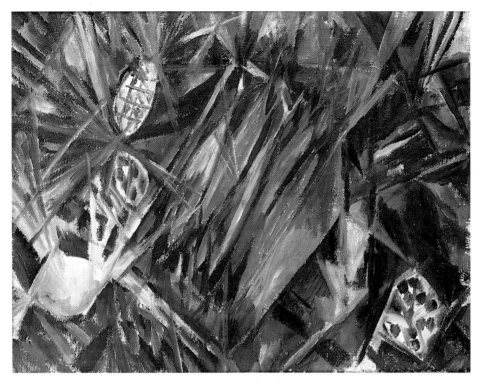

Fig. 45. Mikhail Larionov, *Rayist Sausage and Mackerel,* 1912

Fig. 46. Mikhail Vrubel; Drawing. Reproduced in Zolotoe runo, May 1909

publication of rayist drawings in *Starinnaya lyubov'* in October 1912 and the reference in Mak's article to rayism being "a new trend" that "has just arisen," together with the first exhibition of rayist works in December 1912 suggest that rayism was born in the autumn of 1912 and not before. To ascribe an earlier date would also be stylistically unconvincing, given the development already established for Larionov's work and the progression between paintings such as *Soldier's Head* and *Portrait of a Fool.* Furthermore, Boris Anrep later testified that he had seen no rayist works when he visited Larionov's studio in the summer of 1912 to select works for the Second Post-Impressionist Exhibition. While Anrep's statement is not conclusive it is certainly important.[42]

Larionov pioneered his pugnacious neo-primitive style at exactly the same time as he undertook the rayist revolution in Russian art. Neo-primitivism arose primarily as an attempt to address the indigenous cultural traditions of Russian art in the face of academic and modernist traditions imported from the west, and Larionov's success was to develop an easel art infused with the style and spirit of the Russian people. Neo-primitivism as a self-conscious movement developed in late 1912, though admittedly Larionov had referred to the conventions of traditional Russian art forms as early as 1909. His *genre* paintings of 1909 reflect an interest in the *lubok* and the signboard while many paintings from 1910 to 1912 manipulate the stylistic conventions of icons, folk art, and graffiti from the barrack walls.

More recently Kandinsky and Marc had exploited a new range of such source material in their reproductions of ethnic, folk, and children's art in *Der Blaue Reiter*. Larionov and Goncharova were in contact with Kandinsky at this time, and Larionov, during the latter half of 1912, broadened the base of his neo-primitivism, drawing upon such disparate sources as classical mythology and shamanism for the content and imagery of his paintings and utilizing the conventions of ancient and tribal art for their stylistic expression.[43]

The first fruits of this broader conception of neo-primitivism were a cycle of paintings depicting the seasons of the year. Both *Spring* (pl. 11) and *Summer* (fig. 47) were exhibited alongside Larionov's rayist canvases in the Moscow World of Art and the St. Petersburg Union of Youth exhibitions of December 1912. Each painting is divided into four sections, one of which characterizes the season in a few lines of prose. The verse in *Spring* reads, "Serene beautiful Spring with bright flowers with white clouds," and that in *Summer*, "Burning Summer with storm

clouds scorched earth with blue sky with ripe grain." The neighboring section depicts the peasant activities associated with that season. The two upper sections refer, respectively, to the fruitfulness of the natural world, and to the divinity presiding over the specific season.

Stylistically these are the crudest yet the most charming of Larionov's works. The paintings are divided into asymmetrical sections by uneven lines. Most of the figures are depicted with rigid contours, their bodies and heads treated as ugly, schematized shapes, painted in monochrome colors which stand out starkly against the flat and coarsely painted grounds. The dispersal of secondary objects is apparently random, and the awkward treatment of space, with large images squashed into tiny compartments, adds to the "primitive" quality of the paintings.

The paintings are remarkable not only for their expressive qualities but also for the richness of their coloring and pictorial vocabulary. The pagan deities of *Spring* and *Summer*, the flying birds, caricatured *putti*, archaic animals, cats, strange trees, and scrawled words occur again and again in Larionov's neo-primitive work. The stylistic bases of the paintings and the vocabulary of images that Larionov used were thoroughly eclectic and drawn from different naive and primitive art forms—*lubok*, icon, and tribal, ancient, and classical art—which Larionov combined to create a remarkable *tour de force*. Even Benois, in his review of the Union of Youth show, admitted that *Spring* was an artistically teasing work.[44]

During the course of the exhibition Larionov completed *Autumn* (fig. 48) and *Winter* (fig. 49) in which the two prose verses read, "Happy Autumn sparkling like gold with ripe grapes with intoxicating wine," and "Winter cold snowy windy of storms armor-clad in ice." *Autumn* depicts the harvesting by the peasants of the "ripe grapes" which are then fermented and drunk, while *Winter*, as the description suggests, is a cold painting in its simplicity, ideally evocative of the season. It is interesting that *Winter* is a different shape than the other paintings so that when they were hung together as one large panel, *Winter* created a discordant and asymmetrical effect.

This series also includes two personifications, one of *Spring* (fig. 213) and the other of *Happy Autumn* (Russian Museum, St. Petersburg), both painted in a vulgar Rabelaisian spirit.

Another complex series that Larionov executed at this time was based on the theme of Venus. A newspaper article published in October 1912 mentions that Larionov had already completed a *Katsap Venus* (pl. 12), a *Jewish Venus* (pl. 13), and a *Gypsy Venus* (fig.

Fig. 47. Mikhail Larionov, *Summer*, 1912

Fig. 48. Mikhail Larionov, *Autumn*, 1912–1913

Fig. 49. Mikhail Larionov, *Winter*, 1912–1913

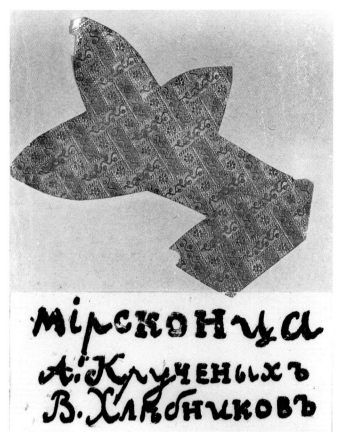

Fig. 50. Nataliya Goncharova, Cover of *Mir s kontsa*, 1912

Fig. 51. Mikhail Larionov, Cover of *Pomada*, 1913

106), as well as sketches for Venuses of other nation-
alities and races.[45] The article notes that these works
exemplify Larionov's interest in ethnological canons
of beauty. This explanation seems inadequate, how-
ever, for both *Katsap Venus* and *Jewish Venus* are rep-
resentations of army prostitutes. The adjective *kat-
sap* is a Ukrainian term of abuse for Great Russians
and is used here to describe a Ukrainian prostitute
who services Muscovite soldiers. This much is evi-
dent from the reproduction of a preliminary drawing
for *Katsap Venus* in the Italian futurist magazine *Lac-
erba* under the title *La Venere del Soldato* (*The Sol-
dier's Venus*). In addition, *Jewish Venus* has a photo-
graph of her soldier client pinned to the wall.

Broadly speaking, the Venus series works within
the subversive traditions of western modernism. In
particular, the formats of both *Katsap Venus* and *Jew-
ish Venus* recall the example of Manet's *Olympia*
(Musée d'Orsay). The pose, the challenging stare, the
flattening of pictorial space, and the cat in *Katsap
Venus* and the pale flesh and green drapes in *Jewish
Venus* are all features that recall Manet's prototype.
In his Venus paintings Larionov adopted the same

stylistic and class-specific approach as Manet but
casts his Venuses in contemporary Russian form,
transforming the weedy Olympia into a buxom pros-
titute. In this respect, however, the Venus series had
its origins in the painting *Sonya the Camp Follower*,
the drawing for which was published by Kruchenykh
(fig. 39). The soldier and Venus themes were thus
ideologically and stylistically connected in Lario-
nov's work.

The theme of carnal love, symbolized by the army
prostitute, was a crucial aspect of Larionov's neo-
primitive ideology. It referred to instinctive feelings,
represented a shocking subject for his audience, but
above all, in the tradition of Manet, replaced the aca-
demic image of Venus with that of a specific type of
woman in contemporary society—an earthly and
tangible goddess of love.

To emphasize the continuity between his rayist
and neo-primitive works Larionov not only exhibited
them together but also interchanged the styles in his
graphic work for books such as *Mir s kontsa* (*The
World Backwards*) by Kruchenykh and Khlebnikov
(fig. 50). This book of pagan verse was profusely illus-

trated in rayist and neo-primitive styles by Larionov, Goncharova, Rogovin, and Tatlin, and typographically it was equally innovative. Each cover was adorned with a paper flower individually cut out by Goncharova, and the texts of the poems were printed either in mimeographed handwriting or in letter stamps of different sizes. The poems themselves contained deliberate typographical errors including spelling mistakes, irregular spaces between words, and capital letters scattered throughout the text. One poem was printed sideways and another was made up of letters printed in mirror-image form.

During early 1913 Larionov and Goncharova continued to collaborate with Kruchenykh. Goncharova drew neo-primitive illustrations for his book *Dve poemy: Pustynniki, pustynnitsa* (*Two Poems: Hermits, The Hermit Woman*) published at the end of January, while Larionov illustrated *Poluzhivoi* (*Half-Alive*) and *Pomada* (*Pomade*), both published in February. *Poluzhivoi* is one continuous poem by Kruchenykh in which the poet describes images of

Fig. 53. Mikhail Larionov, *Rayist Composition No. 8*, 1912–1913

Fig. 52. Mikhail Larionov, *Lady with Hat*, Illustration for *Pomada*, 1913

Fig. 54. Mikhail Larionov, *Portrait of the Japanese Actress Hanako*. Illustration for *Sadok sudei II*, 1913

Fig. 55. Mikhail Larionov, *Rayist Portrait of Nataliya Goncharova.* Illustration for *Sadok sudei II,* 1913

war and violence. Some of Larionov's neo-primitive illustrations reflect these bloody images—bodies decimated by violent strokes, limbs severed from the torso and cruelly displaced. Others portray elongated, melancholy figures which decorate the margins of the text. *Pomada* was particularly important as it was here that Kruchenykh published his first example of *zaum* poetry entitled "Dyr bul shchyl." Larionov's illustrations for the book are again designed in a variety of styles. The cover (fig. 51) featured a neoprimitive *putto* rubbing pomade into the enormous head of the goddess of *Spring 1912* (fig. 213). The reference to pomade was a return to the theme of hairdressing in Larionov's art.

An interesting illustration for *Pomada* was the *Lady with Hat* (fig. 52), a portrait executed in a series of intersecting arcs. Two simple arcs indicate the "lady's" shoulders, a short diagonal, her neck, and two arcs forming an elipse, her head. The mesh of intersecting lines above and behind refer to the exuberant hat she wears. During the next two years Larionov elaborated this design in a series of paintings such as *Rayist Composition No. 8* (fig. 53). In the painting one may discern the rough outline of a figure, its shoulders and head, but in place of the elaborately constructed hat in the drawing, Larionov paints rays which are reflected from the body, obscure the image, and intersect to create a dynamic composition of arcs and diagonals.

By early 1913 Larionov, Goncharova, and the Burlyuks had overcome the differences that had led to their split at the Jack of Diamonds debate the year before. Kruchenykh and Khlebnikov, for example, moved freely between the Larionov and the Burlyuk groups. Furthermore, both groups found common ground in the Union of Youth and in February 1913

were reconciled under its auspices. The Union had organized two evenings of lectures and debates at the Troytsky Theatre in St. Petersburg on the theme of new styles in painting and literature. Both Larionov and David Burlyuk were invited to speak on the first night, Burlyuk to lecture on "Painterly Counterpoint" and Larionov on "Rayism."[46]

Another project that called for the collaboration of both groups was the book *Sadok sudei II* (*Hatchery of Judges II*) which was published in February by the composer and painter Mikhail Matyushin. It contained contributions by most of the literary and painterly avant-garde. Poems by David and Nikolai Burlyuk, Guro, Kruchenykh, Khlebnikov, Livshits, Mayakovsky, and Ekaterina Nizen were printed on the reverse side of patterned wallpaper and illustrated by Larionov, Goncharova, David and Vladimir Burlyuk, and Guro.

Larionov's two illustrations for the book, *Portrait of the Japanese Actress Hanako* (fig. 54) and *Rayist Portrait of Goncharova* (fig. 55), had little in common with the text. Both accompanied poems by Khlebnikov (one of which was "Shaman and Venus") which were written in a neo-primitive style and dealt with primitive and mythological themes. Larionov's illustrations, however, represent a development of the style first observed in *Lady with Hat* (fig. 52). In the *Portrait of Hanako* the depiction of the head using single and intersecting arcs has been reduced to a mere seven curves and a few ray-clusters. This approach amazed the critics: "It's the limit, even of futurism, you can't go any further!"[47] In *Rayist Portrait of Goncharova* the process is more complex, although it relies on essentially the same approach of intersecting arcs and rays.

Both drawings are important as they reflect Larionov's interest in Asian art forms. The *Portrait of Hanako*, the Japanese actress who was a favorite model of Rodin, has obvious associations with Japanese theatre, while the short expressive strokes that compose *Rayist Portrait of Goncharova* are executed in a style akin to Chinese calligraphy. Larionov possessed an impressive collection of Chinese prints and, in his manifesto *Luchizm* (*Rayism*), made specific reference to the Indian-ink brushstrokes of Chinese artists. Fokine recalled the enthusiasm with which Larionov discussed the subject of Japanese prints, and Mitrokhin remembered Larionov taking him to the Japanese Shop in Moscow where one could buy beautiful prints.[48]

Asian arts, together with ethnic objects, the Russian *lubok*, icons, signboards, children's drawings, and naive paintings exerted a powerful influence on Larionov and confirmed that he now fully embraced an interest in art forms that lay outside the western fine art tradition.

The Futurists Take Command

1913–1914

■

In March 1913 two exhibitions organized by Larionov opened simultaneously on the premises of the Artistic Salon on Bolshaya Dmitrovka. The Exhibition of Original Icon Paintings and *Lubki* was an historical show of Russian folk art while the Target was an exhibition of contemporary works by Larionov and his group. The two exhibitions represented the culmination of the neo-primitive phase of Larionov's career and initiated an aspiration toward futurism which, during the course of the year, gradually eclipsed his neo-primitive work.

The Exhibition of Original Icon Paintings and *Lubki* displayed the variety of sources upon which Larionov's neo-primitivism drew and included examples of popular art forms from Europe, Russia, and Asia. The exhibition proved that his own work, as well as that of his group, was integrally related to and a natural product of the culture and creativity of the Russian people and its ancient Asian origins. Larionov himself contributed nearly one hundred thirty icons, over one hundred seventy *lubki*, eighty-five Japanese woodcuts, nearly forty Chinese prints, seventeen Tatar prints, ten French *Epinal* prints, and one Buryat *lubok*. To give the exhibition a greater breadth he also displayed one hundred twenty ethnic art objects from the collection of N. V. Bogoyavlensky.[1] A. I. Prybylovsky and N. G. Arafelov contributed a series of Persian prints and watercolors, and N. M. Bocharov and I. D. Vinogradov lent over fifty Chinese prints from their collections.

The exhibition catalogue is important as it contains two introductory essays by Larionov and Goncharova and lists many of the works exhibited. In his foreword Larionov discussed the origins of the Russian *lubok* while Goncharova, who had a greater affinity with the Asian works, wrote on the Hindu and Persion *lubok*. The critics thought it a splendid exhibition though too small to do justice to the subject.[2]

The Exhibition of Original Icon Paintings and *Lubki* was conceived as a pendant to the Target exhibition which featured the latest work of the Donkey's Tail group. Larionov had already unfurled the plans for this exhibition to the critic of *Moskovskaya gazeta* in January 1913. He explained: "This year we are calling ourselves 'The Target'." Last year's name, 'The Donkey's Tail,' was a challenge to the public. 'The Target' is also a challenge. The name symbolizes the public's attitude to us. The gibes and abuse of those who can't keep up with us and can't perceive the aims of art with our eyes fly into us like arrows into a target."[3]

The "bull's eye" of the Target comprised Larionov, Goncharova, and their Donkey's Tail friends: Anisimov, Bart, Bobrov, Chagall, Ivan Larionov, Le-Dantyu, Malevich, Rogovin, Sagaydachny, Shevchenko, Skuie, Yastrzhembsky, and Kirill Zdanevich. A group photograph (fig. 56) pictures several of the core members with Larionov and Goncharova. The outer rings of the Target included a galaxy of minor talents. One of the aims of the exhibition, as stated in the catalogue, was to present the work of artists not associated with any definite trend or group, and so young students such as Vyacheslav Levkievsky and Sergei Romanovich as well as ordinary housepainters with artistic aspirations were invited to participate. However, there were some significant omissions from the exhibition. Markov, Morgunov, and Tatlin failed to participate, an indication that not everyone was willing to compromise himself or his art by a rigid adherence to the extreme path that Larionov was charting.

Larionov's introduction to the catalogue established thirteen principles which recur as leitmotifs in the subsequent writings of the Target group. Here for the first time Larionov states their aspirations towards the east and national art forms, and protests against the west for reducing them to a vulgar caricature. He rejects the concept of personal artistic expression, considering the art work as an object in its own right, and demands that artists "know their business." This aspect of his aesthetic was derived from

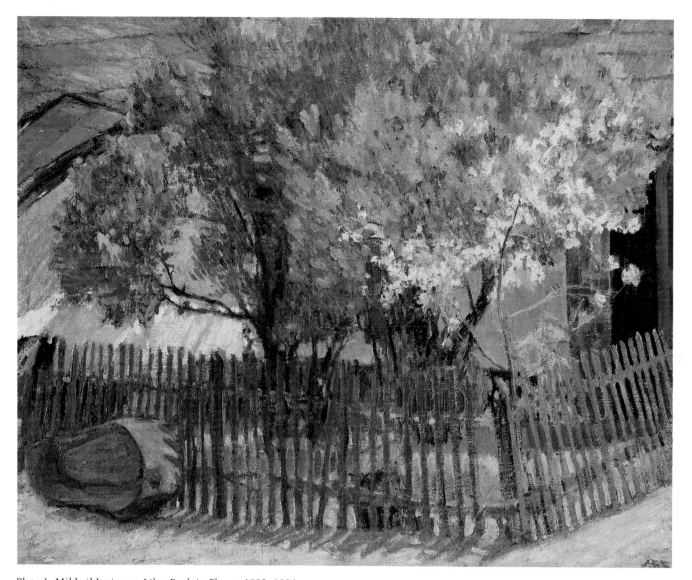

Plate 1. Mikhail Larionov, *Lilac Bush in Flower*, 1905–1906

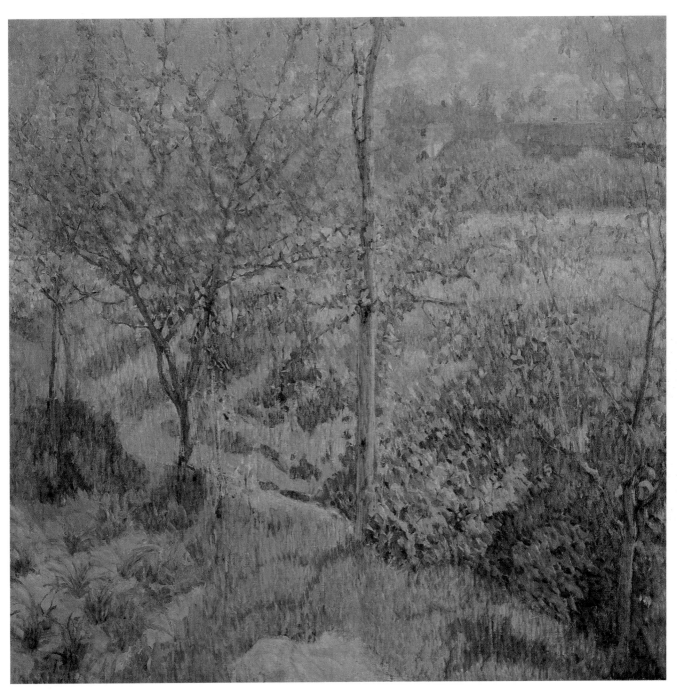

Plate 2. Mikhail Larionov, *Spring Garden*, 1907

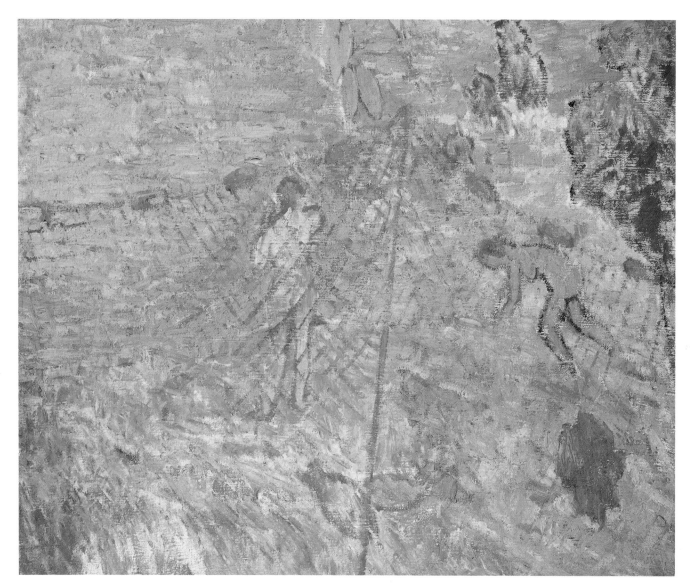

Plate 3. Mikhail Larionov, *Through the Nets*, 1908

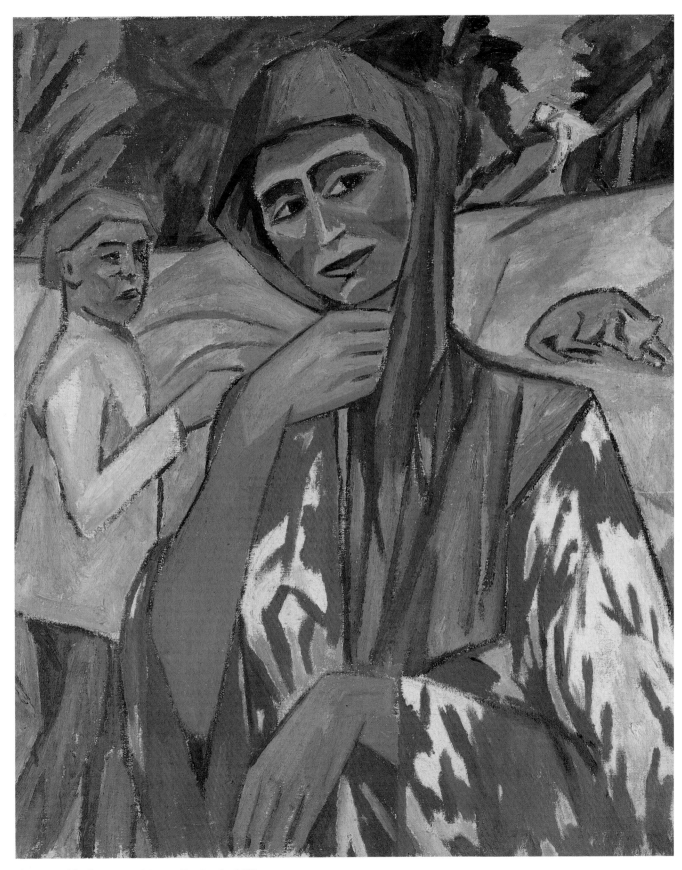

Plate 4. Mikhail Larionov, *Woman Passing By*, 1909

Plate 5. Mikhail Larionov, *Evening after the Rain*, 1909

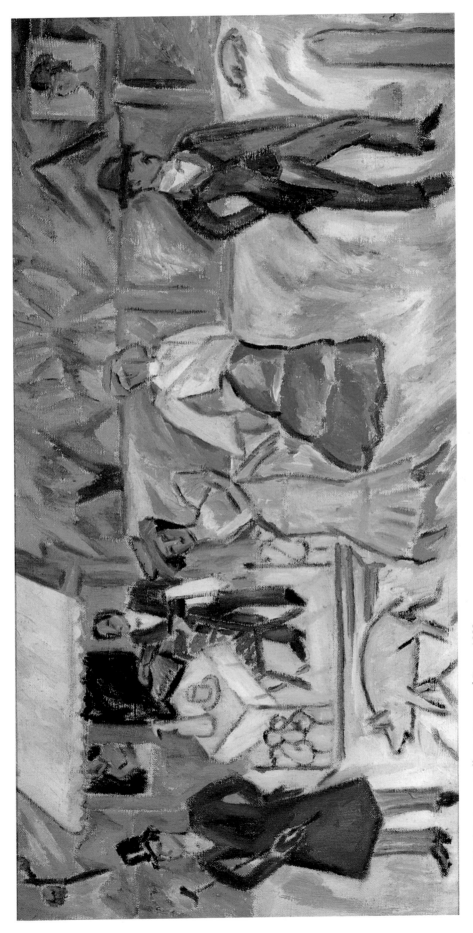

Plate 6. Mikhail Larionov, *Walk in a Provincial Town*, 1909

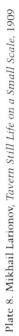

Plate 8. Mikhail Larionov, *Tavern Still Life on a Small Scale*, 1909

Plate 7. Mikhail Larionov, *Provincial Coquette*, 1909

Plate 9. Mikhail Larionov, *Street in a Province*, 1910

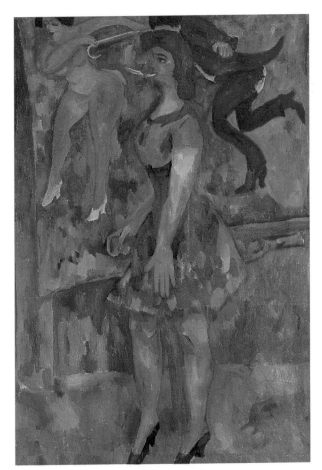

Plate 10. Mikhail Larionov, *Circus Dancer before Her Entrance*, 1911–1912

Plate 11. Mikhail Larionov, *Spring*, 1912

Plate 12. Mikhail Larionov, *Katsap Venus*, 1912

Plate 13. Mikhail Larionov, *Jewish Venus*, 1912

Plate 14. Mikhail Larionov, *Boulevard Venus*, 1913

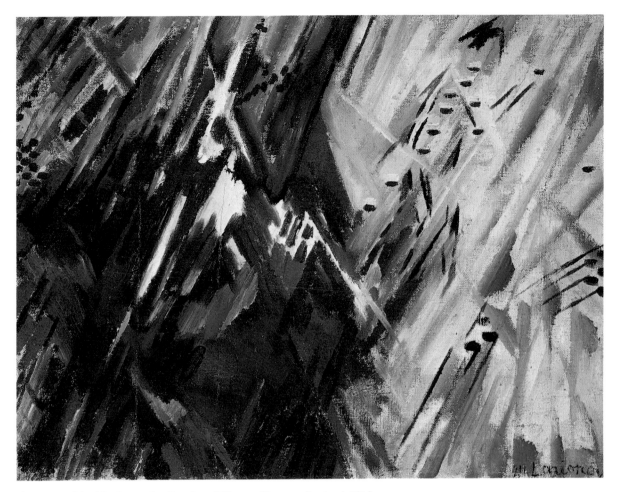

Plate 15. Mikhail Larionov, *Sea Beach and Woman (Pneumo-Rayism)*, 1913

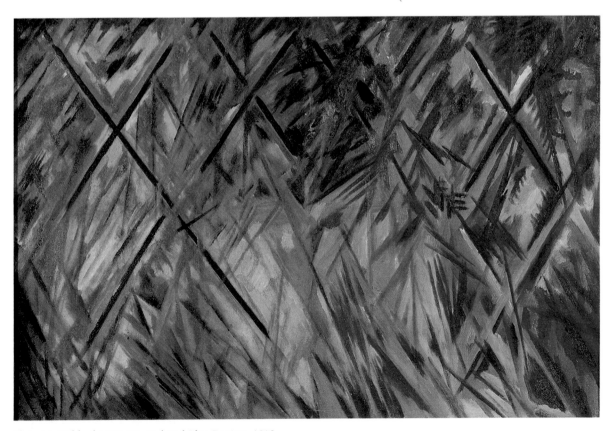

Plate 16. Mikhail Larionov, *Red and Blue Rayism*, 1913

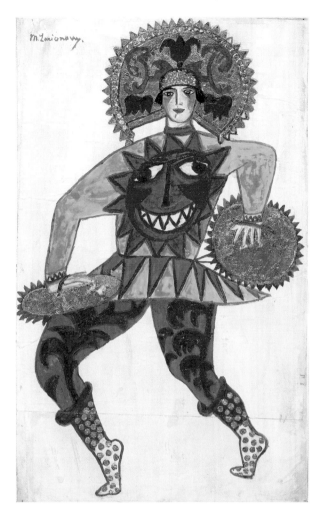

Plate 17. Mikhail Larionov, Massine as Yarila in *Soleil de Nuit*, 1915

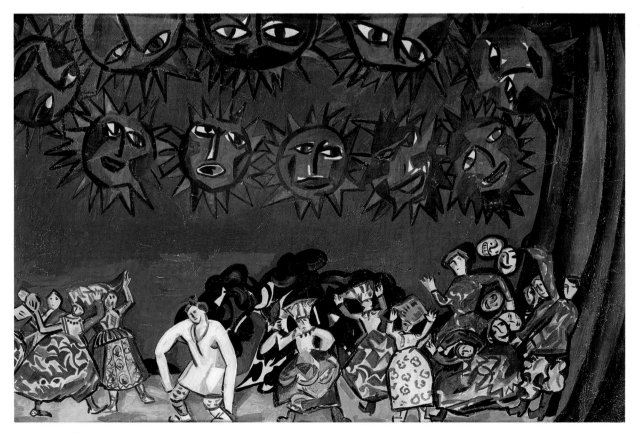

Plate 18. Mikhail Larionov, Set design for *Soleil de Nuit*, 1915

Plate 19. Mikhail Larionov, *The Peacock Mechanical Costume*, 1917–1919. Pochoir print from *Art Théâtral*, 1919

Plate 21. Mikhail Larionov, Character from *Marche Funèbre pour une Tante à Héritage*, 1917–1919. Pochoir print from *Art Théâtral*, 1919

Plate 20. Mikhail Larionov, *The Cricket*, 1917–1919. Pochoir print from *Art Théâtral*, 1919

Plate 22. Mikhail Larionov, Cover design for the score *Trois Morceaux pour Piano* by Lord Berners, 1919

Plate 23. Mikhail Larionov, Illustration to "Chinoiserie" in the score *Trois Morceaux pour Piano* by Lord Berners, 1919

Plate 24. Mikhail Larionov, Illustration to "Valse Sentimentale" in the score *Trois Morceaux pour Piano* by Lord Berners, 1919

Plate 25. Mikhail Larionov, Illustration to "Kasatchok" in the score *Trois Morceaux pour Piano* by Lord Berners, 1919

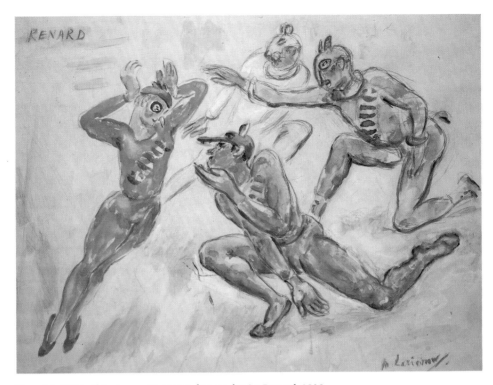

Plate 26. Mikhail Larionov, Costume designs for *Le Renard*, 1929

Plate 27. Mikhail Larionov, *Rayist Composition*, c. 1930

Plate 28. Mikhail Larionov, *Rayist Composition*, c. 1930

the popular and anonymous nature of folk art and its craft traditions. In line with his battle for the autonomy of painting Larionov states that rayism has freed painting to be self-sufficient and to exist according to its own laws, an idea expounded in the rayist manifestos. In proclaiming his recognition of all styles, both past and present, and the right to combine them freely in his work, Larionov also laid the foundation of "everythingism," a concept that reached fruition later in the year. Finally Larionov asserts that these principles are not those of an established group, for artistic societies only lead to stagnation.

A majority of the works on show at the Target were executed in a neo-primitive style, the sources of which could be traced in the Exhibition of Original Icon Paintings and *Lubki*. However, to emphasize the correspondence between their own work and popular art forms, Larionov included in the Target a selection of "contemporary primitive" art. Works by Niko Pirosmanashvili (1862–1918), the Georgian "naive" painter, were exhibited here for the first time, along-

side paintings of Russian life and landscape by Pavlyuchenko, a former miner, and pictures by Timofei Bogomazov, a sergeant-major and amateur painter, whom Larionov had befriended in the army. Children's drawings from the collections of Aleksandr Shevchenko and I. D. Vinogradov were exhibited as well as a score of anonymous drawings. Moreover the catalogue cites works by the Second Corporation of Signboard Painters as being on show at the Target but a letter to the press denied any such participation.[4]

Larionov's own exhibits comprised recent neo-primitive and rayist works which added to the somewhat motley aspect of the entire exhibition. The *Seasons* paintings were hung together as one large panel. *Summer* and *Autumn* and the bottom sections of *Winter* and *Spring* can be seen in the background of the group photograph (fig. 56). Other neo-primitive paintings on view included *Jewish Venus* (pl. 13), which can be identified in the photograph, as well as a sketch of a *Moldavian Venus*. Larionov's first rayist

Fig. 56. Artists participating in the Target exhibition, Moscow, 1913

canvases including *Glass, Rayist Sausage and Mackerel*, and *The Farm* triptych, comprising *Head of a Bull, Portrait of a Fool*, and *Cockerel and Hen*, were also exhibited.

To publicize the opening of the Target on March 23 Larionov and Goncharova organized a public debate on contemporary art and theatre in the Polytechnical Museum. The evening opened with a lecture by Ilya Zdanevich who "gave an account of all the numerous manifestos of the Italian futurists" and illustrated his talk with various antics. An image of Venus de Milo was projected onto the screen while Zdanevich, in a kind of variety act, demonstrated that a shabby American boot was more beautiful.[5] Larionov spoke about rayism, following which Goncharova and Shevchenko gave an illustrated lecture on Russian national art, claiming that Russian art shared more with eastern than western art forms. In addition, three papers were devoted to the question of theatre, an issue of growing importance for the Russian avant-garde at this time. Bonch-Tomachevsky attacked European theatre, Larionov spoke on the role of painting in the theatre, and Arkhangelsky lectured on music and rhythm in the theatre of the future. Unfortunately, the evening concluded in an uproar, and under banner headlines the following day's newspaper described the events:

> Mr. Larionov, the presiding chairman, prevented one of the critics from speaking. The audience protested, surrounding the stage. Running up, Larionov threw an electric light bulb into the audience, then the water decanter. Someone from the presidium hurled a chair into the audience and made off. A student shouted that he had caught the man who threw the chair into the crowd and boxed his ears. A genuine fight began. The police were called into the hall and the meeting was closed.[6]

Inevitably, these events colored the public's attitude towards the Target and its protagonists. The press compared the Russian avant-garde with their Italian contemporaries and began to refer to the artists as *futuristy* (futurists). There were two reasons for this. First, the chaos that invariably accompanied the Russian artistic debates recalled the controversies that had characterized the Italian futurist cabaret evenings of 1910. And second, the Russian avant-garde were developing a real interest in Italian futurism, as demonstrated by Zdanevich's lecture on the eve of the Target. During 1913 and 1914 the term "futurist" was increasingly used by the press to refer to the exploits of the Russian avant-garde but it was also an appellation that both the Larionov and Burlyuk groups used of themselves.

Although Tugendkhold found the opening evening of the Target to be "deplorable" and sections of the exhibition, such as Malevich's contribution, to resemble "a chaos of steam-boilers and cylinders," his review was one of the most objective. He discussed rayism at some length, presented its basic theory, compared it with neo-impressionism (as both movements, he said, attempted to reduce the natural world to its scientific fundamentals), and described the rayist paintings on exhibition at the Target in a favorable light. When discussing the neo-primitive aspirations of the group, Tugendkhold almost became their apologist:

> . . . original icon paintings, eastern and Russian *lubki*, popular toys, and exhibits such as signboards and the works of house painters (those of Bogomazov are very interesting) bear witness to the collective tastes of the Target, to their love of folklore. This is a highly gratifying circumstance, indicating that our young artists are not terribly satisfied with either false individual pride or the neat aestheticism of the Francophiles, but are seeking some objective ground on which they can stand in our cosmopolitan and anarchistic times. It's very good that Larionov collects original icons and *lubki* with such love and tries to make artists out of mere commercial painters. . . . But when this talented artist himself, with the Muscovite directness of simplicity so characteristic of him, paints *The Seasons of the Year* not even in the style of shop signboards but actually in the style of graffiti on the fences, one wants to restrain him from such "popularism" and to cry out: Is this not enough myth creation?[7]

Larionov and Goncharova's study of ancient, eastern, and popular Russian art forms did not preclude the development of rayism. Indeed they both believed that there was an organic connection between their neo-primitive and rayist researches and that rayism was an indispensable corollary of their neo-primitive style. Yuri Annenkov understood this when he declared that rayism originated in Larionov's love of popular art forms and the Russian decorative tradition.[8]

In April 1913 Larionov published his first rayist manifesto in the form of a small booklet entitled *Luchizm* (*Rayism*). The booklet is written in a complex manner and after the first few pages there are no apparent links between either the paragraphs or the themes that Larionov discusses, so that one has to piece his concepts together. The text opens with a discussion of style, in which Larionov cites a wide range of artistic movements and periods from the

Stone Age to impressionism and from locations as diverse as Africa, Australasia, China, and Europe. He then gives a resumé of the development of European art since impressionism and discusses the purely painterly aspects of cubism, futurism, and Orphism at some length.

Larionov next presents an argument for nonobjective painting. He cites the example of art collectors, who buy the paintings of one particular artist, not because they value the subject of the picture, but because they value the distinctive and unique way in which that particular artist manipulates the formal aspects of the medium. This, Larionov says, is why a collector prefers the work of one artist to that of another, even though both may have painted the same subject. He then justifies nonobjective painting by explaining: "The majority of dilettanti would think it very strange if objects as such were to vanish completely from a picture. Although all that they appreciate would remain—color and the painted surface."[9]

At this point, however, Larionov does not follow his course to its logical conclusion. Art, he maintains, must relate to everyday "concrete" life and so rayism combines the formal concerns of the artist with a new rayist perception of the world. Larionov reminds us that our visual faculties are inaccurate in that we do not perceive objects, only the light-rays they reflect. He suggests that artists correct this by adopting a scientific approach based on "the doctrine of luminosity" and a knowledge of radioactive rays, ultraviolet rays, and reflectivity. Consequently, if artists paint what they *know* they see, as opposed to incorrect perceptual images, they must paint the sum of reflected light-rays from an object as well as the reflex rays from nearby objects. This, Larionov declares, is realistic rayism, and represents "the most complete reality of the object." Cézanne was a precursor in this respect. He noticed the reflex rubbing of part of one object against the reflected rays of another, hence the displacement of objects in his work.

Finally, Larionov dismisses the objects of this world altogether and advises artists to concentrate only on the reflected rays themselves. Using this method, Larionov says, the artist may "build" a picture by painting the forms which are "constructed" in the space between objects by the intersection of the reflected light-rays. Such paintings still have their basis in "concrete" life even if they do not depict it, and all the formal qualities that the art connoisseur looks for in a painting will still be present. The coloration of these paintings is extremely important as the density, texture, interrelationship, and "pressure intensity of dominant colors" contribute to the "significance and expressiveness" of these new spatial forms. Consequently the sensation that the picture evokes will be extraordinary; in fact Larionov associates it with the sensation of the fourth dimension. He triumphantly concludes: "Hence the natural downfall of all existing styles and forms in all the art of the past—since they, like life, are only objects for rayist perception and construction in the painting. Hence begins the true liberation of painting, and its own life according to its own laws."[10]

The six reproductions in the manifesto illustrate specific points of rayist theory. For example, *Rayist Construction of a Street* (fig. 57), despite its title, was entirely nonobjective and represented that stage of rayist theory in which the object was dismissed in favor of the spatial forms created by the intersection of its reflected rays in space. In this drawing the only subject is the delicate and intersecting pattern of rays that are reflected from walls, windows, and pavements. Two drawings by Goncharova were also reproduced. *Rayist Construction* features clusters of untidy and rapid rays while *Head of a Clown* (fig. 58) is bolder and more expressive. Executed in late 1912 or early 1913, these three drawings are among the first nonobjective works of Russian art. Contemporary criticism, however, was damning: "These real illustrations of an unreal art convincingly demonstrate that rayism combines theoretical ignorance and feeble drawing. Deliberate farfetchedness is aggravated by a loudness and a thirst for publicity which is noticeable on every page of this brochure."[11]

In retrospect the publication of *Luchizm* was a significant event in the history of modern Russian art. The document represents the first published discussion of what became known as "nonobjective" painting and opened up the debate about "nonobjectivity" in Russian art. As such it may be seen to have had an impact upon both Malevich and Tatlin, as well as upon the post-revolutionary work of Popova and Rodchenko. Although Malevich derided rayism, his later suprematist theory and practice owe a debt to Larionov as they are based on an elaboration of the esoteric, formalist, and nonobjective principles outlined in *Luchizm*.

The other important aspects of the manifesto include Larionov's emphasis on the idea of "constructing" or "building" a painting according to the intersection of rays and his emphasis upon the formal aspects of his art, such as color, mass, texture, and planar composition. Again this was the first publication in Russian of such ideas, and although Larionov uses the word *postroenie* (building or construction process) as opposed to *konstruktsia* (construction), his theories had evident repercussions on Tatlin and his followers and were of undoubted importance in

Fig. 57. Mikhail Larionov, *Rayist Construction of a Street.* Reproduced in Luchizm, 1913

Fig. 58. Nataliya Goncharova, *Head of a Clown*, 1913

Fig. 59. Aleksandr Rodchenko, *Linear Construction*, c. 1919

the development of constructivism in Russia in the early 1920s.

Furthermore, in stylistic terms, the influence of Larionov's rayism can be traced in the post-revolutionary work of several constructivist artists, including Lyubov Popova and Aleksandr Rodchenko. The same overlapping lines and intersecting planes that characterize rayism occur in Popova's gouaches and paintings of *Spatial Force Constructions* of the early 1920s (Tretyakov Gallery, Moscow). In addition the interaction of thin diagonals in Rodchenko's series of *Linear Constructions* (fig. 59) clearly recalls the example of Larionov's *Rayist Construction of a Street* (fig. 57).

During the spring of 1913 Larionov increasingly distanced himself from other avant-garde groups. There were to be no more joint exhibitions with the Union of Youth, for Larionov now entertained his own plans. In April 1913 the press publicized his intentions to organize three new exhibitions.[12] Counting the Jack of Diamonds as the first, the Donkey's Tail as the second, and the Target as the third, these new exhibitions were to be entitled simply "No. 4," "No. 5," and "No. 6." The No. 4 exhibition, featuring the work of the Target group and with "a Russian nationalistic emphasis to counterbalance the western influence on Russian art," was scheduled for autumn 1913 but was postponed until the following spring. The No. 5 exhibition, presenting a retrospective of three hundred fifty works by Goncharova, took place in October but under a different title, and it is possible that the scheduled No. 6 exhibition, devoted to rayist paintings, took place shortly before Larionov and Goncharova left Moscow for Paris.

Larionov also withdrew his collaboration in the illustration of Russian futurist books by Kruchenykh and Khlebnikov. However, to keep abreast of the avant-garde, Larionov and Goncharova needed to present a credible literary as well as artistic front. Several poets such as Sergei Bobrov and Konstantin Bolshakvok were already associated with the Larionov and Goncharova group and remained close to the artists. Kruchenykh's formative role, however, was filled by Ilya Zdanevich (1894–1975), a recent addition to the group, who substantially contributed to its autonomy and impact as a literary-artistic force within the avant-garde. A law student in St. Petersburg, Zdanevich quickly made a name for himself in avant-garde circles as an innovatory poet and propagandist for both Italian and Russian futurism. He met Larionov and Goncharova through his brother Kirill Zdanevich and during 1913 and 1914 associated with them closely. As a triumvirate they worked particularly well together and advanced the cause of Russian futurism in some remarkable ways. Their plans for exhibitions, publications, and bizarre events were fully reported in the press and added a real zest to the development of the Russian avant-garde in the years before the war.

The first individual publications of the group included the monograph *Nataliya Goncharova Mikhail Larionov* (fig. 60), written by Ilya Zdanevich under the pseudonym of Eli Eganbyuri, and the almanac *Osliny khvost i mishen'* (*The Donkey's Tail and Target*), both published by Myunster in July 1913. The monograph represented Zdanevich's first literary commission and is the most informative primary

Fig. 60. Mikhail Larionov, Title page of Eganbyuri's monograph, *Goncharova Larionov*, 1913

source we possess of Larionov's career in Moscow. The text presents an historical account of Russian culture the origins of which Eganbyuri locates in the Mongol invasions. He notes, however, that since the time of Peter the Great traditional Russian art forms have fallen into decline. For Eganbyuri, therefore, the work of Larionov and Goncharova is of historic importance as it represents the first serious examination of indigenous artistic traditions. Larionov and Goncharova are heralded as pioneers in the revival of Russian art, and a lively account of their lives and work follows.

Osliny khvost i mishen', on the other hand, was an almanac comprising two manifestos and two essays written by members of the group. The almanac opens at the group photograph (fig. 56) taken at the Target exhibition in March, which is provocatively inscribed, "We do not demand the attention of the public and ask that they do not demand it from us"! On the next page appears the manifesto "Rayists and Futurepeople" signed by Larionov, Goncharova, Ivan Larionov, Shevchenko, Romanovich, Levkievsky, Bogomazov, Kirill Zdanevich, Obolensky, and Fabbri.

The word "futurepeople" (*budushchniki*) was a neologism invented by Larionov to distinguish the group from followers of David Burlyuk, who from time to time referred to themselves as *budetlyane* (people of the future), a neologism invented by Khlebnikov.

The manifesto was condescending and polemical regarding western artists and members of the Russian avant-garde alike:

> We, Rayists and Futurepeople, don't wish to speak about new or old art, and even less about contemporary western art. . . . We, artists of art's future paths, offer our hand to the futurists, despite all their mistakes, but express our complete contempt for so-called ego-futurists and neo-futurists, talentless, banal people, the very same as the "Jack of Diamonds," "Slap in the Face," and "Union of Youth."[13]

Nonetheless, Larionov was still eager to collaborate whenever possible with the leaders of "contemporary western art" and, shortly before the publication of the manifesto, had written to Kandinsky in Munich, offering to collaborate on a proposed second volume of the almanac *Der Blaue Reiter*.[14] Furthermore, the manifesto's provocative tone was paradoxically contradicted when Larionov declared: "We acknowledge all styles as suitable for the expression of our creativity, those existing both yesterday and today such as cubism, futurism, Orphism, and their synthesis rayism."[15]

The concept that artistic styles from all periods of time are permissible and, in a sense, equivalent to one another, was called "everythingism" (*vsechestvo*) and it was an important tenet for the Larionov group at this time. The origin of the concept can be traced to Russian symbolism and specifically to Andrei Bely's statement that "At the moment we are experiencing all ages and all nations in art; the past rushes before us. This is because we are standing before a great future."[16] In the years before the war, however, this concept was principally elaborated by Larionov and his group, for whom it helped explain the complicated interrelationship between ancient and indigenous Russian art forms and their own neo-primitive and rayist styles. Aleksei Grishchenko wrote at this time of the bridge that young Russian artists were building back to their national artistic traditions; "everythingism" was such a bridge, by which Larionov was able to assimilate styles from different epochs and locations into his broad aesthetic ideology.[17] It was a complex concept which recurs in Larionov's writings and which had a wide application among the group.[18]

A second manifesto entitled "Rayist Painting" was also published in *Osliny khvost i mishen'*. The text of this manifesto was similar to that of the booklet *Luchizm*, but now Larionov added introductory verses from Walt Whitman's *Leaves of Grass* as well as a new conclusion which discussed the subject of pneumo-rayism (*pnevmo-luchizm*). This was a recent development in rayist theory in which Larionov stated his intention to present the spatial forms, created by reflected ray-lines, within a sectional rayist context, by joining extraneous elements together into general masses. The obscure word "pneumo," by which Larionov designated this new aspect of rayist theory, most probably relates to the ancient Greek theory of "pneumatism" and to the concept of the "pneuma" in Stoic philosophy, although contemporary critics were at a loss to understand the term.

Osliny khvost i mishen' also included two critical essays. A review by Varsanofy Parkin entitled "The Donkey's Tail and Target" discussed the painterly work of the group while an article written by S. Khudakov entitled "Literary Artistic Criticism: Debates and Lectures" represented a vicious attack on the literary avant-garde. The poet Sergei Bobrov was tactfully omitted from this tirade owing to his recent collaboration with Goncharova on the book *Vertogradari nad lozami* (*Gardeners over the Vines*). In addition Khudakov was complimentary about the unknown poet Anton Lotov, and his book of poems *Rekord* (*Record*), supposedly illustrated by Goncharova, was highly praised.[19]

Khudakov was also complimentary towards Konstantin Bolshakov, another young poet, who was increasingly drawn into the Larionov orbit at this time. In August 1913 Larionov and Goncharova illustrated Bolshakov's long poem *Le Futur* which was subsequently confiscated by the police on account of its pornographic imagery.[20] Larionov's illustrations depict the urban underworld the poem evokes and in particular the prostitutes who haunt the city at dusk. One such drawing (fig. 61) comprises a woman's head with the image of a bicycle on her cheek and the witty inscription "3 Roubles" (*3 Rublya*), in which the syllable *blya* also signifies the Russian "whore" (*blyad*). Another drawing depicts the gloomy boulevards that are inhabited by "stray coquettes" and "colorless people" (fig. 117). These incorporeal beings are indicated by brief outlines that render them transparent and allow Larionov to indulge his humor by revealing their underwear, suspenders, and false accoutrements.

During the summer of 1913 these drawings acted as prototypes for paintings such as *Sea Beach and*

Fig. 61. Mikhail Larionov, Illustration for *Le Futur*, 1913

Fig. 62. Giacomo Balla, *Dynamism of a Dog on a Leash*, 1912

Woman (pl. 15) that exemplified Larionov's new theory of pneumo-rayism. The reduction of the figure to an outline in *Le Futur* (fig. 117) is taken a stage further in this painting. Here the contours of the bather are fractured and erased so that only the vestiges of a silhouette remain. The figure has been dematerialized, as it were, and integrated with the rayist context of shifting and intersecting planes of color that the beach generates by its reflectivity. Larionov's rays thus integrate the bather with the world she inhabits. This vigorous world of ray-life, existing beyond our everyday experience, is the real subject of the painting and lies at the heart of rayism. Larionov's contemporaries, however, read the painting as nonobjective and hence nonreferential: "Really there's neither a beach nor a woman in the painting, only red, blue, white, and black stripes," declared one critic.[21] *Sea Beach and Woman* represented Larionov's most advanced work at this point and he exhibited the painting at the earliest opportunity at *Der Sturm* Autumn Salon organized by Herwarth Walden in Berlin from September to December 1913.

The exhibition brought together the leading members of the European avant-garde. The Italian futurists were represented as were many artists associated with the cubist aesthetic in Paris, among them Robert and Sonya Delaunay, Gleizes, Léger, Marcoussis, Metzinger, Mondrian, and Picabia. Kandinsky and artists affiliated with the Blue Rider in Munich contributed works as did Central European cubists such as Filla, Gutfreund, and Procházka. Russian exhibitors included Larionov, Goncharova, the Burlyuk brothers, Kulbin, and from Paris, Archipenko, Chagall, and Yakulov. The Autumn Salon, like the Target, also showed examples of naive painting in the work of Henri Rousseau and the Russian "primitive," Kovalenko. In addition, eastern art forms were represented by Indian miniatures and Japanese and Chinese quill paintings owned by Kandinsky and Marc who, like Larionov, possessed important collections of such works.

The exhibition provided a review of contemporary painting and in this respect was important for Larionov. It was here that Balla exhibited his *Dynamism of*

a Dog on a Leash (fig. 62) which was reproduced in the exhibition catalogue and evoked a direct response from Larionov in his painting *Boulevard Venus* (pl. 14) executed in autumn 1913. The subject of Larionov's painting is an urban prostitute whose florid clothes and complexion are echoed in the colorful maelstrom of splintered rays that vibrate around her. Larionov, however, was not afraid to compromise his rayist style with cubist and futurist devices and, like Balla, used multiple imagery to add to the dynamism of the scene. A bar of music and letters recall similar devices in both futurism and analytical cubism. Larionov also developed a transparent effect which he had first used in *Le Futur* (fig. 117), only here the effect is more explicit, revealing breasts, corset, and frilly knickers. The eclectic nature of the painting, the intensity of expression that Larionov achieved, the rich color harmonies and the fluency of execution mark it as one of the key paintings of the early twentieth century.

During the late summer of 1913, Larionov and Goncharova finalized plans for her remarkable one-woman exhibition, which took place in Moscow from October to November at the Artistic Salon on Bolshaya Dmitrovka. This huge retrospective of nearly eight hundred paintings from all periods of Goncharova's career was accompanied by a catalogue with a preface by Goncharova herself. She stridently denounced the culture of the west and embraced the east. The provocative manifesto and the size of the exhibition aroused both interest and criticism. Rosstsii, although he found her work marred by eclecticism, referred to Goncharova as "the most talented, able and 'modern' artist" of her generation.[22] The most complimentary review was by Benois who, repudiating his earlier criticism, was now gushing in praise of the artist:

> Why don't the famous Moscow fashion designers come and learn from her? Why is it that Goncharova's splendid stylistic and decorative skills have hitherto remained unexploited? Where are the publishers who should be printing her *lubki*, where are the theatres who should be commissioning her to paint their temples? But instead of all this, all she has is the reputation of some sort of "Holy Fool" and buffoon. Can one blame her for becoming embittered, for throwing one challenge after another at society?[23]

The exhibition acted as a focus for several complementary events and excited public attention even to its closing day when Ilya Zdanevich lectured on "everythingism."[24]

The most important event was a performance on October 6 of Bolshakov's play *Plyaska ulits* (*Jig of the Streets*) which was dedicated to Goncharova and depicted the nightlife of the city. The décors for the play were designed by Larionov and the music was composed by Aleksei Arkhangelsky. *Plyaska ulits* was unusual in conception in that the hero was performed by three actors in different settings simultaneously. To accomplish this Larionov designed three sets—a restaurant hall, the hero's apartment, and the street outside—and placed them one behind the other. The effect of this arrangement was so novel that one critic reported that Larionov would patent his idea and that *Plyaska ulits* would soon be performed at the proposed "Futurist Theatre" in Moscow.[25]

This sort of Russian avant-garde theatre had complex origins in the cabaret culture of the symbolists and the theories of Evreinov and Komisarzhevsky. Since the question of an avant-garde theatre had first been raised by Larionov at the Target debate in March, at which both Evreinov and Komisarzhevsky were scheduled to speak, other avant-garde groupings had discussed unconventional forms of theatrical activity. During the summer of 1913, Malevich, Matyushin, and Kruchenykh made preparations for the play *Vladimir Mayakovsky: Tragediya* to be performed by Mayakovsky with décors by Shkolnik and Filonov, and for a production of the opera *Pobeda nad solntsem* (*Victory over the Sun*), written by Khlebnikov and Kruchenykh with a score by Matyushin and lighting and décor by Malevich.[26]

There was clearly competition between the Larionov and Malevich groups, for in a letter to Matyushin of 11 September 1913 Malevich urged his colleagues to complete the production of the opera to forestall Larionov from anticipating their première with a performance of his "Rayist theatre."[27] The fear was no idle one, for Larionov's plans to open "The Futurist Theatre" were imminent. On September 8 the magazine *Teatr v karrikaturakh* (*Theatre in Caricatures*) announced that a futurist theatre would open at the Pink Lantern Cabaret on Mamovsky Pereulok in Moscow. The report noted that Larionov, Goncharova, Ilya Zdanevich, Bolshakov, Lotov, and Mayakovsky were working there, that the décors and staging would move, that the music and lighting would conform to the dancing, and that the plays would be "beyond the limits of the language of ideas, being a free and invented onomatopaeia."[28]

A day later *Moskovskaya gazeta* confirmed the report that a futurist theatre would open in Moscow. The paper noted that a patron had subsidized the venture, that plays had already been written, a company

formed, and that Larionov and Goncharova were painting the scenery. Moreover, the article explained the revolutionary theatrical concepts that Larionov now entertained. In Larionov's "Futurist Theatre" everything was to be arranged along "futurist" principles which rejected accepted theatrical conventions. In fact nothing less than a complete subversion of traditional theatre was planned:

> What serves as the stalls in non-futurist theatres will represent the stage. The audience will be placed, depending on the action, either on a dais in the middle of the theatrical hall or over it, on a constructed wire net under the ceiling. In the latter case it will be necessary to watch the play from above, through the mesh of the rack, lying or squatting, whichever is more comfortable".[29]

The performance itself was also to be totally revolutionary. The floor and stage were to be in continuous movement as were the actors, who were to perform a rhythmical dance to the sound of an orchestra of flutes. The futurist composer Levkievsky was composing the music, which was described as "a lively cacophany," like an orchestra tuning up. The makeup was novel in that each actor was to have several ears, eyes, and noses painted on the face, and unusual hair styles made up of wigs piled one on top of the other! In the most revolutionary concept of all, Larionov removed props from the stage and replaced them with actors: "The actors themselves will play the props and costumes. So there will be the actor-hat, the actor-trousers, the actor-handkerchief, the actor-boots, the actor-table, door, window, etc. In general, futurist theatre will not be theatre performing plays but theatre performing theatre."[30]

One can imagine the spectacle, an apotheosis of dynamism, with everything in continuous motion from the stage to the madeup face, which, with extra eyes, ears, and noses, itself suggested mobility. According to *Moskovskaya gazeta* a repertoire for the "Futurist Theatre" already existed, comprising three "works" by the poet Lotov—the dramatic poem "Bu-la-na," evidently an onomatopoeic work, and two comedies, one called *Futu* and the other *Segodnyashny kostyum* (*The Contemporary Costume*). However, it is not known whether any performances took place at the "Futurist Theatre" and so they cannot properly be compared with either *Pobeda nad solntsem* or *Vladimir Mayakovsky: Tragediya*, both of which were successfully performed in December 1913 in St. Petersburg. However, the conceptual basis of Larionov's "Futurist Theatre" was as revolutionary in theatrical terms as the productions by Malevich and his friends.

His ideas for a moving stage and scenery prefigure constructivist theatre and plays such as Meierkhold's production of *Velikodushny rogonosets* (*The Magnanimous Cuckold*) of 1922 in which Popova's set also revolved and turned.

Larionov's conceptual contribution to Russian avant-garde theatre was highly original and, when the "Futurist Theatre" failed to establish itself, Larionov took his new theatrical strategems onto the streets. Already, in September 1913, he had shocked the Moscow public by appearing on the Kuznetsky Bridge with a painted face! This was the first of many public appearances in which Larionov and his *budushchniki* dressed in strange clothes, painted their faces, and paraded on the Moscow streets, attracting public attention and disturbing the peace in a way that demanded police intervention.[31]

Several photographs portray Larionov and his group proudly sporting rayist designs on their cheeks and foreheads. The best of these is an intimate portrait of Larionov carefully painting his left cheek in the confines of his studio before an evening's entertainment (fig. 63). Strangely enough, Larionov's face-painting became a popular novelty in Moscow, and the practice was adopted by fashionable members of society such as A. D. Privalova who followed all the latest trends (fig. 64).[32] News of this fad even spread to Paris when Diaghilev told Michel Georges-Michel that Goncharova had painted flowers on her face and that all the nobility would follow her lead "with horses and houses drawn and painted on their cheeks, foreheads and necks."[33] In fact the Russian press soon reported that "the new art of painting one's face devised by Larionov and Goncharova has now caught on in Paris" where it was called *la mode russe*.[34]

Even the staid magazine *Argus* published a manifesto by Larionov and Zdanevich entitled "Why We Paint Ourselves." It included photographs of Larionov, Goncharova, Ilya Zdanevich, and Le-Dantyu, each with painted faces (figs. 65–67) as well as illustrations of rayist designs with which readers could decorate their own faces and breasts! The two designs on the first page were for the left and right cheek, the former being "a figurative mark standing for a house" and the latter representing "the word 'idea' and a figure," both marks expressing "the relationship between man and city building." The more complicated design (fig. 67), featuring the word "style" or "syllable" (*slog*), was for the breast. The manifesto itself is a fast-paced piece of writing in which painted faces are associated with an assortment of modern achievements: "the frenzied city of arc lamps," "the screech of the trolley," "the drunken sounds of the great

Fig. 63. Larionov painting his face, 1913

tango," "a projector of experiences," "a newsman and a decorator," "a telescope." The ideas follow pell-mell and the actual writing of the manifesto emulates the speed and the rush of sensations that both the Russian and Italian futurists accepted as the quintessence of modern life.

Larionov, Goncharova, and their group usually appeared with painted faces at the Pink Lantern cabaret where they organized futurist evenings. They painted the faces of members of the audience and entertained and abused the crowd in all manner of ways.[35] However, events at the Pink Lantern got out of hand, and

on 19 October 1913, Larionov, Goncharova, Maya-kovsky, and the symbolist poet Balmont caused an enormous scandal. Larionov appeared with a painted face and insulted the audience by referring to them as "the jack-asses of the present day." Balmont added fuel to the fire by declaring: "Long live Larionov! Long live all the idiots who have sat in front of him!" a remarkable outburst for a symbolist poet. Maya-kovsky declaimed his insulting poem *Nate* (*Take This*) while Goncharova struck an army officer. The audience went wild with anger:

Fig. 64. Goncharova painting the face of the poet Konstantin Bolshakov, Larionov with a painted face, and A. D. Privalova with painted arms and chest

Fig. 65. Ornamentation and photographs of Le-Dantyu (upper right) and, from left to right, Larionov, Goncharova, and Zdanevich (bottom right) with painted faces, from the manifesto "Pochemu my raskrashivaemsya"

Fig. 66. Ornamentation and photographs of Zdanevich and Larionov (upper left) and Goncharova (right) with painted faces, from the manifesto "Pochemu my raskrashivaemsya"

Fig. 67. Ornamentation from the manifesto "Pochemu my raskrashivaemsya"

To all the protests Larionov replied: "You're boors!" The public bawled back at Larionov and his colleagues: "You're scoundrels!" The artist Nataliya Goncharova, one of the futurist ringleaders, assaulted someone. The futurists shouted "asses" and "blockheads" again and again. In the end the audience wanted to thrash them. The feeling against the futurists ran so high that if the police had not intervened, everything would have ended in a bloody battle.[36]

Following the incident, the Pink Lantern was closed by the police, but this cannot have disappointed Larionov, Goncharova, or Mayakovsky, since the many reports in the Russian press provided maximum publicity for themselves and Russian futurism.[37]

Apart from the painted face, Larionov also advocated a revolution in contemporary fashion design, and in an interview with the press he stated his intention to publish two manifestos on the subject. Men were advised to go about in sandals with painted feet, to shave off half of their beards or moustaches, to plait yellow tassels in their hair, and to wear a flower behind their ears! Women were to go topless with painted breasts and it was alleged at the time that several Muscovite ladies had offered themselves to Larionov's brushes![38] The press predicted a new futurist scandal and that proved to be the case. Mikhail Le-Dantyu appeared at a futurist evening on December 14 dressed as Larionov had suggested and incited the audience to riot simply by his appearance![39]

By December 1913 Larionov and Goncharova had attracted the attention of film director Vladimir Kasyanov who approached them with the suggestion of making a futurist film. The cinema had interested Larionov as early as 1912 when he exhibited the painting *Scene – The Cinema* (fig. 36) at the Donkey's Tail. More recently Mayakovsky had explored the relationship between futurism and the cinema in three articles for the magazine *Kine-zhurnal* (*Cine-Journal*).[40] Moreover, apart from the creative possibilities of the medium, film represented a major propaganda weapon for Russian futurism. Larionov and Goncharova agreed to star in the film, to invent a plot, and to design the décor using rayist ideograms.

Larionov, Goncharova, and Kasyanov produced a short film, only 431 meters long, which was released in January 1914 under the title *Drama v kabare futuristov No. 13* (*Drama in the Futurists' Cabaret No. 13*). Only one still from the film now survives (fig. 68); it depicts Larionov and Maksimovich, a member of the futurist circle, with painted face and breast, shortly after "the drama" has taken place. For-

tunately Kasyanov recorded the action of the film in his memoirs and they provide an important insight into this first futurist film, indeed the first film in which the twentieth-century avant-garde directly participated.[41]

Drama v kabare futuristov No. 13 opens with a sequence in the cabaret where the artists are painting their faces in preparation for the evening's entertainment. A caption appears: "13 hours has struck. The futurists assemble for the evening." There follows a sequence depicting futurist cabaret numbers in which the poet Lotov declaims a poem—meaningless letters flash onto the screen—Elster dances "the futurist tango," and Goncharova performs a tap dance. These pave the way for the central event of the evening and the real "drama" of the film, "the futuredance of death," during which one partner must murder the other. The futurists draw lots, and Larionov and Maksimovich are chosen to perform the dance on a table. Both are given a curved knife and the "futuredance" begins. Larionov throws Maksimovich from one arm to the other and strikes her with the hilt of the knife, she in retaliation strikes him, and finally he kills her outright.

The caption "Futureburial" appears on the screen. Larionov carries the corpse out of the cabaret (fig. 68) and, with a companion, drives away to deposit the corpse in a snowdrift. Before returning to the cabaret, Larionov stoops to kiss his victim. On his return the futurists discover that Larionov has kissed the corpse of Maksimovich and sentence him to excommunication from the futurist ranks. Unable to bear such a punishment, Larionov drinks poison and drops dead outside the door of the cabaret. The evening ends and the futurists leave. Demonstrating their contempt of death, they indifferently step over Larionov's corpse. The last of them bends down and attaches a note to the corpse, which reads: "expelled from futurism." The final sequence returns to the corpse of Maksimovich lying in the snow and ends with the caption: "a victim of futurism!"

The plot was evidently designed to disconcert the audience and to proclaim Russian futurism as an anarchic force in contemporary society. Kasyanov, however, records that when the film was screened in Moscow in January 1914 the audience treated it as a comedy, and the newspaper critics found the acting feeble and the plot dull, though some were entertained by the futurist music accompanying the film.[42] Any other meaning behind the film is unclear. The "futuredance of death" may be a parody of the tango, which was then becoming popular. Larionov had referred to it in the manifesto "Why We Paint

Fig. 68. Still from the film "Drama in the Futurists' Cabaret No. 13"

Ourselves," though Ginzburg disputes this and Leyda describes the "futuredance" as a parody of the prevalent genre of film-guignol.[43] Gray (1961), however, advances the interesting hypothesis that the film, along with the rest of the avant-garde's public clowning, represented an attempt to restore art to its place in ordinary life. Gray sees this as a development of the tradition of the "social conscience" in Russian art. Certainly, at the time the film was being made, Larionov boldly declared: "We have joined art to life. After the long isolation of artists, we have loudly summoned life, and life has invaded art. It is time for art to invade life. The painting of our faces is the beginning of the invasion."[44]

During 1913 the Larionov group had embraced an aesthetic that not only blurred the distinctions between traditional media such as painting, graphics, literature, theatre, film, and music, but that aspired to everythingism rather than the dogmatic practice of the futurist aesthetic. This was made clear when Larionov, Goncharova, Zdanevich, Le-Dantyu, Levkievsky, and Romanovich, among others, organized the First Evening of the Everythingists in St. Petersburg on 10 December 1913. A press release advertising the event declared that the aims of futurism had been achieved, that it was now outdated and ready to be replaced by everythingism, a new approach "free from time and place."[45] Although Italian futurism had played a crucial role in Larionov's development, his innovations clearly maintained an independent and

original character and this explains his ambivalent reactions to Marinetti's lecture tour of Moscow and St. Petersburg during January and February 1914.

Two days before the leader of the brash Italian futurists arrived in Russia a newspaper article was published reporting Larionov and Goncharova's reaction to Marinetti's impending visit:

M. F. Larionov considers that Marinetti has betrayed the principles of futurism. . . . He has turned futurism into a religion with its own code of tenets and prejudices and so Larionov is turning away from him and, to put it figuratively, "he spits on him." "We are arranging a gala reception for him. Everyone for whom futurism is precious, as the principle of perpetual advancement, will appear at the lecture and we will pelt this renegade with rotten eggs, we will soak him with sour milk! Let him know that even if Italy does not, Russia at least takes vengeance on traitors."[46]

The article initiated a vitriolic exchange among the Russian avant-garde in the pages of the daily press. On the day of Marinetti's arrival the poet Vadim Shershenevich attacked Larionov for exhibiting such a hostile point of view, and shortly after, Malevich followed suit by publicly disassociating himself from Larionov.[47] Then, on the morning following Marinetti's first two lectures, Larionov published a spirited reply to Shershenevich in which he explained that what he had initially said should only be taken figuratively as an expression of his "ideological attitude" to Marinetti. Then, however, rubbing salt into the wound, he declared:

I think that Marinetti does deserve rotten eggs from genuine contemporary futurists and that it's only Russian philistines who applaud him. Personally I consider the ideas of Marinetti uninteresting and long since out of date. . . . Rayism, the doctrine that emerged after futurism, is more pertinent to the future than what Marinetti preaches. The futurism propagated by Marinetti is accepted by the masses, but the people who have really turned towards the future, among whom are myself, N. Goncharova, Le-Dantyu, K. Zdanevich, Lotov, I. Zdanevich, and others, consider it outdated and therefore useless.[48]

Larionov also attacked "the decadent sentimental verses of Shershenevich," the work of the critic Tasteven, on whose invitation Marinetti had come to Russia, and Malevich, who was branded "an uncolonized native" with whom Larionov had "never shared any community of artistic opinions." Inevitably Shershenevich responded to this provocation the following day by accusing Larionov of being uncivilized and barbarian.[49] Then, as Marinetti prepared to leave Moscow for St. Petersburg, Larionov sent a curt and abusive reply to the press, denouncing Marinetti and the Russians who had taken his side: "In response to all the letters, declarations, and objections directed against me, I declare quite frankly: Mr. Marinetti, who preaches old rubbish, is banal and vulgar, fit only for a mediocre audience and narrow-minded followers. I think that what I have said quite clearly defines my opinion on the 'futurism' of Mr. Marinetti and his sympathizers."[50]

For the moment the debate in Moscow ended while Marinetti gave two lectures in St. Petersburg, where Livshits and Khlebnikov published an attack on him in a leaflet which they distributed before his lectures. While Marinetti was in St. Petersburg, David Burlyuk, Kamensky, and Mayakovsky returned from their own lecture tour of the Russian provinces, and they too now entered the newspaper debate with their own points of view.[51] Marinetti gave his final lecture in Moscow on February 13. The leaders of the Russian avant-garde attended and, on discovering that the events of the evening were to be conducted in French, not Russian, they disrupted the gathering. As a Moscow newspaper reported the following day: "A serious scandal which required police intervention occurred during the reading of one of the papers about the futurists at the Literary-Artistic Circle on February 13th. The Moscow futurists Larionov, Burlyuk and Mayakovsky aroused indignation with their verbal assaults and the public began to whistle and demand their removal."[52]

The authorities increasingly took swift and harsh action to counter such behavior. Shortly after this event the Literary-Artistic Circle unanimously censured Larionov's behavior as "intolerable in an educated society" and deprived him forever of the right to attend its meetings. Moreover the Circle introduced a new rule whereby, with the exception of masquerade balls, anyone wearing "fancy dress costumes and with drawings on their faces should be barred from entering the premises!"[53]

At this time, when Russian futurism was at its height, the Russian public were both scandalized and excited by the daring actions of the avant-garde. The press conducted interviews with the artists, of which the most confounding was that given by Larionov and Ilya Zdanevich to *Teatr v karrikaturakh:*

Fig. 69. Goncharova and Larionov painting the sets of *Le Coq d'Or*, 1913–1914

Are you futurists?

Yes, we are futurists.

Do you deny futurism?

Yes, we deny futurism. May it disappear from the face of the earth!

But aren't you contradicting yourselves?

Yes, our aim is to contradict ourselves.

Are you charlatans?

Yes, we are charlatans.

Are you untalented?

Yes, we are untalented.

Is it impossible to talk to you?

Yes, it is.

But what are your new year resolutions?

To be true to ourselves.[54]

Hardly a day went by without the newspapers reporting the activities of Larionov and Goncharova and witty anecdotes about futurism. *Peterburgskaya gazeta,* for example, told the story of a drunkard who broke a shop window with his walking stick and when taken to the police station and charged, pleaded that he was a futurist! The report concluded that it didn't much matter whether or not he really was a futurist because "Hooligans and futurists are one and the same!"[55]

Consequently, Mikhail Fokine, the leading choreographer of Diaghilev's *Ballets Russes,* was particularly disturbed when in December 1913 Diaghilev suggested they visit Goncharova with a view to commissioning her as the designer of their forthcoming ballet *Le Coq d'Or.*[56] Fokine recalled:

I had heard that she and Michael Larionov, who worked with her, belonged to a set of "Moscow Futurists" who painted their faces, organised violent lectures on "new art" and "the art of the future," and that at these lectures, as the strongest argument, pitchers full of water were tossed into the audience. I was apprehensive of staging a Rimsky-Korsakov opera with such collaborators.

After all the horrors I had heard about the "Moscow Futurists," I found myself in the company of the most charming people, modest and serious. . . . Towards the end of the evening I felt thoroughly convinced that Goncharova would produce something unexpected, beautifully coloured, exceedingly natural and at the same time fantastic. As soon as we had left Goncharova, I voted in her favour.[57]

Le Coq d'Or was Larionov's and Goncharova's first work for the conventional theatre, and a new activity and direction in their careers. From this point on, their theatre design began to eclipse their painting, and outside Russia their reputations were to be built on their artistic achievements in the world of ballet. While Diaghilev made arrangements for Larionov and Goncharova to visit Paris for the première of *Le Coq d'Or* at the Opéra in May, Goncharova began preparatory work on the designs, in which she was helped by Larionov (fig. 69).

Before their departure for Paris, Larionov and his group held a final exhibition in Moscow. The Exhibition of Paintings No. 4: Futurists, Rayists, Primitives opened at the Artistic Salon on Bolshaya Dmitrovka

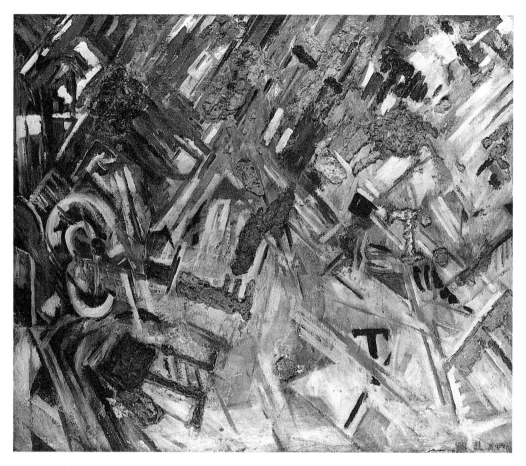

Fig. 70. Mikhail Larionov, *Sunny Day: Pneumo-Rayist Composition*, 1913–1914

in March 1914 and closed in April. Plans for the exhibition had undergone considerable changes since first being mooted as a neo-primitive exhibition in April 1913, and then in October 1913 as an exhibition in which Italian futurist and French Orphist artists were to participate.[58] However, none of these "like minded" westerners appeared and the Exhibition No. 4 featured only several of the Target group from the year before: Bogomazov, Goncharova, Le-Dantyu, Lev-kievsky, Pavlyuchenko, Romanovich, Shevchenko, and Kirill Zdanevich. Larionov also seems to have lost the support of several important figures, such as Chagall and Malevich, as well as a number of less well-known but faithful artists who had exhibited at both the Donkey's Tail and the Target.

Larionov's notoriety, however, ensured that there was no shortage of new contributors to the Exhibition of Paintings No. 4. These included Sergei Baidin, Vasily Chekrygin, Ivan Firsov, Galina Labunskaya, Nikolai Lopatin, Lef Ostofiev, Sergei Podgaevsky, Vera Shekhtel, and two unexpected and important

contributors, Aleksandra Exter and the Hylaean poet Kamensky, who showed some of his "ferro-concrete" poems. Larionov's exhibits here included *Sea Beach and Woman* (pl. 15), which was reproduced in the catalogue with the sub-title "pneumo-rayism," *Boulevard Venus* (pl. 14), and *Glass* (fig. 44). Larionov also showed a series of works painted in late 1913 and early 1914 based on the idea of structure, among which were *Sunny Day* (*Pneumo-Rayist Colorful Structure*), the unidentifiable *Sea Beach* (*Colorful Structure*), and three works with the title *Structural Construction*.

Sunny Day (fig. 70) reveals Larionov at his peak as a nonobjective artist. The handling of materials, the dynamism of the rays, and sheer brilliance of color in these works have a potent expressive force. The magazine *Ogonek* illustrated the painting as the most exciting work of the whole exhibition and declared, "Everything in the painting emanates like a vortex of bright sun spots and strokes. There are no names in the human language for the separate details of

this masterpiece and only in the center, under daring strokes, the fatal word *Ka* gloomily predominates. . . ."[59]

In these nonobjective paintings Larionov used novel techniques. *Sunny Day*, for example, relies on a textured and painted surface made from papier-maché while the use of partial words, such as "Ka," a reference either to Kamensky or to the "Ka" of Khlebnikov's famous poem, pre-dates Malevich's use of the word in his *Aviator* (Russian Museum, St. Petersburg). These "colorful structures" and "structural constructions" are similar in style to *Rayist Composition: Domination of Red* (fig. 115), where there appears to be no reference to the external world whatever. Here there is a conflict not only between the rapidly shifting ray-lines and planes, but also between the colors, which fight for dominance one over the other.

The concept of "the domination of color" marked a new direction in Larionov's rayist theory. As he stated shortly afterwards in his Parisian manifesto "Le Rayonnisme Pictural" (1914), the various colors employed by the rayist painter express different sensations according to their density on the canvas. By varying the density of the pigment Larionov found himself able to "orchestrate" his colors and alter the effects or sensations that each aroused. In *Rayist Composition: Domination of Red* the dominant sensations are those evoked by the vibrant red rays, although the emotions evoked by the other prismatic colors play a role, creating a color symphony.

These paintings represent the conclusion of Larionov's rayist development and the introduction of entirely new possibilities for a younger generation, who after the revolution based their new aesthetics of constructivism upon Larionov's pioneering research. The peculiar titles that Larionov assigned to his nonobjective paintings of 1913–1914, such as "colorful structure" (*krasochnaya struktura*) and "structural construction" (*strukturnoe postroenie*), indicate a new emphasis, that of constructing or "building up" a painting through the process of structuring color and line. After Larionov had left Russia in 1915, the concept was taken up and developed by the constructivists, and it is interesting to note that when Medunetsky and the two Stenberg brothers exhibited as constructivists (*konstruktivisty*) in Moscow in January 1921, they exhibited, among other works, "colour-constructions."[60]

More immediately, Larionov's pioneering ideas were received and developed by a small school of rayist painters who in early April 1914 organized an unusual and forward looking exhibition:

In the premises of one of the private studios on Gorokhova Street an original exhibition has opened by a new circle of artists of the future, calling themselves "rayists." Entering the pitch-dark premises of the exhibition one finds about twenty landscapes in the form of transparencies, painted with special colors on transparent canvas and lit from behind by electricity through colored glass specially selected for each painting. The effect, in particular from the ray lighting, is staggering.[61]

Known as the Exhibition of Rayists, this may be none other than the No. 6 exhibition planned by Larionov in April 1913, although none of the reviews mention Larionov by name. Nonetheless this unusual and highly original exhibition testifies to the influence and fertility of Larionov's aesthetic ideology at this time.

During the course of the Exhibition No. 4, Larionov and Goncharova completed the arrangements for a smaller one-woman exhibition of Goncharova's works, which travelled to St. Petersburg. The exhibition, containing nearly two hundred fifty paintings, opened at the Artistic Bureau of N. E. Dobychina in early April and closed on April 20. The exhibition attracted particular attention since the critic of *Peterburgsky listok* wrote a biting review of the religious paintings on show in which "the Virgin Mary, the Savior, Evangelists, and Saints are all depicted in the most disgusting manner."[62] The works were labelled blasphemous and the paper called for their immediate confiscation. Accordingly the Public Censor removed a room full of religious paintings. However, despite the short duration of the exhibition, the scandal ensured an audience of over two thousand visitors and extensive reviews in the press.

Having closed both the Exhibition of Paintings No. 4 and the St. Petersburg exhibition, Larionov and Goncharova prepared for their journey to the west. The previous four years had witnessed phenomenal activity and later Larionov declared that in the years before the First World War, he had worked harder than at any other period of his life. He had initiated the new styles of neo-primitivism and rayism, organized exhibitions, theorized and published widely, and collaborated with colleagues in the fields of painting, literature, film, and cabaret. The journey to Paris that he now undertook with Goncharova marked the end of this inventive and productive period of his career, but heralded the beginning of a new and long association with Diaghilev and the ballet.

Russian Folk Art and the Sources of Neo-Primitivism

■

The term "neo-primitivism" first appeared in print in Aleksandr Shevchenko's book *Neo-Primitivizm* published in November 1913. Here Shevchenko used the word to denote a style of Russian avant-garde painting inspired by "the *lubok*, the primitive art form, the icon" in which he discovered "the most acute, most direct perception of life."[1] It was the unsophisticated yet vibrant qualities of naive and folk art that the neo-primitive artists sought to capture in their own work. By adopting the stylistic devices and conventions of peasant craftspeople, naive painters, children, and "primitives" of all kinds, they attempted to restore the innocence of vision and vitality of expression that had been eroded by the academies. As Shevchenko was a member of the Target, the term "neo-primitivism" initially referred to the paintings of Larionov, Goncharova, and other members of the group. Subsequently it has been used by art historians to denote a broader stylistic phenomenon applicable to the wider Russian avant-garde in both painting and literature.

Russian neo-primitivism may loosely be equated with French Fauvism and German expressionism in that it rejected "civilized" cultural values, promoted a crude style of painting, and referred to a variety of primitive art forms. Indeed the French and Germans set an important example for the Russians even though the neo-primitive painters shared an ambivalent attitude towards the west. They acknowledged its influence but, in trying to emphasize national characteristics, they sought to underplay it. Goncharova declared that western artists had taught her to look at the indigenous art forms of her own country but she believed the west to be culturally bankrupt as "everything it has is from the East."[2] Shevchenko too acknowledged that Cézanne, Gauguin, and Rousseau "played a role of no small importance in the development of our Russian art" and that he was himself inspired by the Italian primitives, but points out that neo-primitive artists acknowledge such western masters only because they share "the aspiration to-wards the east, its traditions and its forms."[3] In trying to distinguish itself from the west, neo-primitivism became a self-consciously Russian school. Both Shevchenko and Goncharova maintained that neo-primitivism was a profoundly national art movement and in their publications all the Asiatic aspects of Russia's cultural heritage are invoked against western civilization. "Yes!" declared Shevchenko, "we are Asia, and are proud of it because 'Asia is the cradle of the nations,' a good half of our blood is Tatar, and we hail the East to come."[4]

The hostility towards the west derived from the Target group's view of the history of Russian culture. Eganbyuri, for example, stated that Russian culture was rooted in the Asiatic civilization spread by the Mongol invasions but, having developed its own unique forms of expression, it declined from the early eighteenth century when Peter the Great introduced European cultural conventions into Russia. For the Larionov group Russian culture had since then become enslaved to the west and merely reflected European developments. By the turn of the century the *lubok* was no more than a mass-produced print, the icon a cheap manufactured panel, and craft traditions had almost disappeared. Larionov's group wanted to revive this indigenous Russian culture and to rediscover their own national artistic origins and distinctive traditions. Consequently the group rejected the European fine-art tradition taught in the art schools and embraced "primitive" art forms and their alternative conventions.

Shevchenko explained that the term "primitive" had the widest possible definition for the group and that it was applied not only to ancient and peasant art but also to eastern art forms. Hence, the sources of neo-primitivism were many and varied, and Shevchenko specifically cites icons, *lubki*, painted trays, signboards, eastern fabrics, and children's art as "specimens of genuine value and painterly beauty."[5] Many such sources, or "points of departure" as Shevchenko called them, were displayed in both the Tar-

get and the Icon Painting and *Lubok* exhibitions of March 1913.

The interest of the Larionov group in Russian folk art was stimulated by the Russian symbolist position. In the early 1880s the railway magnate Savva Mamontov had founded an arts and crafts colony at Abramtsevo outside Moscow, and a decade later Princess Tenisheva had organized a similar center at Talashkino near Smolensk. Leading artists of the day came to work and study at these estates where cottage industries, wood carving, pottery, and embroidery workshops had been revived.

Both colonies were publicized in Diaghilev's *Mir iskusstva* magazine from 1898 to 1904. Indeed, the theme of the Russian arts and crafts was central to the World of Art aesthetic. Both Tenisheva and Mamontov were at one time patrons of the magazine, the very first World of Art exhibition included pottery and embroidery from Abramtsevo, and many of the artists who worked at the two colonies were members of the World of Art group. Larionov was aware of this revival of traditional arts early in his career since Serov and Korovin were both Abramtsevo artists. Larionov's friendship with Diaghilev and his inclusion in the World of Art circle at the time of the *Salon d'Automne* in 1906 were also significant in this respect. It was in this context that Larionov's interest in the peasant arts and crafts originated and developed. Although he dismissed the work of Filipp Malyavin, who portrayed peasant women in their gay costumes, and recalled "the real peasant girls, so 'live' in comparison with the artificiality of Malyavin's 'Peasant Women,'"[6] Larionov appreciated the unusual style and strange subject matter of artists such as Dobuzhinsky to whom he remarked, "You were born too early—your art is closer to our generation than to your colleagues in the World of Art."[7] Dobuzhinsky's painting *Hairdresser's Window* of 1906 (Tretyakov Gallery, Moscow), which features two made-up mannequin heads, one floating above the other, is particularly reminiscent of Larionov's later style.[8]

Following the demise of the World of Art, an interest in the peasant arts and crafts formed part of the Blue Rose aesthetic, and articles on these subjects were published in *Zolotoe runo*. Pavel Kuznetsov, a friend of Larionov's and the leader of the Blue Rose, wrote about Russian embroideries, and the magazine published extensive articles on Russian icons, Venetsianov and his school, Persian miniatures, and Pomoranian manuscripts.[9] Moreover, a tendency toward primitivism was already inherent in the Blue Rose style. Makovsky, discussing the expressive qualities of their distorted figures, remarked: "They have

heralded that primitivism to which modern art has come in its search for a renaissance at its very sources."[10] Larionov worked closely with the Blue Rose during 1907, and once he became a coeditor of *Zolotoe runo* in 1908, he was exposed to its ideological and aesthetic interest in national and folk art forms. Moreover, at the third Golden Fleece exhibition in 1909 Larionov encountered the *lubki*, icons, lace work, and gingerbread moulds which were on display alongside the contemporary paintings by the younger generation of Russian artists.[11]

In 1910 Alexandre Benois, Nikolai Ryurikh, and Boris Kustodiev, among others, created a second World of Art group. As the group sought to preserve the distinctive character of Russian art they also entertained a national retrospectivism and their work of these years presents a foil against which the radical and far-reaching consequences of Larionov's neo-primitivism may be appreciated. These artists, though not among the avant-garde, were also inspired by Russian folk art and responded to the same need as Larionov to investigate their national culture.

Larionov and Goncharova exhibited with the reformed World of Art but differed with them over the question of how to develop a truly national style. Kustodiev in his paintings and Benois in his set designs for the ballet *Petrushka* remained essentially historical, picturesque, and illustrative while Larionov and Goncharova sought to assimilate the pictorial language of Russian visual culture and express it afresh. For Larionov, the peasant tradition represented the complete integration of art with life and his call to march "hand in hand with our ordinary housepainters" expressed a goal that the cultivated gentlemen of the "World of Art" were unable to achieve.[12] Consequently, although commentators acknowledged that Larionov was working in the signboard tradition, they nonetheless singled out him and his followers as "Fauves" when they exhibited with the World of Art and castigated the organizers of the exhibition for "admitting too many 'Matisses.'"[13]

Although the stylistic innovation and narrative content of paintings such as *Walk in a Provincial Town* (pl. 6) were due to Larionov's interest in contemporary French art, which taught him to appreciate simple and more expressive forms, they also evolved through a study of the work of Venetsianov and his pupils, as well as by reference to the *lubok* and the signboard. The contribution of Aleksei Venetsianov (1780–1847) and his school to Russian art had recently been reviewed in *Zolotoe runo* and, as Isarlov later stated (1923), Larionov was attracted to

these old Russian masters.[14] The influence of Venetsianov in the formulation of Larionov's neo-primitivism lay in the fact that he rejected Academic methods and taught his students to work directly from nature. Venetsianov gathered round him a large group of painters of peasant origin who depicted the life of the ordinary Russian people in wonderful portraits and genre scenes. Thus Venetsianov established an alternative tradition of painting outside the confines of the Academy and in his example Larionov found an important model. Of Venetsianov's pupils, the impact of Krendovsky upon Larionov has already been noted, but the emphasis on genre subjects in the Venetsianov school also influenced the artist. A series of genre paintings of peasants and artisans at work, executed by Lavr Plakhov in the 1840s, is reflected in Larionov's bakers, watersellers, hairdressers, and soldiers.

Pavel Fedotov, another nineteenth-century artist outside the Academy, also influenced Larionov in the use of genre painting as a medium for social satire. Fedotov was famous for his social comedies such as *The Major's Courtship* of 1848 (Tretyakov Gallery, Moscow) in which the pompous major is parodied by a cat which sits on the floor preening itself. Larionov's satirical *Walk in a Provincial Town* may be seen as a reworking of Fedotov's courtship theme in the same tradition.

The humor in Larionov's neo-primitivism, however, was derived largely from the popular Russian culture of the eighteenth and nineteenth centuries: the old proverbs and folktales, the fairground booths (*balagany*) and circus. The stories of clever peasants who cheat death, the vulgar spirit of shrovetide revelries, the travelling buffoons (*skomorkhi*), the farcical acts of contemporary clowns such as Anatolii Durov and Ivan Kozlov permeate Larionov's art. Above all it was the *lubok* that crystallized the essence of popular Russian culture for Larionov and proved to be the most potent stimulus in the development of his neo-primitivism.

The *lubok* was introduced into Russia by German merchants in the sixteenth century and was first indigenously printed by the Orthodox Church in the Ukraine in the early seventeenth century as a weapon against Polish Catholicism. Thereafter, printing of *lubki* spread across Russia and continued until the early twentieth century. Initially the *lubok* was printed using wooden blocks and soot and burnt sienna mixed with boiled linseed oil for ink. Once the outline of the picture had been printed onto the moist paper it was then flat-washed by hand in red, yellow, purple, and green. In the eighteenth century, however,

professional engravers began executing these prints, and through their work German and French influences gained ground and the style became more detailed.

The *lubok* may be classified according to its subject matter which was dictated by contemporary events and the changing tastes of the time. *Barber Cutting the Beard of an Old Believer* (fig. 71), for example, refers to Peter the Great's edict on the shaving of beards to bring Russia into line with contemporary European manners. The *lubok* depicts an Old Believer having his beard forcibly removed, thereby acting as an effective form of propaganda by publicizing the new law among the population and at the same time ridiculing the Old Believers.[15] The Old Believers retaliated by publishing a *lubok* entitled *The Cat of Kazan* (fig. 72) which satirized Peter the Great as a huge cat with bulging eyes and neatly groomed whiskers. The coarse but appropriate text pokes fun at the grand titles the Tsar awarded himself and accuses the cat of farting quietly!

At the end of the seventeenth century educational *lubki*—alphabet sheets and calendars with personifications of the seasons and months—were being printed. The introduction into Russia of a Jacques Callot *Punch and Judy* engraving in the early eighteenth century inspired *lubki* depicting Russian mountebanks and fools. The mid-eighteenth century witnessed a series of *lubki* depicting popular festivities and entertainments such as fistfights and wrestling matches. Later in the century, when Russia was at war with Prussia and Turkey, military themes found their way into *lubki*.

Critical attention was first focused on the *lubok* in the 1880s when Dmitry Rovinsky published his major reference work on the subject.[16] Following this the *lubok* was appreciated by artists such as Alexandre Benois, Vasily Kandinsky, and the young avant-garde who collected them enthusiastically. By 1913 Larionov had assembled a collection of one hundred and seventy Russian *lubki* which were shown in his Icon Painting and *Lubok* exhibition. Larionov's collection was both large and representative. We know from the catalogue that he possessed several *lubki* depicting Peter the Great and two educational *lubki*, *The Twelve Calendar Months* and *The New Russian Alphabet*. His collection also contained several *lubki* of mountebanks and fools—*Paramoshka, Foma and Erema, The Tavern, The Debauchees*, and the witty *Big Nose and Keen Frost*—and *lubki* depicting popular festivities such as *Fisticuffs* and *Shrove-tide Revelries*. There were a number of military *lubki* referring to Russian wars in Siberia and Turkey—*Ermak*

Fig. 71. *Barber Cutting the Beard of an Old Believer*, c. 1770s

Fig. 72. *The Cat of Kazan*, c. 1700–1725

Timofeevich Subjugator of Siberia, Envoy of the Ottoman Porte Halil Pasha, Suvorov's Story—and to the Crimean War 1854–1856, *Attack from Sevastopol* and *The English Attack on the Solovetsky Monastery*. Larionov also possessed a great many *lubki* on religious and biblical themes as well as several which dealt with Russian legendary heroes, such as *The Strong and Famous Hero Anika* and *Bova Korolevich*. A series of *lubki* recording Russian peasant songs and reproduced by copper etching also formed part of Larionov's collection.

Larionov was well-versed in the history of the *lubok*, and in the catalogue of the Icon Painting and *Lubok* exhibition he discussed methods of production and referred to Rovinsky's study for a fuller exposition. Apart from being a connoisseur of the *lubok*, Larionov, in common with other avant-garde artists, worked for the publishing enterprise *The Contemporary Lubok* (*Segodnyashny lubok*) which produced a range of propaganda posters and postcards in support of the war effort. Moreover, a review in 1915 of an exhibition of *lubki* in the Trakhtenberg collection refers to "attempts by Sharleman, Narbut, and Mitrokhin to revive popular 'lubki' . . . and originals by Lentulov, Goncharova, Larionov, Mayakovsky, and Pasternak."[17] In what ways then was the *lubok* important for Larionov's neo-primitive work?

The *lubok* seems to have inspired Larionov's choice of subject matter. Paintings such as *Soldier at the Hairdresser's* (fig. 73) recall the *lubok* issued under Peter the Great depicting the enforced shaving of beards. The *Seasons* emulate *lubki* in Larionov's personal collection—the calendars that personify the seasons and the depictions of popular rituals on annual feast days such as Semik. Larionov's bakers find equivalents in a fashionable eighteenth-century *lubok* entitled *The Pancake Vendor* (fig. 74), and his soldiers and their card games elaborate subjects popular with *lubok* artists from the mid-eighteenth century onwards.

The painting *Soldier on a Horse* (fig. 75) is directly comparable to the *lubok* of *Eruslan Lazarevich* (fig. 76) and later military heroes. The horse's mane falling to one side of the neck, the wide tail, and the stiff prancing posture are all to be found in the *lubok*, and the profile delineation of the horse contributes to the same flat, two-dimensional effect. In addition Larionov completes his composition with stylized references to grass and trees.

Various *lubok* motifs find their way into Larionov's paintings. The drapes and tassels that often frame the *lubok* frequently occur in Larionov's hairdresser paintings. The hunting-dog that accompanies *Foma,*

Fig. 73. Mikhail Larionov, *Soldier at the Hairdresser's*, 1910–1912

Fig. 74. *The Pancake Vendor*, c. 1770s

Paramoshka and Erema appears as a motif in some of the soldier paintings, and the curled-up cat, which occurs in *The Pancake Vendor* (fig. 74) and other *lubki*, reappears in *Winter* (fig. 49) and *Katsap Venus* (pl. 12).

In his paintings Larionov frequently includes a text, a device that is used in the *lubok* from the early eighteenth century onwards. The texts of *lubki* usually contain errors such as omissions, spelling mistakes, and phonetic spellings—"shto" for "chto," the equivalent of the English "wot" for "what." Larionov deliberately imitates these mistakes in his texts in the *Seasons* (pl. 11, figs. 47–49), when in *Summer* he writes *s zrelym khebom* (with ripe weat) instead of *s zrelym khlebom* (with ripe wheat), and in *Autumn, Osen' schaslivaya* (Hapy autumn) instead of *Osen' schastlivaya* (Happy autumn). Moreover the writing style, a combination of long hand and block letters, evokes the crudeness of the *lubok* texts.

Sometimes the text of a *lubok*, instead of occupy-

ing its own space, invades the image, for example in *Foma, Paramoska and Erema*, where the three fools are each identified by name. Larionov employs a similar "naming" procedure in many of his neo-primitive works. In *Soldiers* (fig. 31) various images are named: *Pivo* (Beer), *Soldat* (Soldier), *Sablya* (Sabre). The same process is employed in the *Sonya* and *Manya* series (see fig. 110) where the image of the naked woman is identified by both her name and the correlative of *blyad* (the whore) or *kurva* (the bitch). In a *lubok* entitled *The Timely Repentence* strings of words issue from the mouths of angels and demons just as they do in Larionov's *Soldiers*. This particular correspondence between Larionov's art and the *lubok* was also noted by a contemporary critic who, reviewing the "Second Post-Impressionist Exhibition" in London, referred to Larionov's *Soldiers* as "a large canvas with naive *lubok* inscriptions."[18]

Larionov also adopted figurative conventions in his canvases similar to those employed in *lubki*. The

most obvious of these is the use of flat and schematized shapes in the composition of the figure. Like jigsaw pieces, limbs in *lubki* have their own identifying shapes and are slotted together to form the whole. Larionov first employed this approach in *Walk in a Provincial Town* and the preparatory study *Provincial Dandy* (fig. 77), in which the figure is flattened and reduced to its basic component shapes. The thick contours that delineate the *Provincial Dandy* emulate the black outlines of figures in eighteenth-century *lubki* and they are found in many of Larionov's canvases in this period.

Larionov derived from the *lubok* a characteristic schema for depicting the human face. In the eighteenth-century *lubok* an S-shaped line indicates one eyebrow, the nose, and the nostril opposite that eyebrow. The face was then completed with an arc for the remaining brow, two elipses with dots in the center for eyes, and an elipse with a horizontal line through the middle for the mouth. It is this schema which Larionov used for the goddess of *Autumn* (fig. 48) and which he elaborated in the monstrous head appearing on the title page of Eganbyuri's monograph (fig. 60) and in paintings such as *Spring 1912* (see fig. 213).

Figural distortion is also characteristic of the *lubok*. Arms and legs are either ludicrously small or ridiculously large in relation to the whole while their

Fig. 75. Mikhail Larionov, *Soldier on a Horse*, c. 1912

Fig. 76. *The Hero Eruslan Lazarevich*, c. 1700s

relation to the torso is forced and unnaturalistic. Again Larionov used this technique to great effect in both *Walk in a Provincial Town* and *Provincial Coquette* (pl. 7). Here, the right arm of the coquette is out of proportion to her body and is crudely articulated at the shoulder, while the uncomfortable twist of her body above the waist in relation to her long dress painted in profile is also indebted to *lubok* sources. Similar distortions occur in the hairdresser paintings. *In Soldier at the Hairdresser's* (fig. 73) the barber is elongated with one leg seen in profile and the other from the front. The left shoulder is extended to encompass the left arm while the right arm com-

prises a diminutive hand and wrist protruding from the shoulder. Moreover, objects in *lubki* are often larger than life and the fearsome scissors with which the barber threatens the Old Believer (fig. 71) are matched by the huge shears in Larionov's barbershop.

The peculiar figural levitations found in both icons and *lubki*—angels appearing to dance *sur les pointes* in mid-air and *lubok* figures seemingly floating in space, due either to the absence of feet or the fact that they are never firmly related to their surroundings—are features that are often reflected in Larionov's work. This effect is particularly noticeable in *Provincial Coquette* (pl. 7), where the figure has no feet and

Fig. 77. Mikhail Larionov, *Provincial Dandy*, 1909

floats in the air. The use of a flat, almost mono-chrome background in *Soldiers* (fig. 31) compounds this levitational effect, especially as objects such as the bottles are painted at different angles to what we assume to be the floor. As in both icons and *lubki*, people and objects in Larionov's paintings have an arbitrary spatial relationship between themselves and with their context.

Another characteristic feature of *lubki* is perspectival distortion. Tiled floors are observed from above and create confusion when combined with a profile view of figures who dance on them. Tea tables are depicted from a high viewpoint and the objects on them in profile, which creates the effect of the table tipping towards the viewer and about to spill its contents onto the floor. The café table in *Tavern Still Life* (pl. 8) duplicates this *lubok* convention exactly. One looks down on the table top, yet the glass, samovar,

and crockery, thickly outlined in black, are observed in profile, creating a disturbing visual effect.

For the Russian avant-garde the influence of *lubki* was most pronounced in the design and production of Russian futurist books. Artists like Larionov and poets like Kruchenykh were directly inspired by old Russian chapbook publication, where a series of narrative *lubki* were bound together to tell a story. They were usually printed on one large sheet of paper which was hand colored and then cut into pages and assembled. The same technique was evidently used in the printing of the Russian futurist book *Mir s kontsa* since the signatures of the drawings appear to have been clipped off the pages in the cutting process and are to be found at the top of other pages.

The combination of word and image was an important consideration in the production of futurist books. As Mary Chamot points out (1973) the artistic

Fig. 78. Nataliya Goncharova,
Illustration and typography for *Igra v
adu,* 1912

unity of word and image was one of the qualities of *lubki* which most charmed both artists and poets. Kruchenykh states in his memoirs that his poem *Igra v adu* (*A Game in Hell*) was begun in the style of a *lubok* and the typography used in printing the book of the same title (fig. 78) resembled the quaint wood-cut letters of eighteenth-century *lubki.*[19]

In addition to the *lubok,* ancient Russian icon painting influenced the development of neo-primitivism. Icons were introduced into Russia by Greek priests following the Christian conversion of Prince Vladimir of Kiev in A.D. 989. At first Byzantine icons such as the *Virgin of Vladimir* (Tretyakov Gallery, Moscow) served as models for Russian icon painters, and the earliest Russian icons betray Byzantine influence

in the stately postures of the saints and their stern facial expressions. However, cut off from Byzantium and southern Russia by the Mongol invasions of the thirteenth century, artists in Novgorod and Pskov departed from the austerity of Byzantine tradition and developed their own distinctive approach. Russian icons of this period such as *The Miracle of St. George and the Dragon* (fig. 79) are distinguished by graceful curves, charming and imaginative compositions, and finesse in line and detail. Herein lies the difference between Greek and Russian icons which Larionov recognized when he commented:

The icons of the Russian schools are distinct from those of Greco-Byzantine ones by their graphic

Fig. 79. *The Miracle of St. George and the Dragon* (detail), 14th century

The first works by Malevich to reflect a study of icon painting are *Women in Church* (Stedelijk Museum, Amsterdam) and *The Orthodox* of 1911. The importance of the icon in Malevich's theory and practice can be traced up to 1915 when he hung his famous *Black Square* (Russian Museum, St. Petersburg) across the corner of the room at the 0.10 Exhibition. The *Black Square* usurped the traditional throne of the icon and in this culturally subversive action Malevich consciously appropriated the traditional role of the icon for his new art of suprematism.[21] In his early years Tatlin actually practiced as an icon painter in a traditional studio near the Kremlin and later declared, "If it wasn't for the icons, I should have remained preoccupied with waterdrips, sponges, rags and aquarelles."[22] Goncharova, on the other hand, painted many easel works such as *The Four Evangelists* (Russian Museum, St. Petersburg) and *Virgin and Child* (fig. 80), the subjects of which were taken directly from the repertoire of icon paintings. Each of these paintings reproduces the rich draperies with their boldly delineated folds, the gentle yet strong curves of elongated bodies and limbs, the refined gestures, and the delicate color harmonies found in icons.

Larionov's love of icons is demonstrated by his rich collection which was displayed in the Icon Painting

form, and especially by their very clear and delicate colors, by their nuances and flat application which make the surface vibrate and confer on the Russian icon an infinite profundity. The Byzantine and Greek saints are made of flesh and blood, whereas the Russian ones are not. They are the abstract symbols of another life.[20]

Icons had their greatest artistic influence in the early twentieth century following their "rediscovery" in 1904 when Rublev's *Old Testament Trinity* was cleaned to reveal its original colors. Icons were increasingly collected, cleaned, and appreciated for their simplified yet graceful forms and rich colors not only by the avant-garde, many of whom were decisively influenced by them, but by the wider art establishment. Artists from abroad, such as Matisse, were fascinated by icons. Among the Donkeys Tail and Target groups, Malevich, Tatlin, and Goncharova were particularly inspired by the icon tradition.

Fig. 80. Nataliya Goncharova, *Virgin and Child,* c. 1912–1913

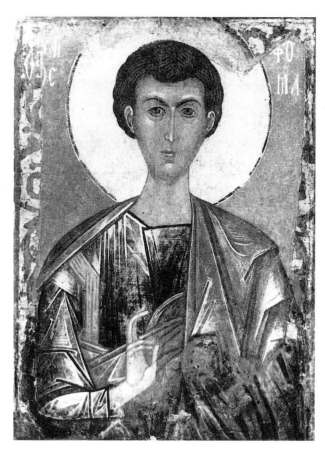

Fig. 81. Mikhail Larionov, *Self-Portrait*, c. 1910–1912

Fig. 82. *St. Thomas the Apostle*, 14th century

and *Lubok* exhibition of 1913. Altogether Larionov showed one hundred and twenty-nine icons. Their date of execution and style are unknown, but their titles, recorded in the catalogue, show that the collection comprised both Old and New Testament images from almost every tier of the traditional iconostasis and that the subject matter was extensive and representative. Larionov also emphasized the traditional means of painting icons by exhibiting two stencils and six drawings. These were known as "tracings" and were important because they preserved the authorized canon of forms derived from the Byzantine icons which were considered "prototypes."

Larionov was also a keen connoisseur of icon painting. His library contained important works on icon painting in the seventeenth century, including a critical monograph by N. P. Likhachev on the Royal Isographer Iosif, an icon painter who was employed by the Moscow Armory to fulfill royal commissions, and two copies of a book on the small yet distinctive icons of the Stroganov school.[2,3] Larionov wrote about icons in his catalogue introduction to the Icon

Painting and *Lubok* exhibition of 1913 and later in an essay entitled "The Icons" completed in Paris in the 1920s (Larionov 1978). The importance of the icon for Larionov lay more in the realm of his neo-primitive ideology than in painterly practice. There are, for example, no paintings by Larionov on Christian themes, in which he might, like Goncharova, have used the stylistic conventions of icon painting. In fact only a few direct comparisons can be made.

Larionov's most obvious borrowing from the icon tradition occurs in *Self-Portrait* (fig. 81), where he uses the same pose as that found in icons such as *St. Thomas the Apostle* (fig. 82). Like the image of the saint, Larionov's portrait fills the picture space, the arms and shoulders compressed by the width of the canvas and the crown of the head extending to the top of the painting. In addition, the crude play between the ochre and white verticals of the shirt deliberately parody the stylized folds and shadows of the draperies of the icons. The sharp edges of the collar perform a function similar to the stole around the neck of saint. The script in the right hand corner of

Fig. 83. Paul Gauguin, *The Yellow Christ,* 1889

Fig. 84. Nataliya Goncharova, *Crucifixion*

the painting, which identifies the work as a "Self-Portrait of Larionov," occupies the place where an attribution to the saint appears in the icon painting. The symmetry of an icon is achieved by the inclusion of three white feathers on the left of the portrait, and the elongation of Larionov's torso, neck, and head is reminiscent of similar conventions in icon portraiture. Larionov uses ochres and browns to depict the flesh and to suggest the effect of a wooden panel as opposed to canvas, upon which his portrait is painted. Finally, the dark outline around Larionov's head suggests a halo. In fact, Larionov's *Self-Portrait* appears to be a subversive work, unlike Goncharova's painterly reinterpretations of icon subjects and conventions.

Larionov may have parodied icons, removing their mystical aura and replacing the holy image with a grinning face and bare chest in order to shock his audience. In its mockery of a traditionally inviolable subject, this controversial approach is similar to that of Gauguin in paintings such as *The Yellow Christ* of 1889 (fig. 83), where Gauguin paints himself, the artist crucified, in place of Christ on the cross. *The Yellow Christ* was well known to Larionov and Goncharova: she later painted a pastiche of the picture entitled *Crucifixion* (fig. 84) in which the Christ is a portrait of Larionov, though the torso, arms, and legs are frail and thin like those in Gauguin's painting. There is clearly a deeper significance to this cultural subversion, for as John House points out, the subversion of traditional culture is a prerequisite to the evocation of "naivety" in art.[24]

The *Seasons* paintings present another interesting case of Larionov's subversion of the icon tradition. The goddess of *Autumn* (fig. 48), observed from the front with her forearms raised, imitates the posture of the Virgin who raises her hands in blessing in a series of icons entitled *Mother of God of the Sign.* A posture, then, which is only appropriate to the richly dressed Madonna of Christianity, is applied by Larionov to a nude and pagan goddess. Furthermore, the assemblage of the four *Seasons* paintings into one large panel at the Target exhibition, may well parody an iconostasis. Apart from Larionov's subversion of the icon tradition in his art, it is worth noting a "positive" influence of that tradition in his *Still Life* (fig. 85). The clear outline of the fruit bowl and the fine drawing and coloration are comparable with the still life in Andrei Rublev's famous *Old Testament Trinity* 1422–1427 (Tretyakov Gallery, Moscow) where all extraneous detail is abandoned and Rublev achieves maximum expression through the simple lines, balanced composition, and elegant coloring. It was these

Fig. 85. Mikhail Larionov, *Still Life,*
c. 1909–1910

qualities which Matisse admired in the icons and which Larionov evokes in his *Still Life.*

Even though Larionov seldom employed the stylistic conventions of icon painting in his art, one can see that his love of icons shaped his general aesthetic at the time. The icon tradition represented the communal expression of a communal faith and although the icon spoke of spiritual realities its vocabulary was cast in a pictorial form that the illiterate peasantry understood. The icon was thus a genuine popular art form. In addition, we know that Larionov appreciated the schematic notation with which the icon painters depicted their subjects,[25] and the unusual spatial conceptions of icons, the inverse perspective, and the depiction of objects as seen from the respective viewpoints of the characters in the icon may have suggested some of the strange spatial resolutions in Larionov's neo-primitive works.

Above all, icons demonstrated the spiritual possibilities of abstracted form. In the popular imagination the icon was believed to be the saint's mate-rialized image and so it offered a direct means of contact with the spiritual world. For artists such as Larionov, Malevich, and Kandinsky, the abstracted forms of the icon, which were keys to the beyond, were of particular importance as each sought to develop the visual medium as a means of expressing the spiritual in art. Larionov's essay "The Icons" succinctly summarizes this point of view:

The Russian icon painters were boldly led towards an important abstraction. This abstraction manifested itself in the use of schemas and pre-established formulas related to a predetermined style through which they expressed the abstract and mystical sense of life. . . . It is through the nuances of color and the finesse of the graphic forms that the religious and mystical state we experience when contemplating icons manifests itself. . . . The beauty and finesse of the drawing of these stylized forms and the fascinating abstract harmony of their coloration aspire to render the world

of the beyond . . . it is a kind of spiritual realism . . . you really believe that they concern another life.[26]

Here Larionov suggests that icons reflect the spiritual through their abstracted forms and colors and, although it is not wholly convincing to relate ideas in a document written after the event to the practice of at least ten years before, it may well be that Larionov's study and appreciation of icons was an important factor in the formulation of the theoretical basis of rayism. In "Le Rayonnisme Pictural" (1914), Larionov addresses the importance of coloration in rayist works in a way similar to his discussion of the coloring of icons. The spirituality and mysticism, which for Larionov is evoked by the coloration and abstraction of graphic forms in icons, are features, under the guise of the fourth dimension, of the manifesto "Why We Paint Ourselves" and of all the rayist manifestos. It is interesting, though not conclusive, that close up, the *assist*—the thin gold hatched lines which cover the garments of the saints in icons and represent divine light—resembles some of the rayist compositions. Clearly the icon exerted a pervasive influence on Larionov's theory and practice, but one that is more subtle and less easy to define than that of the *lubok*.

Other sources for the development of Larionov's neo-primitivism can be found among peasant arts and crafts. Embroidery had long been appreciated by the avant-garde, and examples of lace had been exhibited at the final Golden Fleece exhibition in December 1909. Larionov evidently had an interest in the subject since he possessed an article by K. A. Inostrantsev on "The History of Old Textiles."[27] He also discussed its importance with Camilla Gray, who declared that "the *Seasons* is based on Siberian embroidery."[28] Certainly something of the style and design of embroideries is found in these paintings, especially in the two trees in *Autumn* (fig. 48) and in the execution of the cat in *Winter* (fig. 49). Similarly, the two cats in *Venus with Cats* (Museum Ludwig, Cologne) and *Katsap Venus* (pl. 12) imitate embroidery stitches.

It should be noted that the influence of peasant and folk-art forms in Larionov's art was not restricted to stylistic considerations alone, for folk-art artifacts, which he appreciated for their intrinsic qualities, often appear in his paintings—for example, *Still Life with Crayfish* (fig. 86) features a fine painted tray, another form of folk art, decorated with peasant huts. The painted tray stands alongside ill-blown glass bottles and rests against a crudely printed and brash

colored wallpaper. A decorated earthenware jug appears in several still lifes, for example *Still Life with Radishes* (*Ex* Tomilina-Larionova Coll.). *Seashells* (fig. 215) employs a folk-art rug as background, as does *Still Life with Teapot* (*Ex* Tomilina-Larionova Coll.).

Shop signboards (fig. 87), painted by artists without conventional art training, also attracted the avant-garde. David Burlyuk gathered a splendid collection of signboards, and in 1913 Mayakovsky wrote a poem "K vyveskam" ("To Signboards") in which he commanded his audience to read the signboard as if it was an "iron book" filled with gilt letters, smoked salmon, and the golden curls of turnips.[29] Larionov was aware of the artistic possibilities of the signboard as early as 1909 when he incorporated the image of a signboard for a hat shop into his painting *Walk in a Provincial Town* (pl. 6), and another into the portrait *Provincial Dandy* (fig. 77). Moreover the stiff qualities and smart dress of his provincials recall the dressed mannequins in signboards for clothes shops.

The critics soon recognized the references to signboards in Larionov's paintings. *Hairdresser* shown at the first Union of Youth exhibition was compared with "signboards of the native barbershops in the God-forsaken Jewish villages of the southwest pale about twenty years ago," differing only in that the Jewish artists had achieved "a greater craftsmanship and expression" than Larionov.[30] A year later, when *Soldier at the Hairdresser's* (fig. 73) was exhibited at the World of Art exhibition, one critic found that it "recalls signboards which often adorn the entrance to barbershops in the south"[31] while another thought it evoked "the artistic tastes of a Smolensk marketplace."[32]

Larionov's painting *Bread* (fig. 88) of 1910, executed at the same time as the hairdresser series, reveals his study of the signboards of bakers' shops. What fascinates Larionov is the conglomeration of different shapes and colors and the naive method of structuring them. John Bowlt has drawn attention to the contrasts in mass, which convey the effect of the weight and "objectness" of the bread in Larionov's painting, a quality similar to that found in signboard painting.[33]

In 1913 Larionov proposed to write about signboards as well as other folk-art subjects such as *lubki*, icons, and fretwork in a book entitled *Russkoe iskusstvo* (*Russian Art*).[34] He even invited the Second Corporation of Signboard Painters to exhibit six works at the Target exhibition. Many of the Target group were particularly influenced by signboards: Romanovich exhibited a *Hairdresser* in the style of a Caucasian

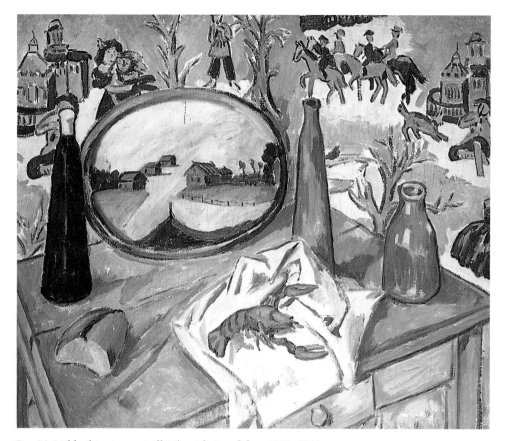

Fig. 86. Mikhail Larionov, *Still Life with Crayfish,* c. 1910–1912

signboard; Shevchenko executed a *Signboard Still Life: Wine and Fruit* in 1913 (Tretyakov Gallery, Moscow); Chagall, an exhibitor at both the Donkey's Tail and the Target exhibitions, had actually trained as a signboard painter. It is unfortunate that we do not know which of Chagall's paintings were included in the Target exhibition but as a Jewish artist of provincial origin his work must have exerted an attraction similar to that of the Georgian signboard painter Niko Pirosmanashvili.

The "naive" artist Pirosmanashvili was the great discovery of the Donkey's Tail group and was lionized by Larionov and his friends in the years before the war. This was not the first time that the avant-garde had championed a painter with no fine-art background. The "Douanier" Rousseau had achieved recognition among Picasso and his friends. They organized a banquet in his honor in 1908 and Kandinsky illustrated seven of Rousseau's paintings in the almanac *Der Blaue Reiter* of 1912, describing him as the author of the "new, greater reality." The acclaim accorded to Rousseau in the west served as a model for the Russians. In 1908 Nikolai Kulbin showed the

works of a blind or partially sighted artist called Nechaev at his exhibition *Studiya impressionistov* (The Impressionists' Studio). In 1910 the Burlyuk brothers gave canvas, brushes, and paints to the untutored Petr Kovalenko, who worked on one of the estates at Chernyanka and, according to Livshits, "made him into a second Rousseau."[35] Larionov would have known of Kovalenko not only through his visit to Chernyanka, but also because the Burlyuks exhibited Kovalenko's paintings in Izdebsky's Salon 2 at Odessa during 1910–11. However, the propagandist zeal of the Larionov group made more of Pirosmanashvili than Kulbin made of his blind man, or the Burlyuks of Kovalenko, and they rocketed the obscure Georgian signpainter to fame within a year.

It was actually the Zdanevich brothers and Mikhail Le-Dantyu who first "discovered" Pirosmanashvili when they returned to Tiflis for their summer vacation in 1912.[36] On their return to St. Petersburg they stopped in Moscow, where Le-Dantyu gave a lecture on Pirosmanashvili and showed two of his paintings. As Le-Dantyu associated closely with Larionov and Goncharova it was probably at this time that they

Fig. 87. Stepanov, Signboards for a clothes shop, c. 1910

first heard of Pirosmanashvili and decided to incorporate his works into the forthcoming Target exhibition.

Although Larionov promoted the work of other "contemporary primitives," such as Pavlyuchenko and Bogomazov, he described Pirosmanashvili as the most important naive artist of the group, "a master in this manner . . . an adept in the painting of walls, principally of Caucasian taverns. His distinctive style, his eastern motifs, those limited means Pirosmani has with which he achieves so much are splendid."[37] After the Target exhibition, Larionov wrote to Ilya Zdanevich praising Pirosmanashvili and asking Zdanevich to write an article on the artist for *Osliny khvost i mishen'* and to send as many of his paintings as possible.[38] Both the interview and letter indicate Larionov's enthusiasm for the work of Pirosmanashvili and, according to Kirill Zdanevich, Larionov even organized a one-man exhibition for Pirosmanashvili in Moscow in October 1913.

What then were the repercussions of Pirosmanashvili's art upon that of Larionov? A comparison of Pirosmanashvili's *The Actress Margarita* (fig. 89) with Larionov's goddess in *Autumn* (fig. 48) reveals the same two-dimensional monochromatic treatment of

the human figure and the "doll-like" stiffness of posture. However, the works of Pirosmanashvili always tend toward naturalism and in this respect Larionov in 1912–1913 was already far removed from Pirosmanashvili. *The Actress Margarita* is set against a fairly naturalistic background of blue sky, tree stumps and grasses, but Larionov's goddess is far more radical, being painted onto a plain blue ground. Similarly, Pirosmanashvili's birds that attend the actress, although naively painted, nonetheless occupy a recognizable flying position and are naturalistic. Not so Larionov's birds, which are painted in plan and are schematically represented. The same could be said for the trees in Larionov's work which are represented in a stylized form with individual branches, twigs, and berries. Pirosmanashvili makes a more logical attempt at the flowers his actress holds, with none of the stylized precision of Larionov. Pirosmanashvili's importance, if any, to Larionov was not in the field of artistic practice, but more as a substantiating factor in the theoretical bases of Larionov's neo-primitivism.

Larionov particularly admired Pirosmanashvili's mural painting. The painting of walls was a popular form of external decoration among the peasantry and still is. We know that Larionov planned to write about frescos in his proposed book *Russkoe iskusstvo.* However, the form of wall decoration that had the greatest appeal for Larionov was the most popular of all, graffiti. In 1919 Larionov shared his enthusiasm for this crude and popular mode of expression with the poet Parnack who recorded, "Larionov experiences emotion at the sight of the chalk drawings by soldiers, at the sight of the graffiti scrawled in tar on the walls and the 'hopscotch' squares on the paving stones."[39]

Graffiti are first evident in Larionov's soldier paintings. In fact Larionov's interest in graffiti probably originated during his military service, when he observed the soldiers in his unit scribbling and drawing on the barrack walls. In *Soldier on a Horse* (fig. 75) Larionov daubs across the canvas either an archaistic *u* or perhaps the number 8, and then the letters *esk*, a phonetically correct but Russian misspelling of the first syllable of *eskadron* (squadron). Other works such as *Soldiers* (fig. 31) and *Resting Soldier* (fig. 33) feature a horse, a pornographic drawing of a woman, and scribbled comments about years of service. The most telling example of graffiti in the soldiers series occurs in the painting *Soldiers Head* (*Ex* Cournand Coll., Paris), a bold neo-primitive work in which the menacing portrait of a soldier is obscured by bold graffiti slang, so coarse that it must have deeply of-

Fig. 88. Mikhail Larionov, *Bread*, 1910

fended his audience when the painting was exhibited.[40] This, Larionov's most scandalous work, was reproduced in the catalogue of *Der Sturm* Autumn Salon of 1913 and a drawing based on the composition (fig. 171) was later published in Aleksandr Blok's *The Twelve.*

Larionov may also have been inspired by pornographic graffiti drawings in his *Voyage en Turquie* (fig. 92). Similarly, the *Manya* series (fig. 110) may originate in the graffiti-style woman who appears in *Resting Soldier* (fig. 33). A drawing related to the *Manya* series (fig. 111) is both sexually explicit in a pornographic manner and is inscribed *Blad'*, a graffiti misspelling of *blyad* (whore). Pornographic graffiti seem to have particularly attracted Larionov and, as a subject of study, graffiti still excited him in the mid-1920s. Mikhail Andreenko remembered that "Larionov made many visits to the area far from the Buttes-Chaumont where my studio was located. He used to sketch some of the drawings scribbled on the walls by

naughty children. They attracted him because the execution of them was lively, natural and without set rules."[41]

Andreenko's recollections of Larionov's response to children's graffiti and Parnack's note about his fondness for "hopscotch" squares also testify to Larionov's lifelong interest in the naive creativity of children. By 1912 many of the avant-garde in the west had begun to appreciate and study children's art. The Italian futurists had exhibited children's drawings and paintings alongside their own work in the Exhibition of Free Art (*Mostra d'Arte Libera*) in Milan in May 1911. Kandinsky and Marc had included reproductions of children's drawings in their almanac *Der Blaue Reiter* in which Marc asked, "Are not children, who conceive directly and from their secret feelings, more creative than those who imitate Greek Art?"[42] The cubists were also interested in the subject, for Maurice Raynal stated, "The cave-man carved, on the walls of his home, figures or animals he had seen. The

Fig. 89. Niko Pirosmanashvili, *The Actress Margarita*, 1910

child, as soon as he is old enough to do so, executes portraits, 'just like daddy,' or gives a lethal imitation (as his father and mother have done) of some rich old maid."[43]

In Russia, the appreciation of children's art by artists had begun somewhat earlier than in the west. In 1908 Nikolai Kulbin advocated a biogenetic view of children's art when in his article "Free Art as the Basis of Life" he stated, "Not everyone has the gift of reading the rudiments of the art created by the most beautiful of animals—prehistoric man and our children."[44] By 1909 a number of artists had become interested in children's art, not least Bakst who commented on children's drawings in an article for *Apollon*.[45] Izdebsky exhibited the work of four children at his Salon of December 1909–July 1910, which Larionov, being an exhibitor, would have seen. A year later, in 1911, two rooms of children's work were part of the exhibition by the Moscow Salon group of artists of which Larionov was a member, and the art critic Tugendkhold wrote an important article in *Severnye zapiski* (*Northern Notes*) on "Children's drawings and their Relationship to Adult Art." Then, in 1913, following the lead of their western counter-

parts, the Russian avant-garde began to promote and study both the art and poetry of children. Two poems by a thirteen-year-old girl from the Ukraine called Militsa were published by Khlebnikov in *Sadok Sudei II*. Just a year later Kruchenykh published a book that claimed to present stories and drawings by children aged seven to eleven, but some or all of them may have been the work of Kruchenykh himself.[46]

At the same time a number of artists and writers were building collections of children's art. According to Markov (1969), Kamensky collected children's drawings, and we know that Shevchenko and I. D. Vinogradov had collections of them, too. Shevchenko reproduced an example in his book *Printsipy kubizma* (1913) along with works by Larionov and Goncharova, and Larionov exhibited twenty-seven items from Shevchenko's collection and nine from that of Vinogradov in the Target exhibition of 1913. In 1912 David Burlyuk wrote of the equivalence between "free drawing" as found in the art of children and the work of the avant-garde and remarked that Larionov's *Soldier* paintings were among the best examples of free drawing.[47]

From this evidence it is all too easy to make sweeping generalizations about the influence of children's art on Larionov, but care must be exercised, for some paintings and graphic works which look childlike are actually based on other sources and use other conventions. The lithograph *Resting Soldier* (fig. 90) appears superficially childlike, although there is nothing there which specifically relates to children's art. The drawing uses a sophisticated schema for depicting the soldier and the conscious overlapping of the limbs is a willful distortion that would not be practiced by a child. Furthermore, the style of the animal, in which all its characteristics have been smoothed away until only a basic schema is left, is far removed from a child's approach to depiction.

However, the image of the flying bird, a major motif of Larionov's neo-primitivism which occurs in the graphic work and animates paintings such as *Autumn* (fig. 48), may be directly related to the art of seven- or eight-year-olds. There is nothing in this simple schema that a child of this age could not attempt. The combination of plan and elevation views, the use of symmetry, and the depiction of the eye are genuine features of children's art. The image of the bird may be a survival from Larionov's own childhood; alternatively he may have observed it in one of the children's drawings on exhibition. Another genuinely childish schema that Larionov adopts is the boat that appears in some of his *Birth of Venus* drawings,[48] again something he might have retained from

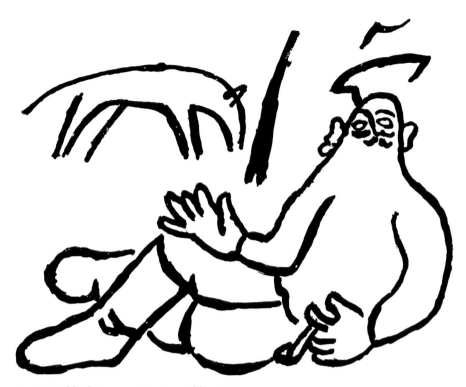

Fig. 90. Mikhail Larionov, *Resting Soldier,* 1912

his own childhood. The figure of Venus, however, is too sophisticated to be called childlike.[49]

The major problem in dealing with the naive and folk-art sources of Larionov's neo-primitive work is that the many traditions of representation outside the fine arts tend to share common characteristics and conventions. *Autumn* may be compared to the *lubok*, icons, embroidery, and children's art, *Soldier at the Hairdresser's* to the *lubok* and the signboard, and *Soldier on a Horse* to the *lubok* and graffiti. To

keep an open mind and to recognize with Shevchenko that the style and subject of a single painting has many such "points of departure" is to grasp the fundamental nature of Larionov's neo-primitive work. He is working with visual elements that have a popular or universal appeal and application, and his neo-primitivism is the distilled essence of popular, naive, and folk-art forms—the visual alphabet of a universal pictorial language.

Antiquity and
the Buryat Shaman

Hostile as the Target group was to Peter the Great and his role in Russian history it was nonetheless thanks to his mediation that an interest in Russia's national heritage developed during the eighteenth century. The Tsar was an avid collector of Russian antiquities and published an edict mandating prosecution of those who concealed or melted down such objects, and requiring that unusual antiquities be collected and recorded. Moreover, it was during his reign that the Russian Academy of Sciences undertook an archaeological and ethnographical exploration of Siberia and that Russia's first public museum, the *Kunstkammer*, was opened to display the Tsar's valuable antiquities.

However, it was only in the mid-nineteenth century that the social sciences of archaeology and ethnography witnessed a rapid development in Russia. The Archaeological Society of St. Petersburg was founded in 1843, and in 1859 an Imperial Archaeological Commission established the Hermitage Museum and undertook excavations. Exciting discoveries were made in the years that followed. In 1865 V. V. Radlov excavated the "frozen tombs" in the High Altai and found that permafrost had preserved the fur clothes and wooden objects of the Tagar culture. Then in 1871 two Palaeolithic sites were discovered at Poltava and Irkutsk, proving decisively that Russia had been inhabited in prehistoric times. The study of ethnography in Russia was pioneered by the Imperial Society of the Friends of Natural Science, Anthropology, and Ethnography, founded in Moscow in 1863, and by the Imperial Russian Geographical Society in St. Petersburg. In the 1870s these institutions began to investigate and describe the social and religious life of the primitive tribes such as the Buryat, Yakut, Samoyed, and Tungus, which were located throughout Siberia and along the Mongolian border.

By the turn of the century archaeological and ethnographical findings were widely published. The six-volume reference work on Russian antiquities by Count I. I. Tolstoy and N. Kondakov, a set of which Larionov possessed in his library, was particularly notable.[1] The transactions of the ethnographical section of the Imperial Society of the Friends of Natural Science, Anthropology, and Ethnography were into their sixtieth volume, and scholastic studies appeared on the subject of shamanism among the Buryat, Yakut, and Goldi tribes in Siberia.

In contemporary artistic circles there was a noticeable response to archaeological and ethnographical discoveries. The symbolist poets and painters as well as members of Diaghilev's World of Art studied these subjects and employed their findings in their respective arts. Nikolai Ryurikh, for example, took part in archaeological excavations from the 1890s onwards and published reports in various historical magazines. Rerikh's archaeological work and first-hand knowledge inspired his designs for two Diaghilev ballets, *Danses Polovtsiennes* (1909) and *Le Sacre du Printemps* (1913), both of which deal with the subject of ancient Russian tribes. Bakst, although his interests lay chiefly in oriental art, also studied classical archaeology. The symbolist poet Konstantin Balmont, going even further afield, studied the art and religion of the Maya in Mexico and made ethnographic studies of "primitive" tribes in South Africa and New Zealand.[2]

Vasily Kandinsky is perhaps the most important Russian artist to cite in connection with ethnography. In 1889 while studying law at Moscow University he was commissioned by the Imperial Society to undertake an ethnographical expedition to the province of Vologda. There he studied the survival of paganism among the local Zyrian tribes and on his return published an article in *Ethnograficheskoe obozrenie* (*Ethnographical Review*) describing their personification of the sun and moon and their belief in local goblins (*domovoi*) and the goddess of the rye (*poludnicha*).[3]

As Larionov began his career in symbolist circles this sort of study attracted him, too. He probably

knew of Kandinsky's ethnographical exploits through his friendship with the Burlyuk brothers, who had worked in the same studio as Kandinsky in Munich, or through his friendship with Vladimir Izdebsky, who belonged to the *Neue Künstlervereinigung* of which Kandinsky was a prominent member. The work of Bakst, Ryurikh, and Balmont would have been known to Larionov, if not at first hand, then from their writings for magazines such as *Apollon* and *Starye gody,* to which Larionov subscribed, *Iskusstvo,* and especially *Zolotoe runo,* with which they were associated.[4]

It was not until Larionov painted *The Gypsy* (fig. 21) in 1909, however, that his work reflects a real interest in ethnography. In formal terms *The Gypsy* has been compared with Gauguin's *Ea Haere Ia Oe* (1893, Hermitage, St. Petersburg), acquired by Morozov in 1908, and certainly the exotic gypsies would have invited comparison with Gauguin's Tahitians. Larionov, rather than idealizing the gypsies, accurately reproduces their physical characteristics. A clear racial identity is implied, and the evident poverty and primitive lifestyle of the gypsy raise questions about the social status of such racial minorities in Southern Russia at this time.

Larionov's concentration on ethnographical detail appears to have been based not only on firsthand observation but also on personal research into the subject. He possessed a copy of the important reference work on gypsies by the Dutch orientalist Michael Jan de Goeje (1836–1909).[5] Even though the book was published in 1903 we do not know exactly when Larionov obtained it, but its existence in his library does indicate that the history and ethnography of gypsies was of more than passing interest to him.

Ethnographical interests are also evident in Larionov's Turkish paintings. In his *Turk* of 1911 (Russian Museum, St. Petersburg) he depicts both figures in customary Turkish costumes—pantaloons and slippers—the woman with a scarf twisted around a low fez and the man wearing a turban. In *Mistress and Maidservant* (fig. 34), an odalisque wears Turkish pantaloons, a jacket with a girdle, and a cap, and the maidservant is nude.

There were obvious precedents for Larionov's Turkish paintings. A nude and dark-skinned maidservant occurs in Ingres's *Turkish Bath* 1862 (Louvre, Paris). More recently in 1910, Martiros Saryan travelled to Turkey and painted a series of works there, and in the same year *Apollon* published Mikhail Kuzmin's "Sir John Fairfax's Voyage to Turkey" with illustrations by Sergei Sudeikin.[6] Larionov's works,

though undoubtedly exotic, contain more ethnographical referents to the actual life and culture of the Turks than Ingres's nudes, Saryan's landscapes, or Sudeikin's lively illustrations. As with the gypsies, Larionov's interest in Turkish ethnography was reflected in his library, which included the early eighteenth-century travelogue by the French physician Jacob Spon, detailing his travels in Greece and the Levant, then part of the Turkish Empire.[7] The book was filled not only with archaeological information (it was the first book to record the ruins of Athens) but also with descriptions of contemporary life and customs in these countries.

This ethnographical approach culminated in Larionov's series of *Venus* paintings in 1912 in which he attempted to explore the theme of racial characteristics. As *Stolichnaya molva* commented, "In these works the artist intends to distinguish those characteristic traits by which each race defines its own ideal of beauty."[8] Larionov's ethnographic concerns also focused on the Siberian people and particularly on their religious conceptions and their practice of shamanism. Simultaneously, Larionov found a growing interest in archaeology[9] that played a substantial role in the development of neo-primitivism. Although his ethnographical and archaeological researches were quite distinct from his studies of folk art, Larionov discovered a compatibility between the two areas and combined them in his assault on the art establishment.

Larionov's archaeological interests lay in prehistoric, Scythian, and ancient Aegean art forms, interests shared by several other artists and poets.[10] He was especially attracted to the prehistoric statuettes of the Cucuteni and Proto-Cucuteni peoples, a Chalcolithic culture that inhabited the Dnestr Valley in which Tiraspol is situated. The Cucuteni site of Tripolye (the birth place of Ivan Larionov) had in fact been excavated at the end of the nineteenth century by V. V. Khvojka, and during 1909 and 1910 Hubert Schmidt excavated a fortified Cucuteni settlement in Northern Moldavia.[11] These excavations uncovered a particular type of statuette (fig. 91) which had no arms, diminutive breasts, protruding buttocks, and legs that tapered together, characteristics that recall Larionov's pochoir in *Voyage en Turquie* (fig. 92). Particularly similar is the unusual depiction of the buttocks, found in prehistoric statuettes, such as those of the Cucuteni, known as "steatopygous statuettes."[12] A striking aspect of the Cucuteni statuettes is the vocabulary of incised designs upon them and there is at least one drawing, *The Birth of Venus,* in which Larionov appears to imitate the effect.[13]

Fig. 91. Proto-Cucuteni Statuette from
Bernovo Luka, Western Ukraine, c. 4500 B.C.

Fig. 92. Mikhail Larionov, Pochoir from *Voyage en Turquie*, c. 1928

The inclusion of nine ancient Indian and Egyptian statuettes in his Icon Painting and *Lubok* exhibition of 1913 bears further witness to his study of ancient statuettes.[14]

Susan Compton (1978) has already suggested the use of "palaeolithic imagery" in a lithograph Larionov provided for Khlebnikov's poem "Selenochka" published in *Mir s kontsa* (fig. 93). The random distribution of pictorial elements is certainly similar to that of cave paintings and petroglyphs, and the striations across the drawing may, as Compton suggests, represent the incisions found across many cave paintings. A portrait drawing for *Pomada* which is obscured by heavy slashing lines may also be inter-

preted in this light, as either striations or fissures in the rock.[15]

From 1912 to 1914 there was also a widespread interest among artists in "Scythian" art forms, which seem a correlate to the preoccupation with prehistoric art, few people at the time differentiating between the two. The term "Scythian" was applied to the golden artifacts taken from barrows, which were shown in the Hermitage, as well as to the large statues known as stone *babas* which decorated the southern Russian steppe (fig. 94). At the turn of the century it was generally believed that these sculptures had been created in prehistoric times, although it is now known that they were made during the elev-

Fig. 93. Mikhail Larionov, Illustration for the poem "Selenochka" in *Mir s kontsa,* 1912

enth and twelfth centuries A.D. Some fine stone *babas* enhanced the Mamontov estate of Abramtsevo, and the Burlyuk family actually owned a stone *baba* which finally came to rest on Nastasyinsky Lane.[16]

Goncharova was particularly interested in ancient stone *babas,* and they occur in three of her neoprimitive paintings—*The God of Fertility, Stone Woman* (Still Life), and *Pillars of Salt* (*Cubist Method*) (fig. 95). In her speech at the Jack of Diamonds debate in March 1912 Goncharova cited "the Scythian stone women" as an example of indigenous cubism in her attempt to prove that cubism was neither new nor entirely a French innovation. Ironically, it was western example that inspired the Russians' interest in their indigenous sculptural forms in the first place. Gauguin had incorporated Breton Calvaries and Polynesian sculptures into many of his paintings. Ancient Iberian sculptures and African

works from the French Congo had been important sources for Picasso's early cubist work and both could be seen in the Morozov and Shchukin collections. Works by Picasso such as *Dryad* (1908) and *Standing Woman* (1908) taught the Russians to look to their own sculptural traditions for inspiration and this they found in the stone *babas.* An interview with Goncharova of April 1910, in which the author discusses Goncharova's painting of a stone idol in terms of stone *babas* and then quotes the painter's aim to achieve "solid form" in the manner of Picasso and Braque, supports this conclusion.[17]

Larionov's interest in the old *babas* can be supported by several instances. As early as 1910 one critic had described his wooden sculpture at the Russian Secession exhibition as being "a stone *baba* of an antediluvian man."[18] In July 1913 he and Sergei Khudakov planned to write about these ancient statues in their book *Russkoe iskusstvo* (*Russian*

Fig. 95. Nataliya Goncharova, *Pillars of Salt*

Fig. 94. *Russian Stone Baba,*
11th century

Art).[19] Later in 1921 Larionov included a stone *baba* in his curtain design for the ballet *Chout* (fig. 178), and at this time Isarlov wrote of Larionov's attraction to "the ancient stone figures of women."[20] The artist evidently retained an affection for these sculptures in the late 1920s when he added a snapshot of two freshly excavated *babas* to his photographic collection.[21]

The importance of these sculptures for Larionov's art lay in their bold outline and parabolic shape. Larionov used this same schema not only in the heyday of neo-primitivism—for example, in the cover design of *Pomada* (fig. 51) and the painting *Spring 1912* (fig. 213)—but also later in his career, when he made illus-

trations for the cover of Mark Slonim's *Portrety sovetskikh pisatelei* (*Portraits of Soviet Writers*) (fig. 207), and towards the end of his life in a drawing for Mary Chamot. The rough, weathered appearance of the stone *babas* and the loss of detail over the centuries are also reflected in the standing figure illustrating Gumilev's poem *Muzhik* (fig. 162) which evokes these very qualities.

In 1912 the Burlyuks were exhibiting a particular curiosity about the Scythian origins of their Crimean homeland. Livshits recalled that during the summer months Vladimir Burlyuk used to "surrender himself passionately" to the excavation of barrows around Chernyanka.[22] During 1912 the futurist group centered around David Burlyuk, which comprised the poets Khlebnikov, Mayakovsky, Kruchenykh, Livshits, and Nikolai Burlyuk, adopted the name "Hylaea," the ancient Greek name for the area inhabited by the Scythian tribe of the Taurii. "Hylaea" was chosen by the Burlyuk group for its specific connotations: they were "the wild men" of Russian culture, and their symbol, "the one and a half eyed archer"

(associated with David Burlyuk who was blind in one eye), was borrowed from Scythian mythology. The particular source for the name "Hylaea" was Book IV of *The Histories* by Herodotus, in which the ancient Greek writer discusses the land, religion, and customs of the Scythians. *The Histories* was well known to Burlyuk's group and it is likely that Larionov, who had been a guest with Khlebnikov at Chernyanka in the summer of 1910, also read Herodotus, as the Scythian tribe of the Callipidae (discussed by Herodotus in Book IV, 16–20) had inhabited the area of present-day Tiraspol. In fact, Herodotus's description of the Scythians seems to have provided Larionov with certain source material. One of the most fascinating episodes in Herodotus's account is that of the Scythian "vapour bath":

. . . on a framework of three sticks, meeting at the top, they stretch pieces of woolen cloth, taking care to get the joins as perfect as they can, and inside this little tent they put a dish with red hot stones in it. Then they take some hemp seed, creep into the tent, and throw the seed onto the hot stones. At once it begins to smoke, giving off a vapour unsurpassed by any vapour bath one could find in Greece. The Scythians enjoy it so much that they howl with pleasure. This is their substitute for an ordinary bath in water, which they never use. The women grind up cypress, cedar and frankincense on a rough stone, mix the powder into a thick paste with a little water, and plaster it all over their bodies and faces. They leave it on for a day, and then, when they remove it, their skin is clean, glossy and fragrant.[23]

This particular episode seems to have inspired one of Larionov's pochoirs for *Voyage en Turquie* (fig. 96) which depicts a naked woman in a crouched posture, whose face and body are colored white (the color of the Scythian paste). She has a smile on her face and her arms are raised joyfully, which may indicate that she is intoxicated with hemp smoke from the vapor bath. The diagonal shading in the background may indicate either hemp smoke or, more likely, howls of pleasure, as this is a familiar device used by Larionov to signify sound (cf. fig. 102). The angular figure and the squatting posture with raised arms are clearly inspired by the same figurative conventions of ancient Aegean civilization that Marija Gimbutas (1974) classifies as "the birth giving goddess," an image of fecundity that occurs in the iconography of ancient Aegean cultures (fig. 97).

In his library Larionov had a copy of the pioneering study on pre-Hellenic civilization in the Aegean by the scholar René Dussaud.[24] This attests to his interest and suggests that pre-Hellenic civilizations in the Aegean may have afforded source material for his art. Particularly worthy of notice is Dussaud's reproduction of a Mycenaean goldleaf figure with two schematic birds on the shoulders which offers at least an interesting parallel with Larionov's *Autumn* (fig. 48) where the goddess is similarly accompanied by two birds.

In his foreword to the catalogue of the Icon Painting and *Lubok* exhibition, Larionov related Assyrian and Babylonian cultures to futurism:

The most surprising, the most modern doctrine, futurism, can be transferred to Assyria or Babylon, and Assyria with the cult of the goddess Astarte and the teaching of Zarathrustra can be brought into what is known as our time. The feeling of novelty and all the interest are in no way lost because these epochs in their essence, development, and movement are the same, and to consider them from the point of view of time, is only unfortunate narrow-mindedness.[25]

It was the principle of everythingism that allowed Larionov to make this unusual correlation between cultures and art movements separated by time. In his preface Larionov continues to refer to this concept and states that "in the reign of the Assyrian emperor Hamurabbi" an exhibition of nineteenth- and twentieth-century *lubki* was organized, a bizarre reference to his own exhibition.

Archaic sources and imagery from Russian prehistory, ancient Scythia, and the ancient Aegean cultures offered Larionov a rich visual vocabulary to draw upon. In their original context, however, it was not so much the form of these art works that was important, but rather their content and meaning, the expression of specific aspects of religious or spiritual belief. Consequently, Larionov's archaeological researches led him to the study of Greek and Roman mythologies and primitive spiritual conceptions, in particular, Siberian shamanism. Although these sources added new pictorial devices to Larionov's neo-primitivism he seems especially to have borrowed their symbols in order to suggest some kind of "primitive" content in his art. Both shamanism and classical mythology are systems of religious belief, and their ideology and symbolism often parallel each other. For Larionov they represented the two great poles of western and eastern paganism, influences that had played major roles in shaping the character

Fig. 96. Mikhail Larionov, Pochoir from *Voyage en Turquie*, c. 1928

Fig. 97. Depictions of the birth giving goddess on pottery fragments from Central Europe, c. 6000–5000 B.C.

of Russia and its people upon which his neo-primitivism was based.

Shamanism is a magico-religious phenomenon of primitive societies, including those of Siberia and Central Asia.[26] Although the shamans are central to the religious life of the tribe, their role is specialized[27] and they are only called upon when the fate of the soul is at stake (during illness or after death), whenever a misfortune takes place within the tribe, or when an important rite has to be performed involving contact with the deities. In these cases the shamans fall into an ecstatic trance, and by means of "magical flight," they move through the spirit world to locate a lost and endangered soul (held to be the cause of sickness), to guide it after death, or to seek the advice of spirits and deities on important matters concerning the tribe.

It was in Siberia and Central Asia that shamanism was first documented and described by early travellers, and there that it has had its most complete manifestation. In Russia an extensive literature on the subject of Siberian shamanism had developed by 1912. The first major study by Shashkov was published in 1864, and during the 1880s and 1890s at least a hundred major studies appeared on the subject in relation to tribes such as the Buryat, Mongols, Yakut, and Goldi.[28] After the turn of the century several expeditions investigated the history and culture of the Siberian tribes and as a result the Russian press began to publish articles on shamanism. *Birzhevyya vedomosti*, for example, serialized an essay "Spiritism and Shamanism" by a member of the Turzhansk Expedition during March 1910.[29]

By 1911 the Russian avant-garde had turned its attention to shamanism. In January of that year the Union of Youth featured "shamanic dances" in their special evening of entertainments "Khoromnyya deistviya" ("Mansion Scenes"), which were reported to have thrilled the audience.[30] During 1912 Khlebnikov wrote a long poem entitled *Shaman i Venera* (*Shaman and Venus*) which was published in *Sadok sudei II*. Viktor Shklovsky recalled that at about this time "a shaman was brought to the Historical Museum in Moscow. Having behind him the age-old culture of the shamans, this shaman wasn't bashful. He picked up his tambourine and cast his spells for some professors; he saw spirits and fell into an ecstasy. Then he left for Siberia, to cast some spells there—only this time not for professors."[31]

In his library Larionov had an important study of shamanism among the Buryat by the respected ethnographer M. N. Khangalov.[32] The book discusses the role of the shaman in Buryat society and details

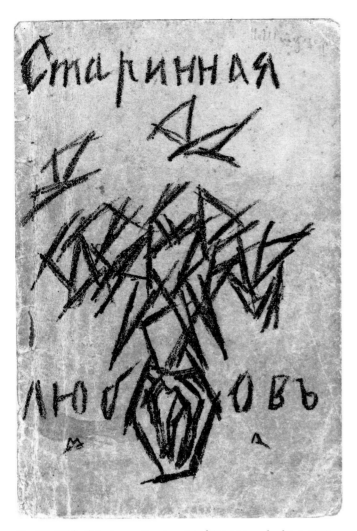

Fig. 98. Mikhail Larionov, Front cover of *Starinnaya lyubov'*, 1912

Fig. 99. Mikhail Larionov, Back cover of *Starinnaya lyubov'*, 1912

various chants and rites, in particular, the great ceremonials such as that performed by the Balagan Buryat to the western Khan spirits in Spring. Khangalov also describes important concepts in Buryat shamanism such as "soul-borrowing" and cites tribal myths about their descent from the divine Tengeri spirits, the object of Buryat worship. In addition Larionov owned an original Buryat sacred drawing, which he displayed in a section of its own at the Icon Painting and *Lubok* exhibition in March 1913.[33]

Various aspects of Buryat shamanism appear to be reflected in Larionov's art. For example, the Russian futurist book *Starinnaya lyubov'* seems to refer to the Buryat myth of Khara-Gyrgan, the first Buryat shaman, who entered into direct competition with God. The legend is important as it explains to the Buryat why contemporary shamans cannot perform the miraculous feats of their mythological ancestors.

According to the Buryat, Khara-Gyrgan declared that his shamanic powers were infinite and so God decided to put him to the test. God took a girl's soul and sealed it in a bottle, sticking his own finger in the neck so that it could not escape. The girl herself fell ill and Khara-Gyrgan was called to find her soul and make her well again. Khara-Gyrgan flew through the sky on his drum, noticed her soul trapped in the bottle, changed into a spider and stung God in the face. God instantly pulled his finger out of the bottle and the girl's spirit escaped. Afterwards God was so furious that he reduced the powers of Khara-Gyrgan and of all shamans after him.

Larionov may refer to this legend in his cover designs for *Starinnaya lyubov'* where the central event of the legend is recognizable. On the front cover (fig. 98) Larionov depicts a woman trapped in a vase or bottle while on the back cover (fig. 99) the stopper has

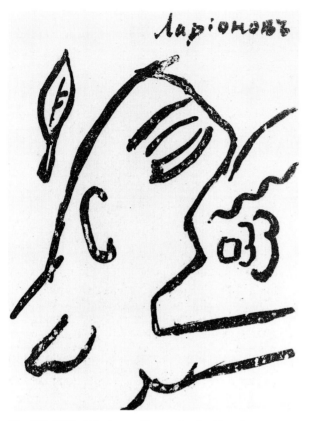

Fig. 100. Mikhail Larionov, Illustration for *Mir s kontsa*, 1912

suggests that he is already in a trance. The figure has a small wing on his shoulder (and cf. fig. 92) and an extended lower jaw, suggesting that the shaman is in a state of metamorphosis. Such an effect may have been suggested to Larionov from his reading about the tutelary animal spirit of the Buryat shamans, whose name is Khubilgan, a term that Eliade translates as "Metamorphosis." This spirit enables the shaman to transform his spirit into animal or bird form and so adopt its characteristics.[35]

The very title *Mir s kontsa* (*World Backwards*) recalls the way in which the people of North Asia conceive the world after death where everything takes place in reverse. For example, when it is night in this world it is day in the next, and during a funeral, grave objects are broken so that they will be whole in the next world. In the other world events and processes actually occur "backwards"—for example, rivers in the next world, according to the Buryat, flow backwards to their sources. This idea is also found in classical mythology.[36] Apart from the title, the poetic and artistic content of *Mir s kontsa* suggests classical mythology and primitive north Asian beliefs.

The image of the shaman also occurs in an illustration for *Pomada*, entitled *The Songstress* (fig. 101), which depicts a female shaman in a crouched, animal

been removed, the vase is overturned, and the girl's spirit is free to escape. This particular legend seems to have enjoyed great popularity in ethnographic literature, being recorded by Shashkov in 1864 and reproduced in subsequent accounts of shamanism such as that by Mikhailovskii (1895).

Each shaman has helping spirits, which appear in the form of animals, and before falling into a trance, the shaman summons the animal spirits by sounding a drum. After a while the shaman imitates the movements and noises of the animal helper and, by this means, indicates that he has taken possession of the spirit. Castagné gives a vivid description of this aspect of shamanism among the Kirgiz-Tatar tribes, reporting that the shaman "barks like a dog, sniffs at the audience, lows like an ox, bellows, cries, bleats like a lamb, grunts like a pig, whinnies, coos, imitating with remarkable accuracy the cries of animals, the songs of birds, the sound of their flight, and so on, all of which greatly impresses his audience."[34]

A number of Larionov's drawings appear to depict a shaman at this point in his or her ritual. An illustration for *Mir s kontsa* (fig. 100) depicts the head of a man who is intoning "Ozz," an apparently meaningless sound. The lack of an eyeball within the eyelids

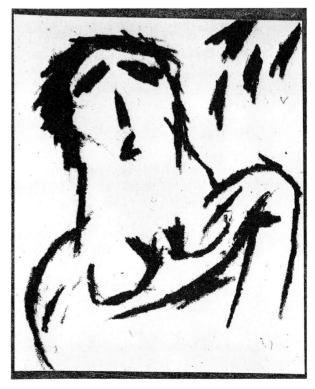

Fig. 101. Mikhail Larionov, *The Songstress*, illustration for *Pomada*, 1913

Fig. 102. Mikhail Larionov, Preparatory sketch for pochoir of
An Imaginary Voyage to Turkey

posture, whose song is indicated by the four black arrows at the right-hand side. The same subject appears in a preparatory drawing for *Voyage en Turquie* (fig. 102), where the song of the female shaman is indicated by diagonal strokes at the top right, the tutelary animal or helping spirit in the form of a bird at the top left is obeying her summons, and the eyeballs are again omitted to suggest a trance-like state.

The shamanic song, which Larionov transcribes in his illustration as "Ozz," was evidently an important source for the poetry of the Donkey's Tail group which was close in conception to that of Kruchenykh and Khlebnikov. The poem *Ulichnaya melodiya* (*Street Melody*), for example, written by Anton Lotov, is introduced by the same sound:

／ ／ ／ ／ ／ ／ ／ ／

Oz z zz zzz o
Kha dur tan
Esi Esi
Sandal gadal
Si Si
Pa
Ni ts[37]

The apparently meaningless language that the shaman utters is related to glossolalia which Kruchenykh himself described as a precursor of his own *zaum* poems.[38] In particular, Kruchenykh studied the glossolalia of Russian religious sectarians such as the Khlysts, founded in the early eighteenth century, and declared that the religious dissenters of Russian history who spoke the "meaningless' language of the Holy Ghost had already used "the new word."[39] The Khlysts were much discussed in avant-garde circles of the time: Livshits referred to "Varlaam Shiskov's Khlystic glossolalia," Andrei Bely wrote about the Khlysts in his novel *Serebryany golub'* (*The Silver Dove*), the title of which refers to the ritualistic emblem of the Khlysts, and Larionov apparently consulted an important article on the subject.[40]

Consequently, it is likely that the "meaningless" ecstatic language of shamanism would have interested the avant-garde poets. In this respect we should note the Kruchenykh in his manifesto "The New Ways of the Word" referred to "primitive coarseness" and that Khlebnikov described a shamanic performance in his poem *Shaman i Venera*. Khlebnikov referred to "the language of the gods" and used animal noises, particularly bird-song, in poems such as *Utro v lesu* (*Morning in the Wood*) and *Zangezi*.[41] Livshits provides important evidence on this point, describing Khlebnikov as "satiated with glossolalia" and suggesting that Kruchenykh was inspired by Shamanic chants.[42] Indeed, these may well have been an additional and complementary source for Kruchenykh and Khlebnikov in their development of *zaum* poetry.[43] This is further suggested by the collaboration of Larionov and Kruchenykh on the book *Pomada* in which Kruchenykh published his first *zaum* poem, the famous *Dyr bul shchyl*, and to which Larionov contributed his drawing *The Songstress* (fig. 101). It is also interesting, though not conclusive, that when *Dyr bul shchyl* was read aloud to an audience in Moscow, Kruchenykh was ridiculed as being no more than a shaman.[44]

In the shamanic ritual it is the bird that is most frequently imitated and invoked, for by incarnating the spirit of the bird the shamans believe themselves able to fly.[45] The bird is one of the most common and constant images in Larionov's art. The stylized bird (fig. 103) first appeared in his painting and graphic work of 1912. Later it recurred in theatre designs, the illustrations for Blok's *The Twelve*, and later still in drawings of the 1940s.[46] The bird plays a complex role in shamanism. It acts not only as a tutelary spirit, but among different Siberian tribes it is held to incarnate either an ancestor spirit, a soul yet to be born

Fig. 103. Mikhail Larionov, Cover of the book *16 Risunkov*, 1913–1914

into human form, or a transmigrated soul.[47] The belief that the bird incarnates a human soul also occurs outside shamanism—for example, in the Alcyone myth Alcyone, grieving over the drowned body of her husband, King Ceyx, is mysteriously transformed into a bird.[48] Three of the *lubki* in Larionov's personal collection were based on this legend and were exhibited in the Icon Painting and *Lubok* exhibition under the title of *The Bird Alcyone*,[49] additional evidence that Larionov adopted this symbolism for his neo-primitive birds.

The symbolism of the bird as a transmigrated or human soul is also found in the poetry of Khlebnikov, who was recognized as something of an ornithologist by several of his colleagues.[50] The hero of Khlebnikov's poem *Ka* is an ancient Egyptian spirit described in the poem as having "bird-like characteristics." Indeed, Khlebnikov's source for the poem was the ancient Egyptian belief that on death the human soul fragmented into the *Ka*, the *Akh*, and the *Ba.* The *Ka* represented the personality of the deceased,

the *Akh* referred to "the blessed spirit" in the world beyond, and the *Ba*, the soul, which was written in hieroglyphics as the Jeribu bird and was conceived as a bird that could fly forth through a *Ba* hole in the tomb and haunt the world. This symbolism, which obsessed Khlebnikov, was certainly known to Larionov, who worked closely with him and had made his own study of ancient Egyptian art.[51] Larionov's imagery thus assumed a universal significance in that in different ancient and primitive societies the bird symbolizes a similar concept, a human spirit or soul that has no bodily form.

Although shamans in some tribes perform naked during certain ceremonies, hence the nudity of the shamans in Larionov's drawings (cf. fig. 102), they also possess elaborate costumes full of ornithological references and symbols which are also believed to incarnate spirits. Shashkov was the first to detail the various aspects of the costume and concentrates particularly on the feather cap or headdress which symbolizes bird-flight. Such symbolism is crucial: "Feathers are mentioned almost everywhere in the descriptions of shamanic costumes. More significantly, the very structure of the costume seeks to imitate as faithfully as possible the shape of a bird. . . . The Mongol shaman has 'wings' on his shoulders and feels that he is changed into a bird as soon as he dons his costume."[52]

These ornithological references symbolize the shaman's mystical ability to fly into the heavens, across the world, or into the underworld.[53] The feather above the head of Larionov's shaman (figs. 92, 100) not only recalls the feather in shamanic costume but carries the same symbolism. Moreover, the wing on the shoulder may refer to the costume of the Mongol shaman described in the books of Potanin or by Khlebnikov, who wrote specifically about a Mongol shaman in his poem *Shaman i Venera.* Another drawing by Larionov, *Silhouette in a Landscape* (Ex Tomilina-Larionova Coll.), illustrates a figure wearing a shamanic feather cap.

Larionov's chief interest in shamanism seems to have been in the mystical flight that the shaman undertakes after falling into a trance, achieved not only by singing and dancing to the rhythm of a tambourine or drum, but also by drinking alcohol and smoking cannabis, which induces hallucinations.[54]

Smoking and drinking were principal themes in the drawings and paintings of *An Imaginary Voyage to Turkey.* In *Mistress and Maidservant* (fig. 34), for example, the odalisque and her servant smoke chibouks, and the drinking of alcohol is alluded to by the

bottle and glass in the background (note also the white feathers in the maidservant's hair). The same subjects occur in Larionov's later pochoirs entitled *Voyage en Turquie*, one of which represents the Scythian "vapour bath" discussed above (fig. 96). The most important work of this series, however, which provides a key to the understanding of Larionov's "imaginary voyage" in the context of the mystical shamanic journey, is a pochoir depicting Larionov himself in profile, smoking a pipe (fig. 104). The absence of an eyeball suggests a trance state, as do the white, abstract clouds, in which recognizable shapes seem to take shape, such as a white bird flying down towards Larionov's head. The bird is the guardian spirit that guides the shamans on their journeys into the heavens, the underworld, or across the earth to distant countries.[55] It is an imaginary journey that the shaman undertakes, hence Larionov's title for the Turkish paintings and pochoirs.

At the time when Larionov was working on *An*

Fig. 105. Nataliya Goncharova, Illustration for *Mir s kontsa,* 1912

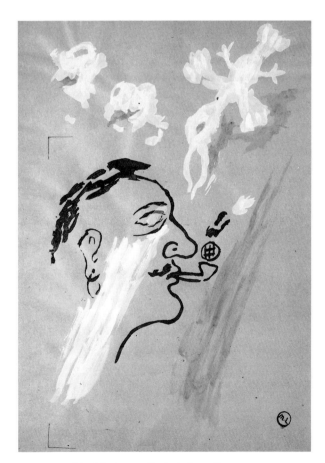

Fig. 104. Mikhail Larionov, Pochoir from *Voyage en Turquie,* c. 1928

Imaginary Voyage to Turkey the shamanic journey was also alluded to in a poem by Kruchenykh entitled *Puteshestvie po vsemu svetu* (*A Voyage Across the Whole World*), written in a stream-of-consciousness style, which was published in *Mir s konsta*. It is significant that the poem was illustrated, between the title and first verses of the poem, by Goncharova (fig. 105). Her illustration features a cross-legged and naked female wearing a feather headdress which may be interpreted as the shaman and initiator of Kruchenykh's mysterious journey.

As noted above, when shamans fall into a trance they are believed to grow wings on their shoulders so that they can fly through the air, an image frequently found in Larionov's work at this time. Such figures occur on the cover of *Pomada* (fig. 51), in *Spring* (pl. 11), and in *Gypsy Venus* (fig. 106). However these little winged figures may also be derived from the classical image of *erotes* or *putti* and the same image may represent other aspects of classical belief—for example,

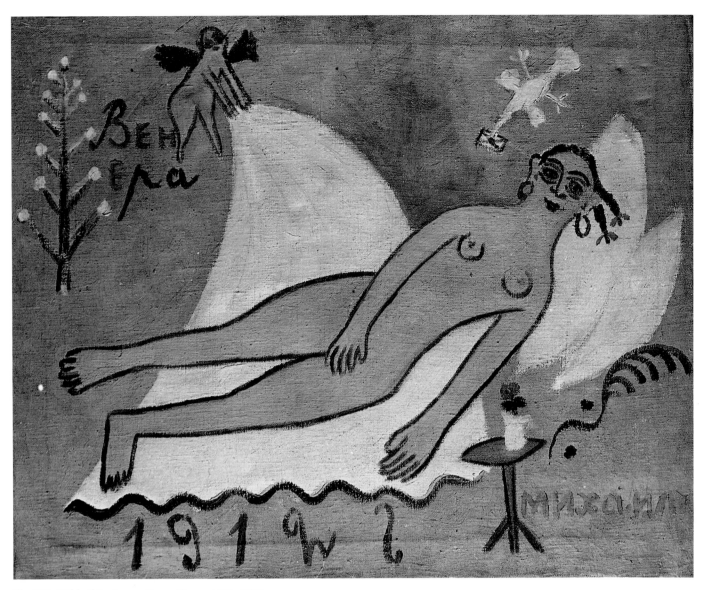

Fig. 106. Mikhail Larionov, *Gypsy Venus*, 1912–1913

the souls of the dead (like the Egyptian *Ba*) were believed to sprout wings and fly to Hades, conducted by Hermes Psychopompus.[56] The image also occurs in the *lubok*, fresco, and icon traditions, where winged parodies of the human figure represent evil spirits. The important point is that the same image in different belief systems signifies the same concept: states such as ecstasy, love, and death in which physical experience is transcended and transformed into the spiritual and in which there is communion between the phenomenal and numinal worlds. In Larionov's art this image assumes a kind of universal signification and functions like that of the flying bird.

Larionov may have used a classical image with which to convey a shamanic concept since the opposite process occurs in a drawing for the back cover of

Treize Dances as late as 1929 (fig. 107). Here the classical figure of Hermes, recognizable by the wings on his cap and his lyre, is depicted using the conventions of sacred Buryat drawings (fig. 108).

The relationship between classical mythology and Siberian shamanism was most positively stated by Khlebnikov in his poem *Shaman i Venera* published in *Sadok sudei II* on which Larionov collaborated. It may be postulated that Khlebnikov and Larionov were working together on this theme as several aspects of the poem are mirrored in Larionov's art. The two protagonists of the poem are the shaman and Venus, persistent subjects in Larionov's work. Besides the shamanic referents, one may cite several distinctly classical referents in Larionov's work in connection with his *Venus* series. Several drawings

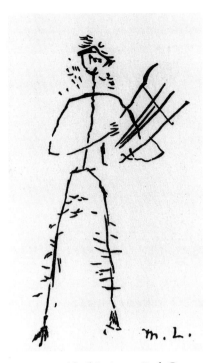

Fig. 107. Mikhail Larionov, Back Cover of *Treize Dances*

Fig. 108. Sacred Buryat drawing depicting the Tengeri spirits, recorded by Khangalov in Sketch Book No. 36, p. 1064

depicting a woman in shallow sea-water represent the birth of Venus as recorded by Hesiod. Larionov's *Katsap Venus* (pl. 12) occupies a classical pose, as does *Jewish Venus* (pl. 13), which also features a rose, referring to the classical myth of Venus and Adonis in which Venus, running to the dying Adonis, caught her foot on the thorn of a white rose and drops of her blood stained the flower red.

In adopting a representation of Venus that evokes Venus Pandemos, Larionov was reacting against the predominant trend of European art over the centuries to subordinate the image of Venus to the cold and intellectual ideals of beauty fostered by classical culture. Isarlov noted that "Larionov's achievement was that he discarded the 'Venus' of the elect and created the real, popular goddess of love. Larionov's Venus is the replete, sweating prostitute with heavily painted cheeks and thin hair."[57]

The shaman and Venus, then, were important subjects for both Khlebnikov and Larionov. There may also be a connection between Larionov's *Manya* series and Khlebnikov's book *Izbornik stikhov 1907–1914* (*Collection of Verses 1907–1914*) of 1914, which was illustrated by Pavel Filonov among others. One of the poems in the collection was entitled *Derevyannye idoly* (*Wooden Idols*), referring to the wooden totems and statuettes that are believed to incarnate ancestor spirits and the spirits of the tribe.[58] Of course wooden idols also have a ritual function and may be classified accordingly—one such type (fig.

109), for example, is of a female figure used in initiation ceremonies. The chief characteristics of these are their nakedness, diminutive arms, and widespread legs, through which the participants crawl in ceremonies symbolizing rebirth. This figure offers a striking parallel with Larionov's *Manya* drawings (fig. 110), in which the dominant characteristics of the crude totemic image are likewise its lack of arms and widespread legs. Possibly the *Manya* figures are meant to be wooden idols, similar to those of Khlebnikov's poetry. It is interesting to note that in 1915 Larionov designed an idol to stand on the stage of the ballet *Soleil de Nuit*.[59]

Another drawing by Larionov entitled *The Whore* (fig. 111) is a more explicit version of the *Manya* series and helps to identify another source that may have informed the *Manya* drawings and prints. The small wooden dolls that the Siberian Eskimos carve for their children or amulet belts (see fig. 112) duplicate exactly the stylistic features of both *Manya* and *The Whore*. There are the widespread legs with no feet, a complete absence of arms, large breasts, a well-defined pubic area, a little cap or hat on the head, and the whole executed in a roughly carved outline.[60]

The interplay of these two sources indicate a complex combination in Larionov's art of tribal imagery and art forms with that of their ritual function. Although *Manya* is a Russian diminutive of *Mariya* and, in association with the word *kurva*, means "Mary the bitch," *Manya* also carries sexual connotations

Fig. 109. Painted Wooden Figure, Abelam Tribe, East Sepik Province, Papua New Guinea, late nineteenth or early twentieth century

Fig. 110. Mikhail Larionov, *Manya the Bitch*, pochoir from *Voyage en Turkie*, c. 1928

(*manyashy* = alluring) and classical connotations, too, which are not out of place in the context of tribal religions and art. In Roman mythology, Mania was guardian of the spirits of the dead which inhabited the underworld and were "worshipped in a species of shamanism or ancestor worship."[61] At the Roman festival of the Compitalia, every household dedicated effigies to Mania, a practice well documented in the literature. The final point to make is that in Altaian shamanism *Manyak* refers not only to the shaman's costume but also to the items that hang from it, one of which is a little doll, not unlike the Eskimo figurine (fig. 112).[62]

Here, again, Larionov chooses an image and word that contain a multiplicity of interrelated references. The word *Manya* refers in Roman and Siberian belief to a doll with a ritual function, the image of *Manya* combines the stylistic features of a wooden doll and a wooden totem. Both word and image complement each other and possess a kind of universal signification, like the image of the flying bird and the winged shaman/*putto* figure. This approach to images and words is reminiscent of the work of Khlebnikov who was at this time researching linguistic roots in order to create a universal language. As Edward Brown states, "Khlebnikov's experiments with language had important theoretical implications. He entertained a philosophy of language which postulated a single, original and universal tongue whose primeval riches lay concealed under the fixed habits—which vary from one language to another—of grammar, syntax, and conventional spelling."[63] Khlebnikov himself stated that he wanted to find "the general unity of the world's languages, built out of the units of the alphabet."[64] The approaches of Khlebnikov and Larionov to universal meaning or signification in language and visual images are extremely close and there is probably much truth in Gray's statement that the devices of the Russian futurist poets can be traced back to the work of Larionov and Goncharova.[65]

Given Larionov's use of shamanic and classical symbolism, we may assess the extent to which these two fields help us understand Larionov's most important neo-primitive works, such as the *Seasons* paintings (pl. 11, figs. 47–49). These four paintings deal with the customs, rites, and beliefs of primitive Russian communities during each season. Each painting is divided into four sections. There is what we may call a "descriptive square" which, in the manner of *lubki*, describes the climatic conditions and human activities pertaining to the specific season. Then there is

an "earthly square" containing references to human habits during that period. These two squares always appear in the bottom half of the picture, as they describe earthly and objective phenomena. The two upper squares of each painting deal with the supernatural world. The "natural square" refers to nature and animal spirits, and the "divine square" refers to the world of divinities.

In his division of the *Seasons* paintings into four parts occupying specific positions, Larionov emulates Siberian tribal art in general, as well as that of

Fig. 111. Mikhail Larionov, *The Whore*, c. 1913

Fig. 112. Angmagsalik Eskimo statuette, early twentieth century

the Buryat, where a picture is divided horizontally into a hierarchy of planes according to the different types of physical and spiritual spheres with which the artist is dealing. In the Buryat drawing shown here (fig. 108), for example, we progress by stages from the earthly sphere at the bottom to the heavenly sphere at the top, each specific physical and spiritual plane being clearly demarcated by simple lines.[66] Several familiar symbols recur in the *Seasons* series. The image of the bird occurs ten times, but only in the "natural" and "divine" squares. Here they represent spirits serving the divinities and have special significance in combination with the sheaf of corn in *Summer* (fig. 47)—spirits of the corn are conceived as birds in many primitive and tribal beliefs[67]—and with the tree in *Autumn* (fig. 48).

The divinities in each painting are particularly interesting for they are a mélange of both classical and primitive Russian elements, a technique already discussed in relation to the design for the back cover of *Treize Dances*. In Roman and Pompeian frescoes that depict the seasons, for example, Spring is a young woman holding flowers, Summer holds a sickle and is accompanied by an ear of corn, Autumn is associated with grapes and wine making, and Winter bears a wrap with which to keep warm. All these classical elements appear in the relevant "divine square" of Larionov's paintings. In many ways then the *Seasons* belong firmly to the artistic tradition dating back to classical fresco. One may even suggest that Larionov's four deities are the classical Flora, Ceres, Bacchus, and Boreas, because of the association of flowers, fruit, corn, and wine with the former three, and the wailing of Boreas, the North Wind, symbolized by the zigzag line emanating from his mouth in the "divine square" of *Winter* (fig. 49).

The depiction of the divinities, the human figures, and the animals, however, is both Russian and primitive. The schema for the faces is based upon that found in the Russian *lubok*, as is the stylization of the cat in *Winter*. The trees and houses in the "earthly square" of *Winter* and the small human figures in the "earthly square" of *Spring* may owe something to Buryat drawing style: the tree conceived as a vertical line with a few short diagonals sloping off it, and the simplified front and side views of the human figure, are not unlike those in the Buryat drawing (fig. 108).

The *Seasons* series, then, is a complex manifestation of neo-primitivism in Russian avant-garde art, in which a significant role is played by shamanic symbolism, classical mythology, and tribal, traditional, and folk-art sources (*lubki*, icons, embroidery)—a vocabulary of deliberately pagan symbolism and subject matter, principally depicted according to folk art conventions. It is difficult to avoid the conclusion that in his remarkably wide researches, Larionov was attempting to discover in neo-primitivism a universal pictorial language, which would act as a visual counterpart to the universal language that the poets Khlebnikov and Kruchenykh were attempting to discover in their research into the roots of languages and words.

These studies, and neo-primitivism itself, were seen by Larionov as being an indispensable corollary of his abstract and nonobjective rayist paintings and drawings. Not only did he develop neo-primitivism and rayism at exactly the same time, but he continued to paint and exhibit neo-primitive and rayist paintings alongside each other at exhibitions such as the Target and the Exhibition of Paintings No. 4: Rayists, Futurists, Primitives. In 1913 he had related the most modern art movements to Astarte and Zarathustra, and even in 1918 the same idea possessed him when he wrote to Lord Berners suggesting an art magazine that would deal with the most ancient and most modern of art. Why this relationship? The Italian futurists provided one answer when they declared that they were "the primitives of a new sensitiveness, multiplied hundredfold."[68] The same claim was made by Larionov and Goncharova—they were to be the primitives of a new, rayist perception of the world around them, developed by reference to Italian futurist example and related to the four-dimensional "cosmic" consciousness of Charles Howard Hinton and Petr Demyanovich Ouspensky.

The Cubist and Futurist Roots of Rayism

Larionov's contradictory statements in the manifesto "Rayists and Futurepeople" reveal an ambivalent attitude towards contemporary abstract movements in the arts in western Europe. On the one hand he denigrates "modern western art" but, on the other, acknowledges "all styles as suitable for the expression of our art . . . Cubism, Futurism, Orphism and their synthesis Rayism."[1] What was the relationship between rayism and these abstract movements in the west, how much did Larionov really know of cubism and futurism at the time, and what did they contribute to rayist theory and practice?

At the genesis of rayism in the summer and autumn of 1912, the Russian avant-garde were generally well informed about contemporary western art. In the years before the war many Russian artists had travelled and worked abroad and several Russians were influential in the Parisian art world. Serge Diaghilev forged important links between Russia and Paris through his exhibition of Russian art at the *Salon d'Automne* in 1906, which brought Bakst, Kuznetsov, and Larionov to the French capital. Diaghilev's influence in Paris grew in the succeeding years due to his Russian opera seasons and, from 1909 onwards, through the annual performances of the *Ballets Russes* in Paris. Alexandra Exter, who commuted between Paris, Moscow, and Kiev was also a crucial figure. In 1908 she met Picasso, Braque, Apollinaire, and Max Jacob and between 1909 and the start of the war she became an important link between Russia and the west. Exter was also interested in futurism and in 1912 she was introduced to Boccioni through Archipenko and became friendly with both Soffici and Léger. Moreover she was a regular contributor to the Parisian Salons as well as the famous *Section d'Or* where she exhibited among the cubists. Serge Ferat (Yastrebtsov), who had met Apollinaire and Picasso at the Académie Julian in 1911, edited the famous journal *Les Soirées de Paris* and cultivated friendships with both the cubists and the futurists. The Russian artist Sonya Terk, who had married Robert Delaunay

in 1910, occupied a prestigious position and forged links with artists such as Yakulov, who visited them in 1913. There was also Mariya Vasilieva who in 1908 organized the Académie Russe and later the Académie Vassilieff where Léger lectured.[2]

Academies such as these and the Parisian studios attracted a variety of Russian artists. In 1910 Natan Altman studied at the Académie Vassilieff and Ivan Puni at the Académie Julian. At the Académie *La Palette* where the cubist painters Gleizes, Metzinger, and Le Fauconnier taught, Lentulov worked under Le Fauconnier in 1911 and in the autumn of 1912 Udaltsova and Popova came to study with Metzinger and Le Fauconnier. The warren of studios in the old exhibition building in Montparnasse known as *La Ruche* (The Beehive) had for a number of years supported a sizable Russian contingent including Chagall, Archipenko, Lipchitz, Zadkine, and Soutine. Here, close links were formed between the Russians and Léger, Lhote, Laurens, Modigliani, Soffici, and the cubist poets. Archipenko was an active member of the cubist group and exhibited at all the latest salons including the *Section d'Or*. Paris was also a haven for Russian Jewish artists such as Kikoïne, Krémègne, and Mané-Katz who, like Chagall and Soutine, had left Russia in search of personal and artistic freedom.

A number of other Russian artists, all known to Larionov and Goncharova, were also acquainted with Paris. In 1908 Léopold Survage (Shtyurstvage) settled there and met the cubist painters and poets through Archipenko. Baranov-Rossiné moved to Paris in 1910 where he became friendly with the Delaunays. Mashkov visited Paris in 1908 and Filonov is reported to have been there in 1912.[3] Chekrygin and Konchalovsky arrived in 1913, and in 1914 Tatlin worked for a time in Picasso's studio. In 1910 several Russian artists, including Falk, Yakulov, and Popova, also visited Italy, where futurism, in theory at least, was beginning to develop. Exter had worked in Italy, as had Puni in 1912 and Matveev in 1913. In the summer of

1912 David Burlyuk visited Paris, Milan, Rome, and Munich, and excitedly wrote to Livshits: "I am getting all the futurist manifestos."[4] The flow of artists was not just one way from Russia to the west, and from 1909 to 1913, Denis, Boccioni, Matisse, Nolde, and Marinetti all visited Russia. Kandinsky frequently returned to his homeland. The Parisian art critic Alexandre Mercereau also visited Russia and maintained a close relationship with the Jack of Diamonds group, choosing the French works for their exhibitions.

Exhibitions of western art in Russia were another rich source of information about contemporary painting abroad. The tradition of such exhibitions in Russia dated back to the World of Art, which showed European symbolist painting, and the Golden Fleece, which displayed impressionist, post-impressionist, and Fauve work.[5] The Izdebsky Salon hung the works of Balla, Braque, Gleizes, Le Fauconnier, Marcoussis, and Metzinger, and the first Jack of Diamonds exhibition in 1910, featured paintings by Gleizes and Le Fauconnier (though neither exhibition at this stage showed any cubist or futurist work). The first cubist paintings to be exhibited in Russia appeared in the Jack of Diamonds exhibition of March 1912. Especially notable was the work of Delaunay, Léger, Gleizes, Le Fauconnier, and Picasso. An important exhibition of contemporary French art, which opened in Moscow in January 1913, featured Léger's latest painting *Woman in Blue* as well as works by Gris and Metzinger.[6]

The Russians also contributed to international exhibitions in the west that featured cubist and futurist painting. Larionov and Goncharova sent works to Roger Fry's Second Post-Impressionist Exhibition of 1912 which displayed cubist paintings by Braque and Picasso. The large post-impressionist exhibition of 1913 in Budapest, to which Goncharova and the Burlyuks contributed, included works by Delaunay, Gleizes, Le Fauconnier, Metzinger, and Picasso.[7] Larionov, Goncharova, and the Burlyuks also exhibited in the *Der Sturm* Autumn Salon of 1913 which featured a wide range of cubist, futurist, and simultanéist work. Exter had exhibited in the cubist Salons in Paris, Malevich and Puni showed paintings in the *Indépendants* of 1914, and the Free International Futurist Exhibition in Rome included the work of Rozanova, Kulbin, Exter, Larionov, and Goncharova.

Perhaps the most important source for Russians seeking information about western developments were publications and reproductions. Exhibition catalogues carried illustrations of paintings and texts of manifestos. Art magazines from Paris and Italy reported the latest events.[8] Articles on cubism and futurism appeared in the Russian art magazines along with translations of important texts. Marinetti's "Founding and Manifesto of Futurism" was reviewed and translated into Russian in 1909 shortly after its publication in *Le Figaro*.[9] The magazine *Apollon* regularly published a column by Paulo Buzzi on the activities of the Italian futurists which, as early as 1910, reviewed and translated portions of the Italian futurist leaflet *Futurist Painting: Technical Manifesto*.[10] In the second edition of their magazine in June 1912 the Union of Youth published translations of the *Technical Manifesto*, "The Exhibitors to the Public," which was the foreword to the exhibition catalogue of the touring futurist exhibition of 1912, and a text by Le Fauconnier entitled "The Work of Art," originally published in the catalogue to the second *Neue Künstlervereinigung* exhibition held in Munich in 1910.[11] Furthermore, in the third edition of their magazine in March 1913 the Union of Youth printed an influential review of Gleizes's and Metzinger's book *Du Cubisme*.[12] Two translations of the book followed on the heels of this review, one by Max Voloshin and the other by Ekaterina Nizen in which works by Gleizes, Metzinger, Gris, Léger, Picasso, Braque, Duchamp, and Picabia were reproduced.[13] In the same year the Jack of Diamonds published an illustrated almanac which included translations of Le Fauconnier's catalogue preface, "The Modern Sensibility and the Picture," for the *Moderne Kunst Kring* exhibition in Amsterdam in 1912, a modified translation of Apollinaire's essay on Léger from *Les Peintres Cubistes*, and reproductions of Léger's paintings *Smokers* and *Nudes in the Forest*.[14] The Russian newspapers, too, reported on the latest artistic events abroad and reproduced paintings.[15]

The Russians also hosted well-informed lectures about contemporary western art.[16] Within the Larionov group Ilya Zdanevich discussed various Italian futurist manifestos at the opening of the Target exhibition in March 1913 and, shortly after, lectured on the subject of Italian futurism in St. Petersburg when, according to Rostislavov, "in the tone of a prophet he read a whole heap of futurist manifestos and showed reproductions of futurist paintings on the screen."[17] As Zdanevich was a close personal friend at the time, it is likely that Larionov had access to the Italian manifestos and lantern slides of paintings that Zdanevich had collected.

In his manifesto *Luchizm* of April 1913 Larionov demonstrates what appears to be a keen knowledge of futurism, cubism, and Orphism, giving a brief

thumbnail sketch of each movement. About Italian futurism he writes:

> . . . this doctrine seeks reforms not only in the sphere of painterly art, but is concerned with all kinds of art.
>
> In painting futurism promotes mainly the doctrine of motion or dynamism.
>
> In essence painting is static—hence dynamics as a style of motion. Futurism expands the picture: it places the artist in the center of the picture, it examines the object from different points of view, it advocates the translucency of objects, the painting of what the artist knows not what he sees, the depiction on the canvas of the whole sum of impressions, the depiction of a series of moments at one point in time, it introduces narrative and literature.
>
> Futurism introduces a refreshing stream into contemporary art. . . . If the futurists had genuine painterly traditions, like the French, their doctrine would not have become part of French painting, as has now happened.[18]

Here, Larionov acknowledged that futurism was an interdisciplinary movement, affecting literature, music, sculpture, photography, and "all kinds of art." He recognized that the most significant aspect of futurism in painting is what the Italians called "the dynamic sensation," the attempt to recreate on canvas the sensation of the moving image in front of the retina. Larionov describes their method as "the depiction on the canvas of the sum total of impressions," a phrase similar to that used by the futurists themselves in their manifesto "The Exhibitors to the Public": "we try to render the sum total of visual sensations."[19] He also understood the relationship between futurism and French cubism, noting that futurism had to move to France in order to assert itself.

Several of Larionov's statements concerning futurism were evidently inspired by phrases in the Russian translations of the two Italian futurist manifestos published in *Soyuz molodezhi 2:* compare, for example Larionov's statement that "Futurism expands the picture—it places the artist in the centre of the picture" with the futurist claim that "we shall henceforward put the spectator in the centre of the painting."[20] It seems clear that the translated manifestos were an important source for his knowledge of futurism. Moreover, the translations of the two manifestos were published in June 1912 at an opportune moment for Larionov, for this was the date he ascribed to the writing of his manifesto *Luchizm,* and it was in the

summer of 1912 that he began to paint his first rayist works.

A key concept of the Italian futurist aesthetic, discussed at length in "The Exhibitors to the Public," was that of "lines of force." These rhythmical vibrations, which emanate from both objects and people in futurist paintings and which express their latent or manifest dynamism, may be seen as the parent of Larionov's ray-lines. Indeed, what Boccioni and his Italian colleagues said about lines of force seems merely to be rephrased by Larionov in his rayist manifestos. The Italians, for example, wrote that "every object influences its neighbour, not by reflections of light . . . but by a real competition of lines and by real conflicts of planes."[21] Larionov's painting *Glass* (fig. 44) illustrates this concept particularly well in that the refracted rays distort the bottles and glasses that form them. Larionov in his manifesto "Le Rayonnisme Pictural" states, "Every form exists objectively in space by reason of the rays from the other forms that surround it [and] . . . there exists a real and undeniable intersection of rays proceeding from various forms."[22]

The Italians advocated that objects be translated on the canvas, not according to surface appearance, but according to the lines of force which distinguish them and through which every object tends towards the infinite.[23] Larionov advocated the same with regard to the ray-line, stating that if we wish to paint literally what we see then we must paint "the sum of rays reflected from the object."[24] Furthermore, he observed that one would have to paint all the other rays in the vicinity of the object at the same time, an idea borrowed from the *Futurist Painting: Technical Manifesto* of 1910 where the authors explained that to paint a human figure the artist must depict "the whole of its surrounding atmosphere."[25] In theory then, Larionov's concept of ray-lines seems to derive from the futurist conception of lines of force.

Carlo Carrà was one of the first of the futurists to give visual expression to the concept of lines of force, in his painting *The Funeral of the Anarchist Galli* of 1910–1911 (fig. 113). A monochrome reproduction of the work was published in the catalogues of the futurist exhibition that was then touring Europe.[26] In fact "The Exhibitors to the Public" explained the use and function of the lines of force with particular reference to this painting:

> If we paint the phases of a riot, the crowd bustling with uplifted fists and the noisy onslaughts of cavalry are translated upon the canvas in sheaves of lines corresponding with all the conflicting

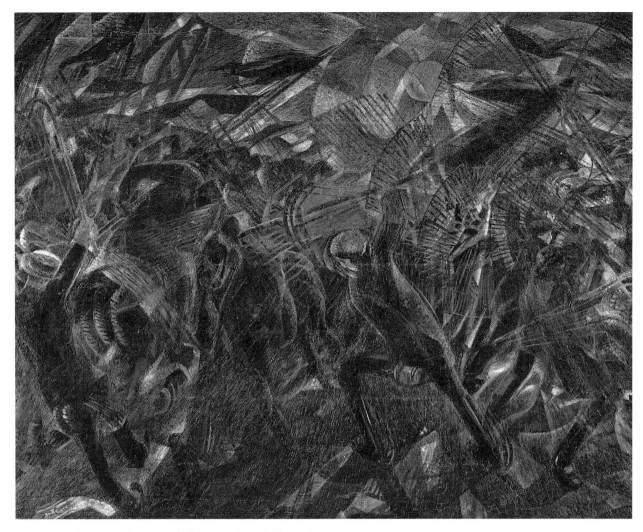

Fig. 113. Carlo Carrà, *The Funeral of the Anarchist Galli*, 1910–1911

forces. . . . These force lines must encircle and in-volve the spectator so that he will, in a manner, be forced to struggle himself with the persons in the picture.[27]

The fan-shaped groupings of force-lines in *The Fu-neral of the Anarchist Galli* which express the dy-namism and violence of the riot are not dissimilar to those found in Larionov's *Rayist Constirction of a Street* (fig. 57), where similar fan-shaped lines explode from a point, and long ray-lines intersect each other. The concept of the spectator being encircled and in-volved, and having to struggle, is something that is also found in rayism. Larionov claimed that his works were slippery and difficult to penetrate, that the sensation of the fourth dimension that they evoke would be beyond our understanding; and in practice, too, there is a sense in which we have to struggle with

the rayist picture space, especially in pneumo-rayist works.

It is interesting to compare Larionov's nonobjec-tive pneumo-rayist paintings, such as *Red and Blue Rayism* (pl. 16), with the nonobjective works of Ital-ian futurism, such as Giacomo Balla's *Radial* and *Irri-descent Interpenetrations*. The paintings of Larionov and Balla are comparable in that they attempt to ren-der refracted light rays visible on the canvas. More-over, the rays interpenetrate—Larionov's clash and fight while Balla's quietly dovetail and intermingle. There are, of course, stylistic differences: Balla's work is precise and ordered, Larionov's coarse and con-fused; Balla's coloring is more restrained and "scien-tific" than Larionov's which is bold and emotive. There are, however, some common devices that both artists use: for example, the peculiar spiral or vortex in the bottom right hand corner of Larionov's *Rayist*

Construction of a Street (fig. 57) also occurs in one of Balla's *Irridescent Interpenetrations* (National Gallery of Modern Art, Rome).

There are other devices in pneumo-rayist works that recall the Italian futurist manifestos. "One may remark, also, in our pictures spots, lines, zones of colour which do not correspond to any reality, but which . . . musically prepare and enhance the emotion of the spectator. . . . Those lines, those spots, those zones of colour, apparently illogical and meaningless, are the mysterious keys to our pictures."[28] Often such "spots, lines and zones of colour" appear in pneumo-rayist paintings. The term "zones of colour" vividly describes the bright patchwork of moving ray-planes that Larionov adopts in his paintings, and both *Sea Beach and Woman* (pl. 15) and *Street Lighting* (fig. 114) are filled with black spots

and peculiar parallel lines that seem to have a musical significance—in the former, many of the dots appear to be musical notes. In fact the relationship between futurist "zones of colour" and music was something that Larionov began to investigate in his work. In the manifesto "Le Rayonnisme Pictural" he explained:

The sensation a color can arouse, the emotion it can express is greater or lesser in proportion as its depth on the surface plane increases or decreases. . . . Hitherto this law has been applicable only to music, but it is incontestable also with regard to painting: colors have a timbre that changes according to the quality of their vibrations, that is, of their density and loudness. . . . So we are dealing with painting that is dedicated to the domination

Fig. 114. Mikhail Larionov, *Street Lighting,* c. 1913–1914

Fig. 115. Mikhail Larionov, *Rayist Composition, Domination of Red*, 1913–1914

of color, to the study of the resonances deriving from the pure orchestration of its timbres.[29]

Larionov's painting *Rayist Composition: Domination of Red* (fig. 115) was a practical application of this theory, in which he used the varying density of the colored paint layers to create timbres that he could orchestrate, the most dominant of which is the red. In this way, Larionov, like the Italian futurists, tried musically to prepare and enhance the emotion of the spectator, and to emphasize the point he even included two bars of music in the painting.

The relationship between color and music was an important feature of Italian futurism, although it was a topic of general interest among artists at the time. In his manifesto *Luchizm*, Larionov writes at length about the basis of Orphism in the musical sonority of colors, the correspondence of musical sounds to light

waves, and the construction of paintings according to musical laws. Although Larionov criticized this approach, he evidently felt that Orphism was a kindred movement to rayism and deserved recognition.

Larionov would also have been aware that Nikolai Kulbin had written about the relationship between color and music in his essay *Svobodnaya muzyka* ("Free Music") published with an essay by Aleksei Borisyak *O Zhivopisi muzyki* ("On Musical Painting") in *Studiya impressionistov* of 1910. He would have seen the remarkable paintings of the Lithuanian composer and painter Churlyenis, in whose work color and music are related, at the World of Art exhibition in Moscow in November 1911. The composer Skryabin (1871–1915) had associated sound and color in his production of *Prometheus: The Fire Poem* of 1910, in which the music was accompanied by a *clavier à lumières* that projected around the auditorium

Fig. 116. Mikhail Larionov, *Street Noises*, illustration for *Mir s kontsa*, 1912

colored lights that corresponded to particular chords. An article about the performance was published in *Muzyka* of January 1911 by Leonid Sabaneev who, shortly after, wrote another article on the subject for the almanac *Der Blaue Reiter*. Kandinsky's stage work *The Yellow Sound*, which was also discussed in the almanac, attempted something similar.

The futurists loved contemporary urban sounds and included them in their concept of music. Boccioni painted *The Noise of the Street Enters the House* (Kunstmuseum Hannover mit Sammlung Sprengel), Carrà interpreted the screeching of wheels and brakes as *What the Tramcar Told Me* (Städtische Galerie, Frankfurt), and Severini wrote to Soffici that he was obsessed with the painting of noises.[30] In his drawing *Street Noises* (fig. 116) Larionov explored the subject more explicitly. Here he represents a busy

street and one seems to hear the clattering noise of droshkies on cobblestones, the shouts and whip-cracks of coachmen, and the hum of electric wires attached to a telegraph post. These are the sources of the noises to which the drawing alludes but the sound itself is indicated by a bar of notes in the top left-hand corner.

The evocation of street noise through visual representation was an important aspect of the Italian futurist aesthetic not only because it contributed to the modernity of their subject matter but also because it helped create "the synthesis of what one remembers and of what one sees . . . in order to make the spectator live in the centre of the picture."[31] Carrà, in his painting *Synthesis of a Café Concert* (Estorick Coll., London), attempted to create a synthesized image of audial and visual experience in a *café-chantant*. Russolo aimed at a similar synthesis in his *Memories*

of a Night (Private Coll., New York), reproduced in the 1912 catalogue of the travelling futurist exhibition and recently cited as a direct influence on Goncharova's *City by Night*.[32] Larionov in the manifesto "Le Rayonnisme Pictural" declared that he too wished to "create a synthesis image in the mind of the spectator."[33] His drawing *Street Noises* (fig. 116) is an excellent example, in Italian futurist vein, of a synthesized image of what one experiences when walking in a street. Larionov combines sounds and visual aspects. There is a recollection of words, numbers, and letters that leap out at the pedestrian from shop windows, signboards, posters, and adverts, as well as a splendid combination of ambiguous images, of which the clearest is the horse. At this point Larionov seems to have outdone the futurists—nothing as versatile as *Street Noises* had yet appeared in the futurists' oeuvre.

It is interesting to note that in 1913 Eganbyuri discussed Larionov's rayist painting *Glass* in terms of this Italian futurist concept of synthesis: "Larionov . . . simply paints 'glass' as a universal condition of glass with all its manifestations and properties—fragility, ease in breaking, sharpness, transparency, brittleness, ability to make sounds, i.e., the sum of all the sensations obtainable from glass."[34] *Glass* then was conceived in terms similar to that of the "synthesis image" of the Italian futurists. During 1913 the futurists developed their ideas about a synthesis of experiences, sensations, and noises. Carrà published his *Painting of Sounds, Noises and Smells,* and Russolo, *The Art of Noise,* a later edition of which was in Larionov's library. Russolo advocated composing music based on sounds that were related to the noises of everyday experience.[35]

Larionov was working in this same vein during 1913. An illustration of a *Street Scene* (fig. 117) for the book *Le Futur* portrays "a synthesis of what one remembers and of what one sees." The bar of notes in the top left-hand corner indicates the noises of the street, as do the musical sharps thrown off by high-heeled shoes hitting the cobblestones. There is a recollection of numbers, words, a horse-pulled cab, a wheel, and details like the Severini-style sequins on the lady's dress. Above all, however, Larionov conveys an impression of motion and movement. All these aspects combine to create a synthesis image of everyday experience in a city street.

The "synthesis of what one remembers and of what one sees" played an important role in the futurist concept of "states of mind." In their painterly expression of "states of mind" not only did the futurists resort to a synthesis of sounds and visual images but with the aim of placing the spectators in the center of the picture and forcing them to experience the action and psychological atmosphere depicted, they also used the expressive qualities of lines. This was something learned from the neo-impressionists who had been interested in psycho-physics and the work of Charles Henri. In their manifestos the futurists explained:

> In the pictorial description of the various states of mind of a leave-taking, perpendicular lines undulating and as it were worn out, clinging here and there to silhouettes of empty bodies, may well express languidness and discouragement. Confused and trepidating lines, either straight or curved, mingled with the outlined hurried gestures of people calling one another, will express a sensation of chaotic excitement. On the other hand, horizontal lines, fleeting, rapid and jerky, brutally cutting into half lost profiles of faces . . . will give the tumultuous feelings of persons going away.[36]

Larionov's *Street Scene* (fig. 117) appears to attempt a literal interpretation of this theory. All the figures are executed as mere outlines, "silhouettes of empty bodies," to which a variety of lines are attached. There are stiff diagonals, undulating curves, bold lines, languid lines, some clinging tight to bodies, others projecting sharply from hats. There is even a reference to a "lost profile" being cut in half in the top right-hand corner where a face is dissected by a vertical and a horizontal line. The partial word *fil,* which is almost attached to the face, could in fact refer to *profil,* a truncated verbal reference to the truncated profiles of faces cited in the Italian manifesto. On the other hand, the Italian manifesto may have suggested to Larionov something similar to the experience of watching a motion picture at the cinema, in which case *fil* may refer to *film.* In fact, Larionov had examined the visual sensations of films more than a year before in *Scene – The Cinema* (fig. 36) where he had already worked on the deconstruction of the figure by using vertical lines.

The confusion of lines in *Street Scene* is compounded by drawing certain limbs and objects in several positions to indicate movement. This represents Larionov's first attempt to portray what the Italians called "the dynamic sensation." A passage in the *Technical Manifesto* states:

> The gesture which we reproduce on canvas shall no longer be a fixed moment in universal dynamism. It shall simply be the dynamic sensation itself. . . .

Fig. 117. Mikhail Larionov, Illustration for *Le Futur*, 1913

A profile is never motionless before our eyes, but it constantly appears and disappears. On account of the persistency of the image upon the retina moving objects constantly multiply themselves . . . thus a running horse has not four legs, but twenty and their movements are triangular.[37]

In *Street Scene* Larionov indicates motion by the general repetition of outlines—in the summer of 1913 this was the limit to which he was able to express "the dynamic sensation." In September, however, Larionov, having seen a reproduction of Balla's *Dynamism of a Dog on a Leash* (fig. 62) in the catalogue of *Der Sturm* Autumn Salon to which he contributed, evokes "the dynamic sensation" in his remarkable canvas *Boulevard Venus* (pl. 14) by directly imitating Balla's work. The multiple imagery of the woman's legs suggests her progress down the street while the turning of her head is suggested by three different

viewpoints. *Boulevard Venus,* however, is not as precise and as "scientific" as the work of Balla, and Larionov still seems to be enjoying a joke at Balla's expense by painting the woman's legs as if she were spreadeagled.

In this painting Larionov uses an interesting and humorous device, transparency, which seems to have been suggested in part by Italian futurist theory and practice. In *Luchizm* Larionov had already noted that the futurists advocated "the translucency of objects." As early as 1910 they declared that "movement and light destroy the materiality of bodies."[38] A sense of transparency is created in several futurist paintings by their portrayal of rapid motion. However, the futurists were also fascinated by the newly developed X-ray photography which rendered the world of everyday appearance transparent and revealed its inner workings. In their manifestos they declared, "Who can still believe in the opacity of bodies, since our

sharpened and multiplied sensitiveness has already penetrated the obscure manifestations of the medium? Why should we forget in our creations the doubled power of our sight capable of giving results analogous to those of' X'-rays?"[39] Balla was particularly interested in the visual effects of X-ray photography and in one of his notebooks referred to an Italian book entitled *Raggi di Röntgen e loro Practiche Applicazioni,* by Italo Tonta, which contained fourteen plates of X-ray photographs.[40]

Larionov first used the effect of transparency in *Street Scene* (fig. 117), to reveal the underwear and suspenders of the passers-by. He then developed the idea in *Boulevard Venus* (pl. 14), to reveal not only the underwear and breasts of the woman but also the bone of her left leg as she lifts it out of the right-hand side of the picture. Although Larionov did not specifically refer to X-rays in his manifestos, he did refer to ultraviolet and radioactive rays as being of importance to rayism, and he also owned a copy of the same book of X-ray photographs that Balla had studied and noted.[41]

It is also interesting to consider Larionov's lengthy prescriptions in manifestos and interviews with the Russian press concerning Russian futurist dress and appearance in light of Balla's application of futurism to clothing. In fact, both Larionov's manifesto "Why We Paint Ourselves" and Balla's "Futurist Manifesto of Men's Clothing" were written in December 1913. Both manifestos advocated the application of one's artistic principles to the outside world and both advocated rapid change: Balla talked of futurist clothes "made to last for a short time only" in order to provide "constant and novel enjoyment for our bodies";[42] and Larionov declared, "We paint ourselves for an hour and a change of experience calls for a change of painting."[43]

In this respect though, Larionov was ahead of Balla and the Italian futurists in both theory and practice. Already, in the summer of 1913, he had thought deeply about the application of rayist principles to the outside world, and this led him to conceive of nothing less than a reconstruction of the universe: "There are reasons to suppose that the whole world, in its concrete and spiritual totality, can be recreated in painterly form."[44] It was two years later in March 1915 that the futurists expressed a similar viewpoint in the manifesto *The Futurist Reconstruction of the Universe.* In practice, too, Larionov and his group painted their faces and dressed in bizarre clothes a good two years before there is any evidence to suggest that Balla and his colleagues actually made their

clothes. Similarly, Larionov championed the futurist film before his Italian counterparts, with the production of *Drama v kabare futuristov No. 13 (Drama in the Futurists' Cabaret No. 13)* in December 1913, preceding the first Italian futurist film, *Vita Futurista* of 1916, by three years, although, like Larionov, the Italian futurists had been interested in cinema from a theoretical point of view since 1912.[45]

Although Larionov had rejected modern western art in the manifesto "Rayists and Futurepeople" (1913), even at that point he and his group did not entirely forsake futurism, as they had condescended to "offer our hand to the futurists, despite all their mistakes."[46] Furthermore, Larionov's work on the book *Le Futur* with Bolshakov, Goncharova, and Firsov in August 1913 also contradicts the provocative attitude to the west expressed in the manifesto "Rayists and Futurepeople." *Le Futur* was the only Russian futurist book with a French title and the illustrations were clearly futurist in spirit. Larionov's amusing drawing of a woman's head with a bicycle racing across her cheek (fig. 61) cleverly updates the famous futurist phrase: "How often have we not seen upon the cheek of the person with whom we are talking the horse which passes at the end of the street,"[47] and a drawing of a clock mechanism (fig. 118) referred to the Italian futurist love of modern machinery, standardized time, and motion. Moreover, Larionov dedicated a copy of *Le Futur* to his "dear friend" Marinetti (fig. 119), and this unique inscribed copy, now missing from the National Art Library in the Victoria & Albert Museum, bore a series of amusing annotations by Larionov in French that described some of the illustrations. For example, in the drawing of the lady with a bicycle on her cheek Larionov explains the significance of the letters and numbers as "les trois roubles de Larionoff"!

Some art historians have drawn attention to Larionov's rejection of the word "futurist" as a designation for himself, his art, or his group. This argument centers on the fact that in the title of his manifesto "Rayists and Futurepeople" Larionov uses his own neologism *budushchniki* as opposed to *futuristy*. The term *budushchniki*, however, was rarely used and it seems that Larionov, from a propagandist point of view, was quite happy to be associated in name at least with his Italian counterparts. In Eganbyuri's monograph, for example, the work of both Larionov and Goncharova is at times called futurist. Some of Goncharova's paintings in her one-woman exhibitions were subtitled as futurist, and the title of the Exhibition of Paintings No. 4: Futurists, Rayists, Primitives used

Fig. 118. Mikhail Larionov,
Illustration for *Le Futur*, 1913

the word *futuristy*. Various members of the Donkey's Tail group also referred to themselves as "futurists" (*futuristy*).[48]

A more important factor which is often cited is Larionov's insulting reaction to Marinetti's visit to Russia in January 1914. Given Larionov's evident enthusiasm in his work for Italian futurism, what are we to make of this polemical dialogue, in which Larionov attacked both Marinetti and those Russians who took his side? It should be considered that for Larionov, never one to commit himself unreservedly to any one movement, futurism by late 1913 may have outlived its usefulness. It was being replaced by everythingism, which proclaimed the demise of the futurist aesthetic. Although Larionov had shared some of the aspirations, theories, stylistic devices, and sources of the futurists, he had in several respects advanced beyond their position. His articulation of

Fig. 119. Flyleaf of *Le Futur* dedicated by Larionov and
Goncharova to Marinetti

futurist theatre and cinema, his performance aesthetic, and his development of independent rayist and neo-primitive styles marked his work as essentially different from that of the Italians.

Larionov's rejection of futurism in early 1914 probably reflected his position at the time, but his public hostility and antagonism suggest that he was indulging in a futurist polemic for the purpose of promoting Marinetti's visit. There is no evidence that Larionov's attack caused any resentment on Marinetti's part and, in fact, the leader of the futurists later wrote about his visit to Moscow in his memoirs and recalled Larionov's ambivalent but ultimately accommodating behavior.[49] It was probably Marinetti who invited Larionov and Goncharova, as well as several other members of the Russian avant-garde, to contribute to the Free International Futurist Exhibition held in Rome in April and May 1914. Therefore, despite his statements to the contrary in the Russian press and in his own manifestos, Larionov remained close in spirit to the Italian futurists.

What then was his attitude to, and relationship with, the French cubists? In his manifesto "Rayist Painting" Larionov discussed cubism and its practi-

tioners at greater length than in *Luchizm*. He began with a description of its general nature and a classification of its artists:

> Cubism teaches one to expose the third dimension by means of form (but not aerial and linear perspective together with form) and to transfer forms onto the canvas the moment they are created. Of all techniques, chiaroscuro, in the main, is adopted by Cubism. . . . Cubism manifests itself in almost all existing forms—classical, academic (Metzinger), romantic (Le Fauconnier, Braque), realist (Gleizes, Léger, Goncharova)—and in forms of an abstract kind (Picasso), . . . postcubism, which is concerned with the synthesis of forms as opposed to the analytical decomposition of forms . . . and Orphism which advocates the musicality of objects—heralded by the artist Apollinaire.[50]

Larionov's account is somewhat confusing and cannot be related to any immediately identifiable writings on cubism that he may have come across. His emphasis on form and chiaroscuro may be taken from part 4 of *Du Cubisme* by Gleizes and Metzinger but the context in which the terms are used is different. Similarly, the division of cubism into four types—classical/academic, romantic, realist, and abstract—is reminiscent of Apollinaire's division of cubism into four categories in *Les Peintres Cubistes*. Larionov's categories, however, are not those of Apollinaire and cannot be related to his scientific, physical, orphic, and instinctive cubism. Larionov's analysis does reveal his understanding that cubism at this point was a diverse phenomenon, but he does not elucidate his terminology and so his categories remain ambiguous. Finally, Larionov evidently understood the fundamental difference between the analytical and synthetic stages of cubism, and he mentions Orphism, but his reference to Apollinaire as an artist is inexplicable apart from ignorance on Larionov's part.

The somewhat confusing generalizations made about cubism in the first half of Larionov's discussion are partly offset by the second half which shows a better understanding:

> Picasso, with the aim of understanding an object concretely, stuck wallpaper, newspaper clippings onto a picture, painted with sand, ground glass; made a plaster relief—modelled objects out of *papier-maché* and then painted them (some of his "violins" are painted in this manner).[51]

Here Larionov gives an accurate description of Picasso's contemporaneous work, suggesting contact

with someone who knew Picasso or had visited his studio recently, perhaps Grishchenko who had recently returned from Paris. Larionov's seeming ignorance about cubist theory at this point is at first rather surprising, but a detailed knowledge of cubism only developed in Russia during 1913, and although before this date artists such as David Burlyuk and Goncharova had discussed cubism at some length, they had done so only in a general way.

A lack of theoretical background did not prevent Larionov or Goncharova from adopting some of the more obvious stylistic devices of cubism in their own painting. One of the first Larionov borrowed from cubism was the integration of the figure into the picture space, a technique used by Braque in his *Grand Nu* (Alex Maguy Coll., Paris), exhibited in the second Golden Fleece exhibition.[52] Braque uses *passage* in the painting of the background, which creates a tightly interlocked spatial system and an ambiguity where planes merge into one another. He also follows the compositional elements of the figure into the background so that the curve of the right forearm and the left elbow are both echoed by arcs. Consequently, there is little to distinguish foreground and background, and the figure is integrated into the pattern of the picture surface.

The same techniques are employed by Larionov in *Study of a Woman* (fig. 37) and *Head of a Soldier* (fig. 120). In the latter the use of *passage* flattens the portrait and renders the background indistinct; planes merge together and the illusion of depth is destroyed. Larionov, like Braque, also follows the compositional elements of the figure into the background. A broad white arc in the top left echoes the curve of the soldier's hat, a curving broad black line in the bottom right echoes the chest, and the black outlines of the chin, mouth, and nose are continued into the background to create ambiguous planes. As in the *Grand Nu* foreground and background are indistinguishable and the figure is tightly locked into its context. The same is true of *Study of a Woman. Passage* identifies foreground and background as being one, and the thick black lines and planes that have been constructed about the woman's head serve to integrate both the portrait and its background into an overall surface pattern. Although Larionov uses *passage* and cubist methods to lock the figure into the picture space there are no cubist irregularities in his treatment of the figures themselves, which, though schematized, are presented in simple profile and full-face poses.

The planar treatment of the sky and the use of large irregular planes to construct the figure in Larionov's painting *The Beach* (fig. 121) recall Picasso's landscape *Factory at Horta* (Hermitage, St. Petersburg) and his *Dryad* (Hermitage, St. Petersburg), a monumental early cubist figure painting, both of which could be seen in the Shchukin collection. *The Beach* can also be compared to Le Fauconnier's oil study for his *Abundance* (fig. 122), exhibited at the second Jack of Diamonds exhibition in Moscow in 1912. The painting itself was reproduced in the same year in the almanac *Der Blaue Reiter*. Larionov's bather imitates *Abundance* in both subject, a large nude-figure, and in style, in its restrained color range, the ambiguity of the background in relation to the figure, the composition of the bather from flat planes and geometrical volumes, and the posture of the right arm, which is placed over the head, similar to the study for *Abundance.*

The Beach also employs some familiar cubist devices in the treatment of the figure. The head of the nude is a composite of a full-face and profile view, and various parts of the figure are observed from different viewpoints, the best example being the breasts. However, this multiple imagery is certainly not cubist and the nude's three breasts and five arms, all in different positions, owe more to futurism if the intention were to indicate a trajectory of movement. As it is, the nude remains quite static, and this suggests that Larionov's version of cubism is to paint a composite of her different poses, an interesting point, as it demonstrates a novel approach to the destruction of one-point perspective, a method not found in French cubism.

A similar approach is adopted in *Glass* (fig. 44). The large wine glass in the painting is depicted in the tradition of French cubism, with the profile view of the bowl and stem integrated with the plan view of the base. This, however is an exception in the work of Larionov who prefers to combine in one picture a series of objects painted from different positions and from different points of view. Thus, the tumblers in *Glass* are each individually seen in perspective, but taken together tilt at all sorts of odd angles. The tumblers, in turn, contradict the brown bottle which sits flat on the table, and it contradicts the green bottle balancing at forty-five degrees on its corner. None of these objects is organized in a cubist way but, taken together, they destroy the illusion of one-point perspective.

The Beach is perhaps the nearest that Larionov ever came to cubism proper, although an interesting comparison may be made between a portrait sketch by Larionov of 1912–1913 (fig. 123) and a series of portrait drawings made by Picasso in 1909, one of which

Fig. 120. Mikhail Larionov, *Head of a Soldier*, 1912

was reproduced in the catalogue of the Second Post-Impressionist Exhibition in December 1912 (fig. 124). Larionov's sketch is more schematized than the Picasso, and the background is fractured by ray-lines and planes. But those differences aside, the construction of Larionov's drawing is similar to that of Picasso's head: both are composed of strong delineating lines and broad geometrical planes, some of which are shaded and some of which are bland. In both works these planes indicate the volumes and structure of the face. An analysis of the head in terms of light and shade is a feature of Larionov's drawing. The light illuminates the brow and cheek while the eye-sockets, mouth, and far side of the face remain in shade. Light and shade also play an important role in the Picasso portrait and may explain Larionov's comment that "chiaroscuro, in the main, is adopted by cubism."[53]

Here then we see Larionov experimenting with cubist drawing as it was known to him through the reproduction of Picasso's work. Eganbyuri dates Larionov's drawing to 1911 but this is unlikely. It was probably pre-dated to imply that Larionov had practiced cubism before his contemporaries in the Jack of Diamonds group. Other drawings by Larionov such as the large nude for *Le Futur* (fig. 125) also show the

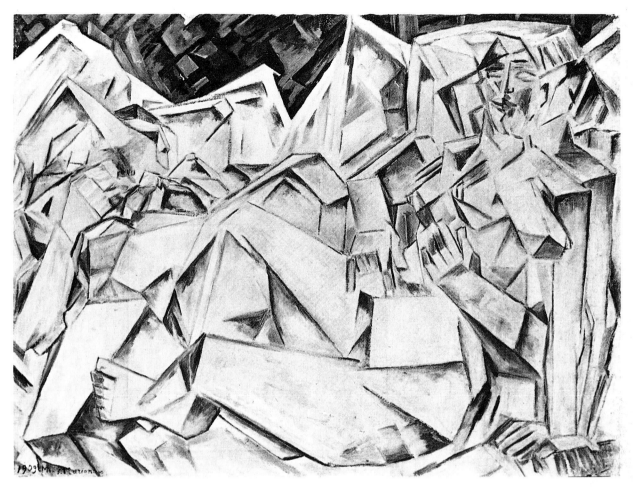

Fig. 121. Mikhail Larionov, *The Beach*, 1913

influence of cubism. In the reduction of the body to facets, planes, and volumes and the distorted relocation of limbs such as the right arm, this drawing again recalls Picasso's early cubist figure paintings in the Shchukin Collection.

The influence of Léger may be traced in Larionov's painting *Lady with Hat* (fig. 126). Here, Larionov adopts an elliptical schema for the woman's head first used by Léger in paintings such as *Woman at a Table* (fig. 127). In other respects the two works diverge: Larionov decorates his composition with grids of spots, representing the lace veil of the hat, and a complex of ray-lines; Léger divides the body of his figure into half-cylinders and other solids. The specific schema used for the head, however, clearly echoes the work of Léger, which Larionov may have seen on exhibition or in reproduction.

By 1913 Larionov also incorporated letters and numbers into his paintings in imitation of analytical cubism. Although words had already occurred in Larionov's work in the context of shop signboards and graffiti, the stencilled and typographical qualities of the letters, broken words, and numbers that Larionov

scattered across the picture plane in his drawings for *Le Futur* (fig. 61) and the *Portrait of Vladimir Tatlin* (fig. 128) were somewhat different and fulfilled a function similar to those in analytical cubist painting. In *Portrait of Valdimir Tatlin* the picture surface is laden with typographical decoration. The number "28" imitates a stencil, like the letters and numbers in Braque's painting *The Portugese* (Kunstmuseum, Bâle). Larionov even duplicates Braque's use of the word *bal* in *The Portugese*, transliterating it into black Russian letters. The significance of the numbers and letters, however, is difficult to guess. The number "28" and the letter "G" may relate to Tatlin's age (*28 goda* = 28 years), and hence the date when the picture was painted, while *BAL* in combination with the yellow suffix *DA* is the Russian for "blockhead," but whether or not this is the meaning Larionov intended is unclear. The portrait itself is, however, figurative and not cubist, apart from the fracturing across the chest which may owe something to early cubist works such as Picasso's *Portrait of Vollard* of 1910 (Pushkin Museum, Moscow) acquired by Morozov in 1913.

Fig. 122. Henri Le Fauconnier, *Study for Abundance*, 1910

Larionov's attack on the west and its art was evidently a polemical stance, for he certainly adopted aspects of futurism and cubism, and the theory and practice of both movements played an important role in the theory and development of rayism and especially of its cubo-futurist elaboration. Although Larionov used cubist devices and techniques he was more conversant with futurism and it was more important than cubism for Larionov and his group. For Malevich, who became more absorbed in cubism, this was evidently a bone of contention. By the summer of 1913 he had left the Donkey's Tail and Target group and was not represented in their almanac. He shifted his allegiance to the Union of Youth and, in a letter to Matyushin, accused Larionov of merely dabbling in cubism and suggested that his works were the weaker for it: "I feel convinced that no one in Russia has produced a pure Cubist work—all these sticks of Larionov's and others are an easy thing."[54] Livshits was similarly dismissive when he commented: "Rayism, with which Larionov tried to 'outstrip' the Italians, fitted into Boccioni's waistcoat pocket."[55]

Fig. 123. Mikhail Larionov, *Drawing*, 1912–1913

Fig. 124. Pablo Picasso, *Head*, 1909

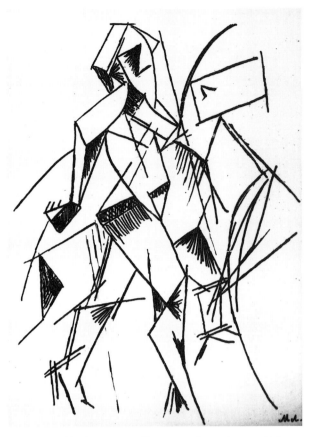

Fig. 125. Mikhail Larionov, Illustration for *Le Futur*, 1913

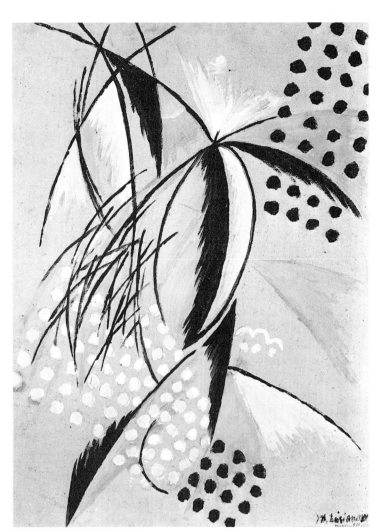

Fig. 126. Mikhail Larionov, *Lady with Hat*, 1913

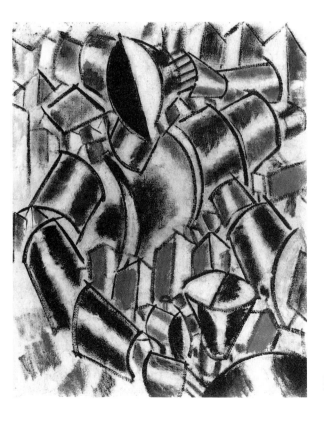

Fig. 127. Fernand Léger,
Woman at a Table, 1913

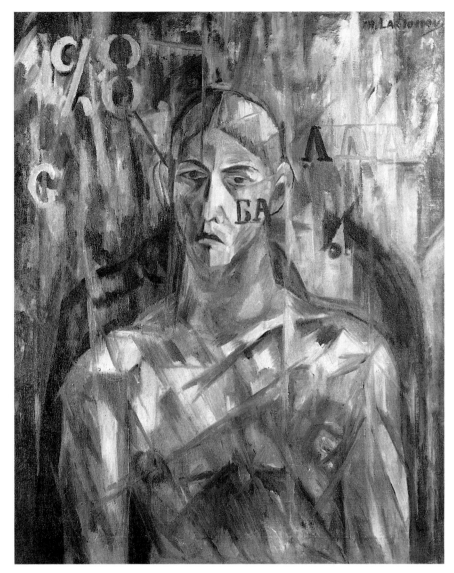

Fig. 128. Mikhail Larionov, *Portrait of Vladimir Tatlin*

It is interesting, though, to juxtapose these Russian opinions with Apollinaire's view of rayism. In an article on Larionov and Goncharova, published in *Les Soirées de Paris* in 1914, his more experienced and perhaps impartial eye saw in rayism *not* an inferior form of cubism or futurism, but an original development, capable of standing on its own as an independent movement, and yet one that was a highly individual and distinctive response to contemporary western developments and was integrally related to the cubist and futurist aesthetic:

Mikhail Larionov . . . has brought a new refinement, not only to Russian painting but to European painting as a whole: Rayism . . . Mikhail Larionov's art reveals an extremely strong personality, capable of expressing the shades of feeling and sensation he experiences with a degree of precision that makes his luminous, extremely sober, and exact art a genuine aesthetic discovery. . . . This art is in accord with the newest and most daring experiments undertaken by French artists.

These experiments show that a universal art is being created, an art in which painting, sculpture, poetry, music and even science in all its manifold aspects will be combined . . . to transform our vision of the world and to arrive, at last, at an understanding of the universe.[56]

The Modern Prometheus: Ouspensky's Four-Dimensional Superman

In 1949 Paul Laporte suggested a causal relationship between avant-garde science and art in the early twentieth century. He argued that references to "the fourth dimension" and "non-Euclidean geometry" in the literature of the French cubists indicated their interest in the relativity theories of Einstein and Minkowski.[1] Since then Linda D. Henderson (1971 and 1983) has challenged the idea that relativity theory had any influence upon cubism. She argues that Einstein's *Special Theory of Relativity* (1905) did not refer to either the fourth dimension or non-Euclidean geometry and that although Minkowski conceived of time as the fourth dimension in his *Space-Time Continuum* (1908), his space was free from non-Euclidean curvature. The two concepts were only combined in Einstein's *General Theory of Relativity* (1916) but even then the discussion of the theories of Einstein and Minkowski was virtually restricted to scientific circles. In fact the Theory of Relativity was only popularized after Einstein's theories were proved by the bending of light-rays during the eclipse of May 1919. The impact of this event was especially evident at the time in the work of artists such as Rodchenko, who dealt with the subject in his nonobjective compositions of 1919 and 1920. Henderson concludes, "Clearly, the mistake of art historians anxious to explain references to the fourth dimension and non-Euclidean geometry has been to read back into Cubist writings of 1911 and 1912 a breakthrough in physics which was not published until 1916."[2]

Having dismissed relativity theory, Henderson looks for the meaning of the term "the fourth dimension" in the work of Charles Howard Hinton (1853–1907), an English mathematics teacher working in America, who published popular books and pamphlets on the subject. Unlike our current understanding of the fourth dimension as time, Hinton wrote about a fourth dimension of space, which he assumed to be at right angles to each of our three mutually perpendicular dimensions. Henderson notes that the interpretation of the fourth dimension as an extra dimension of space was widespread in the late nineteenth and early twentieth centuries and found expression in literary forms ranging from scholarly and scientific expositions in books and periodicals to popular treatments of the subject in science fiction, popular philosophy, and even spiritualist and theosophist writings.[3] As references to the fourth dimension occur in all four of Larionov's rayist manifestos, a case clearly exists for investigating the relationship between these theories and Larionov's art.

Charles Howard Hinton was the most important theoretician of the fourth dimension. In his two most influential works, *A New Era of Thought* (1888) and *The Fourth Dimension* (1904), Hinton discussed the essential notions used in conceiving the fourth dimension and, by simple analogy, described the nature of four-dimensional space. For example, by analyzing the properties of a square, bounded on all four sides by one-dimensional lines, and a cube bounded on all six sides by two-dimensional planes, Hinton was able to describe the simplest four-dimensional solid, known as a "hypercube" or "tesseract," as being bounded on all eight sides by three-dimensional cubes. However, his attempt to educate the reader's "space sense" so as to perceive the mechanics of four-dimensional space was more complex and involved reconstructing in the mind's eye the various multi-colored three-dimensional cubic sections of a "tesseract" as it passes perpendicularly through our three-dimensional space.

Hinton's study of the fourth dimension as a mathematical concept led him to consider its effect on human life and Henderson describes this aspect of his work as "hyperspace philosophy." Hinton argued that we must be four-dimensional beings—otherwise

we would be unable to conceive a fourth dimension—and he suggested that our consciousness is trapped within three dimensions so that we can only perceive a three-dimensional section of our four-dimensional selves. Thus, in Hinton's system, the three-dimensional world is one of appearances alone and may no longer be considered as ultimately real. In America Hinton's work formed the foundation for much discussion on the fourth dimension. The subject became so popular that in 1909 *Scientific American* organized an essay contest for the best popular explanation of the term. The contest attracted a worldwide response, and Claude Bragdon, one of the winning participants, later published a theosophical view of the fourth dimension in *Man the Square* (1912) and *A Primer of Higher Space* (1913).

The work of both Hinton and Bragdon had an important effect on the Russian philosopher Petr Demyanovich Ouspensky (1878–1947). By profession a writer in St. Petersburg, Ouspensky was an esoteric mystic "in search of the miraculous."[4] He had travelled widely in the east but returned home in 1909 to publish *Chetvertoe izmerenie* (*The Fourth Dimension*). After this Ouspensky wrote his famous philosophical work *Tertium Organum* and his essay "Superman" which were published in 1911 and 1912, respectively. He then embarked on another trip to the east, hoping to find a guru to tutor him. After returning to Moscow in 1915 he met "the miraculous" in the person of Georgy Ivanovich Gurdzhiev (1877–1949), whom he followed until 1924.

In *Chetvertoe izmerenie* Ouspensky briefly discusses the work of Hinton before stating his own ideas, such as symmetry in nature being an evidence of the fourth dimension. *Tertium Organum*, however, breaks new ground in Ouspensky's thought. The book adopts as its philosophical basis Hinton's belief that we are four-dimensional beings, our consciousness trapped in three dimensions. *Tertium Organum* states that an expansion of our consciousness into the fourth dimension is possible by cultivating intuition, which is the "fourth unit of psychic life." Only by developing our consciousness in this way can we experience our true four-dimensional reality and understand the present enigmas of the three-dimensional world and its phenomena: space, time, matter, and motion. Ouspensky equates this four-dimensional state of consciousness with Dr. R. M. Bucke's "cosmic consciousness."[5] In Ouspensky's system our phenomenal world is merely a three-dimensional section of the noumenal world of four dimensions, where our true existence is located.

The transition from three-dimensional consciousness to four-dimensional "cosmic consciousness" is the achievement, Ouspensky tells us, of a "superman," the subject of his essay, where he sets out the necessary stages of development of the will, emotions, and intellect before "cosmic consciousness" can be attained. Ouspensky warns, however, that on expansion of the consciousness we will "sense a precipice, an abyss everywhere . . . and experience indeed an incredible horror, fear, and sadness, until this fear and sadness shall transform themselves into the joy of the sensing of a new reality."[6] To prepare for this new order of things in the fourth dimension, where phenomena and spatial relationships are significantly different from our three-dimensional world, we must learn a third canon of thought, a new system of logic that expresses the nature of the four-dimensional reality: " 'A' is both 'A' and not 'A.' Everything is both 'A' and not 'A.' Everything is all."[7]

Despite the barriers of geography and language, Hinton's *The Fourth Dimension* and Bragdon's *Man the Square* had reached Russia shortly after their publication. Ouspensky's books were on sale as early as 1909 and were available in the Russian public libraries, and popular scientific works in Russian on the same subject were readily available.[8] The concept of the fourth dimension must have appealed to Larionov in several ways. First, it represented an interesting and available nexus of ideas concerning the nature of life, which Larionov had declared he would reorganize through the medium of his art.[9] Second, Ouspensky had assigned a significant role to the artist. Flashes of "cosmic consciousness," Ouspensky declared, are experienced by both artists and mystics, and should be cultivated as the first step in the apprehension of the fourth dimension: "Art anticipates a psychic evolution and divines its future forms."[10] Most important, the concept of the fourth dimension was of general interest to the artistic avant-garde of the time and is referred to by Apollinaire, Boccioni, Duchamp, Metzinger, and Weber.[11] Several Russian artists explored the idea in some depth. As early as 1910 Nikolai Kulbin had referred to the subject in a public lecture in St. Petersburg, and as late as 1915 Malevich referred to the fourth dimension in the titles of his paintings exhibited at the "0.10" exhibition in Moscow.[12]

It is more than likely that Larionov came across the idea of the fourth dimension through his contact with Mikhail Matyushin at the Union of Youth. Matyushin had copies of Hinton's books in his library and, during the winter of 1912–1913, wrote an unpublished manuscript "The Sensation of the Fourth Dimension."[13] We also know from an undated letter

to Spandikov that Matyushin was interested in the question of "cosmic consciousness" as he refers to the work of M. V. Lodyzhensky.[14] In addition, Matyushin published a review of *Du Cubisme* by Gleizes and Metzinger in the third edition of the Union of Youth almanac, in which he implied the four-dimensional and mystical nature of French cubism by juxtaposing portions of *Du Cubisme* and quotations from *Tertium Organum*. The concept of the fourth dimension evidently had a wide circulation at the time and many were conversant with Matyushin's work on the subject. Livshits, for example, remarked, "The predominance of the irrational moment in creativity—which derived from the original conception of Gleizes and Metzinger—had something in common with Hinton's doctrine of the fourth dimension (as Matyushin perceived correctly)."[15]

It is therefore no surprise to find direct reference to the term "the fourth dimension" in Larionov's manifestos, which make clear its central role in the theory of rayist painting. In *Luchizm* of April 1913 Larionov writes, "The picture appears slippery, it imparts a sensation of the extratemporal and the spatial—in it arises the sensation of what could be called the fourth dimension, since the length, breadth, and density of the paint-layer are the only signs of our surrounding world. All the sensations arising from the picture are of a different order."[16] Larionov repeats himself in his two succeeding manifestos "Rayists and Future-people" and "Rayist Painting." Only in "Le Rayonnisme Pictural," published in the Parisian *Montjoie!* in 1914, is the wording slightly but significantly altered:

> In rayist painting the intrinsic life and continuum of the colored masses form a synthesis image in the mind of the spectator, which slips outside of time and space. One glimpses the famous fourth dimension—since its length, its breadth, and the density of the superposition of its colors are the only signs of the visible world—and all the other sensations born from an image are of another order."[17]

According to Larionov, the rayist painter captures on canvas the "intangible forms" and "immaterial objects" which are created by the intersection of reflected rays from two or more physical objects. Larionov notes that the whole of space is filled with such peculiar creations but that they may only be perceived and isolated for painting by the artist's will. In theory at least rayism is concerned with the depiction of these intangible spatial forms, and in "realis-

tic rayism" the representation of objects are only a means to this end. The reflected rays that delineate the spatial forms are depicted by colored lines, while the spatial forms themselves are rendered by textured colored masses. Colored line and texture are the two fundamental, purely painterly laws according to which rayist painting exists and develops, and a picture, Larionov tells us, consists only of these two things and the sensation that arises from them—that is "the sensation of the fourth dimension."

Before discussing the four-dimensional sensation of rayist paintings, several analogies may be drawn between Larionov's method of constructing "intangible forms" and "immaterial objects" in space from the reflected rays of objects, and Hinton's technique of generating four-dimensional "hypersolids" from three-dimensional forms. Hinton noted, "From every point of a cube interior as well as exterior, we must imagine that it is possible to draw a line in the unknown direction. The assemblage of these lines would create a higher solid."[18] Hinton draws lines from his three-dimensional solids and so, too, does Larionov. Rays are depicted on the canvas by colored lines and they are never painted as emanating from a light source, only as they are reflected from the object. In *Glass* (fig. 44), for example, the bottles, tumblers, wine glass, and table top project reflected ray-lines from their surfaces. The assemblage of Hinton's lines constitutes a "hypersolid" just as the sum of Larionov's reflected ray-lines constitute "immaterial objects" and "intangible forms in space" (cf. *Rayist Construction of a Street*, (fig. 57), and *Sea Beach and Woman (Pneumo-Rayism)* (pl. 15). Then, just as Hinton uses a three-dimensional cube to generate a "hypercube" or tesseract, so Larionov and Goncharova use three-dimensional objects to obtain "intangible forms in space." Even when the painting is pneumo-rayist, the departure point in the third dimension is usually given in the title—for example, Larionov's *Sea Beach and Woman (Pneumo-Rayism)* or Goncharova's: *Cats: Rayist Perception in Rose, Black and Yellow* (Guggenheim Museum, New York). Furthermore, as Hinton advocated study of the tesseract so that we might perceive the workings of four-dimensional space, Larionov moved from "realistic rayism" to "pneumo-rayism" as a result of educating his own "space sense" to perceive the spatial forms, first, by observing how three-dimensional objects radiate them, and then by direct perception. Thus the methods of the fourth-dimension theorist and the rayist painter are analogous.

It might be argued that rayism has more to do with optics and the nature of light than it does with the

fourth dimension, and in early rayist theory of 1913 this is true. Larionov stated that rayism proceeded from "the doctrine of luminosity"; he referred to ultraviolet rays and made it clear that rays proceed from a light source before being reflected. In his 1914 manifesto "Le Rayonnisme Pictural," however, there is no mention of light, luminosity, or light-rays, and the ray-line has taken on a totally different character. Here rayism is "the dramatic representation of the struggle of the plastic emanations radiating from all things: the painting of space revealed, neither by the contour of objects nor even by their formal coloring, but by the ceaseless and intense drama of the rays that constitute their unity."[19] Reflected rays of light have now become "plastic emanations" (*émanations plastiques*) which the object itself radiates, without the need of a light source. A few lines later this is reinforced when Larionov comments that new spatial forms will be created between tangible objects "by their own radiation" (*par leur propre rayonnement*). He states that rayism is "the painting of space" (*la peinture de l'espace*), not of light as we might expect, and "the unity" of things is constituted by the drama of their ray-lines, as if objects in our space are three-dimensional fragments of a four-dimensional unity, the relationship between them being indicated by the ray-lines.

The fact is that the aim of both the fourth-dimension theorist and the rayist painter are the same—to glimpse the famous fourth dimension. In the rayist manifestos Larionov argued that a sensation of the fourth dimension is evoked as rayist paintings appeared "slippery" and difficult to penetrate, creating a sensation outside of our experience of time and three-dimensional space. The lines and colored masses create a "synthesis image" in the mind of the spectator, comparable perhaps to Hinton's tesseract exercises which create a synthesis image of a four-dimensional-space form in the mind of the reader.

In practice pneumo-rayist works such as Larionov's *Red and Blue Rayism* (pl. 16) are difficult to read. The colored masses are in movement, while the ray-lines create planes that shift and change violently. We are left with a feeling of confusion; there is no object by which we can locate ourselves in relation to what we see, and from which we can impose our knowledge of three-dimensional space upon the picture space. It is as if we experience a flash of "cosmic consciousness" like Ouspensky's supermen as they behold the four-dimensional vista, bewildered and afraid because their canon of logical thought cannot impose order on what they perceive. Similarly, with pneumo-rayism we are plunged into a world where spatial forms appear, slide by, and are subsumed in other forms. No

form can be isolated by which we can judge others. The interpenetrating ray-lines and planes weave in and out of the complex picture space with the result that the painting appears to be in total flux.

Larionov is right: the picture is "slippery," it imparts a sensation that is spatial and yet does not conform to our "space sense."[20] The sensation is certainly extra-temporal. Unlike the fresh and vibrant fruit in the still lifes of Matisse, the young or middle-aged art dealers in the cubist portraits (Vollard and Kahnweiler), or the apocalyptic scenes of Kandinsky's *Compositions*, Larionov's pneumo-rayist works transcend any reference to time. Indeed, Ouspensky in *Tertium Organum* asserted that time as we know it was nonexistent in the fourth dimension, since time is only the incorrect sensation of four-dimensional motion upon our three-dimensional space. Consequently in four dimensions, "Moments of different epochs, divided by great intervals of time, exist simultaneously, and may touch one another."[21] In passing we may note that this concept had an obvious bearing on the development of everythingism, in which Larionov intersected his own time with epochs of the past. To support this view we need only cite Livshits who declares, "Essentially, 'everythingism' was extremely simple: all ages and movements in art were declared equal. Each of them served as a source of inspiration for the everythingists who had conquered time and space."[22]

If, as Larionov says in all four manifestos, the length and breadth of the painting, along with the density of the paint, are the only signs of the world as we view the painting in three dimensions then, by implication, the spatial forms that are the subject of these paintings refer to the fourth dimension. Moreover, he states that the "synthesis image" which the rays evoke is beyond time and space. As an abstract expression of the objective three-dimensional world, this "synthesis image" encompasses what Larionov also calls "the most complete reality of the object" and has clear analogies with the four-dimensional "synthesis image" obtained by meditating on Hinton's tesseract. Larionov further says that the sensations evoked by the creation of these new forms in space are of a different order than the three-dimensional order we know. Pneumo-rayism, then, recreates in painterly form the sensation of the fourth dimension, "that super-real order that mankind must always seek."[23] Paintings by Goncharova such as *Blue and Green Forest* (fig. 129) may also be interpreted in this light, especially as Ouspensky had discussed the forest as an example of the fourth state of life activity.[24]

For Ouspensky "inner unity" and cultivation of

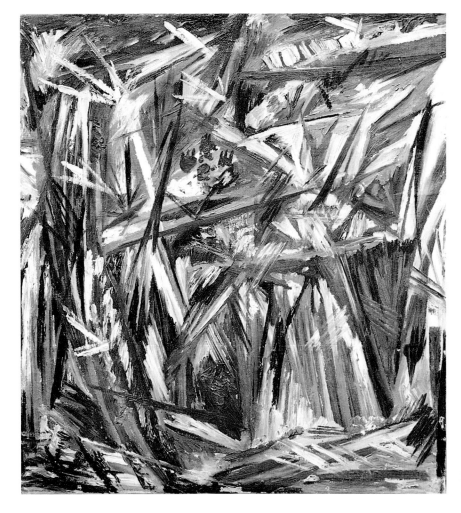

Fig. 129. Nataliya Goncharova:
Blue and Green Forest, 1913–14

the will were the first steps towards developing the consciousness so as to perceive the fourth dimension, and in this light some of Larionov's comments in *Luchizm* take on a deeper meaning. When Larionov said that the spatial forms depicted in rayist paintings could only be perceived and chosen by the artist, he was evidently following Ouspensky's direction in *Tertium Organum:* "The artist must be a clairvoyant: he must see that which others do not see; he must be a magician: must possess the power to make others see that which they themselves do not see but which he does see."[25] Here Ouspensky refers to four-dimensional vision, for in fourth-dimension theory only by using an extra dimension of space can one see that which others cannot. Indeed, Claude Bragdon (1913, pl. 19) specifically argued that just as three-dimensional vision could see beyond the boundaries of a two-dimensional plane, i.e., observe its surface, so four-dimensional vision could penetrate the boundaries of a three-dimensional solid and reveal its inner volume. Thus the nature of vision would be fundamentally altered by four dimensions of space and the three-dimensional world could be rendered transparent. Ouspensky attributes to the artist this clairvoyant sight: what the artist sees and we do not must be interpreted for us on canvas.

The fourth-dimension theory of transparency offers at least a remarkable parallel with Larionov's and Goncharova's use of transparent effects in their paintings. In fact Ivan Firsov, a Muscovite painter with whom Larionov and Goncharova collaborated, had by this time developed his own theory of transparency and, although his theory does not appear to have survived in written form, its influence can be noted in a number of Goncharova's works.[26] The last item in Eganbyuri's list of Goncharova's paintings is referred to as a *Construction Based on Transparency: Theory of I. Firsov* and four paintings with the same title were shown in her one-woman exhibition in Moscow. More recently Mary Chamot has suggested that Goncharova's *Still Life with Bottle, Jar of Fruit and Fish* (fig. 130) is painted according to this theory because

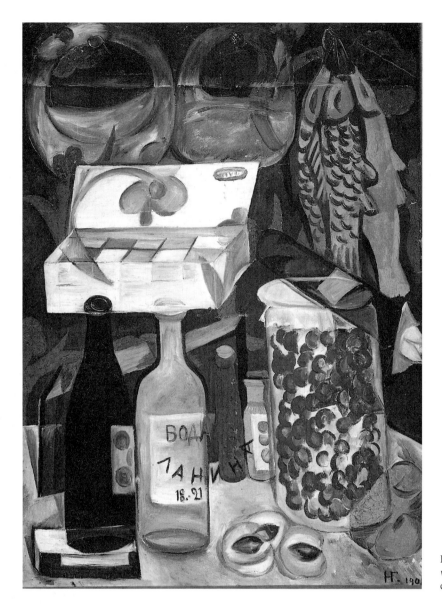

Fig. 130. Nataliya Goncharova, *Still Life with Bottle, Jar of Fruit, and Fish*, c. 1912–1913

an inscription on the reverse refers to transparency. Objects in the painting are rendered transparent and we can see the stones of the apricots through their flesh.

Larionov never directly attributed any of his works to Firsov's theory. However, both artists were involved in the production of the futurist book *Le Futur*, and one of Larionov's illustrations to the book (fig. 117), the first to feature transparent effects, may have been made under Firsov's influence. In the lithograph we clearly see the underwear of the ladies on the left and right. Still, this is not visual penetration into someone's very interior, which Bragdon and other theorists believed possible from the fourth dimension. For an illustration of this phenomenon we must look at Larionov's *Boulevard Venus* (pl. 14),

where again the figure's underwear can be observed, but more significantly the bone of her left leg as she lifts it out of the right-hand side of the picture is clearly depicted.

Larionov and Goncharova were clairvoyants in Ouspensky's sense of the word and painted not only the intangible forms of four-dimensional space but also our transparent and illusionary three-dimensional world as seen from the fourth dimension. In his manifestos Larionov explained that the human eye was an imperfect apparatus as the images it transmits to the brain have to be corrected by the other senses.[27] Thus Larionov and Goncharova acquired the attributes of four-dimensional sight in order to paint those things we cannot see, but which Larionov assures us "the painter's eye can see."[28] One suspects that modern

science and the study of X-ray photography contributed substantially to this particular development in their work. X-rays produce the four-dimensional effect of transparency and this partly accounts for the relationship between the fourth dimension and the radioactive and ultraviolet rays in the 1913 rayist manifestos.

Larionov and Goncharova followed other of Ouspensky's prescriptions for becoming supermen conscious of four dimensions. Ouspensky emphasized that the feelings and emotions of the superman should exceed those of ordinary humans, as intellectual development into a higher dimension had to be accompanied by a comparable emotional development. Larionov spoke for them both when he said, "More than anything else we value intensity of feeling, and its great sense of uplifting."[29]

Ouspensky also noted that the superman should be connected with the mysterious, the inexplicable, and the magical. Larionov and Goncharova certainly cultivated a mystique around themselves. Diaghilev and Fokine were inexplicably introduced to their paintings in a room lit only by candles. The strange designs they painted on their faces were described by the contemporary press as "cabalistic"[30] and the artists themselves referred to their painted faces as "the first speech to find unknown truths."[31] Again this idea seems to be taken from Ouspensky who connected the concept of the superman with the theosophical belief in the discovery of hidden knowledge. For Larionov and Goncharova the unknown truth, the hidden knowledge, was probably the revelation of the fourth dimension, for they stated, "We paint ourselves because a clean face is offensive, because we want to herald the unknown, to rearrange life, and to bear man's multiple soul to the upper reaches of reality."[32] The rearrangement of life had been Ouspensky's plea in *Tertium Organum*, a plea for a new logic, for a higher, four-dimensional existence.

It seems reasonable to suggest on the above evidence that a causal relationship may exist between the development of rayism and popular ideas of the fourth spatial dimension with their mystical and philosophical elaboration by Ouspensky. Between 1912 and 1914 such ideas were important for the two artists in developing and explaining their new style of nonobjective painting. However, to suggest that Larionov and Goncharova took these ideas *per se* very seriously would be wrong. The two artists used such ideas only in association with their art and even then sometimes with great frivolity. Witness Larionov's use of transparency theory to indulge his bawdy Rabelaisian humor in painting underwear.

Other members of Larionov's group, however, were later close to Ouspensky and his tutor Gurdzhiev. The brothers Ilya and Kirill Zdanevich, for example, met them in Tiflis during 1919–1920. Ilya corresponded with Gurdzhiev and wrote an article about him in July 1919 for the avant-garde newspaper *41 Degrees*. Kirill drew and painted portraits of Gurdzhiev (fig. 131) and during early 1920 was a member of Gurdzhiev's Institute for the Harmonious Development of Man in Tiflis. His membership card still exists to testify to the fact (fig. 132).

This is an interesting development, considering the close relationship between Larionov and the Zdanevich brothers in the early 1920s. At present it is unknown whether Larionov ever met Ouspensky or Gurdzhiev, either in Russia, or in France where they moved in 1922. However, Larionov maintained his interest in the fourth dimension and the Ouspenskian superman at least until the early 1920s when he still fostered an esoteric explanation of rayism. He must have discussed this aspect of rayism at some length with W. A. Propert, the historian of the *Ballets Russes*, who in 1921 commented:

> The Cubist will leave you an odd feature here and there by which you can identify a face. The rayonist will have none of that. His is a new world where the mysterious fourth dimension crops up, to the upsetting of the other three. . . . It is a stimulating thought that a new world awaits us if we but train our eyes to see it; though possibly a rayonist like a medium is born and not made. However that may be, we must be grateful to this pair of visionaries for the many things of beauty (on the lower plane) that they have set before our untrained eyes, and await patiently and cheerfully for the day when we too shall be counted among the illuminati.[33]

It is important to indicate, however, that Larionov's interest in pseudo-science was balanced by an interest in contemporary discoveries in the scientific field proper. His use of X-ray effects has already been discussed, but perhaps the most important influence on rayist theory and practice in this respect was the discovery of radium and radioactive rays. In this Larionov shared an interest with the Italian futurists, who in 1912 referred to "the vivifying current of science," and more particularly with the poet Vasily Kamensky who in an unpublished manuscript of 1914 declared, "Our energy is the energy of Radium. . . . Our principal = the dazzling renewal of scientific discoveries."[34] Larionov's reference to radioactive rays as one of the tenets of rayism in both *Luchizm* of April 1913 and "Rayist Painting" of July 1913 reflects

Fig. 132. Membership card of Kirill Zdanevich for the Tiflis branch of Gurdzhiev's *Institute for the Harmonious Development of Man*, 1920

Fig. 131. Kirill Zdanevich, *Portrait of Gurdzhiev*

his knowledge of the discoveries and experiments of Madame Curie. In fact Madame Curie's writings *Radioactivity* and *The Discovery of Radium* were first translated into Russian at this time.[35]

These works described how radioactive rays or particles were emitted by certain substances, the most active of which was radium, which Madame Curie had produced in its pure state by 1910. Knowledge of radioactivity may well account for Larionov's changing concept of the ray-line from its description as a refracted ray of light in the manifesto *Luchizm* of 1913 to its portrayal as a "plastic emanation radiating from all things" in "Le Rayonnisme Pictural" of 1914. Indeed all objects show a weak radioactivity caused by the presence of small amounts of radioactive elements in their composition, and Larionov specifically refers to this when in the 1914 manifesto he comments, "The painter sees new forms created between tangible forms by their own radiation, and these new forms are the only ones that he places on his canvas."[36] An interest in, and study of, radioactivity on Larionov's part necessitated a wider knowledge about radiation and the different ways in which rays travel. There are two types of radiation, electromagnetic and corpuscular. Wireless waves, infrared rays, visible light-rays, ultraviolet rays, X-rays, and gamma rays are all electromagnetic radiations, having no solidity and travelling in waves at the speed of light. Cathode rays, positive rays, molecular rays, and alpha and beta rays, on the other hand, are radiations consisting of streams of tiny particles moving in the same direction at velocities ranging from zero to nearly the speed of light.

Throughout his manifesto *Luchizm*, Larionov continually referred to electromagnetic rays, first, by talking about visible light-rays which proceed from a light source, are reflected from the object, and enter our field of vision, and second, by referring to ultraviolet rays as being one of the tenets of rayism. His interest in X-rays and X-ray photography also falls into the field of electromagnetic radiation. Although Larionov was up-to-date on radioactivity he appears less well informed about the ways in which electromagnetic rays travelled. For example, in *Luchizm* he comments, "Luminosity owes its existence to reflected light (between objects in space this forms a kind of colored dust)."[37] Here he seems to be referring to the ether theory, and in particular to luminous ether, the medium that was believed to transmit electromagnetic rays and light-rays. During the nineteenth century most authorities believed in the existence of ether, a medium that permeated space and transmitted gravitational, electric, and magnetic forces, even light-rays. By 1912 the ether theory had been scientifically discredited, yet still found its way into the rayist manifestos.

Larionov may also have been interested in the way corpuscular radiations, such as alpha and beta rays, travelled. At this time it was possible to render visi-

Fig. 133. Wilson Cloud Chamber, 1912

Fig. 134. Tracks of Alpha particles in the Wilson Cloud Chamber

ble the actual movements or tracks of such rays by using an apparatus known as the Wilson cloud chamber invented in 1894–1895. The cloud chamber (fig. 133) comprises a metal cylinder with a glass top, containing air saturated with moisture, through which a powerful beam of light is directed. A small quantity of radium is placed inside the cylinder and a hand pump is used to compress the air inside. When the pump is released suddenly, the air cools and becomes supersaturated with moisture. At this point alpha and beta rays, which are emitted by the radium, ionize the atoms into a line of droplets that reflect the light-rays from the light source and so make visible the path or track of the ray, which can be observed through the glass top. If the particles of the rays hit an atomic nucleus, they split in two and follow different paths. The visual effect of these rays in a cloud chamber is rather striking and by 1912 photographs were being made of such cloud chamber experiments (fig. 134).

The ray-lines in *Rayist Construction of a Street* (fig. 57) bear an interesting resemblance to the tracings of the paths of rays that are emitted and made visible in a cloud chamber, particularly the way in which Larionov's long and thin ray-lines vary in density and come to an abrupt end. Often in cloud chamber photographs, spirals appear, as well as other phe-

Fig. 135. Nataliya Goncharova, *The Electric Machine*, 1913

nomena which record themselves on the photograph, creating a grained effect. These features are similar to those found in *Rayist Construction of a Street*. Furthermore, Goncharova's painting *The Electric Machine* (fig. 135) testifies to an interest in the apparatus of physics. In fact, the painting may be seen to incorporate the essential elements of a cloud chamber: a source of electricity and light, two hand pumps, and to the left of center, a cylinder, rendered transparent to reveal some kind of raylike activity in its base.

Throughout his life Larionov remained interested in science, and in addition to Italo Tonta's book of X-ray photographs, which was in his library, other publications that he collected contained interesting articles on the development of science at the turn of

the century.[38] Given such a broad interest, it would not be surprising if Larionov knew of a major breakthrough in the science of crystallography in 1912, just when he was developing the theory of rayism. In that year Max von Laue discovered how to penetrate the inner structure of crystals by projecting a narrow beam of X-rays onto a crystal and then photographing the defraction of the rays, which form a pattern of spots on the plate.

This discovery had no direct effect on Larionov's work but may have turned his attention to the beautiful patterns created by conventional close-up photographs of crystals, composed of intersecting lines and splinters similar to pneumo-rayist works. Although no firm evidence exists to support such a conjecture,

the relationship between rayism and crystallography has been discussed by John Milner who cites Nikolai Kulbin's fascinating statement:

> In the crystal lies the very greatest symmetry, the utmost regularity of position. The salt crystal, a cube, is but one example of the great harmony. In it all surfaces, edges, and angles are equal; all of its relations are exact. . . . It is difficult, very difficult to read spontaneously the hieroglyphics of life or the structure of the crystal.[39]

Milner continues by describing Larionov's *Portrait of Vladimir Tatlin* (fig. 128) in terms of "crystalline cross-hatching," "crystalline structure," and "crystalline form." An analogy between rayism and the external structure of crystals also inspired Gumilev when he wrote his poem *Goncharova i Larionov* in 1917, in which he referred to "shafts of light and piles of stones."

As with his study of the fourth dimension, Larionov's interest in contemporary science did not end with the beginning of the First World War. As late as 1919 Valentin Parnack dedicated his poem *Rady (Radium)* to Larionov and Goncharova and used it as the introduction to their folio of theatrical prints, *Art Théâtral*. The poem was a paean to the power of radium:

> A single gramme of radium will explode the whole terrestial globe; progeny of planetary forces! To the worlds it carries an unremitting blow! Whirling around the joyous pill will pierce the world to its very axis . . . rasing to the ground ante-diluvian volcanoes. The universe is out of breath . . . no taxi-meter ticked as fast . . . for new ideas, unprecedented music, impossible dances, Radium, enraptures you.[40]

When the poem was republished in *Motdinamo/Slovodvig* (1920) it was accompanied by two strange illustrations by Larionov—one depicting a shoulder and breast surmounted by a construction of ray-lines (a reference to the use of radium in medicine?) and another, a portrait in profile (fig. 136), which bears a striking resemblance to portrait photographs of Madame Curie. In fact the theme of medicine and modern medical apparatus recurs throughout the book, particularly in the poem *Zabastovka vrachov (The Doctors' Strike)*.

The new physical world beyond the range of the human eye, revealed by the latest developments in contemporary science, and the intriguing philosophical and spiritual world postulated by the latest

Fig. 136. Mikhail Larionov, Illustration for the poem *Radium* in *Motdinamo*, 1920

pseudo-science, both of which characterized "the whole brilliant style of modern times . . . a great epoch, one that has known no equal in the entire history of the world,"[41] acted as fruitful sources for Larionov in the decade 1912–1922. Not only did they inspire the theory and style of rayism but they also provided philosophical justification for Larionov's revolutionary abstract and nonobjective works. More than this, however, the striking parallel between Ouspensky's intensely emotional superman, in search of higher dimensions, and a nervous and emotional Buryat Shaman, in search of higher spiritual realms, must have fascinated Larionov. For Larionov saw himself as one of "the primitives of a new sensitiveness"[42] and the shaman of the avant-garde. His aim was to "herald the unknown, to rearrange life" and, acting as mankind's aesthetic psychopomp, "to bear man's multiple soul to the upper reaches of reality."[43]

CHAPTER NINE

Towards an Avant-Garde Theatre

1914–1917

■

On 20 April 1914 Larionov and Goncharova left Russia for Paris to supervise the rehearsals for *Le Coq d'Or* and to complete work on the décor.[1] *En route* they visited Rome where, according to Giuseppe Sprovieri, their works were exhibited at the International Exhibition of Free Futurists in Sprovieri's Galleria Futurista during April and May. The exhibition was important in that it brought together the work of Italian, Russian, English, Belgian, and North American artists, who either considered themselves to be futurists, or whose work was close to futurism. The Russians were the largest foreign group represented and included Archipenko, Vladimir Burlyuk, Exter, Kandinsky, Kulbin, and Rozanova.[2]

While in Rome, Larionov and Goncharova were part of the Russian art circle led by Olga Resnevich-Signorelli, with whom they formed a close friendship. This circle included Eva Kuhn, Raissa Olkienskaya-Naldi, and Mikhail Semenov, one of Diaghilev's friends.[3] Larionov also organized a conference on the relationship between rayism and futurism to clarify his position with regard to the Italians. Giuseppe Sprovieri recalls:

Larionov explained that the definition of "futurism" was much too wide to be limited to one specific movement alone. He found himself in the midst of a world-wide phenomenon of changing artistic sensibility. Everything he observed was pointing towards the future, was rejecting the shackles of the past, and logically deserved the name of "Futurism." In Russia it had been adopted independently of its success in Italy, but in every country this general renewal was displaying its own individual characteristics. In Russia, rayism, founded by Larionov himself, when compared with various analogous movements around the world, found the closest affinity specifically with Italian futurism.[4]

Goncharova also participated in the conference, stating that although theoretical formulas were different,

there was a close affinity in spirit and stylistic expression among the international avant-garde. She concluded that proclaiming oneself to be a futurist was both an honor and a means of receiving attention.

Following their visit Larionov and Goncharova travelled to Paris, where their reputations had preceded them as a result of Diaghilev's publicity campaign for *Le Coq d'Or*. A forthcoming exhibition of their paintings at the Galerie Paul Guillaume also aroused considerable interest. The two artists were met in Paris by Diaghilev and the writer Michel Georges-Michel. Initially they stayed in the Hôtel Helder, one block away from the Opéra, and each day Larionov and Goncharova worked there, painting the décor for *Le Coq d'Or*.[5] Mikhail Fokine, the choreographer, later commented, "It was very touching to observe how she, together with Larionov, painted by hand the entire assortment of stage props. Each object on the stage was a masterpiece. Now, seeing the enthusiasm of these two artists, I could not recall without amusement my fears about the flying pitchers."[6]

This was Larionov's introduction to the *Ballets Russes* and here for the first time he came to know the composers Stravinsky and Tcherepnine, and the choreographers and dancers Fokine, Boris Romanov, Karsavina, Massine, and Adolph Bolm. Larionov also renewed his friendship with Diaghilev, Bakst, and Benois. The latter was responsible for the novel arrangement of *Le Coq d'Or*, which was conceived as an "opera-ballet" in which a choir sang the libretto from the wings of the stage while the dancers performed. *Le Coq d'Or* was given at the Opéra on May 24 and was enormously successful.[7] Goncharova's colorful scenery and costumes, based on Russian folk art (fig. 137), and the music of Rimsky-Korsakov drew large crowds and, according to Lifar, saved the season.

Larionov and Goncharova often collaborated on the designs for ballets and, although the majority of designs for *Le Coq d'Or* were by Goncharova, Larionov's first identifiable designs for the theatre are

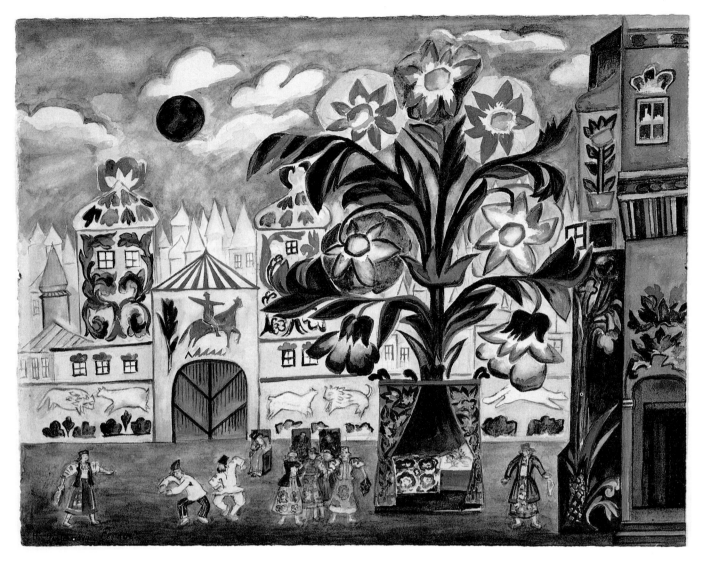

Fig. 137. Nataliya Goncharova, Set design for *Le Coq d'Or*, 1913–1914

some drawings that he made for this production. One of these (fig. 138) is a transcription from a Russian carved panel depicting a peacock and traditional ornamentation which indicates a neo-primitive approach to the design of the opera-ballet. Even though the most obvious style for a tale set in medieval Russia, the neo-primitive costumes and décor for *Le Coq d'Or* contrast with the work of Russian colleagues like Malevich, who had adopted cubo-futurism in his designs for the opera *Pobeda nad solntsem* (*Victory over the Sun*) as well as a rayist play of lights. Although Larionov had considered the application of rayism in theatrical production during his time in Moscow, from the beginning of his career with the *Ballets Russes* both he and Goncharova preferred neo-primitivism in their concept of avant-garde theatre.

After the first night of *Le Coq d'Or*, Larionov and

Goncharova moved to 65 Boulevard Arago where they stayed with their friend Boris Anrep, who had organized the Russian section of the Second Post-Impressionist Exhibition in London in 1912. Larionov and Goncharova now became firm friends with Apollinaire and were often seen in his company at the Café Flore on the Boulevard St. Germain, discussing final arrangements for their exhibition at the Galerie Paul Guillaume. Apollinaire wrote the introduction to their catalogue, and played an important role in publicizing the exhibition and introducing Larionov and Goncharova to the French avant-garde. In particular, Apollinaire wrote two lengthy articles on the artists for *Paris-Journal* and *Les Soirées de Paris* in which he sang their praises in glowing terms: they had sought out "the secrets of the rich oriental tradition," they were "originators" with "unique gifts," whose "genuine aesthetic discoveries" were to oc-

Fig. 138. Mikhail Larionov, Design for *Le Coq d'Or*, 1914

cupy a prominent place in contemporary art.[8] The poet Ricciotto Canudo ensured more publicity by asking Larionov to write on the subject of rayism for his magazine *Montjoie!*. In response Larionov wrote the manifesto "Le Rayonnisme Pictural" which appeared in the April–June edition, printed just before the opening of the exhibition. It was a short and concise manifesto, calculated to excite the attention of his French audience, which it did admirably.

The exhibition of Larionov's and Goncharova's work opened at the Galerie Paul Guillaume on June 17, and following its close at the end of the month it toured to Berlin to be shown by Herwarth Walden in Der Sturm Gallery. Goncharova showed fifty-four paintings and a body of graphic work, while Larionov exhibited only twenty-eight paintings and fifteen lithographs. Among these were major neo-primitive works such as *Soldiers* (fig. 31), *Bread* (fig. 88), *The Baker, Hairdresser*, and three of the *Seasons* series. He also showed the formidable *Boulevard Venus* (pl. 14) as well as several rayist works including *Glass* (fig. 44), three pneumo-rayist *Sea Beach* paintings (see pl. 15), and *Sunny Day* (fig. 70) which he dedicated, and gave, to Apollinaire.

The art critic Waldemar George attended the opening of the exhibition and his description of the evening is a fascinating account of Larionov's introduction to the Parisian art world.[9] Among those present George recalled arbiters of taste and fashion such as Paul Poiret, Paul Iribe, Coco Chanel, and the Marchioness Cassati, dancers Ida Rubinstein and Pavlova, and habitués of the ballet Jacques-Emile Blanche and José-Maria and Misia Sert.[10] Apollinaire was seen discussing the paintings with cubist critics André Salmon, Maurice Raynal, and Alexandre Mercereau, and Canudo was observed arguing with Max Jacob and Delaunay. A handful of avant-garde poets were there, including Cocteau, Blaise Cendrars, and Ribemont-Dessaignes. George also recalled many artists who attended the opening: Brancusi, Braque, Picasso, and Derain, who walked around the gallery amazed, Duchamp, de la Fresnaye, Gleizes, Gris, Laurencin, Léger, Marcoussis, Metzinger, Modigliani, Survage, and Villon.

Among the new friendships that Larionov and Goncharova made at this time in Paris, they grew especially fond of the Italian futurist painter Ardengo Soffici (1879–1964), and in June 1914 they dedicated a copy of Eganbyuri's monograph to him.[11] It was through Soffici that Larionov gained access to the Italian futurist magazine *Lacerba*.[12] With his works receiving critical attention in France, Italy, and Germany, Larionov began to develop an international

reputation as one of the leaders of the European avant-garde.

Larionov and Goncharova remained in Paris with Anrep until the end of July, when they went on holiday to the Hôtel du Châlet at St. Troyan on the Ile d'Oléron in the Bay of Biscay. They had only been there a few days when on August 1 Germany declared war on Russia and Larionov was called into the Russian army. Because of the hostility of Austria-Hungary towards Russia which resulted in a declaration of war on August 6, Larionov and Goncharova returned to Moscow via Switzerland, Italy, Greece, Constantinople, and Odessa. On his arrival he was mobilized as an adjutant-chief in the ranks of the 210th Bronnitsky Infantry Regiment of the 53rd Infantry Division, which formed the XXVI Corps of the First Army under the command of General Renenkampf.

By August 20 a large part of the First Army had been deployed on the northeast Prussian Front. The XXVI Corps, however, had not yet joined the First Army, and so Larionov was not involved in the rapid Russian invasion of Prussia which halted north of the Masurian Lakes. Larionov's corps joined the First Army on September 7 on the right flank of a defensive cordon which was under fire from German artillery. After beginning a retreat to the Russian frontier on the Nieman River, Larionov's corps dug in at Sredniki and it was here on October 1 that Larionov was wounded. According to Serge Fotinsky, Larionov was concussed by an exploding shell and then developed nephritis.[13] The artist spent three months in hospital before being invalided out of the army on 5 January 1915. The injury that Larionov sustained had a serious and prolonged effect on his life and creative ability, and when studying his later work this factor should be taken into account. Fotinsky later recalled Larionov's restlessness:

Because of his injury he lost the determination and persistency that a creative person has to have. He was unable to settle on anything, he couldn't concentrate, I think it was a nervous matter to be explained medically. As a result of this he no longer worked when in Paris, or very little anyway . . . he couldn't stay still, he went to bed at four o'clock in the morning and slept until two or three in the afternoon, after this he left, he walked, he went to people's homes, he talked. . . . Deep down he was not at peace, there was something gnawing at him, a kind of anxiety. . . . Moreover he produced nothing. Yes, he painted some portraits, some studies when he was in the south of France, but if you

compare those with what he did up to 1915 there's a great difference.[14]

Both Pierre Vorms and Marcel Mihalovici have testified to Larionov's lack of concentration in his work with them during the 1920s and early 1930s. Other features of Larionov's postwar career—a lack of painterly vitality, the diversification of his activities, and the less innovative and problematical nature of his works—also date from this period.

During the period of Larionov's convalescence Goncharova was particularly active. The success of *Le Coq d'Or* had brought her to the attention of directors and producers in Moscow and she received several design commissions. She also produced a folio of fourteen lithographs inspired by the war and entitled *Misticheskie obrazy voiny* (*Mystical Images of War*); in which visions from the book of *Revelation* were interspersed with national emblems.[15] The mystical view of war that Goncharova entertained also found expression in her illustrations for a book of poems by Tikhon Churilin entitled *Vesna posle smerti* (*Spring after Death*).[16] Larionov may also have been involved in the war effort as an artist. One authority suggests that he collaborated with *Segodnyashny lubok* (*The Contemporary Lubok*), a publishing house established shortly after the declaration of war to produce patriotic and propaganda posters and postcards.[17] Several of the avant-garde supported the war effort by working for *Segodnyashny lubok*. Mayakovsky wrote witty verses for the posters designed by Malevich, Lentulov, and Chekrygin, among others. If Larionov was involved in this venture, none of his posters can now be positively identified.

Larionov's return to the world of Russian art was marked by his active participation in The Year 1915 held in March. This was an important exhibition as it brought together not only the leaders of the Russian avant-garde such as the Burlyuk brothers, Falk, Goncharova, Grishchenko, Konchalovsky, Kuprin, Larionov, Lentulov, Malevich, Mashkov, Miturich, and Yakulov, but also Russians who had been working abroad, particularly Kandinsky and Chagall. Among the nine works that Larionov exhibited were two *Still Lifes*, *Circus Horsewoman*, *Head of an Old Man*, *Constantinople* (inspired by the artist's acquaintance with the city on his return from France), a second painting on the theme of *Boulevard Venus*, and a series of recent collages that included two portraits of Goncharova and an unusual work entitled *Iron Battle*.[18]

It was the collages that marked a decisive step forward in Larionov's aesthetic ideology. One of the col-

lage portraits was subtitled *Plastic Rayism* (*Plastichesky Luchizm*) which referred to a fairly recent concept in rayist theory, occurring for the first time in the manifesto "Le Rayonnisme Pictural" in which Larionov defined rayism as a dramatic representation of "the struggle between the plastic emanations radiating from all things." In practice, though, this concept resulted in collage works inspired by the principles of synthetic cubism and the papiers collées of Picasso and Braque. As Tugendkhold noted in his review of the exhibition:

> This time the Muscovites have not limited themselves merely to sticking pieces of paper onto their canvases. For Larionov, simply sticking cuttings from theatrical posters onto his portrait of Goncharova, to remind the public of her work on *Le Coq d'Or* and *The Fan*, was altogether inadequate, far too basic and not ambiguous enough. He decided that it was possible to abandon the canvas altogether, by showing the public real things, which are either painted in bright colors or left as they are. So in his other "portrait" of Goncharova, made out of bits of paper, he has attached a real piece of hair.[19]

Tugendkhold also describes *Iron Battle* as a board covered with "military maps, sweet wrappers, and national flags, with a child's toy house in the form of a fortress stuck onto it and small black sticks representing cannon."[20] In both subject and execution this recalls the work of Italian futurists such as Carrà, who included flags and newspaper clippings in his collage *Interventionist Manifestos* of 1914 and used found objects in his collage *Pursuit* of 1915 (Mattioli Coll., Milan).

Larionov's use of collage and real objects also relates to the practices of the Russian avant-garde at this time. Malevich began to adopt collage techniques in canvases such as *Woman at a Poster Column* of 1914 (Stedelijck Museum, Amsterdam), Popova had executed a painted paper relief in 1915 (Ludwig Museum, Cologne), and Tatlin exhibited several "painterly reliefs" at The Year 1915. Larionov remained as keen as ever to keep abreast of the latest artistic developments and to assimilate them, no matter how loosely, into his existing rayist ideology.

Larionov's unusual collage works were not out of place in an exhibition which itself was unconventional in conception. Apart from the easel paintings on display, The Year 1915 also included several bizarre exhibits by the more extreme members of the avant-garde. Lentulov in his autobiography recalled, "The Burlyuk's hung up a pair of trousers and stuck a bottle to them. . . . Mayakovsky exhibited a top hat

that he had cut in two and nailed two gloves next to it. . . . Kamensky asked the jury persuasively to let him exhibit a live mouse in a trap."[21] But even in this, the most daring section of the exhibition, Larionov again stole the show, for as Viktor Shklovsky recorded; "Larionov put some objects and paints around a ventilator. The ventilator was electric; it was switched on, started running, and the artist stood in fascination before a painting that had absorbed movement."[22] Contemporary reviews of the exhibition also refer to Larionov's ventilator which set in motion a mobile of painted objects, and in this respect Waldemar George refers to the artist as a progenitor of kinetic sculpture and even the originator of the mobile.[23]

Although Larionov's ventilator incorporated mechanical motion, he was not the only artist at the time to adopt such a novel approach. In fact, the descriptions of his mobile invite comparison with the "plastic-dynamic complexes" developed at this time by Balla and Depero. Only one month before the opening of The Year 1915, the two Italian futurists had published an illustrated manifesto entitled *The Futurist Reconstruction of the Universe* where they described the creation of the first "complex" and then identified the characteristic components and qualities of such assemblages.[24] The "plastic-dynamic complex" could be made from all kinds of materials but had to incorporate "mechanical and electrical devices . . . musical and noise making elements."[25] Larionov's mobile utilized objects, presumably of different materials, while the ventilator itself was a mechanical and electrical device that made noise. Therefore, his mobile also functioned as an answer to Balla and Depero's desire "to shape plastic complexes which we will set in motion," as well as being a witty interpretation of their phrase, "The lyrical appreciation of the universe . . . relies on plastic dynamism to provide a dynamic, plastic and noisy expression of universal vibration."[26] The "plastic dynamism" of Larionov's mobile, its noisiness and changing shapes and colors, were a direct expression of the "universal vibrations" of the ventilator.

The importance of *The Futurist Reconstruction of the Universe* for Larionov should not be minimized, as he was certainly in contact with the Italian futurists at this time. On 10 May 1915 Larionov's drawing *Katsap Venus* was published in *Lacerba* under the title *La Venere del Soldato*.[27] Moreover, a fascination with contemporary Italian futurist activities and a vigorous personal interpretation of them would represent a natural development of Larionov's prewar position on futurism.

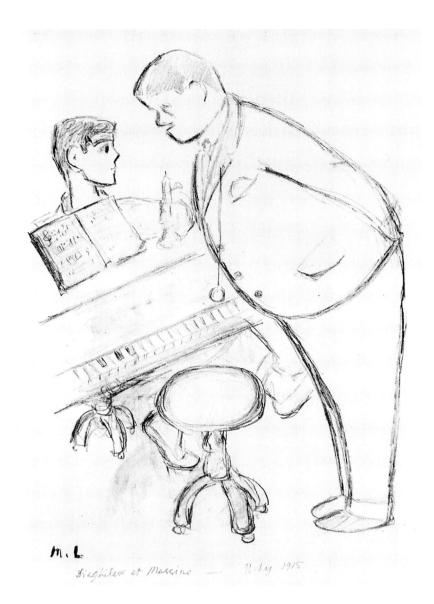

M. L

Diaghilew et Massine — July 1915

Fig. 139. Mikhail Larionov, *Massine and Diaghilev at Ouchy*, 1915

During Larionov's convalescence in early 1915 there was a steady stream of telegrams from Diaghilev in Switzerland, who, after the dispersal of the *Ballets Russes* on the declaration of war, was trying to rebuild his company. By June 1915 Diaghilev's demands that Larionov and Goncharova move to Switzerland were growing more frequent and insistent. Finally he sent a curt telegram: "Leave immediately. Waiting anxiously. Diaghilev, Stravinsky," upon which both Larionov and Goncharova capitulated.[28]

The two artists left Russia on 23 June 1915 never to return. They travelled from Moscow to Petrograd, out of the country, and through Finland, Sweden, Norway, England, and France to the Hôtel Beau Rivage in Geneva, where they arrived on July 16. Shortly after, they moved to a pension at Ouchy to be near Diaghilev. At Ouchy Larionov and Goncharova became close friends with Diaghilev's immediate circle, which included the dancing master Cecchetti, the dancer and new choreographer Massine, the *régisseur* Grigoriev, and Bakst, all of whom were living at the Villa Belle Rive, where Larionov and Goncharova took a studio. Larionov's drawings from this period depict the life at Ouchy, some featuring working scenes (fig. 139) in which Diaghilev and Massine discuss the music for forthcoming ballets. In the history of the *Ballets Russes* this period marked the beginning of a new phase. The choreography of Nijinsky and Fokine was to be outdone by that of the young

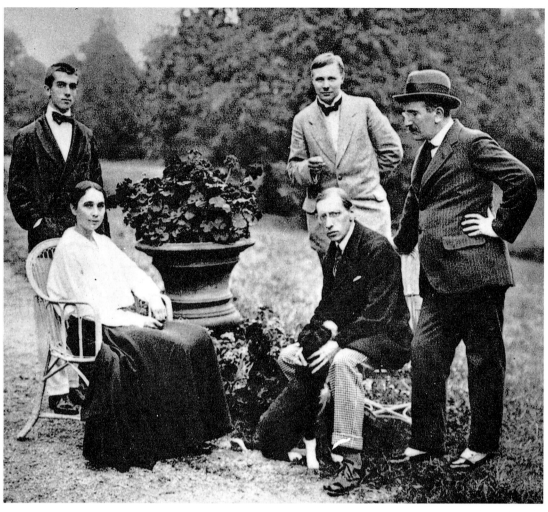

Fig. 140. Massine, Goncharova, Larionov, Stravinsky, and Bakst (left to right) at Morges, Switzerland, 1915

Leonide Massine, and the authority that Benois and Bakst had exercised as designers of the costumes and décor now passed to Larionov and Goncharova.

The composer Igor Stravinsky (1882–1971) lived not far from Ouchy at Morges, and Larionov in the company of Goncharova, Massine, and Bakst often visited him there.[29] It was at Morges that their famous group photograph was taken (fig. 140), there also that Stravinsky dedicated his recent composition *Berceuses du Chat* to both Larionov and Goncharova, and there that Larionov painted his *Portrait of Stravinsky* (fig. 141). This portrait is an unusual painting in which the features of the composer's face have been rearranged in a mildly cubist or futurist way. Although the painting includes lines and planes of color in the manner of rayism, the use is now more decorative than structural. In the 1912 *Portrait of a Fool* (fig. 42) the face is fractured into geo-

metrical planes by similar ray-lines, but here the lines hardly impinge on Stravinsky's head. Instead they decorate his jacket and form diagonals and grids in the background. The pipe and pens, on the other hand, are painted in a naturalistic way. The colors have been crudely scraped onto the canvas, leaving an unfinished appearance. On the whole, the uncertain manner of execution, in which Larionov appears at a loss to apply thoroughly one particular aesthetic, exemplifies Fotinsky's statement that Larionov had lost a certain persistency and determination in his approach to painting following his injury in the war. Paradoxically, this was not true of his skills as a designer for the theatre, and while Diaghilev was trying to reconstruct his *corps de ballet* and hire leading dancers to replace Fokine and Karsavina, Larionov and Goncharova on his instructions were collaborating with Massine on several new productions.

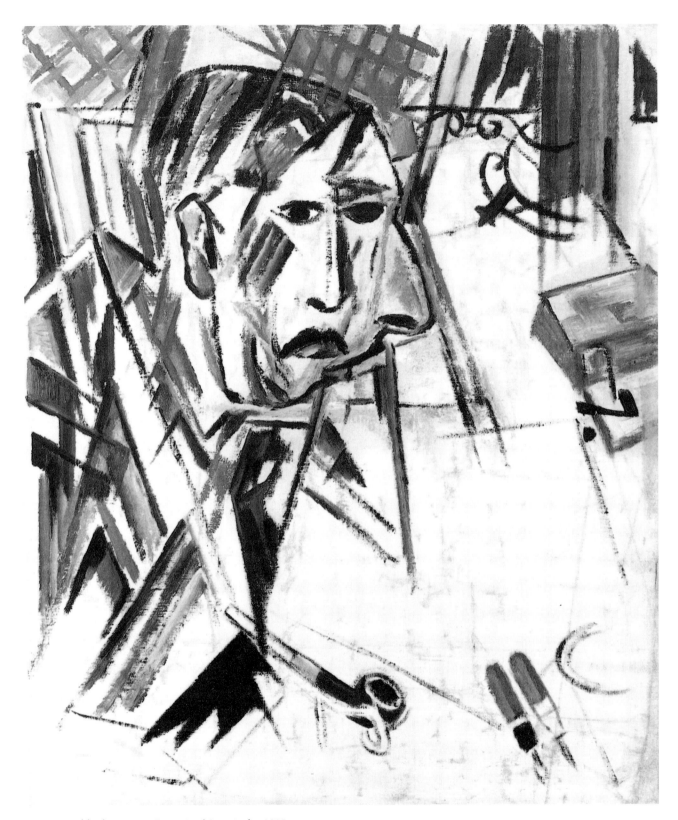

Fig. 141. Mikhail Larionov, *Portrait of Stravinsky*, 1915

At first the group began work on *Liturgie*, a ballet planned in 1914 when Diaghilev and Massine visited Italy and saw the Ravenna mosaics and works of the early Italian masters in Florence and Rome. Diaghilev had then conceived the idea of staging a liturgical ballet based on the Passion, and now Larionov was asked to supervise Massine and the evolution of the choreography, which was to be based on eurythmics, while Goncharova designed décor and costumes based on the Russian icon tradition.[30] Unfortunately the ballet never got beyond rehearsals and was soon abandoned.

Preparations for two other ballets were also initiated at this time. They were *Le Bouffon*, with music by Prokofiev, which was to be designed by Larionov, and *Les Noces*, with music by Stravinsky, to be designed by Goncharova. The two ballets were only discussed as projects, as the scores had not been completed and Diaghilev continually postponed the rehearsals. Despite this, Larionov and Goncharova began preparatory drawings in the autumn of 1915. *Le Bouffon* and *Les Noces* were not staged until 1921 and 1923, respectively, and the designs underwent considerable change, a process that Goncharova correctly called "a metamorphosis."[31]

Having abandoned *Liturgie* and only begun *Le Bouffon* and *Les Noces*, the group turned to the ballet *Soleil de Nuit*, based on Rimsky-Korsakov's *Snegurochka* (*Snow Maiden*). Larionov was commissioned to execute the designs, and Massine was instructed to attend to the choreography, although once again Larionov was appointed as his supervisor. The choice of Larionov as a choreographic tutor indicates that the artist was already well schooled in choreographic theory and stage practice, knowledge he had evidently obtained in Moscow, but how and where is not known. George states that Larionov had been a frequent visitor to the Moscow Art Theatre where, in 1911, he met Edward Gordon Craig who was producing Shakespeare's *Hamlet* there.[32] George also suggests that Larionov learned much from his World of Art friends Bakst and Benois, as well as from teachers such as Korovin at the Moscow School. Some sources, principally Parnack, and after him George, Schaikevitch, and Chamot, assert that Larionov had designed scenery for Hofmannsthal's *Les Jongleurs* at the Théâtre Intime (Intimichesky Teatr) in Moscow before 1914, and that during the same period Goncharova designed décors and costumes for two pantomimes based on Hofmannsthal, *Le Bedeau* and *Les Noces de Zobeide*, which were produced in the private studio of Krakht in Moscow.[33] While such early productions would indeed have furnished Larionov and Goncharova with theatrical experience, there is, as yet, no evidence to support these claims.

Massine and Larionov worked well together on *Soleil de Nuit*. Massine later recalled:

> Larionov was again asked to supervise the choreography. He was intrigued and suggested that it should revolve round the person of the sun-god Yarila to whom the peasants pay tribute in ritual ceremonies and dances, fusing it with the legend of the snow maiden, the daughter of King Frost, who is destined to melt in the heat of the sun when she falls in love with a mortal. I also decided to incorporate into the action the character of Bobyl, the innocent or village half-wit, and to end the ballet with the traditional dance of the buffoons.[34]

Moreover, Larionov suggested to Massine that the choreography be based on Russian peasant dances. In particular, they used the *Khorovod* and a dance that Massine and his friends had performed as children. According to Massine, Larionov then embellished these dances with "primitive, earthy gestures." Massine himself declared that "it was through Larionov that I first came to understand the true nature of these old ritual peasant dances."[35] The choreography thus complemented Larionov's designs for the ballet, which were executed in the most exotic neoprimitive style.

The leitmotif of the whole design concept was the bold image of the grinning sun, which appeared on the chest of Massine's shirt and was reproduced as a bright garland in the sky of the set designs (pls. 17–18). The color scheme for the sets was executed in strongly contrasting primaries of red, blue, and yellow, while for the costumes Larionov adopted a striking range of colors and tones from peach, gold, and orange to scarlet, maroon, purple, and blue. Larionov used this exotic color range to maximize the effect of the wealth and variety of folk ornamentation in the costumes, such as the appliqué floral motifs and dogtooth flounces. Equally breathtaking were the huge flat suns strapped to Massine's hands and his magnificent red and gold headdress. In fact this specific design concept was clearly inspired by the precedent of the flamboyant costume designs for Louis XIV as the Sun King in the historic *Ballet Royal de la Nuit* of 1653. Just as stunning were the brightly colored dresses worn by the women, their pendulous earrings and beads, their huge butterfly hats (the traditional *kokoshniki* and *kichki*), and the unusual choreographic poses they assumed (fig. 142).

Spectacle had its price, however, and the hats were so large that they fell off and eventually had to be tied

Fig. 142. Photograph of Choreographic Forms for *Soleil de Nuit*, 1915

around the neck and under the chin. As a costume designer Larionov seldom acceded to the requirements of the dancer and, despite all the complaints, the costumes for *Soleil de Nuit* remained cumbersome.

As in his neo-primitive painting, Larionov drew on specific sources for his designs for *Soleil de Nuit,* one of the most important being children's dolls. Several preparatory sketches (fig. 143) reproduce the stiff angular postures of dolls, as well as the traditional costume, headdress, and ornamentation specific to dolls of certain provinces. Both Larionov and Goncharova were familiar with these dolls, which had already played a role in the formation of their neo-primitive ideology. In 1912 Goncharova had referred to "the

painted wooden dolls sold at fairs" as being cubist *avant la lettre* and Larionov had shown several dolls of various kinds at the Exhibition of Original Icon Paintings and *Lubki* in 1913. With *Soleil de Nuit* Larionov found a new field for his neo-primitivism, ballet, in both its choreographic and design aspects, creating a neo-primitive *gesamtkunstwerk* in the tradition of *Le Sacre du Printemps* and *Le Coq d'Or.*[36]

Massine's choreography and Larionov's designs for the costumes and décor were completed during the early winter of 1915, by which time Diaghilev had formed a new company, and in December they all moved to Geneva to prepare for their first première since the declaration of war. *Soleil de Nuit* was given to a full house in the Grand Théâtre of Geneva on

Fig. 143. Mikhail Larionov, Costume design for *Soleil de Nuit*, 1915

December 20 as part of the *Ballets Russes* Grand Gala in aid of the Red Cross. As Stravinsky noted, the evening netted 400,000 gold francs and was a "triumphant success."[37] From Geneva, Larionov and the *Ballets Russes* moved to the Paris Opéra to prepare for a similar gala, where *Soleil de Nuit* was given a second showing on December 29. Following this performance the *Ballets Russes* took a train for Bordeaux and, on 1 January 1916, sailed to New York for an American tour.

Larionov and Goncharova, however, remained in Paris. Initially they stayed at the Hôtel Castille in the Rue Cambon, near the Opéra, but shortly after, rented accommodation at 6 Rue Tournefort. Larionov now renewed the friendships he had made in 1914, especially with Waldemar George and Fernand Léger.[38] He also associated closely with Apollinaire who, evidently with Larionov's permission, published an embarrassing account of the artist in *Mercure de France*.[39] Goncharova meanwhile published a folio of

her costume designs for *Liturgie* as well as a folio of lithographic portraits of *Ballets Russes* personalities.[40] Both artists, though, maintained contact with their friends in Russia, and during this period Goncharova sent a cover design and illustrations to Sergei Bobrov for inclusion in a large miscellany of poetry published at the end of April by the Centrifuge group.[41]

The *Ballets Russes* tour of America ended on April 29, and on May 6 they sailed from New York to Cadiz, performed a short season in Madrid, and then broke for a holiday during June and July before starting their next season in San Sebastian in August. Larionov and Goncharova had arranged to join Diaghilev in Spain during the summer and left Paris on July 8 for San Sebastian where Larionov began work on *Kikimora*. This ballet celebrated the famous witch of Russian folklore and children's tales, and the action, accompanied by the music of Liadov, was particularly violent. The curtain rose on Kikimora, asleep in her cra-

Fig. 144. Mikhail Larionov, Set design for *Kikimora*, 1916

dle, attended by a cat. In the throes of a nightmare she gnashed her teeth and waved her arms in contorted movements. Then emerging from her cradle she, as Massine describes it, "was revealed in all her ugliness, wearing one of Larionov's most outlandishly repellent costumes—a stained, patched blouse and skirt with red gaudy stockings, and a wig of dark matted hair."[42] Kikimora then lashed the cat with a rope and finally crushed its skull with blows from an axe! Massine comments, "In this highly charged *pas de deux* I had to maintain a constant interplay between the feline movements of the animal desperately trying to defend itself and the malicious fury of the witch. Fortunately both Sokolova and Idzikovsky understood the specifically Russian violence inherent in the legend, which was further emphasised by Liadov's music."[43]

In his designs for *Kikimora*, Larionov again adopted a neo-primitive approach, and Russian folk art pervaded the décor and costumes of the whole ballet. The set design for *Kikimora* (fig. 144), for example, features two magnificent dragon heads in imitation of the decorative handles of wooden ladles carved by the Russian peasantry. It also includes a fine tiled stove, an indispensable accessory to Russian folk tales, on which the fool of the house usually reclines, picking his nose. A preparatory design for the stove (fig. 145) demonstrates Larionov's particular study of the decorative imagery on old Russian ceramic tiles. Perhaps the most startling aspect of the design of this ballet was Kikimora's gruesome makeup—her face painted with three stripes, and a vicious comb lodged in her hair. This particular feature of the design had obvious affinities, as Parnack recognized, with Lario-

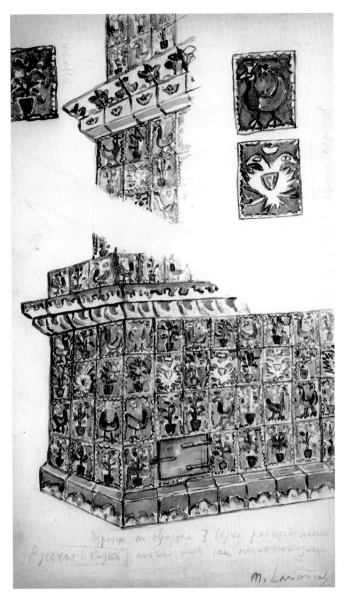

Fig. 145. Mikhail Larionov, Design for the tiled stove in *Kikimora*, 1916

nov's own face painting, as well as with primitive societies that paint their faces.

During the production of *Kikimora*, Goncharova made designs for three projects, two of which, the ballet *Triana* to music of Albeniz and the ballet *Espana* to the *Rhapsodie Espagnole* of Ravel, remained unrealized. However, the ballet *Sadko* on which she worked was more successful. This ballet had first been presented by Diaghilev at the Théâtre du Châtelet in Paris in 1911, to music by Rimsky-Korsakov, with choreography by Fokine and designs by Boris Anisfeld. Now Diaghilev had commissioned a new

version with choreography by Adolf Bolm and costumes by Goncharova.

Both *Kikimora* and *Sadko* were completed over the summer and were given for the first time during a one-week season of the *Ballets Russes* in August at the Teatro Victoria Eugenia in San Sebastian. Following this, the company moved to Bilbao before travelling to Bordeaux and sailing to New York on September 8 for their second American tour. Diaghilev, Massine, Grigoriev, Bakst, Goncharova, and Larionov, however, travelled to Rome where, until the company's return in March 1917, they worked on new projects.[44]

On arriving in Rome in mid-September 1916, Larionov and Goncharova took rooms in the Hotel Minerva and remained there until their departure on 4 April 1917. During this period Larionov occupied a key position within the fascinating cultural circle centered around Diaghilev. Bakst was preparing designs for the ballet *Les Femmes de Bonne Humeur*. Balla had been approached to make designs for Stravinsky's *Feu d'Artifice*, and Depero for the latter's *Le Chant du Rossignol*. Stravinsky himself arrived in Rome in early 1917 to give advice. At the same time Picasso and Cocteau arrived to begin work on the ballet *Parade*. Constant companions of the group included the eccentric English composer Lord Gerald Berners, the Italian composer Alfredo Casella, and the Italian futurists Prampolini, Bragaglia, Marinetti, and Cangiullo, who was trying to persuade Diaghilev to stage his *Zoological Garden*.

In this unique creative atmosphere Larionov began work for Diaghilev not only as a stage designer but also as his artistic coordinator and adviser. As Giuseppe Sprovieri later recalled:

Diaghilev called Larionov to Rome, not so much to put new things on the stage, but because he recognized his unique talent, not only as a painter, but as a choreographer, which none of his other collaborators had. In fact he gave him the job of supervising the choreography especially when it came to putting Massine through his paces and this marked the beginning of a new era in the *Ballets Russes*. It was this task which gave Larionov the opportunity to meet Italian arists such as the futurists Balla and Depero and the musicians Rieti, Casella, Respighi, and Tommasini.[45]

While thus engaged Larionov also began designs for a new ballet entitled *Contes Russes* composed entirely of Russian folk tales—the *Kikimora* story, *Bova Korolevich*, and *Baba Yaga*, the three tales bound together by orchestral interludes and peasant dances.

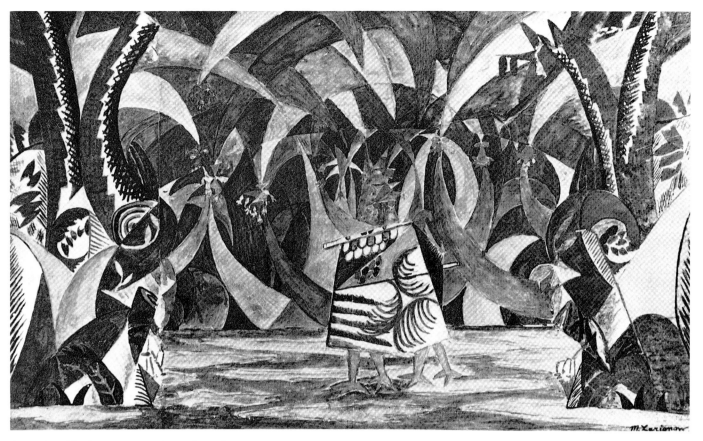

Fig. 146. Mikhail Larionov, Set design for *Baba Yaga*, 1917

Perhaps because of his wider commitments to the *Ballets Russes*, various artists were asked to help Larionov with the design work including Goncharova and the Italian futurist Depero.

With *Baba Yaga* Larionov introduced a new geometric trend in his designs and a further encroachment on the role of the dancer. In the set design for *Baba Yaga* (fig. 146) the leaves and trees of the forest are constructed from intersecting arcs. For Baba Yaga's hut, which in Russian stories spins round on four hens' feet, Larionov designed a structure rather like a roof, which was worn over the bodies of two dancers, severely restricting their movement. Larionov also planned geometrical painted structures to act as coulisses for the ballet—one such appears in the background of a contemporary photograph of Goncharova (fig. 147) and may be identified as a coulisse from its later reproduction in *Der Sturm* magazine.[46] There are a number of preparatory studies on both paper and canvas for this particular construction (fig. 148), and paintings and designs in similar styles may have been intended as plans for other

three-dimensional coulisse constructions, which were later exhibited in 1918 at the *Galerie Sauvage* in Paris. The designs for *Baba Yaga* represented a break with the neo-primitive designs of *Soleil de Nuit* and *Kikimora*, and the trends exhibited here were to have far-reaching implications in Larionov's thinking about avant-garde theatre for the following three years.

This new approach in Larionov's theatre design may be explained by his contacts in Rome. He was of course friendly with Picasso and Cocteau who were preparing designs for *Parade*, which was to be shown in Paris during the same season as *Contes Russes*. In *Parade* the traditional role of the dancer was restricted by the cumbersome cubist costumes. The influence of cubism upon Larionov's theatre designs of the period may be traced in a gouache for a woman's costume (fig. 149), where the body and skirt are treated as geometrical solids and forms. Such a hard-edged, "cubic" design, like those of Picasso for *Parade*, represents the very antithesis of the traditional approach to theatrical costume and militates against

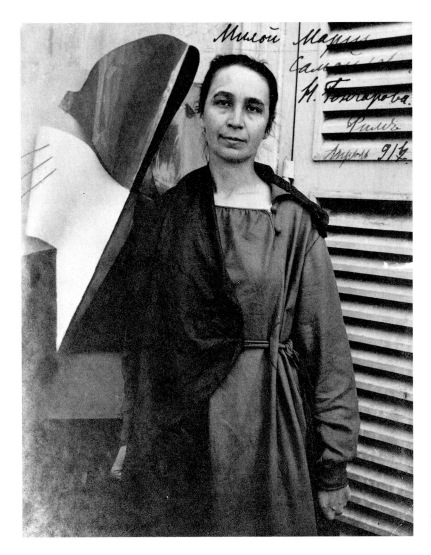

Fig. 147. Goncharova in Rome 1916–1917.
Behind her is a construction for a *coulisse* by
Larionov

the graceful movements of the dancer. In a sense Lari-
onov had already followed this line in his complex
designs for *Soleil de Nuit*, but cubism provided him
with a model and a different external vocabulary. Fur-
thermore, in his reduction of the costume to a struc-
ture of geometrical forms, Larionov's design was a
basic prototype for the *Histoires Naturelles* costume
designs of the ensuing years. Hence it reveals the ex-
tent to which these later works, although they are
essentially futurist, are also indebted to cubism.

The futurists Balla and Depero were planning an
even greater *coup* than Picasso's with what they
called mechanical theatre, which obviated the neces-
sity for any human agent whatsoever upon the stage.
Despite the importance of Larionov's relations with
Picasso and Cocteau, if we wish to shed light on the
transformation of his notion of avant-garde theatre

design, we must once again look to his contacts with
the Italian futurists.

Many documents from this period testify to Lario-
nov's close relationship with the futurists. During
the winter both he and Goncharova visited the Boc-
cioni retrospective exhibition in Milan.[47] Then in
the new year Marinetti and Prampolini organized a
banquet in Larionov's honor, at which they presented
him with an inscribed futurist poster.[48] Marinetti
even corresponded with Larionov after rejoining his
army unit at Cormons, sending him a futurist post-
card boldly proclaiming war to be the only hygiene,
the only morality.[49] It is also recorded that Bragaglia
invited Larionov and Goncharova to hold an exhibi-
tion of rayist works in his studio, but no catalogue
seems to have survived. However, the event was
marked by the publication of *Radiantismo*, an Italian

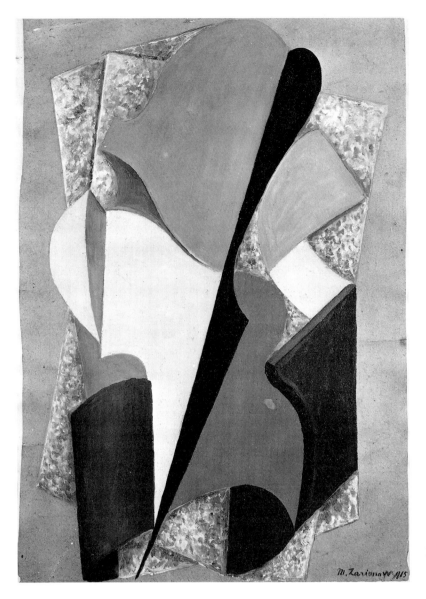

Fig. 148. Mikhail Larionov, *Spiral* (Preparatory study for architectural ornament/*coulisse*), 1916–1917. Pre-dated

manifesto comprising passages from *Luchizm* and "Le Rayonnisme Pictural," which had been compiled and translated by Nina Antonelli.

Within this context the dominant concepts of avant-garde theatre were those of "mechanical" and "synthetic" theatre, propounded principally by Balla and Depero. Both concepts had been implicit for some years in Italian futurism—in the futurist theatre evenings, in the futurist desire to revolutionize drama, and in the inspiration of the popular music hall which, according to Marinetti, could subvert bourgeois theatre.[50] More recently, in "The Futurist Stage (Manifesto)" of 1915, Prampolini had called for the autonomy of the stage designer to interpret on a bare stage the emotive equivalents of a work by a complex play of chromatic lighting (cf. *Feu d'Artifice*). In early 1915 the *Manifesto of Futurist Synthetic Theatre* emphasized that performances should be brief, which could be achieved by synthesizing words, gestures, ideas, and sensations, and cited Marinetti's "drama of objects," *Vengono*, as an example of "synthetic theatre."

During 1915 and 1916 Boccioni, Balla, Depero, and Cangiullo performed synthetic theatre throughout Italy. Balla's four-minute ballet *Feu d'Artifice* staged by Diaghilev on 12 April 1917 eliminated the dancer altogether and used only the play of colored lights on three-dimensional painted shapes surmounted by

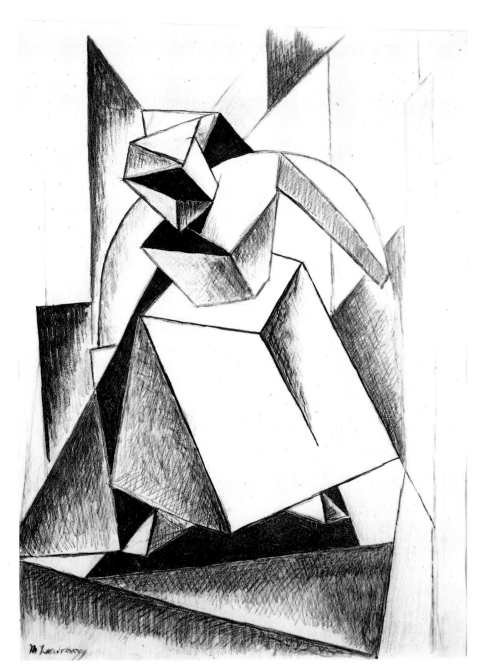

Fig. 149. Mikhail Larionov, *Costume Design*

forms made of translucent materials. Moreover, in 1916 Marinetti published his "Manifesto of Dynamic and Synoptic Declamation," in which he advocated that the performer should eliminate idiosyncratic detail and aim for a depersonalized "abstract" and mechanical delivery, whence developed the concept of mechanical theatre where the actor or dancer was replaced by a mechanism. It was in this context in early 1917 that Larionov began work on a new ballet entitled *Histoires Naturelles.*[51]

Histoires Naturelles was based on Jules Renard's book of animal character studies by the same title and was to use music by Ravel. Diaghilev may well have been considering the possibility of staging *Histoires Naturelles* at this point, as he was in contact with Ravel concerning a score to accompany a li-

bretto for a ballet on a similar subject, Cangiullo's *Zoological Garden*. Neither *Histoires Naturelles* nor *Zoological Garden* was staged, but Larionov made a number of costume designs for *Histoires Naturelles* which have survived in the form of pochoirs, published in the album *L'Art Décoratif Théâtral Moderne* (1919). The whole ballet was conceived as an experiment in "mechanical" theatre. Lifar tells us that it was to be presented against moving scenery created by projected colored images, and without any form of dance.[52] Moreover, Larionov's costume designs, such as those for *The Peacock* and *The Cricket* (pls. 19–20) which he described as being "mechanical," were deliberately designed so as to restrict the movements of the actor or dancer on the stage to a series of sharp, mechanical, and angular gestures.

Central to the concept of "mechanical" theatre was what Balla and Depero called the "metallic animal." In their manifesto *The Futurist Reconstruction of the Universe* in 1915, they declared; "Fusion of art and science, chemistry, physics, continuous and unexpected pyrotechnics all incorporated into a new creature, a creature that will speak, shout and dance automatically. We Futurists, Balla and Depero, will construct millions of metallic animals for the vastest war."[53] The "metallic animal" was discussed in the manifesto in the context of futurist toys, and the concept was evidently inspired by some of the amusing mechanical children's toys that were then on the market. Only a year later, when Depero was asked by Diaghilev to produce designs for Stravinsky's *Le Chant du Rossignol*, he decided to incorporate a mechanical nightingale into the ballet.[54]

Balla and Depero's interest in mechanical animals may have influenced Larionov's designs for *Histoires Naturelles*, which include at least four mechanical costumes—*The Peacock*, *The Cricket*, *The Kingfisher*, and *The Swan*. The fan-shaped tail and the pivots that hinge the movable parts in Larionov's design for *The Peacock* (pl. 19) directly imitate a mechanical toy. The pochoir of *The Cricket* in the Victoria & Albert Museum bears Larionov's inscription: "Costume mécanique aussi que se met en mouvement exclusivement par la voix. Musique de Ravel. Brevet N. O. 009721840536." The number imitates the use of patent numbers on mechanical toys, and the reference to the movement of the costume being directly coordinated to the voice refers back to Balla and Depero's "metallic animal" which will "speak, shout and dance automatically."[55]

Larionov's mechanical designs for *Histoires Naturelles*, however, may also reflect Ravel's interests. As early as 1905 Ravel had taken a canal holiday and

had been impressed by the machinery and industrial architecture that he observed along the riverbanks. He wrote:

> How can I convey to you the impression of these marvellous castles of iron, these incandescent cathedrals, the marvellous symphony of conveyor belts, whistles and mighty hammer blows by which one is surrounded? . . . Looking at this mechanical landscape one begins to feel one is an automaton oneself . . . I'm storing it all up and I think quite a lot will come out of this voyage.[56]

Perhaps a lot did come from the voyage, for in 1906 Ravel composed the music for Jules Renard's *Histoires Naturelles*, first performed in January 1907, where some of the musical effects, such as the cricket who can be heard winding up his watch, imitate children's mechanical toys. In fact mechanical sounds permeate Ravel's music. In *L'Heure Espagnole* the clocks tick, and in *Noël des Jouets* the toys come to life. In effect, Larionov's designs responded not only to the development of "mechanical theatre," but also to Ravel's interests and the sources of the music.

Larionov's concept of avant-garde theatre design had now expanded beyond a straightforward neo-primitive approach to include something more in line with the cubists and futurists. Larionov's work at this time was closest aesthetically and ideologically to that of Depero. In Larionov's designs for *Lady with Fans* (fig. 150) and Depero's costume designs for the dancers in Stravinsky's *Le Chant du Rossignol*, the figures are constructed from long isosceles triangles with fanlike projections. The dancers are circumscribed by ovals and arcs and their dress includes stylized decorative frills and unusual floral trumpets. In fact one particular design for *Le Chant du Rossignol* (fig. 151) bears Depero's signature and Larionov's studio stamp, suggesting collaboration.

Larionov's designs for *Histoires Naturelles* also share similarities with Depero's work at this time. The curving bands of color that distinguish the tail of his *Peacock* occur in Depero's *Portrait of Marinetti* of 1917 (Coll. Luce Marinetti Barbi, Rome), and *The Kingfisher* (fig. 152), designed in the style of a mechanical man, bears a direct relationship to Depero's designs of 1918 for his *Ballet Plastici* and to a preparatory drawing for *Mechanical Man with Moustache* (fig. 153) where the treatment of the body is similar to that of the *Kingfisher*, as is the walking stick.

Larionov and Depero were undoubtedly close during this period in Rome and it is now impossible to disentangle the complex web of their interrelated work at this time. It may be that their novel approach

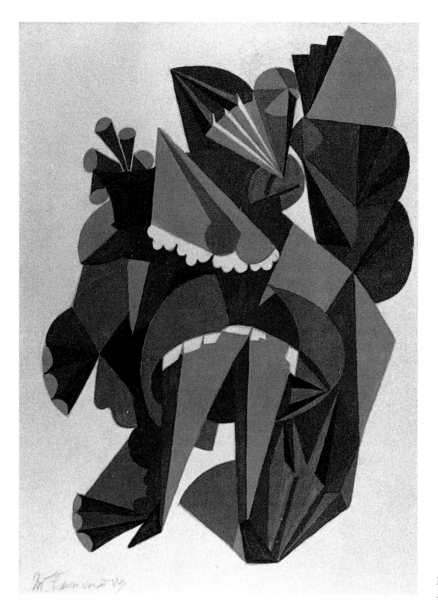

Fig. 150. Mikhail Larionov, *Costume for Lady with Fans*, 1916–1917

to theatrical design was the result of collaboration, but later a furious Depero complained bitterly that Larionov had plagiarized his inventions in the folio of theatrical designs, *Art Théâtral*, which included both *The Peacock* and *The Kingfisher*![57]

Behind these Italian developments in the theatre, and not least behind Larionov's work, lay the shadow of Edward Gordon Craig (1872–1966). In the second issue of his magazine *The Mask* in April 1908 Craig had written an article entitled "The Actor and the Über-Marionette." Here he advocated that the actor should be replaced with a "being" entirely free from emotions, which could be moved and controlled from afar—a mechanical actor, the *über-marionette.* Through the pages of *The Mask* Craig left his mark

upon the development of modern theatre. Larionov possessed an almost complete set of *The Mask* and would have been well aquainted with Craig's ideas.[58]

At this time Larionov developed an interest in shadow puppets and shadow theatre, which ranged from children's toy theatres and amusements to the shadow theatre of the east—the *Karagöz* performances of Turkey, Greece, and Egypt, and the magnificent shadow-puppet theatre of Indonesia. Craig was an authority on shadow theatre and puppets, and from April 1918 published a periodical called *The Marionette.* It was the composer Lord Berners, however, who was responsible for stimulating Larionov's interest in this field.

Lord Berners (Gerald Hugh Tyrwhitt-Wilson, 1883–

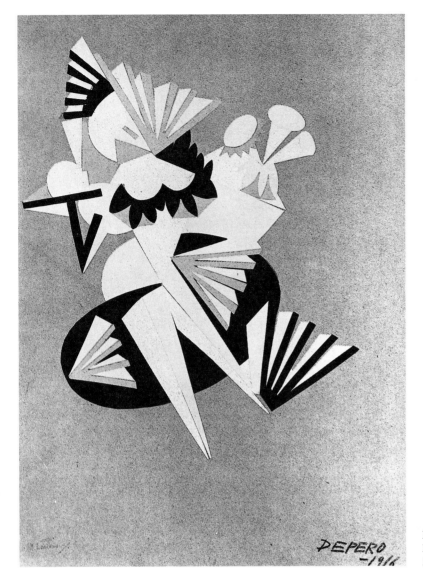

Fig. 151. Fortunato Depero and Mikhail Larionov, Costume design for *Le Chant du Rossignol*, 1916

1950) was a diplomat who had been posted as an honorary attaché to the British Embassy in Constantinople before being transferred to the British Embassy in Rome, where he remained until 1919. Since 1915 he had been a student of Casella and had received advice from Stravinsky, but otherwise Berners was a self-taught composer, who delighted in writing satirical music such as *Trois Petites Marches Funèbres: Pour un Homme d'Etat, Pour un Canari, Pour une Tante à Héritage* of 1914. As a child he had been interested in the theatrical effects of colored lights.[59] By 1917 Berners had combined his satirical music with his interest in shadow theatre and chose Larionov as his collaborator. Together they planned a performance for what Larionov later called a *Théâtre des Ombres Colorées*, which would feature shadow puppets by Larionov and Berner's music from *Trois Petites Marches Funèbres*. The *Théâtre des Ombres Colorées* which Larionov and Berners devised may have been a full-scale shadow-theatre production similar to *Karagöz* or, alternatively, a production for a children's toy theatre.[60] In either case the numerous designs that Larionov made for this production were intended to function as shadow puppets. To help him in his designs Larionov studied works on the subject by scholars such as Lemercier de Neuville, which provided him not only with an historical review of shadow theatre, but also with practical instruction on how to construct such a theatre, how to make the puppets, and how to manipulate them.[61]

Several of Larionov's designs for shadow puppets are now extant, including characters from the *Marche*

Funèbre pour un Homme d'Etat (fig. 154), the *Marche Funèbre pour un Canari* (fig. 155), and the *Marche Funèbre pour une Tante à Héritage* (pl. 21). Each design is an assemblage of colored geometrical shapes which are pivoted so as to allow simple movements. Roger Fry, in fact, remarked that Larionov's clever coordination of movement and design in these shadow puppets and mechanical costumes was one of their most successful aspects and concluded that "his designs are not merely decoratively satisfying; they also have a vivid expressive purpose."[62]

The relationship between Larionov and Lord Berners developed very quickly and became extremely close. During the winter of 1916–1917 Berners was writing *Trois Morceaux pour Piano: Chinoiserie, Valse Sentimentale, Kasatchok,* and he dedicated *Chinoiserie* to Larionov and *Kasatchok* to Goncharova. At this point he may even have mentioned the possibility of publishing the score of this music and that of an earlier piece, *Le Poisson d'Or,* with illustrations by the two artists, something that actually happened in 1919 (see below, chap. 10). Berners evidently found his collaboration with Larionov a stimulating experience. A watercolor design by the composer on

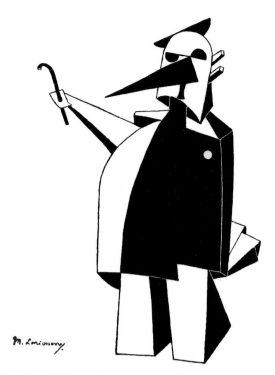

Fig. 152. Mikhail Larionov, *The Kingfisher,* 1917–1919. Print from *Art Théâtral,* 1919

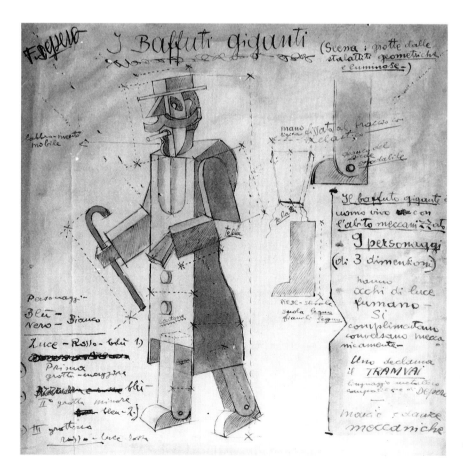

Fig. 153. Fortunato Depero, *Design for Mechanical Man with Moustache,* 1918

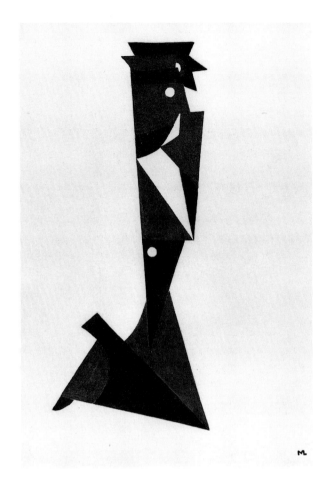

Fig. 154. Mikhail Larionov, Character from *Marche Funèbre pour un Homme d'Etat*, 1917–1919

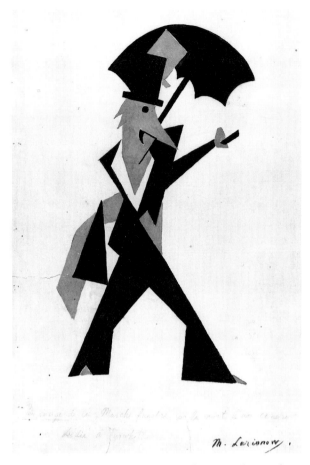

Fig. 155. Mikhail Larionov, Character from *Marche Funèbre pour un Canari*, 1917–1919

the manuscript cover of *Les Trois Petites Marches Funèbres: II Pour un Canari* is similar in both style and humor to Larionov's work. The *Trois Petites Marches Funèbres* were evidently never performed in the *Théâtre des Ombres Colorées* but, following Larionov's departure from Rome, Berners began to write music specifically for shadow theatre and marionette productions which he successfully staged with Depero.

The main company of the *Ballets Russes* returned from their American tour in March 1917, and began rehearsing *Contes Russes, Parade,* and *Les Femmes de Bonne Humeur,* and making final preparations for a short season that they were to give at the Teatro Costanzi in Rome. Soon after the opening of the season at the Costanzi and now that work on *Contes Russes* was nearing its conclusion, Larionov and Goncharova planned their return to Paris. The last important event of their stay in Italy was their contribution to the Exhibition of Russian Artists in Rome held at the Literary Center in the Via Colonetti, and

once this exhibition had closed the two artists left Rome on April 4.[63]

The war years were among the most successful and exciting of Larionov's career. He had been crowned in Paris as one of the leaders of the international avant-garde, and his association with Diaghilev had opened up a wide range of contacts in France, Spain, and Italy. Furthermore, his career had witnessed a striking evolution as an artist and painter in the world of the theatre and his work had developed a remarkable breadth in this field. Diaghilev had provided the means by which Larionov was able to transpose his aesthetic ideology from the two-dimensional canvas to the three-dimensional stage. Having begun with a richly inventive neo-primitivism, the winter of 1916–1917 in Rome represented a crucial period, when, thanks to the impressive company gathered there, Larionov was able to assess and absorb the different currents of thought in avant-garde theatre design and to make them the basis of his own experimentation.

Up and Coming in Paris and London

1917–1919

■

Diaghilev and the *Ballets Russes* left Rome following the performance of *Feu d'Artifice* in mid-April. They toured to Naples and Florence and finally arrived in Paris in early May to prepare for their season at the Théâtre du Châtelet. By this time Larionov had completed work on his new ballet *Contes Russes,* but last-minute preparations were still being made for *Parade,* and this enabled Larionov to sketch and caricature Picasso, Cocteau, and Satie as they hurried around making final arrangements (fig. 156). Larionov also sketched Diaghilev's closest circle of friends. The eminent ballet critic Valerian Svetlov was the subject of a fine portrait drawing (fig. 157), which shows Larionov to have lost none of his verve when it comes to realism in this particular medium. Svetlov was friendly with both Larionov and Goncharova and was among the first to write a critical appreciation of their theatrical work.[1] Different, and more characteristic of Larionov's drawing style in these years, are the amusing portraits of Apollinaire which are executed with energetic pen strokes and one of which (fig. 158) depicts the poet following his recent trepanation, with bandages round his head. These drawings are almost caricatures and reveal Larionov's ability to identify and exaggerate Apollinaire's characteristic postures, hands thrust deep into trouser pockets, and facial features, his tapering nose and square head.

Apollinaire was much in evidence in the Diaghilev circle at this time as both he and Georges-Michel were contributing essays to the handsome program that accompanied the forthcoming ballet season. In addition to their two essays the gala program contained color reproductions of designs for the new ballets by Larionov, Picasso, and Bakst, plots of all the ballets being performed, photographs of the dancers in their costumes, and drawings and photographs

of the leading members of the company, including Larionov (fig. 159).

Contes Russes was given its première at the Théâtre du Châtelet on May 11, the opening night of the season. Diaghilev's practice at a première was to "sandwich" new ballets between old favorites, and so the two new ballets, *Les Femmes de Bonne Humeur* and *Contes Russes,* were preceded by *L'Oiseau de Feu* and followed by *Les Dances du Prince Igor,* which were both extremely popular. *Contes Russes* itself opened with the narrator of the ballet dancing to an orchestral prelude based on the music of a Russian Christmas carol. This led into *Kikimora* which told how the spirit of wickedness first came into the world. The plot followed that of the 1916 version, with Larionov's bizarre and frightening designs for Kikimora and her cat causing a great deal of excitement. Valerian Svetlov noted that Larionov had a weakness for the grotesque, which was why Russian folktales attracted him, and that this was the fundamental and organic characteristic of his talent.[2]

An orchestral lament and a danced interlude followed *Kikimora* and introduced the story of *Bova Korolevich,* a Russian Don Quixote who rides through the steppes to rescue a princess bewitched by an evil dragon. An orchestral lullaby and another danced interlude separates *Bova Korolevich* from the last story, that of *Baba Yaga* the ogress who, with her goblins, haunts a wood in which a little girl has lost her way. The spirits capture the girl and, dancing around her, lead her to Baba Yaga's hut (fig. 146), where the ogress prepares to devour her. The child, however, makes the sign of the cross, and the evil forces are dispelled. Finally, the orchestra played a piece entitled *Legende des Oiseaux (Legend of the Birds),* before the entire ballet ended with a traditional Russian folk dance.

Contes Russes was a success in Paris as it proved to

Fig. 156. Mikhail Larionov, *Caricature of the Parade Team*, 1917

be elsewhere. Svetlov acclaimed Larionov's gifts as a stage designer referring to the attractive and picturesque qualities of his décors and his discordant coloring. He hailed both Larionov and Goncharova as "the first apostles of Russian Cubism and Futurism in theatrical art" and, in his definition of cubism as the static in painting and futurism as the dynamic, he declared that in *Contes Russes* Larionov was "both a Cubist in his décors and a Futurist in his costumes."[3] It was this all-embracing approach that Svetlov designated as the hallmark of Larionov's theatrical work and his success as a stage designer: "All the elements of the theatre are necessary: for him décors, costumes, lighting, the props, music, and subject: from all of these he forges an amalgam of plastic collaboration. That's why Larionov's décors and costumes are always deeply theatrical, expressive and sonorous."[4]

In early June the *Ballets Russes* left Paris to tour Spain, South America, and Portugal before returning to Spain and then to Paris in August 1918. During this period Larionov and Goncharova, who had elected to stay in Paris, saw nothing of the company. Larionov

and Goncharova again lodged at the Hôtel Castille in the Rue Cambon and settled into Parisian artistic life, subscribing to the latest artistic and literary magazines and associating closely with the editors and contributors.[5] They naturally befriended many of the Russians working in Paris at the time, including Chana Orlova, who drew lively portraits of the couple, and Osip Zadkine, who met them every Thursday at the Closerie des Lilas where, he reported, they sat "like two stone *babas*, while people cast them glances full of curiosity."[6] Larionov and Goncharova also befriended the Acmeist poet Nikolai Gumilev whom, on his arrival in Paris in July 1917, they positively monopolized.

Gumilev spent approximately six months in Paris as an official attaché of the Provisional Government's Military Commissariat. During this period, before he was posted to London, the poet formed a close relationship with Larionov and Goncharova which has been described in Larionov's letters to Gleb Struve. Gumilev and the two artists saw each other nearly every day as Gumilev was living at the Hôtel Galilée,

Fig. 157. Mikhail Larionov, *Portrait of Valerian Svetlov*, 1917

Fig. 158. Mikhail Larionov, *Guillaume Apollinaire*, 1917

just a stone's throw from the Hôtel Castille, and the close personal relationship naturally fostered a fruitful creative association. Larionov and Goncharova executed several portraits of the poet, among which Larionov's drawing (fig. 160), inspired by Gumilev's bold facial features, relies upon strong and expressive lines to capture something of the character of the elusive and temperamental poet. Goncharova, on the other hand, with characteristic finesse and imaginative flair, pictured the poet seated at a writing desk against a gorgeous oriental backdrop (fig. 161), composing the first stanza of his poem *Kitayskaya devushka* (*Chinese Maiden*). The wall-hanging behind him features the metallic bird with the resplendent golden tail that is referred to in a later stanza of the poem. Gumilev responded with a poetical portrait of the two artists entitled *Goncharova i Larionov:*

> The tender and splendid East
> Goncharova discovered within herself,
> The grandeur of real life
> Larionov sternly possesses.

Goncharova discovered within herself
The delirium and singing of peacock colors,
Larionov sternly possesses
The spinning of ferrous fire.

The delirium and the singing of peacock colors
From India to Byzantium,
The spinning of ferrous fire—
The wailing of the subdued element.

From India to Byzantium
Who's dozing, if not Russia?
The wailing of the subdued element—
Is this not the element renewed?

Who's dozing if not Russia?
Who has a dream of Christ and Buddha?
Is this not the element renewed—
Sheaves of light rays and piles of stones?

The one who dreams of Christ and Buddha,
Has set forth on fantastic paths.
Sheaves of light rays and piles of stones—
Oh, how the miners roar with laughter!

Fig. 159. Mikhail Larionov, 1917, *Ballets Russes* Gala Program, Paris, 1917

They set forth on fantastic paths
In sweet Persian miniatures.
Oh, how the miners roar with laughter
Everywhere, in the fields and the gloomy pits.

In sweet Persian miniatures
The grandeur of real life.
Everywhere, in the fields and the gloomy pits
The tender and splendid East.[7]

The poem was modelled on a Malaysian form of poetry known as the *pantum*, and was one of several eastern poetical forms with which Gumilev was experimenting at the time and for which, Larionov tells us, he had developed a passion. It was also an eminently suitable form for a poem concerning Larionov

and Goncharova, who themselves had such a high regard for eastern art forms. Moreover, the structure of the poem, in which the second and fourth lines of a stanza are repeated as the first and third lines of the following stanza, is perhaps an iconic representation of Larionov and Goncharova's cubo-futurist style of painting, in which an image is fragmented and its parts reproduced in different positions across the canvas.

Apart from its literary qualities, the *pantum* to the two artists demonstrates Gumilev's insight into Larionov and Goncharova's art. Here he characterizes the bases of their aesthetic ideology with an apposite choice of imagery and vocabulary. The first couplet of each stanza refers to Goncharova's enthusiasm for

Fig. 160. Mikhail Larionov, *Portrait of Gumilev*, 1917

nika itself. For Goncharova it represented a second chance to stage a Byzantine ballet, following the demise of *Liturgie*, but unfortunately plans for both *Gondla* and *Theodora* fell through and the two ballets went unrehearsed and unperformed.

Larionov and Goncharova also collaborated in the illustration of an album of manuscript poems that Gumilev wrote during his stay in Paris, which he left with Boris Anrep in London in 1918 before returning to Russia. The artist Dmitry Stelletsky, who was also in Paris at the time and knew Gumilev, designed two illustrations for the album. Larionov contributed two drawings in a coarse and primitive style, both for the poem *Muzhik (Peasant)*.[10] This evocative poem takes as its theme the conflict between the mysterious forces of Old Russia, symbolized by the *muzhik*, and the principles of western culture which the capital imposes upon the country. When the *muzhik* visits

Fig. 161. Nataliya Goncharova, *Portrait of Gumilev*, 1917

eastern art forms while the second couplet refers to Larionov's metaphysical interests.[8] The *pantum* is a remarkable and unusual homage to Larionov and Goncharova and testifies to more than a mere surface acquaintance.

Larionov, who was still acting as the commissioning adviser for the *Ballets Russes*, suggested that Gumilev provide the libretti for two ballets to be designed by himself and Goncharova. Gumilev proposed the text of *Gondla* as the basis for one ballet and wrote a piece called *Theodora*, a first draft of *Otravlennaya tunika*, for the second. For *Gondla* Larionov wanted to engage the composer Lord Berners, and for *Theodora*, the Italian composer Respighi, both of whom he had recently met in Rome. Whereas *Gondla* had already been written and published, *Theodora* was worked out in collaboration with the two artists.[9] Goncharova's enthusiasm for Byzantine art played an important role in the development of *Theodora* and hence in the origins of *Otravlennaya tu-*

St. Petersburg to enchant the Tsarina the whole city rises to defend itself against this representative of unknown forces that lie buried deep not only geographically in the heart of Russia but psychologically in its collective unconscious. The first drawing by Larionov (fig. 162), in its rough style and heavy outline, is reminiscent of a stone *baba*, a visual metaphor for the mythical and mystical Russia that gives birth to the *muzhik* who appears overleaf (fig. 163), a crude and monstrous figure, stalking through the forest and undergrowth of ancient Russia. The two illustrations capture the sombre atmosphere of Old Russia which the poem evokes.

During the latter half of 1917 and early 1918, Larionov continued to work for the *Ballets Russes*, and was still engaged with the designs for *Le Bouffon*. The score by Prokofiev, first commissioned in the spring of 1915, was now complete, but Diaghilev vacillated as to when to stage the ballet, and plans for its production were once again shelved. Larionov also made designs for a ballet entitled *La Fée des Poupées*, a ballet that Diaghilev had planned in Rome to combine the music of Rossini with the libretto of the German ballet *Die Puppenfee*. Bakst, however, had been chosen as the designer of *La Fée des Poupées* or, as it was renamed, *La Boutique Fantasque,* and Larionov's only official role was to commission Respighi in Rome to orchestrate Rossini's piano music. Yet when Diaghilev, Massine, and Bakst were organizing the choreography in Barcelona, Larionov continued to make designs for it, though why he should have done so remains unclear.[11]

A large number of Larionov's and Goncharova's ballet designs, including those for *La Fée des Poupées,* were exhibited during April and May of 1918 at their exhibition *L'Art Décoratif Théâtral Moderne* held at the Galerie Sauvage in the Rue St. Honoré. Both Larionov and Goncharova exhibited some recent paintings, including *Deux Dames,* a rayist work by Larionov, and three studies or constructions for coulisses (fig. 148), entitled *Ornements d'Architecture,* but the major portion of the exhibition comprised stage and costume designs. Goncharova exhibited nearly a hundred designs for ballets including *Le Coq d'Or, Sadko, Liturgie, Espana, Triana,* and *Les Noces.* Larionov's designs included almost twenty for *Soleil de Nuit,* nearly thirty for *Contes Russes,* a good dozen for *Le Bouffon,* and over twenty for *La Fée des Poupées.* None of the designs for the mechanical and shadow productions conceived in Rome were exhibited here, suggesting that they were still incomplete.

Larionov had not given up the idea of staging puppet performances and was at this very time collaborating on such a production with the Italian composer Alfredo Casella, whom he had met in Rome in 1917. Casella had invited Larionov to make designs for his new choral ballet entitled *Donna Serpente,* the libretto of which was based on a fairy tale by the Italian dramatist Count Carlo Gozzi. Larionov made a point of studying the original sources and examining Gozzi's theatrical work in preparation for the production.[12] However, Larionov was also keen to promote his own theatrical innovations, and in *Donna Serpente* he attempted to stage a contemporary production by giving the eighteenth-century tale a modern setting in which the men wear dinner jackets and the ladies, evening dresses, and by introducing twentieth-century military and political figures into the plot."[13]

It is difficult to identify any conventional theatrical designs by Larionov for *Donna Serpente* but there are several versions of a puppet design (fig. 164) for the point at which Altidor curses his fairy wife Miranda and she turns into a snake. Executed in the same spirit as his work for Lord Berners, this design functions both as an ordinary puppet and as a shadow puppet. The contraption in the upper half of the design, a blue square framing the head and an orange triangle that is fixed to it, are linked by chains to a wooden bar and evidently work as puppet strings, allowing the body to extend, contract, or sway from side to side. The design also functions as a shadow puppet, and the bold outlined coils of the snake's body, its camouflaging patches, and the rectangular panel with cut-out letters would show up on the screen and identify the character. The two diagonal bars that support the snake may be an allusion to the rods of the puppeteer. Unfortunately, Casella gave up the idea of *Donna Serpente* as a choral ballet and Larionov's designs were never used.

In the summer of 1918 the shelling of Paris rendered the capital unsafe and so, at the end of July, Larionov and Goncharova moved from the Hôtel Castille, which had been their home for sixteen months, and took up residence at Pivotins, in the Commune de Vieilmanay in Nièvre. From here Larionov kept in contact with his friends, especially Apollinaire, with whom he carried on a lively and witty correspondence.[14] Picasso had recently married the *Ballets Russes* dancer Olga Koklova in a Russian Orthodox ceremony in the Cathedral of St. Alexander Nevsky in Paris, and in August during his honeymoon sent a postcard to Larionov and Goncharova, inviting them to write and send drawings.[15]

One of Larionov's most interesting relationships at

Fig. 162. Mikhail Larionov, Illustration for the poem *Muzhik*, 1917

Fig. 163. Mikhail Larionov, Illustration for the poem *Muzhik*, 1917

English. What do you think of that? At the moment all my thoughts are taken up with this magazine.[16]

Berners had commissioned Larionov and Goncharova to make illustrations and cover designs for the publication of three of his scores. Larionov's design for the front cover of *Trois Petites Marches Funèbres* was never published but the black square pierced by a circle is of some interest (fig. 165). It is difficult to avoid a comparison with Malevich's *Black Square*, exhibited in Moscow at the "0.10" exhibition in December 1915, even though it is unlikely that Larionov's black square is a serious response to suprematism. Larionov did not agree with Malevich, nor did he accept suprematism or its artistic implications. Already, he had referred to Malevich as "old fashioned," and suprematism—or "the restriction of one's work to symmetrical figures," as he put it—as "absurd and boring."[17]

Larionov's illustrations for Berners' score *Trois Morceaux pour Piano* and Goncharova's frontispiece

Fig. 164. Mikhail Larionov, *Donna Serpente*, 1918

this time was with Lord Berners. Since their first meeting in Rome, they had maintained contact. Larionov, in a letter to Berners dated 27 November 1918, suggested producing three short ballets based on Berner's latest music, *Trois Morceaux pour Piano*, as well as the publication of an Anglo-Russian art magazine:

I think it's possible to make ballets of your three new pieces, and for my part, if you wish, I will gladly make the costumes and décors, and will do all I can to this end. . . . I am thinking of a magazine concerning both modern and the most ancient of art. I have had the idea of publishing it in both Russian and English, thus making English art known to the Russian public, and Russian art to the

3MARCHES FUNEBRES

LORD BERNERS

LARIONOW

Fig. 165. Mikhail Larionov, Unpublished cover design for the score *Trois Petites Marches Funèbres* by Lord Berners, c. 1919

and vignette for his *Le Poisson d'Or* were successfully published by Chester's of London in January and June 1919, respectively. For *Trois Morceaux* Larionov provided blue and brown drawings (pls. 22–25) that evoke the piano pieces that they accompany— *Chinoiserie, Valse Sentimentale,* and *Kasatchok.* The flat monochrome geometrical shapes, and the stencilled letters and dots scattered over the page, were to become Larionov's favorite graphic devices during the early 1920s. Nor are the drawings without wit. The title for *Valse Sentimentale* is abbreviated to *Valse Sentime,* a pun on a *centime* or penny waltz. The illustrations appear to have been prepared during mid-1918 and were probably given to Berners along with three similar designs for shadow puppets in early November 1918.[18]

The album caused great curiosity in musical circles when it was published. The witty review by the critic of *The Musical Times* was typical of contemporary response:

The illustrations must be seen to be believed. They are not likely to be understood, and the accompanying titles are also calculated to keep one in the dark. Thus, the casually disposed letters C H I C H I R I, with a few floating blue and brown full-stops, do not go far towards "Chinoiserie." Before the second piece we read V A L Ƨ E Ƨ E N T I M E. Apparently Mr. Larionov got tired hereabouts. You will notice the subtle humour in the disposition of the S and I. Admitting that "Valse Sentimentale" is perhaps rather a heavy dose for a stenciller, I turned to No. 3, feeling sure that "Kazatchok" would not be decapitated. But evidently Mr. Larionov had mislaid his Z and forgotten an A, for only "katchok" appeared, as casually dispersed as the rest. . . . It was a relief to get on to the music. Not that this was plain sailing. A reading at the necessary slow pace was about as comfortable as a progress over broken glass bottles.[19]

During 1919 Larionov's name became more familiar to the English public through his connection with the *Ballets Russes.* In August 1918 the company had arrived in London, where Diaghilev had obtained a six-month season at the Coliseum. Fourteen pieces of scenery for Larionov's ballet *Contes Russes* had been burned in a train during the tour of South America, and while in London Diaghilev decided to have these replaced. He also took the opportunity to suggest several additions to the ballet, including a celebration at the end of the *Kikimora* story where a crowd of peasants acclaim Kikimora and her cat. A new sequence was added to *Bova Korolevich* in the form of a lament

of the Swan Princess (*Lamentation de la Princesse Cygne*), in which the dragon, who has bewitched the princess, allows her to roam at night by a magic pool before returning to his palace in the morning. Finally, after the battle between Bova and the dragon, Diaghilev added another sequence entitled *Funérailles du Dragon* (*Funeral of the Dragon*), where the Russian peasants carry the dragon's heads in a solemn ceremony which turns into a celebratory dance.

Consequently, considerable work on *Contes Russes* was required. Massine had to create the choreography for the new additions to the ballet, and Vladimir Polunin, the company's scene painter, had to recreate the scenery destroyed in the fire and paint the new décors, which presented many technical problems.[20] Diaghilev asked Polunin to design a drop-curtain for the *Lamentation de la Princesse Cygne,* and only when Polunin refused and insisted on a design from Larionov, did Diaghilev telegram the artist on November 26.[21] Larionov made the required designs and supplied them by post in early December, less than a month before the planned première, along with two letters suggesting changes to the costumes and dances, ideas that were politely ignored by Diaghilev.[22] Furthermore, taking advantage of Larionov's absence, Polunin records that Diaghilev "decided to have the scene for the third act painted in green, remarking, 'I want it to be spring like instead of looking like a banana forest.' And the scene took on the aspect of spring much to the displeasure of the designer (as I learned later)."[23]

The English première of *Contes Russes* took place on 23 December 1918 and, despite all the problems, was a triumph for the *Ballets Russes* and for Larionov. The ballet was enthusiastically reviewed by both the critics and the press. Roger Fry wrote that the ballet was "the most lovely spectacle that I've ever seen on the stage."[24] The critic of *The Times* thought that Larionov's designs for the devils in *Baba Yaga* could be successfully marketed as a new line in Christmas toys, and declared, ". . . the grotesque setting is so quaint and unlike anything that one usually associates with a children's entertainment, the dancing of the whole team is so exhilarating, that one cannot wonder at the enthusiasm which greeted it."[25]

The *Ballets Russes* remained in London through Christmas 1918 and the whole of 1919. During this time Larionov's ballets continued to excite the public and as late as November 1919 they still attracted favorable criticism:

Children's Tales and *The Midnight Sun.* Both are Russian in subject, designed as to scenery and cos-

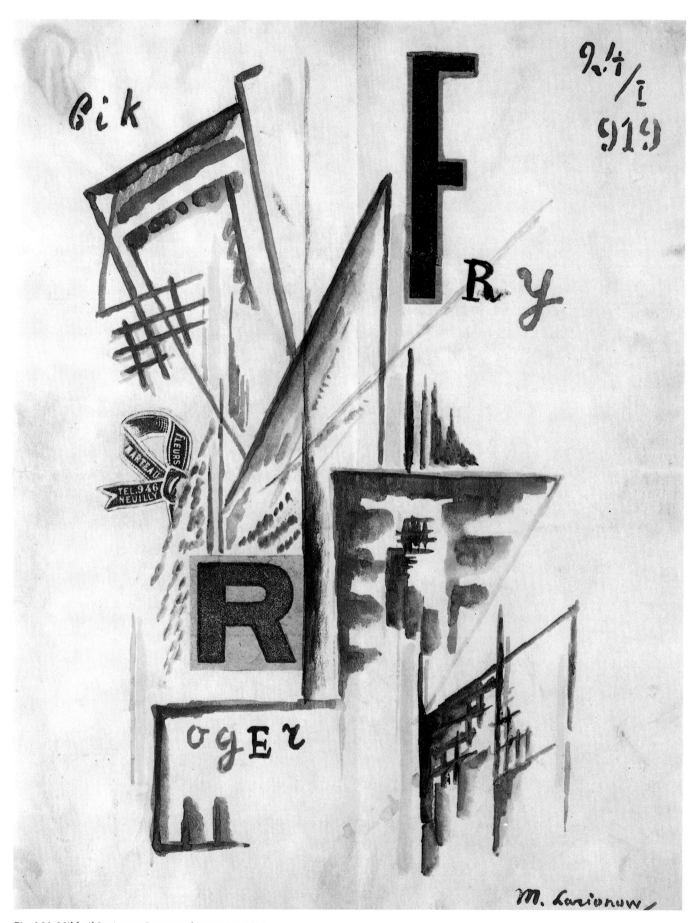

Fig. 166. Mikhail Larionov, *Portrait of Roger Fry*, 1919

174

tumes by Larionoff, whose handling of the opportunities for colour which these peasant dances and folk tales provide is triumphantly daring. The peculiar fascination of *Children's Tales* is hard to define; but it might be written of these strange little tableaux of witches, dragons and enchanted swan maidens, as Pushkin wrote of the wise cat and other marvels which form the theme of Rimsky-Korsakoff's *A Fairy Tale:* "There dwells the true spirit of Russia. I have been there."[26]

It is doubtful whether Larionov attended the première of the revised *Contes Russes* at the Coliseum. He did, however, have an eye to the appreciation of his work in Britain and to this end had established written contact with Roger Fry. In a letter to André Gide of 9 February 1919 Fry wrote that Larionov had sent him "some most interesting letters" about his designs for the *Ballets Russes,* and that he in turn was writing an article about Larionov for the *Burlington Magazine.*[27] Although Larionov had not yet met Fry, he executed a splendid watercolor and collage portrait of him (fig. 166). The portrait displays Larionov's continued fascination with the stylistic qualities of printed images, in the stencil-style date in this portrait, as well as his witty use of collage. The use of newsprint letters and the flower ribbon alluding to Fry's bow tie recall his collage paintings exhibited in The Year 1915.

Larionov's friendship with Roger Fry led to the organization of an unusual exhibition at the Omega Workshops in London in February 1919 (fig. 167). The Exhibition of Sketches by Larionov and Drawings by the Girls of the Dudley High School featured thirteen works by Larionov and a number of drawings by schoolgirls, who were taught by Marion Richardson, one of the pioneers of British art education. Larionov's contribution included his experimental theatre designs for *Histoires Naturelles, Trois Petites Marches Funèbres, Donna Serpente,* and *La Reine d'Ethiope,* and he also showed some drawings on blue and brown paper.[28] Apart from the list of Larionov's exhibits, the rest of the catalogue, written by Roger Fry, was devoted to Marion Richardson and her pupils.

Richardson had studied at Birmingham Art School under Catterson Smith, a former assistant of Burne-Jones and William Morris, who advocated the artistic expression of mental imagery and taught his students to paint what they remembered or visualized in their mind. When she became Art Mistress at Dudley High School in 1912, Richardson based her own teaching techniques on the work of Catterson Smith. She en-

couraged her pupils to give artistic expression to their mental imagery, and to help them she devised the "word picture." The pupils, after closing their eyes and listening to Richardson's description of a "picture" she had seen, were then asked to paint the picture that evolved in their own minds during the description. They were encouraged to criticize and discuss their own work and to make written evaluations.

The collaboration of Larionov, Fry, and Richardson on the Omega exhibition was an expression of a mutual interest—the relationship between Fauve, expressionist, and neo-primitive trends in contemporary painting, and children's art. Children's art had been of importance in the development of Russian neo-primitivism. Moreover Larionov, who maintained a deep interest in the art of children throughout his life, must have been fascinated by Rich-

Fig. 167. Catalogue of the Exhibition of Works by Larionov and the Girls of Dudley High School, 1919

Fig. 168. M. Macdonald, *The Russian Ballet*, 1919

ardson's techniques of teaching art as well as by the remarkable results achieved by her pupils. Roger Fry also had an interest in the comparison of the work of artists such as Larionov and the art of children. The subject was an important theme in his writings, and in 1917 he tried to provoke discussion of the topic by arranging the exhibition Drawings by Children of Artists.[29] It was at this exhibition that Fry first met Richardson, after which he added to it some drawings by her pupils. Richardson had been intrigued by the same question ever since 1912, when she visited the Second Post-Impressionist Exhibition and was astounded by the similarities between the paintings on exhibit and the work of her own pupils.

More importantly, Richardson and Larionov shared a mutual appreciation of each other's work which yielded surprising results for both. In late 1918 or early 1919 Fry had introduced Richardson to the *Ballets Russes*, and consequently she was allowed to attend rehearsals, go behind the scenes, and meet the company. In the *Ballets Russes* she discovered rich source material for her teaching, as scenes from the ballets made exciting "word pictures" for the children. The headmistress of Dudley at that time recalled; "Many a time Marion went up to London after school to see the Russian Ballet, returned by the last train, and walked from Dudley Post, getting home after midnight. The next day she gave the children vivid word pictures of the ballets she had seen, with the result that many lovely paintings were made."[30]

It was Larionov's ballet designs, and especially those for *Soleil de Nuit*, that exerted the strongest influence on Richardson. In her autobiography she states; "We had already made a series of drawings from my description of the ballets *Children's Tales* and *The Midnight Sun*. Roger Fry had been especially pleased with them."[31] Indeed, nearly fifty children's paintings based on Richardson's descriptions of the Russian ballets still exist in the Marion Richardson Archive, and seventeen of these may be positively identified as being based on "word pictures" of Larionov's *Soleil de Nuit*.[32] The majority of these delightful paintings, like that by M. Macdonald (fig. 168), reproduce the string of smiling suns that were

painted on the backcloth, the suns strapped to Massine's hands, or the decorative red and green coulisses. Other pictures, such as that by Ada Thacker (Marion Richardson Archive), are more imaginative and less straightforward transcriptions of Richardson's word pictures. Ada used Richardson's description of the long shirtsleeves worn by Larionov's buffoons but imagined her own backcloth with windows, door, and a magnificent blue sun emanating gold and orange rays.

Five of the *Soleil de Nuit* word pictures were dated March 1919 by the children, and the coincidence between this date and Larionov's exhibition at the Omega with Richardson's pupils raises some provocative but at present unanswerable questions about the creative relationship between artist and art teacher at this time. Richardson's use of Larionov's theatrical design concepts for her word pictures represents the unusual reciprocal influence of Fine Art upon children's art, and Larionov's work thus played a fascinating if limited role in the development of art education in Britain. A year later, in order to earn supplementary income, Goncharova gave art lessons to French children and adopted Richardson's techniques.[33]

Roger Fry must have played a crucial role in the relationship between Richardson and Larionov. He had not only championed Richardson's cause since 1917 but now, in 1919, became the first person to acclaim Larionov's theatrical work in Britain. In his scholarly article published in *Burlington Magazine* he reproduced and discussed not only Larionov's work for *Soleil de Nuit* and *Contes Russes,* but also the mechanical costumes and designs for shadow puppets then on display in the Omega exhibition. In particular, Fry admired Larionov's original and skillful use of color, as well as his ability to evolve forms in both costume and puppet design that expressed the nature of a particular character and suited the specific movements it would make. He concluded that Larionov occupied a unique role in modern history, being the very first to have "set a real work of visual art within the frame of a proscenium."[34]

The spring of 1919 was a crucial period for Larionov as he was now in a position to assess the different approaches he had made in theatrical design since his first collaboration with Diaghilev in 1915. In fact, both Larionov and Goncharova were reviewing their theatrical work in an album of representative designs which they were to publish under the title of *Gontcharova Larionow: L'Art Décoratif Théâtral Moderne.* The album included Larionov's neo-primitive and experimental designs since 1915 which would find a magnificent resolution in his designs for *Chout* in 1921.

At present, though, there were more practical and urgent considerations. Larionov and Goncharova had temporarily given up hope of returning to Russia. The country was deep in civil war and their friends had fled from Moscow and Petrograd. Kruchenykh and the Zdanevich brothers were in Tiflis, David Burlyuk had taken his family to Vladivostok and was preparing to move to Japan, and many who had the means had already taken a ferry for Bergen and left their homeland for good. Larionov and Goncharova decided to end their years of wandering and to establish a home in Paris, at least until events in Russia had settled. Accordingly on 5 May 1919, the two artists left Pivotins and returned to Paris, where they rented a small fourth-floor flat at 43 Rue de Seine and a small studio at 13 Rue Visconti. Now a new period began in Larionov's life. There was to be a decade full of excitement and optimism following the war, a time when Montparnasse beckoned and Larionov became a leading member of the School of Paris.

Montparnasse Bienvenue

1919–1929

■

Larionov and Goncharova celebrated their arrival in Paris with a large exhibition of their theatrical work in May 1919 at the Galerie Barbazanges in the Rue Faubourg St. Honoré. The exhibition was similar to that at the Galerie Sauvage the year before in that Goncharova showed substantially the same paintings and designs and Larionov showed his work for the ballets *Soleil de Nuit, Contes Russes, Le Bouffon,* and *Fée des Poupées.* In addition, however, Larionov exhibited illustrations to the music of Lord Berners, including those recently published by Chester, as well as several mechanical costume designs for Berners' *Trois Petites Marches Funèbres,* a dozen designs for *Histoires Naturelles,* and a few for *Donna Serpente.*

The impressive folio *L'Art Décoratif Théâtral Moderne* (fig. 169) was published concurrently with the exhibition. It comprised an essay about the two artists by Valentin Parnack and reproductions, in the form of pochoirs and prints, of several of their designs on display.[1] The text discusses Larionov's theories about dance and theatre, and details the theatrical projects with which he was then involved. Parnack, like Svetlov before him, suggests that the harmony between form and color, costume and décor, costume and movement, and design and music is fundamental to Larionov's concept of theatrical design. He proclaims Larionov to be the initiator of new types of choreography that include dances based on free movements, types of gait, animal movements, mechanical dance, and social dance related to work. Unfortunately these categories remain ambiguous though some obviously relate to projects such as *Histoires Naturelles* and *Trois Petites Marches Funèbres.* In particular, Parnack refers to the choreographic aspects of Parisian life which so enraptured the artist:

Larionov is a lover of machines, parts of cars, metros, tramways, streets, neon signs, the rhythm of crowds in the stations, arriving and leaving, the movements of waiters and clients in the restaurants, the movement of the streetwalkers, the sports linked with work—cars, bicycles—the camouflage of guns, the motions of billiards, of singing cadmium, the flutes of rose-madder. Syncopations of Negro and American music . . . garages, stations, bridges, the Eiffel Tower.[2]

The excitement and bustle of the description is futurist in tone, and Parnack reveals that Larionov is still fascinated by modernism and responsive to the latest technological and social developments in his art.

Parnack also discusses two satirical ballets that Larionov was then designing. *Le Fumier* (*The Manure Heap*) was concerned with the rhythmical movements of a farmer ploughing his field and planting beans in the furrows. This was what Larionov called "social dance," born from the rhythms of the work routine. The second ballet to which Parnack refers is *Le Bureau des Idées* in which people purchase bright ideas from a bureau but subsequently corrupt them when putting them into practice. We know that Larionov planned two other ballets, one called the *Commedia dell'Arte Moderna,* and the other *La Conférence de la Paix,* which celebrated the signing of the Versailles Peace Treaty on 28 June 1919. Little is known of these productions, though an interesting curtain design for *La Conférence de la Paix* exists which was inspired by the pile of redundant armaments gathered together and garlanded in the Place de la Concorde after the Armistice.[3] Unfortunately, none of these ballets were completed and Larionov's novel ideas remained unrealized.

In June Larionov arranged several soirées to accompany the exhibition at the Galerie Barbazanges. These presented music by Stravinsky, Berners, and *Les Six* and recitals of poems by Cocteau, Jacob, Cendrars, and Reverdy.[4] Larionov organized another soirée at the Barbazanges in July in aid of the Russian Canteen for Free Meals. Originally, he planned to perform *La Conférence de la Paix* and his *Commedia*

Fig. 169. Mikhail Larionov, Cover
of *L'Art Décoratif Théâtral
Moderne*, La Cible, Paris, 1919

dell'Arte Moderna at this event, but at the last moment the two pieces were replaced by a program of poetry, music, and dance in which Parnack, Cendrars, and Cocteau recited their poems, Lipkovska sang Russian songs, Sonya Pavlova danced, and Casella played his *Pagine di Guerra*.[5]

The heady summer following the war gave way to the escapism of the twenties and a new flourishing of social and cultural life in Paris. Larionov's response was characteristically hedonist and he indulged himself in the lively café culture and artistic nightlife of Paris. Larionov did little creative work in this period. Those who knew him intimately ascribed this to his nervous condition while others, among them Stra-

vinsky, believed that like Oblomov, Larionov enjoyed laziness and that Goncharova did most of the work. Larionov's medical condition certainly exacerbated a lazy streak in his character but this was compensated by an omnivorous interest in artistic events and by his organizational skills. Vera Popova gave a more objective view when she said, "In fact Larionov was Goncharova's impressario from the start of their Parisian life. He went everywhere, knew everyone, and obtained all her commissions himself, while Goncharova never moved but remained at home to work."[6]

Towards the end of the year Larionov received news that his brother had died while fighting in the Red

Army. Perhaps as a result, the artist became fascinated by Aleksandr Blok's revolutionary poem *Dvenadtsat'* (*The Twelve*) about the heroic soldiers of the Red Army and their battle for the Gospel of Bolshevism. During early 1920 Larionov, Goncharova, and Serge Romov prepared two versions of the poem for publication by Povolotzky. A French edition entitled *Les Douze*, with illustrations by Larionov, was published in April, and a Russian edition entitled *Dvenadtsat'*. *Skify* (*The Twelve. The Scythians*), with illustrations by Larionov and Goncharova, was published in June.

Larionov's illustrations reveal his technical and creative mastery of graphic media. Those for the French edition offer interesting interpretations of the characters who people the dark world of the poem. They include the old woman weeping at the sight of a Soviet banner (fig. 170), the fine lady who slips in the snow, and the bourgeois, lost at the crossroads, looking like a question mark. Against the bleak ground of the paper, suggestive of the snowy landscape, Larionov drew annotated figures and blurred forms, evoking the chilling and anonymous qualities of the poem. His portrait of the soldier Vanka, who sleeps with Katya the prostitute, is again noncommital (fig. 171). The untitled drawing with its schematic outline and vacant face suggests that Larionov's aim is not to depict a specific character but to represent the "unknown" soldier of the Red Army. The graffiti is explicit and obscene. The marbled veins, which separate us from the portrait and hence add to the feeling of alienation, are a visual pun on the phrase "first class" (*pod mramor*) which literally means "under marble." Another illustration (fig. 172) depicts the monstrous outline of the soldiers silhouetted against the fresh snowfall, their features obscured by the black night and blizzard. In the final illustration Larionov depicted Jesus Christ who leads the twelve onwards in their revolutionary cause.

Larionov's illustrations for the Russian edition, however, were rugged and coarse. The soldiers are no longer ambiguous figures lost in snow but are the bold revolutionaries who later appeared on the cover of the English version of the poem (fig. 173). The love scene between Katya and Vanka as it is illustrated in the Russian version evokes a brutal quality commensurate with the violence of the poem (fig. 174). Larionov had already treated this theme in his postcard *Sonya the Whore* (fig. 39) on which this particular illustration was based.

For Blok's poem *Skify* (*The Scythians*), in the same volume, Larionov illustrated the metaphors of the poem. The reference in verse five to "Doom spreading

Fig. 170. Mikhail Larionov, Illustration for *Les Douze* by Alexandre Blok, 1920

her wings," an image borrowed from the twelfth-century Russian epic *Slovo o polku Igoreve* (*The Lay of Igor's Host*), is interpreted as a bird flying over a skull (tailpiece). Larionov also depicts the Scythian imagery of the poem. His illustration to verse twelve (fig. 175), in which the Scythians brag that they can tame wild horses and women slaves, is executed in the style of a Turkish shadow puppet. Larionov's finest illustration is of verse fifteen which contains the most potent imagery in the poem. Here the Scythians present a civilized face to the west but suddenly reveal their Asiatic "mug" (fig. 176). The image is a metaphor for Russia and it was one to which Larionov particularly responded since neo-primitivism had attempted to present the genuine Asiatic aspect of Russian art. His illustration depicts the barbarous face of

Fig. 171. Mikhail Larionov, Illustration for *Les Douze* by Alexandre Blok, 1920

Fig. 172. Mikhail Larionov, Illustration for *Les Douze* by Alexandre Blok, 1920

the east which hides behind the docile mask presented to the west.

In November 1920 Chatto & Windus in London published an English translation of Blok's poem by C. E. Bechhofer with illustrations from the French version of the book.[7] Larionov's cover designs (fig. 173), which were superior to that of the French edition, were executed in a new and vigorous way. The soldiers of the Red Army are depicted by thick stepped lines and irregular monochrome blocks, creating a monumental effect that elevates them to the plane of mythical heroes. Their severity, however, is comically relieved by a spray of pellets from their guns. Unfortunately, Blok's poem was greeted with incomprehension. Walter Propert, who saw the French version in 1920, admired Larionov's "gaily

drawn" and "terrifying illustrations," but was bewildered that they should illustrate "an abominable book of Bolshevik marching songs"![8]

During 1920 Larionov also made a cover design for Casella's score *Pupazzetti* (fig. 177) which was published in London a year later by Chester. This commission arose out of Larionov's collaboration with Casella and their common interest in puppet theatre. The design develops the concept of dots and rectangles employed for the cover of *The Twelve* and, although the degree of abstraction is more advanced here, the drawing retains an anthropomorphic quality characteristic of Larionov's graphic work at this time. Larionov also experimented with graphics in illustrations to a volume of poems by Parnack entitled *Motdinamo Slovodvig* which feature insubstan-

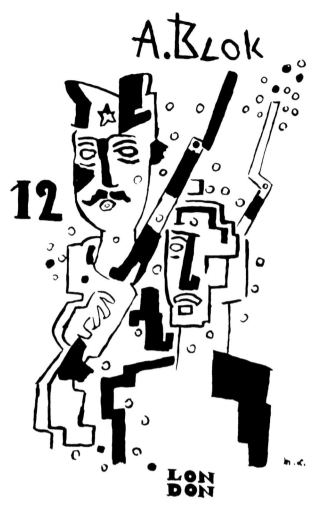

Fig. 174. Mikhail Larionov, Illustration for *Dvenadtsat' Skify* by Aleksandr Blok, 1920

Fig. 173. Mikhail Larionov, Front cover of *The Twelve* by Alexander Blok, Chatto and Windus, 1920

Fig. 175. Mikhail Larionov, Illustration for *Dvenadtsat' Skify* by Aleksandr Blok, 1920

Fig. 176. Mikhail Larionov, Illustration for *Dvenadtsat' Skify* by Aleksandr Blok, 1920

tial linear extrapolations or compositions of contrasting black and white forms.

In October, Kirill Zdanevich arrived in Paris from Tiflis, where he too had gained a reputation as an illustrator of avant-garde publications. It was five years since Larionov and Goncharova had seen Zdanevich and as a gift he brought them copies of several avant-garde books with experimental typography and illustrations. These typified the subversive and anti-aesthetic approach to poetry and book illustration undertaken by the Zdanevich brothers, Terentiev, and Kruchenykh in Tiflis in the post-revolutionary years.[9]

At this time Larionov was preparing the final designs for the ballet *Le Bouffon* which Diaghilev planned to stage in Paris in May 1921 under the Russian title *Chout*. Initially these designs were conceived in a restrained neo-primitive manner but subsequently Larionov evolved sets and costumes that were a brilliant mélange of neo-primitivism and cubo-futurism. The French and Russian texts in the bottom corners of the curtain design (fig. 178) recall Larionov's *Seasons* paintings and the influence of the *lubok* in the way that they explain the subject of the ballet. Beyond this the design has no connection with the libretto and depicts instead a stone saint from Notre-Dame in Paris and a stone *baba* associated with St. Basil's in Moscow. The central panel, however, features the gothic spires, rose window, gargoyles, and "onion" domes of the respective cathe-

Fig. 177. Mikhail Larionov, Cover of the score *Pupazzetti* by Alfredo Casella (1920)

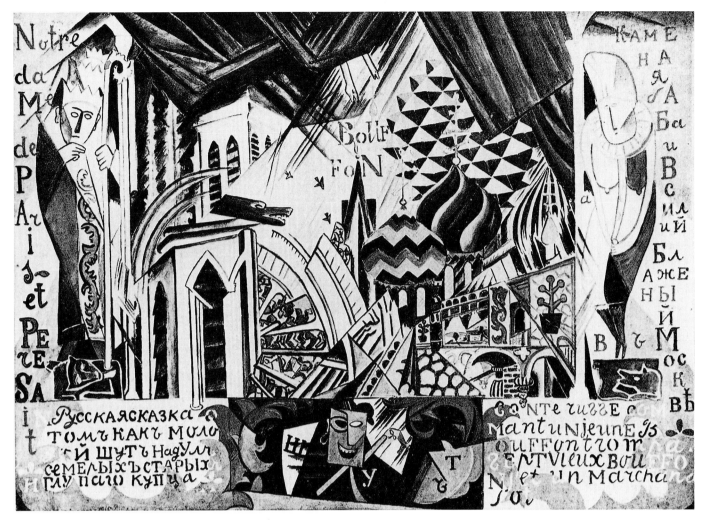

Fig. 178. Mikhail Larionov, Curtain design for *Chout*

drals which are fragmented and recombined in a cubo-futurist manner.

Similarly, Larionov's design for the first scene of *Chout* (fig. 179), depicting the interior of the fool's house, is based directly on the *lubok* tradition. The stove and stylized cloud of smoke belching from its chimney is copied from *The Pancake Vendor* (fig. 74) as are other interior features such as the shelves of bread. To these neo-primitive aspects Larionov adds cubo-futurist devices: spatial ambiguity is created by the intersecting triangles of the floor and the timber walls and roof of the background; other set designs feature the interpenetrating planes of shattered roofs and displacements on either side of a diagonal.

The sensational costume designs were equally striking. Those for the buffoons were executed in red, white, yellow, and green, and comprised stripes, spots, intersecting lines, and stylized ornamentation. The confusion between color and pattern was compounded by complex accoutrements such as triangular epaulettes. The same principles were adopted in the costumes for the fool and his wife (fig. 180). Here colored bands and triangles were employed with rich ornamentation while the tunic and pantaloons of the fool and the hem and hoop of his wife's costume were strengthened with cane to keep their shape. Despite their striking visual qualities the costumes were appallingly uncomfortable. Larionov had gained a reputation among the *Ballets Russes* for the most brilliant yet most impractical costumes that the company were ever called upon to wear. By now he was inured to their criticisms and pressed on to subjugate the role of the dancer to the will of his aesthetic.

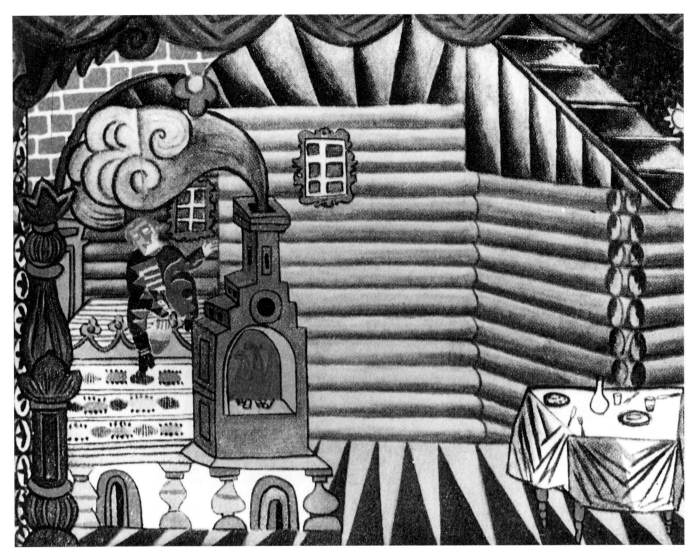

Fig. 179. Mikhail Larionov, Set design for Scene 1 of *Chout*, 1921

Owing to the fact that Massine had been given his notice in January while the *Ballets Russes* were in Rome, Diaghilev invited Larionov to design the choreography and dramatic action of *Chout* with the aid of the dancer Slavinsky. According to Haskell, Diaghilev even asked Larionov to dance in the ballet but he claimed to have stagefright and refused![10] This was the third time that Larionov had contributed to the choreography of the company, a unique achievement for a painter, and it testifies to his extensive knowledge of dance and choreography that Diaghilev placed so much trust in him.

On 15 March 1921 Larionov signed a contract stating that he would accompany the *Ballets Russes* for three months in the capacity of artistic director, and

shortly afterwards he left Paris to join the company in Madrid.[11] Here Larionov met Sergei Prokofiev (1891–1953), the composer of the score, and together with Slavinsky, they completed the plot of the ballet and began rehearsals. Larionov became particularly friendly with Prokofiev in the coming decade and made him the subject of numerous drawings and engravings (fig. 181). Following the end of the *Ballets Russes* season in Madrid in April, the company moved to Monte Carlo where work on *Chout* continued. Here Larionov renewed his friendship with Juan Gris whom Diaghilev had commissioned to draw portraits of Larionov and Slavinsky for reproduction in the *Chout* program. Shortly afterwards, the *Ballets Russes* travelled to Paris for their season at the Gaieté

Fig. 180. Mikhail Larionov, *The Fool and His Wife*, in *Chout*, 1921

The French audience remained indifferent to *Chout* because of the complex plot, Larionov's outrageous costumes, the difficult music by Prokofiev, and the fact that the "choreography" was closer to pantomime than ballet. The critics, however, claimed the production to be a masterpiece and declared Larionov's design and choreography to be a crucial manifestation of cubism on the stage.[12] Eganbyuri argued that Larionov was a precursor of Picasso in this respect as his designs for the ballet dated from 1915, preempting Picasso's application of cubism in *Parade* by two years. The costumes for *Chout* were certainly astonishing creations, but they had undergone a long metamorphosis, and it is unlikely that the final costume designs were conceived as early as 1915. They were, nonetheless, worthy of the enthusiasm lavished upon them by the critics.

When the season in Paris ended, Larionov accompanied the *Ballets Russes* to London to supervise the British première of *Chout* at the Prince's Theatre on June 8 and 9. The English audience, however, were scandalized by the ballet and voiced their protests. The critic of *Vogue* complained that *Chout* was "a nightmare of impudent, bad-boy perversity, for which the perpetrators deserved rather to be spanked and put to bed than criticised."[13] The critic of *The Observer* thought that "*Chout* itself is the worst of bores . . . the shrillest of elementary colours are painted on the backcloths and dresses . . . the retina of the eye was almost torn assunder . . . The new artform, as represented by *Chout*, has not yet learned to walk. It can scream very piercingly whilst waiting for its bottle."[14] No one had a good word for the ballet and, although Diaghilev defended it in *The Times*, *Chout* was temporarily dropped from the repertoire.

Larionov remained in London for the opening of the First Russian Exhibition of Arts and Crafts at the Whitechapel Gallery later in the month. The exhibition brought together over four hundred and fifty works by more than seventy Russian artists working in Paris or London, and Larionov and Goncharova dominated the show with nearly eighty paintings and theatre designs. Larionov recalled that the opening night was crowded with artists and writers and that he met Wyndham Lewis, who invited him and the Russian dancers to the Eiffel Tower Cabaret.[15] Larionov stayed in London for over two months, living first in Kensington, but later he moved to Tower Street, near the British Museum, where he was closer to both the theatre and the exhibition.

On his return to Paris Larionov exhibited his works widely at the various Parisian salons, including the *Salon des Tuilleries* and the *Salon d'Automne* to

Lyrique where *Chout* was given its première on May 17.

Chout had a complicated plot in which a young fool tricks seven old fools into believing that his whip brings the dead back to life. The old fools buy the whip and murder their wives, but the whip fails to work. The young fool disguises himself as a female cook and when the old fools arrive for revenge, they take him hostage. The seven old fools are then visited by a rich merchant who intends to marry one of their daughters. The merchant however prefers the cook and leads him to the bridal chamber. In the bedroom the cook complains to the merchant that he feels ill and asks to be lowered from the window by a bed sheet. Once on the ground the cook ties the sheet to a goat, and when the merchant hauls the sheet back he is inconsolable to find his beloved turned into a goat. The old fools mock the merchant but then the young fool bursts in with seven soldiers and demands the return of his cook. When they offer him the goat in return he has them arrested and fines the merchant a hundred roubles!

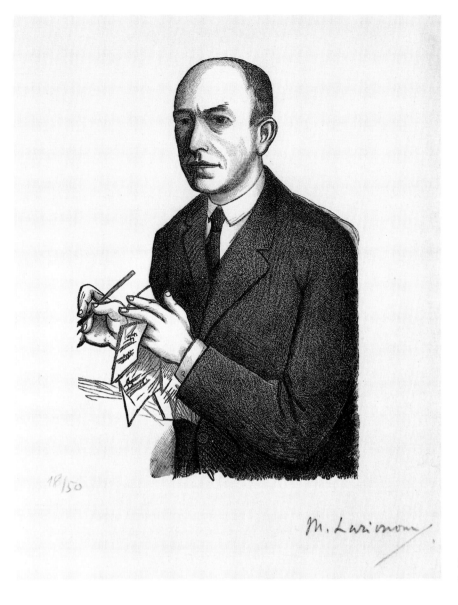

Fig. 181. Mikhail Larionov, *Portrait of Prokofiev*, c. 1921

which he and Goncharova contributed every year throughout the decade. Then, in early November 1921, Ilya Zdanevich emigrated to Paris and stayed for several months with Larionov and Goncharova in the Rue de Seine.[16] During the revolutionary years Zdanevich had been active in the cultural life of Tiflis, where he had founded an avant-garde literary society called "The University of 41 Degrees." Zdanevich had now matured into a poet of some merit, and his stay with Larionov and Goncharova was mutually rewarding. Larionov introduced Zdanevich to the artists and poets of Montparnasse as well as to the leading cafés, galleries, and publishing houses. Zdanevich, on the other hand, shared with his old futurist allies all that had happened in Tiflis, and es-

pecially the new poetical theories that had been developed by himself, Kruchenykh, and Terentiev.

At the end of November Zdanevich gave a public lecture on "New Schools of Russian Poetry" in the studio of the singer Olenine d'Alheim. It was Larionov, however, who organized the venue and designed the décor for the evening. He also designed the striking orange and black posters as well as the charming carmine and black invitation cards (fig. 182). The surprising typographical layout of these was evidently inspired by the innovations undertaken by Zdanevich in his Tiflis publications, even though there are none of the fractured words and overprintings that the poet pioneered in books such as *Milliork* (1919). The design of Larionov's invitation card is based

Fig. 182. Mikhail Larionov, Invitation card to the lecture *New Schools of Russian Poetry*, Paris, 1921

more on rayist principles, featuring the dynamic intersection of diagonal lines of type, which explode from a point as if coming from the mouth of an unseen orator.

Using his extensive network of contacts Larionov arranged for the distribution of the invitations to editors, critics, and poets, including Canudo, Pierre Albert Birot, and Raymond Cogniat, all of whom attended the lecture that successfully introduced Zdanevich and his *zaum* poetry to the literary world of Paris. After this, even though Larionov and Zdanevich continued to associate with each other and participate in communal ventures, their relationship, no longer sustained by a common aesthetic ideology or the kind of intense creative activity they had known during their futurist years in Moscow, began to wane.

Larionov continued to stay in contact with members of the Russian avant-garde who had remained in their homeland. Both Rogovin and Chekrygin wrote long letters to Larionov during 1921. Rogovin, excited by constructivist developments in Russian art, complained of Larionov's absence and tried to persuade him to return to Russia:

Your obstinate persistence to remain in Paris surprises me greatly. I think that a painter like yourself cannot live to the full outside his native land. What's so good about Paris? There's nothing especially attractive while here everything is extremely interesting and new, especially for someone of your genius. There are new people, there is material for art and unlimited painting.[17]

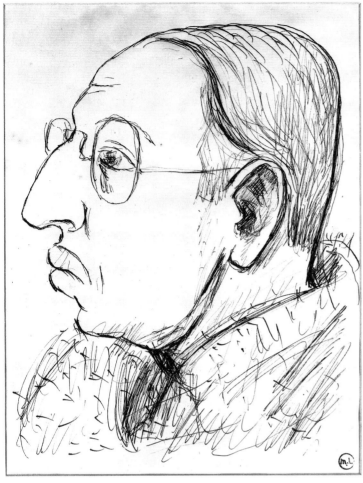

Fig. 183. Mikhail Larionov, *Portrait of Stravinsky*, c. 1922

Fig. 184. Mikhail Larionov, *Bronislava Nijinska*, c. 1922

Chekrygin also informed Larionov about artistic events in Russia but he complained of the artistic climate, warned Larionov not to return for "life here is intolerably hard," and enquired about Paris: "Is it possible to work there freely, are there paints, canvas, brushes, exhibitions, pencils, paper? . . . The desire for Paris, for its atmosphere and Lefranc's paints came upon me like a pregnant woman's desire for a watermelon."[18] The anticipated flight to Paris, artistic freedom and Larionov, remained a dream, however, for the artist died prematurely in the summer of the following year.

Larionov had no intention of leaving Paris. He found its artistic and social life too exciting and, above all, there was the financial security and artistic recognition with Diaghilev, who had recently offered Larionov another commission—to make designs for *Le Renard*, a short ballet to music by Stravinsky. Larionov and Stravinsky enjoyed a close relationship and

the artist made numerous sketches of the composer with Stravinsky's profile penned in with bold strokes (fig. 183). To collaborate on the new work Diaghilev employed the young Bronislava Nijinska (1891–1972) who had recently joined Diaghilev as the new choreographer of the *Ballets Russes*. Not only was Nijinska the choreographer of *Le Renard* but she also danced the leading role in the ballet when it was first performed at the Opéra in Paris on May 18. Larionov's delightful portrait of Nijinska (fig. 184) indicates the fineness of her facial features by delicate pencil lines and rejects the heavy caricatural qualities found in the portrait of Stravinsky.

Larionov's curtain design for *Le Renard* (fig. 185) was based on his neo-primitive painting *Winter* (fig. 49), executed a decade before, though the descriptive panel in Russian identifies the title and production details of the ballet. The set (fig. 186) represented a barn while the costumes were executed in a re-

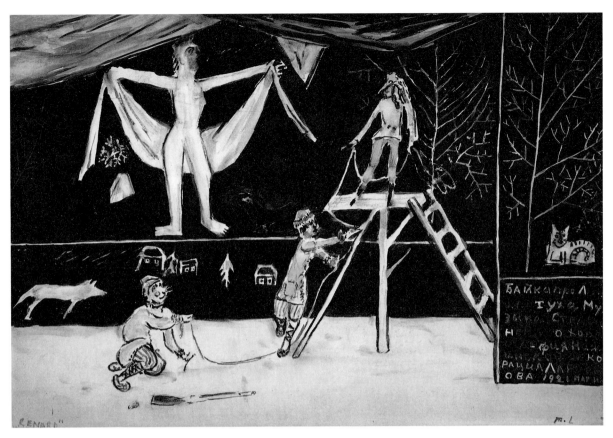

Fig. 185. Mikhail Larionov, Set design for *Le Renard,* 1922

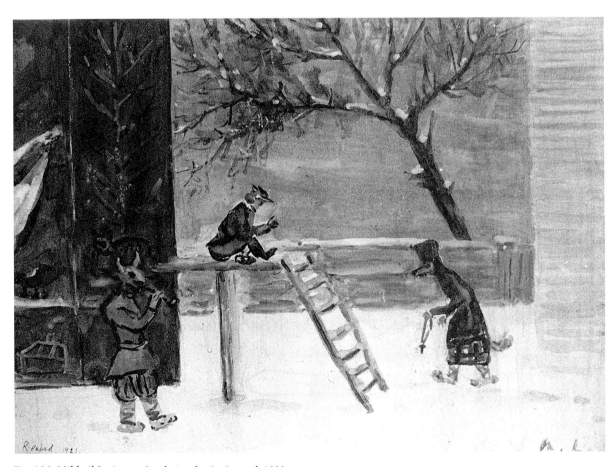

Fig. 186. Mikhail Larionov, Set design for *Le Renard,* 1922

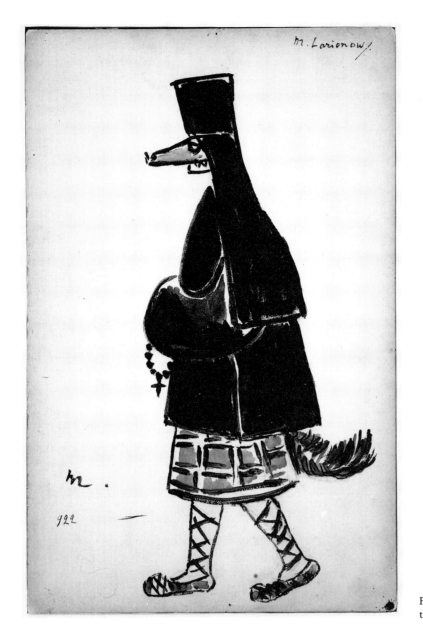

Fig. 187. Mikhail Larionov, Costume design for the fox disguised as a nun in *Le Renard*, 1922

strained neo-primitive style, for example, the design for the Fox disguised as a Russian Orthodox nun (fig. 187). According to Stravinsky this was not a satirical image but simply good-natured fun inspired by the fact that nuns were untouchables in Russian society. A novel departure for Larionov in these designs was his use of masks to differentiate the characters. Svetlov had drawn attention to Larionov's use of the "comic mask" in *Kikimora* in 1916, and Parnack in *Art Théâtral* had discussed Larionov's interest in masks created by "great surfaces, yellow green and grey." In his preparatory work for *Le Renard* Larionov made drawings of masks in the same grotesque style

as those illustrating Blok's *Skify* though he finally settled for masks indicating the characteristic features of the animal cast.[19]

Le Renard was a sung ballet and since it only required four dancers to perform it, the choir were accommodated in the orchestra pit. The plot of the ballet is based on Russian folk stories of Reynard the Fox as recounted by Afanasiev and center on Renard's various attempts to capture the Cockerel who is rescued each time by his two friends, the Cat and the Billy Goat. Stravinsky was delighted with *Le Renard*, but the audience did not share his opinion. Stravinsky put this down to his "two intimate acts" being

sandwiched between the rest of the ballets forming the program, to the "crushing environment" of the Opéra, and to "the mentality of the audience composed mainly of the famous *abonnés*" (season-ticket holders).[20] Walter Propert, on the other hand, suggested that the audience found "the music too harsh, the scenery too childish or the dancing too grotesque."[21] In any case *Le Renard* was temporarily dropped from the repertoire.

Larionov and Goncharova had now established an international reputation as theatrical designers. Exhibitions in New York and Tokyo contributed to their international status.[22] They also participated in the International Theatre Exhibition at the Stedelijk Museum in Amsterdam during January and February 1922. The exhibition displayed the work of one hundred theatrical designers in eight exhibition halls. Craig and Appia were allotted a room to themselves while Larionov and Goncharova exhibited with Benois, Bakst, Komisarzhevsky, Shervashidze, and Sudeikin. Larionov showed his designs for *Soleil de Nuit, Histoires Naturelles, Contes Russes,* and *Chout* as well as his designs for Lord Berners. It is worth noting that the exhibition also featured ethnographical and oriental masks.

During August 1922 Larionov and Goncharova visited Berlin to supervise the production of *Pierette's Veil,* for which Goncharova had made the designs, at Boris Romanov's "Russian Romantic Theatre." Interest in the two artists had been heightened in Germany by articles in various publications. *Chout* was the subject of an essay in *Teatr (Theatre),*[23] Ilya Zdanevich wrote about the two artists in the luxurious literary and artistic journal *Zhar-ptitsa (The Fire-Bird)* and many of their theatrical designs had been reproduced in *Der Sturm.*[24] The première of the ballet on September 26 created a sensation among the Russian community in Berlin. The ballet was enthusiastically reviewed in *Teatr*[25] and was described by Nina Berberova (who saw it with Boris Pasternak, Ehrenburg, Shklovsky, Tsvetaeva, and Bely) as one of the greatest theatrical experiences of her life.[26]

Larionov and Goncharova returned to Paris in October and in November met Mayakovsky who had recently arrived in the French capital. It was at this time that Mayakovsky invited Larionov to illustrate his poem *Solntse (The Sun)* which was published in Moscow in June 1923. During these years Larionov frequently used a design again and again. Several illustrations for *Solntse* were reworkings of existing graphics.[27] The innovative designs for the book themselves reappeared in various guises; the design for the cover, for example, depicting a grid of rect-

angular forms overlaid by diagonal rays, was reproduced as an independent graphic work in the Bauhaus folio *Neue Europaeische Graphik: Italienische v Russische Kuenstler* which was published at the same time (fig. 188).

Generally, most of the illustrations for *Solntse* were executed in a geometrical fashion with anthropomorphic qualities (fig. 189) and were derived from Larionov's designs for Lord Berners. However, the monochrome and angular shapes of Larionov's graphic forms with their stylized references to hands, arms, legs, and feet were also part of the general trend towards geometrical abstraction. Artists such as Gris, Archipenko, and Léger entertained a similar approach to the human figure in the early 1920s. Léger's figure studies for the ballet *La Création du Monde* (fig. 190), produced by the *Ballets Suédois* just a year later, bear a striking resemblance to Larionov's graphic style at this time.

It was one of the designs for *Solntse* that Larionov chose as the logo for the annual charity ball sponsored by the influential *Union des Artistes Russes à Paris* in 1923 (fig. 191). Larionov, in fact, was charged with the organization of the ball which that year was called the *Grand Bal des Artistes Travesti-Transmental.*[28] Preparations began in January 1923 when Larionov planned the interior decoration of the Salle Bullier where the *Grand Bal* was to be held. He arranged for the columns to be hung with poems by Cocteau, Khlebnikov, Kruchenykh, Soupault, Tzara, Mayakovsky, and Pound. Larionov invited as many artists as possible to design special booths to be exhibited at the ball and then auctioned in aid of charity. He described his idea to Survage in a letter:

Being on the committee this year I am charged to invite you to design a cabinet and decorate it according to your own tastes and ideas. Leave an opening for the spectators. The dimensions are to be roughly as follows: Height: 2.35 metres. Breadth: 2.00 metres. Height of the barrier: 65–70 cms. You can work on a plain white calico with distemper colors. The booth will be sold as *The Survage Booth.* If you are unable to buy the materials we will undertake the cost. There will be other cabinets made by Bart, Picasso, Gris, Gleizes, Léger, Goncharova, and myself.[29]

Altogether there were fifty decorated booths, including those designed by Tzara, Romov, Zadkine, Fotinsky, Sudeikin, Izbedsky, and the American artist Gerald Murphy, who was a student of Goncharova and with whom Larionov was friendly.[30]

Larionov also arranged the entertainments for the

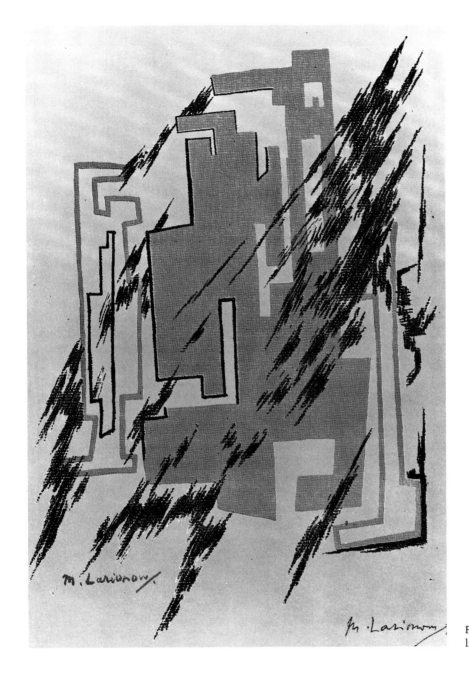

Fig. 188. Mikhail Larionov, Color
lithograph for *Bauhaus Mappe No. 4*

Grand Bal. The Fratellini clowns were invited to per-
form, as was Arnau, the Catalan guitarist. Vera Ro-
senstein and Lizica Codreano danced in costumes de-
signed by Goncharova to choreography by Larionov
and the music of Mihalovici, conducted by the com-
poser himself, dressed in a red pajama top and scarlet
curtain! They also performed a dance from Larionov's
Kikimora and a dance, with choreography and cos-
tumes by Larionov, called *Le Carnival de Venise.*
Foujita reconstructed a Japanese village fair, De-
launay appeared with his Trans-Atlantic Company of

Pickpockets, Count Tolstoy conducted a Russian
choir, and Nina Payne her jazz band. There were
also exhibitions: Goncharova organized a boutique
of masks, Sonya Delaunay a boutique of dresses,
Vasilieva showed her puppet fortune-teller, and Lip-
nitsky, the photographer of the *Ballets Russes*, exhib-
ited his "Concavo-Convex" photographs.

The ball was called *Travesti* because everyone wore
fancy dress, but it was also called *Transmental*,
which referred to the poetical theories of *zaum*.[31]
There were specific links between the *Grand Bal*

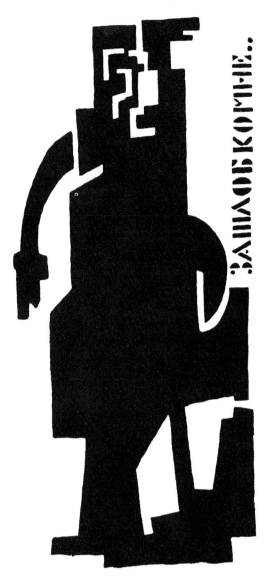

Fig. 189. Mikhail Larionov, Illustration to
Solntse by Vladimir Mayakovsky, 1923

Fig. 190. Fernand Léger, Figure Study for *La Création du Monde*, 1924

and the Dada movement, which sprang from Larionov's association with Zdanevich, Tristan Tzara, and Ribemont-Dessaignes. Larionov invited many Dada artists to participate. Dada poems were reproduced in the program booklet, and many of the events were of a distinctly Dada nature, such as the "aunt sally" game with a four-headed fetus!

About one hundred and fifty painters, poets, and cultural personalities played an active part in the *Grand Bal.* Goncharova designed two large posters (fig. 192) to publicize the socially important event, and Larionov himself designed the cover of the program, the small posters, and tickets (fig. 191), over five thousand of which were printed! The ball began

at 9:00 pm on February 23 and ended at 5:00 am the following morning, and the *Union des Artistes Russes* netted 75,000 francs for their benevolent fund from the tickets alone.

Following the success of the *Grand Bal* Larionov was elected vice-president of the *Union des Artistes Russes* and under his auspices preparations began in early 1924 for the *Bal Banal.* Goncharova designed both the posters and tickets for this ball (fig. 193), and the program booklet carried contributions by Derain, Matisse, Braque, Brancusi, Metzinger, Léger, Puni, Utrillo, Dufy, and others. Special events at the *Bal Banal* included a *tableau vivant* with *mise en scène* and costumes by Larionov, *Le Triomphe du Cubisme*

Fig. 191. Mikhail Larionov, Ticket for the *Bal Travesti,* Paris, 1923

by Ilya Zdanevich with designs by Granovsky and Bart, some Georgian dances performed by Antadze, and *Fantaisies Japonaises* by Foujita. There were also witty events such as "the laying of the first stone of the modern Montparnasse Tower" by a certain Mr. Babel! A documentary photograph of Zdanevich wearing his costume from *Le Triomphe du Cubisme* (fig. 194) again illustrates the Dada nature of the ball. Pieces of string hung from the costume with the message "Advice to Young Girls" and these were attached to small trapdoors cut into the costume. When a string was pulled the flap opened to reveal either the small of his back or his navel![32]

In July, to celebrate the opening of the Olympic Games in Paris, the *Bal Olympique* was organized. Neither Larionov nor Goncharova were included on the committee, but the two artists contributed various items to the entertainment. Larionov ap-

peared with a "New System of Fantastic Projections" utilizing colored designs by Tchelichev, Tereshchkovich, Bart, and others. Goncharova designed puppets and costumes for a charming play entitled *Un Moment Espagnol avec un Lion* staged by Julie Sazonova and performed by her Marionette Theatre of Petrograd.

Julie Sazonova opened her puppet theatre in Petrograd in February 1916 with the aid of the artists Nikolai Kalmakov and Konstantin Somov, but during the revolution she had emigrated to France. The staging of *Un Moment Espagnol avec un Lion* marked Sazonova's comeback as a puppeteer, and following the *Bal Olympique* Sazonova commissioned the artists to design and stage two puppet performances for her Christmas program at the Théâtre du Vieux Colombier. These included *La Fête au Village*, set to the music of Tcherepnine, and *Karagueuz.* Larionov

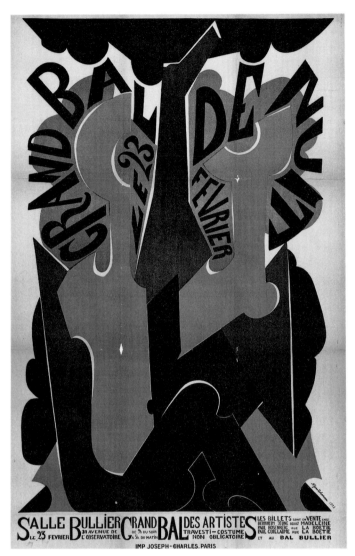

Fig. 192. Nataliya Goncharova, Poster for the *Bal Travesti*, Paris, 1923

Fig. 193. Nataliya Goncharova, Ticket for the *Bal Banal*, Paris, 1924

wrote the libretto and organized the staging of *La Fête au Village*, and Goncharova designed the puppets, curtains, and décors. As for *Karagueuz* Larionov envisaged a Turkish shadow-puppet performance based on the wicked and irrepressible character of Karagueuz. Sazonova also invited Nikolai Milioti to design a puppet orchestra, which played a Scarlatti suite, as well as puppets, costumes, and décors for *Livietta e Traccolo* to music by Frank Martin.

Larionov's plans for *Karagueuz* represented a development of his long-standing interests in things Turk-

ish and in shadow theatre. More specifically Larionov had experimented with designs for Turkish shadow puppets for several years, as demonstrated by an illustration to Blok's poem *Skify* (fig. 175) in the style of the Karagöz shadow puppets. Larionov began his preparations for *Karagueuz* by commissioning a score for the ballet from Bohislav Martinu but, when the latter declined, Larionov invited the Rumanian composer Marcel Mihalovici to collaborate on the project. Mihalovici agreed and, having studied books on popular Turkish songs and melodies at the Bib-

the woman to death. The Sultan returns to charge Karagueuz with Zouleika's death, but she appears and the Sultan learns that she has been the most faithful of his wives.

The performance of both *Karagueuz* and *La Fête au Village* was scheduled for Christmas Eve 1924 at the Théâtre du Vieux Colombier, founded by Jacques Copeau in 1913 and internationally famous for its reconstruction of an Elizabethan stage. Moreover, the Sazonova season had been well publicized in a series of gay orange posters designed by Goncharova (fig. 195). One may imagine the consternation therefore when on Christmas Eve the décors and curtains framed the theatre but the shadow puppets were nowhere in evidence. Mihalovici recalled:

> All Montparnasse descended on the Rue du Vieux Colombier to support Sazonova's première. But only the ballets of Nicholas Tcherepnine and Frank Martin, which figured on the same program, could be shown. Then Larionov asked me to conduct my score while he, perched on a stool on the stage, demonstrated the décors and curtains of *Karagueuz* and explained all about them to the public. It was a sensational success. But Jean Tedesco, the director of the Vieux Colombier at that time, thought that this type of spectacle did not conform to the style of his theatre and cut the lights. The audience were furious and stampeded onto the stage: a riot of epic proportions took place. The police were called quickly and carried the combatants off in a rough manner. . . . And so it was that our ballet never even saw the footlights![34]

Mihalovici's report recalls a futurist "free for all" from the days before the war. Larionov must have been delighted; he had not been embroiled in such a scandal for a decade.[35]

Larionov and Goncharova's collaboration with Sazonova reflects a wider interest in puppet theatre among the Russian avant-garde at this time. Popova and Exter had made puppet designs for the famous puppeteer Nina Simonovich-Efimova during 1918 and 1919. Around 1920 Yakulov made marionettes out of papier-maché, cork, iron, and wire, and in Tiflis the poet Terentiev discussed Ilya Zdanevich's futurist dramas in terms of the traditions of Russian puppet theatre.[36] The Russians in Paris were also interested in marionettes. Both Vasilieva and Olga Sudeikina made puppets and dolls, and Zdanevich staged a marionette performance of his play *L'Ane à Louer*.[37] Even Alexandra Exter, as late as 1926, made a remarkable series of puppets for an animated film.[38]

Despite the fiasco at the Vieux Colombier, Lario-

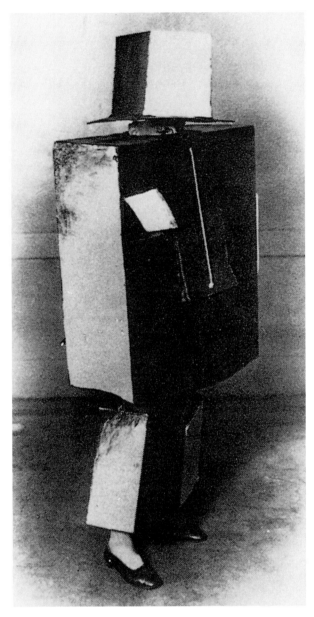

Fig. 194. Zdanevich at the *Bal Banal* wearing the costume for his play *Le Triomphe du Cubisme*

liothèque Nationale, invented the musical themes for the score of *Karagueuz*.[33]

Larionov meanwhile wrote the libretto which employed a large cast of characters and featured an entertaining plot. In the Sultan's absence Karagueuz is employed as chaperone to his wife Zouleika. Karagueuz poses as a lady of the harem but Zouleika exchanges clothes with an odalisque and Karagueuz follows the wrong lady. At night the false Zouleika crosses a bridge in the arms of an officer. To teach her a lesson Karagueuz disguises himself as a dragon but frightens

du 24
Décembre
1924

au 1er
Janvier
1925

Au
Vieux
Colombier

21, rue du
Vieux colombier

Le Théâtre des Petits Comédiens de Bois

de Julie Sazonowa

Fondé en 1915 a Pétrograd

1. SUITE DE SCARLATTI

*Exécutée par l'Orchestre des Petits Comédiens de Bois —
Orchestration de Frank Martin; Personnages de l'Orchestre
et des Loges d'après les maquettes de N. Milliotti*

2. LA FETE AU VILLAGE

*Ballet - Pantomime. Livret et mise en scène de Larionow — Musique
de N. Tcherepnine, Personnages, portail, rideau, décors et
costumes d'après les maquettes de N. Gontcharowa
Soprano : Mme de Gonitch — Ténor : M. Léonoff*

ENTR'ACTE

Musique de Frank Martin — Personnages de N. Milliotti

3. LIVIETTA E TRACCOLO

*Intermède en deux tableaux Musique de G.-B. Pergolesi —
Personnages, décors, rideaux, et costumes d'après les maquettes de
N. Milliotti, Mise en scène de Julie Sazonowa.
Soprano: Mme de Gonitch — Baryton : M. Braminoff*

4. KARAGUEUZ, GARDIEN DE L'HONNEUR DE SON AMI

*(Théâtre turc d'Ombres colorées) — Livret, mise en scène,
rideau, décors et lumière d'après Larionow
Musique de M. Mihalovici — Trente Figures authentiques
turques de la collection de Julie Sazonowa ;
Figures d'après les maquettes de N. Gontcharowa et Larionow*

Chefs d'Orchestre : Frank Martin, M. Mihalovici

Pour les Représentations des 24 et 26 Décembre, l'Orchestre de
LA FÊTE AU VILLAGE sera dirigé par N. TCHEREPNINE
Piano double et Clavecin de la MAISON PLEYEL

OUVERTURE DE LA LOCATION :
MERCREDI 10 DÉCEMBRE
PRIX DES PLACES :
20 fr. — 15 fr. — 11 fr. — 8 fr. — 5 fr.

Fig. 195. Poster advertising *Karagueuz* and *Fête au Village* at the
Théatre du Vieux Colombier, Paris, 1924

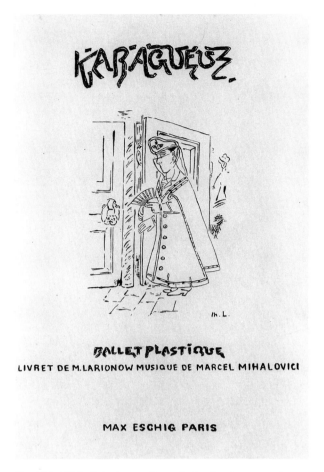

Fig. 196. Mikhail Larionov, Cover design for the score of
Karagueuz by Marcel Mihalovici

nov continued to work on *Karagueuz* during 1925
and hoped for a renewed collaboration with Mihalo-
vici. At the start of 1926 such an opportunity oc-
curred when Adolph Bolm arrived in Paris to commis-
sion new ballets for the Chicago Allied Arts Co. and
agreed to stage a conventional ballet version of *Kara-
gueuz*.[39] Larionov's curtain design for the ballet
(Nationalbibliothek, Vienna) depicts the rounded
shadow-figure shapes of three Turks smoking *chi-
bouks* under a large tree. A costume design, depicting
Karagueuz disguised as a lady of the harem, was later
reproduced on the cover of the score for *Karagueuz*
(fig. 196). Here Karagueuz wears a cape and *yash-mak*,
and bears a strong resemblance to Turkish shadow
puppets depicting Karagueuz in this role.

The ballet was scheduled for production during
March 1927 but, although Amberg (1946) cites it
among the ballets actually produced by the Chicago
Allied Arts Co., the December 1926 season was to be
their last and *Karagueuz*, although announced, was
not performed. Nevertheless, Larionov's plans for *Ka-*

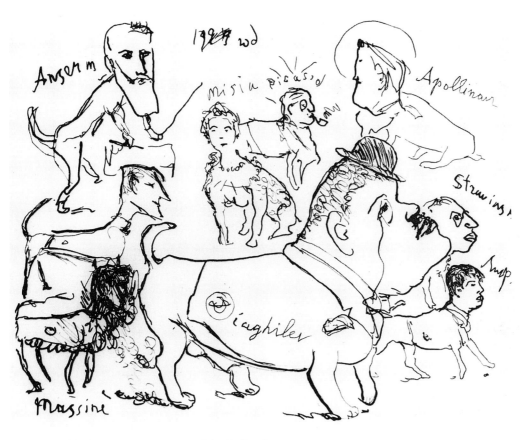

Fig. 197. Mikhail Larionov, Caricature of the *Ballets Russes*

ragueuz played a significant role in his creative ideology and practice during the mid-1920s.

During the summer of 1926 Diaghilev commissioned Goncharova to design new costumes and décors for the ballet *L'Oiseau de Feu* (*The Fire Bird*), which he planned to revive in London later in the year. Goncharova preferred to remain in Paris, and so it fell to Larionov to take the completed décors to London and to supervise the production of the ballet. Larionov left Paris with the *Ballets Russes* and arrived in London in mid-November, where he stayed for ten days at Diaghilev's expense in the Savoy Hotel.[40] At the Lyceum Theatre Larionov attended and advised at the rehearsals not only of *The Fire Bird*, but also of Lord Berners' new ballet *The Triumph of Neptune*. Both were enthusiastically received by the British audience.

Although Larionov had not been engaged by the *Ballets Russes* as a designer since the production of *Le Renard*, he continued to work for Diaghilev in an advisory and administrative capacity. It was Larionov who recruited Survage to design the décor and cos-

tumes for the opera-ballet *Mavra* and Larionov who helped him to complete the commission in three wearisome days and nights in 1922. He had helped Goncharova in her designs for *Les Noces* in 1923 and had been chosen by Diaghilev as the designer of the projected ballet *La Cour des Miracles* to the music of Lesueur. Larionov had advised on the ballet *Le Train Bleu* in 1924, and was portrayed in Marevna's well-known painting as one of *The Friends of "Le Train Bleu"* (Modern Art Foundation, Geneva). He had also commissioned Mikhail Andreenko as the scene-painter entrusted with the execution of Goncharova's designs for *L'Oiseau de Feu*. In fact, whenever the *Ballets Russes* returned to Paris, Larionov was to be found working in the company.

Larionov's caricatures of the *Ballets Russes* as a troupe of loathsome dogs (fig. 197) belong to these latter years in the company's history. Familiar characters in these drawings are the conductor Ernest Ansermet, waving a baton in his paw, the haughty Jean Cocteau, Misia Sert, Picasso, the deceased and hence haloed Apollinaire, Stravinsky, the young and buoy-

ant Serge Lifar, the well-groomed Diaghilev, and the unfortunate Massine who is the recipient of Diaghilev's dirty dealings!

Larionov's career during this same period was also distinguished by his response to the Soviets. Like the Imperial Russian eagle facing both east and west, he had an eye to events in his homeland. In 1917 he had welcomed the revolution and been enraptured by Blok's *Dvenadtsat'*. Larionov's *Jewish Venus* (pl. 13) was shown in the exhibition to celebrate the Third Comintern Congress in the summer of 1921 and he had eagerly illustrated Mayakovsky's *Solntse*. Throughout the decade Larionov and Goncharova sought to promote Soviet art and initiate a cultural interchange between the Soviet Union and their adopted country.

In 1925 both Larionov and Goncharova were involved in the promotion of the Soviet Pavilions at the Venice Biennale and at the famous *Exposition des Arts Décoratifs* in Paris. Goncharova designed the cover of the booklet for the former[41] while Larionov, in collaboration with Goncharova, Zdanevich, and Fotinsky, organized the *Bal de la Grande Ourse*, which was scheduled for May to celebrate the opening of the latter. The title of the ball was a pun on the French initials of the Soviet Union, the "Russian Bear," and the Plough constellation, and the visiting Soviets were invited to participate. The poster for the ball cites "The Group of Russian Constructivist Architects" as being on the organizing committee while the program booklet cites Rodchenko's name in the list of contributors and reproduces a poster design by him for the *Mospoligraf* pencil factory. The brochure also reproduces a drawing of the interior of Melnikov's Soviet Pavilion but to what extent the Soviets were actually involved in the *Bal de la Grande Ourse* remains uncertain.[42]

In the Soviet Union itself, Larionov's reputation continued to increase. His work was now regarded as part of the national heritage and was stored in the Tretyakov, the State Museum Repository and the Museum of Artistic Culture. He contributed to a retrospective exhibition of the Jack of Diamonds organized by the Tretyakov gallery in March 1927, which officially and publicly attributed to the society and its members an historic role in the development of Russian and Soviet art. Afterwards Larionov donated *Morning in the Barracks* to the Tretyakov. Later in the year his paintings were shown in the Exhibition of New Trends in Art in the Russian Museum and he marked this occasion by a generous donation of pastels and gouaches.

During this time Larionov was in correspondence

with Le-Dantyu and Malevich, and Goncharova received letters from the Soviet art critic Nikolai Punin.[43] Towards the end of 1927 Larionov also established a working relationship with the Moscow Academy of Sciences and Arts which appointed him and his two colleagues, the artist Serge Fotinsky and the director of the influential Galerie Billiet, Pierre Vorms, as the French organizers of a large exhibition of contemporary French art to be held in Moscow during the summer of 1928. Larionov was keen to organize a reciprocal exhibition of Soviet painting which would be shown at the Galerie Billiet in Paris while the French exhibition was on show in Moscow. To this end he approached his friend in Moscow, the artist Lev Zhegin, the leader of the group *La Voie de la Peinture*, who arranged to send to France one hundred works by his group as well as many paintings, pastels, and drawings by Chekrygin.

The Exhibition of Contemporary French Art in Moscow (fig. 198) was the larger and more important of the two exhibitions. In the spring of 1928 an invitation to the exhibition was issued to the Parisian avant-garde, and by April over two hundred and fifty works had been assembled at the Galerie Billiet to travel to Moscow. There were two sections to the exhibition. One, the work of over forty painters and sculptors who were members of the School of Paris, including Brancusi, De Chirico, Ernst, Foujita, Laurens, Léger, Marcoussis, Modigliani, Ozenfant, Severini, and Utrillo, was shown at the State Museum of Modern Western Art in Moscow. The other, the work of three dozen Russian artists working in France, including Chagall, Exter, Goncharova, Grishchenko, Larionov, Lipchitz, and Zadkine, was shown at the Tretyakov Gallery. The exhibition ran from May to June and was accompanied by an informative catalogue containing four essays by Lunacharsky, Kogan, Efros, and Ternovets. The exhibition received a great deal of publicity from the articles and reviews that Ternovets contributed to the Soviet press.[44] The importance of the exhibition lay in the fact that for the first time in almost twenty years Soviet artists, who had been virtually cut off from the west since the war, could assess both the development of French art and the evolution of their compatriots in Paris. The exhibition had a decisive impact on Soviet art and, as Fotinsky and Vorms later acknowledged, its success was largely due to Larionov's initiatives.

Vorms recalled that Larionov had a real flair as an organizer of exhibitions and it is clear that in these years his organizational skills received more attention than his art. Critics such as Abram Efros were unable to explain the sudden decline in Larionov's

СОВРЕМЕННОЕ ·ФРАНЦУЗСКОЕ ИСКУССТВО

КАТАЛОГ ВЫСТАВКИ

МОСКВА—1928

Fig. 198. Cover of the catalogue to the Exhibition of Contemporary French Art, Moscow, 1928

productivity and creative spirit, and in Efros' catalogue essay to the Moscow exhibition he bemoaned the loss of Larionov to the world of Russian art:

Larionov paints very little. He has become unproductive. He is in a prolonged period of abstinence or resignation. This period is strange for an artist who formerly, with such fertility and rapidity, showered our art with his experiments and caprices. Larionov's creative hiatus has come at a bad time since he occupies a classic role in Franco-Russian painting. He is central. His works reveal that he evidently knows the measure of things and hasn't lost his former discrimination. He belongs neither to the Russian nor expatriate camps but maintains that unique equilibrium whereby remaining a Russian artist, he continues to be a European master. Nonetheless, I have to say that for us, Larionov's current sterility is like the loss of a compass.[45]

Indeed Larionov only exhibited two watercolors and two still lifes in Moscow. One of these was an oil study on wood for his unusual mixed-media composition The Smoker (fig. 199). The date of this work remains uncertain though the exhibition of the study in Moscow suggests that it was created in the late 1920s and not earlier. The upper section comprises wooden planks nailed together against which the profile of the smoker is molded from plaster of Paris. He smokes a straw pipe and a swab of cotton wool indicates the puffs of smoke. In the lower section a female figure is draped in a spiral of paper which is attached to her back by large nails, one of which is used for her eye. The subject of The Smoker is a familiar one in Larionov's oeuvre. Its treatment here recalls the old Russian signboards but in the use of unusual mixed media it relates more to the tradition of Dada assemblage. The other painting by Larionov, which was reproduced in the catalogue, was a Still Life (fig. 200). The execution of the painting is sketchy and rapid. Although it suggests that Larionov still found inspiration in the imagery of his neo-primitive period, it has none of the immediacy and power of the early works, but is mysterious and haunting, effects compounded by the absence of objects and the awareness of a void of space.

Larionov's still lifes evoked little interest in the Soviet Union, though Robert Falk was particularly impressed when he saw them later in the year at the Indépendants in Paris.[46] Falk's enthusiasm is interesting in the light of his own later development, for paintings such as Dove and Rose of 1952 (Semenov Coll., Moscow) rely on the same devices and evoke the same qualities as Larionov's Still Life. Falk retained a high regard for Larionov, claiming he had been gifted with "perfect sight," and during his time in Paris often berated the artist: "You have the eye of a Bonnard! Why don't you use it!"[47] Even though Larionov's contemporary work was not understood in Russia, his early work was gaining acceptance. Coincidental with the Exhibition of Contemporary French Art was the publication of Nikolai Punin's essay "The Impressionist Period in the Oeuvre of M. F. Larionov," the first published appreciation of Larionov's work in Russia since the publication of Eganbyuri's monograph.

In 1928 Larionov fell ill with kidney-stones. A trip to the south of France with Robert Falk was cancelled and later in the summer he left Paris with Goncharova to recuperate at the Villa Lei Cigalo at Favière. Larionov and Goncharova enjoyed the company of young artists and writers who had taken accommodation near by them in Favière.[48] Here they met Joan

Fig. 199. Mikhail Larionov, *The Smoker*, c. 1927

and Stanislas Osiakovski who owned the Literary Book Company Gallery in London. Diaghilev had opened an exhibition of *Ballets Russes* costume and décor designs there in 1928 and it was here in February 1929 that Larionov organized an exhibition of his recently published folio of pochoirs, *Voyage en Turquie.*

This series of thirty-two pochoirs was printed in Paris in the late 1920s, although it is still impossible to say exactly when. A few of the works are based on neo-primitive precedents. The chibouk smoker (fig. 201), for example, has its origins in the paintings and graphics of the *The Mistress and Maidservant* (fig. 34). Others date from Larionov's work on *Karagueuz*, and yet others, which feature gruesome bathers in beach dress (fig. 202), seem to have no relationship with Turkey whatsoever, but derive from drawings that Larionov made during his holidays in the south of France in the late 1920s. These latter works are the best in the series. They are executed in either a brief or savagely expressive style and possess a boldness of color which animates the entire folio.[49]

Another fine example of Larionov's graphic work from this period is his cover design for the music score *Treize Dances* of 1929 (fig. 203). The album contained one dance by each of thirteen composers of different nationalities including both Mihalovici and Martinu. Larionov supplied two fine lithographs as illustrations. For the front cover he designed an animated and vivaciously drawn gypsy dancer inspired by the Rumanian peasant dance that Mihalovici contributed to the album, and for the back, a musician, which may be identified as Hermes playing a lyre (fig. 107).

Despite another bout of illness early in 1929 Larionov accepted what was to be his final commission for the *Ballets Russes.* Diaghilev had planned a revised version of *Le Renard* at the Théâtre Sarah Bernhardt in May with new décors and costumes by Larionov and new choreography by Serge Lifar. During March Larionov and Lifar worked on the ballet in Paris and decided to incorporate into the cast some trained acrobats who would perform the feats that the dancers could not. Larionov managed to hire four jumping Arabs who fitted the bill admirably! Then at the end of the month Lifar left Paris to join the *Ballets Russes* in Monte Carlo where he began rehearsals for the new ballet.

Larionov dispensed with the traditional Russian costume designs that he had used previously and specified only leotards with the names of the animal characters stencilled over them in large, bold letters (pl. 26). Simple masks were also used to differentiate

Fig. 200. Mikhail Larionov, *Still Life*, c. 1927

Fig. 201. Mikhail Larionov, Pochoir from *Voyage en Turquie*, c. 1928

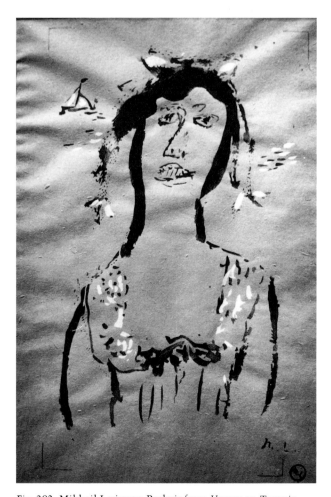

Fig. 202. Mikhail Larionov, Pochoir from *Voyage en Turquie*, c. 1928

TREIZE DANSES

CONRAD BECK
MARCEL DELANNOY
PIERRE·O·FERROUD

TIBOR HARSANYI
JACQUES LARMANJAT
NICOLAI LOPATNIKOFF

BOHUSLAV MARTINŭ
GEORGES MIGOT
MARCEL MIHALOVICI
MANUEL ROSENTHAL
ERWIN SCHULHOFF

ALEXANDRE TANSMAN
JEAN WIENER

m.L

EDITIONS MAX ESCHIG PARIS

Fig. 203. Mikhail Larionov, Front
cover of the score *Treize Dances*

the cast. His watercolor designs for the costumes of the ballet are among the most masterful of his career. No longer was the dancer bound by the massive accoutrements of the costume, for Larionov had discovered a new simplicity and grace in his theatrical design which enhanced the choreography in this new version of *Le Renard*. In his design for the décor Larionov made use of a device pioneered by Venetsianov in his painting *The Threshing Barn* of 1821–1822 (Russian Museum, St. Petersburg) where Venetsianov cuts away the side wall of a wooden barn to reveal the action of the harvesters inside. Similarly, in *Le Renard* the gable end of a wooden barn has its front and back walls cut out to reveal the interior and, beyond that, a view onto a cold and chilling wood. Larionov hung ropes across the stage from which the acrobats could swing, and built a large feeding table from which Cock could leap. In later years Larionov referred to the décor for this second version of *Le Renard* as "constructivist," perhaps to associate it with the latest avant-garde trend of the day. In fact, it had no relationship whatsoever to constructivism, as Larionov well knew, since he was familiar with the real constructivist décors for the Diaghilev ballets of 1927 such as *La Chatte* designed by Gabo and Pevsner or *Le Pas d'Acier* by Yakulov.

In May the *Ballets Russes* left Monte Carlo and returned to Paris to prepare for their season at the Théâtre Sarah Bernhardt where *Le Renard* was given on May 21. Lifar described the première as an immense success and the artist and choreographer took their bows on the stage to an ovation in which the loud cries throughout the theatre completely drowned the applause. Among the older avant-garde, however, the ballet was received with disgust. Konstantin Somov wrote that the choreography came down to nothing but acrobatics and St. Vitus dance, and he listened to Stravinsky's music with utter loathing: "Its all so false, without a spark of inspiration, its not music,"[50] Younger artists such as Kliment Redko, whom Larionov had befriended and introduced to the *Ballets Russes*, disagreed. Redko found the Diaghilev enterprise to be both "an interesting and worthwhile phenomenon in western Europe."[51] Following the end of the season at the Sarah Bernhardt, Larionov and Goncharova remained in Paris until July, when they again went on holiday to the Villa Lei Cigalo at Favière. Diaghilev, after a season in London, left for Venice.

But now, at the end of the decade, economic and political events were changing life in Europe, the Soviet Union, and America. Some of Larionov's closest friends, such as Léon Bakst, Amedeo Modigliani, Guillaume Apollinaire, and Juan Gris, had died. The quality of the exhibitions had also declined. Robert Falk, when he showed at the *Indépendants* in 1930, noted the appalling standards of the exhibits and the fact that Larionov and his friends no longer exhibited there.[52] Paris itself was changing. The tramways were torn up, new cafés and brash nightclubs appeared, and the streets were crowded with cars. Everything, including the *Rotonde*, was modernized and lost its character. The artists dispersed, abandoning the world of Montparnasse. Michel Georges-Michel, sensing the end of an epoch, dedicated his latest novel, *Les Montparnos*, to the artists of Montparnasse who had created the distinct spirit of artistic life in Paris during the 1920s.[53] He included an illustration by each artist in his book—Modigliani, Picasso, Foujita, Gris, Léger, Soutine, Survage, Metzinger, Bakst, Severini, Picabia, Kisling, Larionov, and Goncharova. A chapter of the book was dedicated to Diaghilev, and in that chapter was a reproduction of a simple portrait by Larionov. But by the time that the book was published in September, Diaghilev too was dead.

CHAPTER TWELVE

"Zhizn' Prokhodit, Lyubov' Net"

1930–1964

■

> I want to tell you a little story about Larionov and Goncharova. . . . One night at 10 o'clock, not too late, someone rang at the door. I opened it, it was Larionov and Goncharova: "We've been somewhere, we haven't dined and so we've come to your place, where we can eat well." Together we began to prepare some food, and after dinner Larionov said to me: "Listen old friend, have you got a sheet of paper and some coloured pencils?" I gave them to him; he made a coloured drawing for me of a reclining nude whose head resembled that of Goncharova when she was young. But the most curious thing was that he gave the drawing a dedication: "Life passes, but Love never." And in Russian this is *Zhizn' prokhodit, Lyubov' net.* (Serge Fotinsky in "Entretiens avec Serge Fotinsky à propos de Michel Larionov," recorded interview, 1960s. Pierre Vorms Archive, France.)

Larionov and Goncharova were on holiday at the Villa Lei Cigalo at Favière when they heard of Diaghilev's death. Several *Ballets Russes* dancers and some of Larionov's friends were also at Favière that August. Joan Osiakovski recalled that when she and her husband arrived at the Villa for lunch, everyone was in tears. When she asked Larionov whether someone could be found to replace Diaghilev, he replied "No, they will all quarrel." And that is exactly what happened![1] Immediately after Diaghilev's death Lifar and Kochno actually fought over his corpse, and soon the *Ballets Russes* disintegrated as one and then another tried to replace Diaghilev and to snatch the laurels for themselves. Larionov remained aloof from the squabbling.

During 1930 Larionov commemorated Diaghilev's life and work by organizing a large exhibition of *Ballets Russes* designs at the Galerie Billiet. Pierre Vorms, the director of the gallery, and Larionov visited various artists who had worked for Diaghilev, inviting them to contribute work to the exhibition. This took several months however, and Vorms found Larionov's collaboration frustrating:

> He would make an appointment to meet me at three o'clock to go, say, to Picasso's studio. Well, Larionov would arrive nearer five o'clock and I would say, "Let's get going to Picasso's, we'll have to hurry, we're late." But he would say, "Oh no! We'll not go to Picasso's today. Meyerhold has just arrived from Moscow and he's in the middle of a

rehearsal at the Théâtre Montparnasse. We'll go there, it'll be very interesting." Yes, it was exciting, but it was never the program that we had planned. Our temperaments did not correspond in this, but all the same we managed to do some very good work using this freakish method.[2]

Serge Lifar lent items from his personal collection, others were borrowed from the artists including Benois, Braque, De Chirico, Derain, Ernst, Gabo, Matisse, Miro, Picasso, Rouault, and Utrillo. Works by Bakst and Gris were lent by the dealer Kahnweiler and their respective relatives. Vorms published an illustrated book to accompany the exhibition. Written by Goncharova, Waldemar George, and Georges-Michel, it was devoted specifically to the theatrical designs commissioned by Diaghilev and represented the first appreciation of the innovative role that artists had played within the company.

Both Larionov, the organizer, and André Boll, who had written the preface to the catalogue, attended the opening of the exhibition in October 1930 (fig. 204). It was an historic occasion as it was the first of many retrospectives that followed Diaghilev's death. Moreover, Diaghilev's genius shone through the exhibition. It reflected the unique talent that had welded the leading painters, composers, choreographers, and dancers of the day into a viable creative unit to produce over eighty beautiful, challenging, and meaningful works. Larionov himself regarded Diaghilev as a modern-day *bogatyr* (Russian epic hero) and con-

Fig. 204. Serge Lifar, Mikhail Larionov and Andre Boll (left to right) at the *Ballets Russes* exhibition, Galerie Billiet, Paris, 1930

tinued to extol his genius. In fact, Larionov's first memoir of the impresario was published in conjunction with the exhibition in a special edition of *La Revue Musicale* which was dedicated to Diaghilev's memory.

Diaghilev's death initiated a new phase in Larionov's and Goncharova's theatrical career since they were now free to collaborate with various opera, drama, and ballet companies. During 1930, Larionov made designs for Prokofiev's *Symphonie Classique*, presented by the Opéra-Ballet of Michel Benois, with choreography by Slavinsky, at the Théâtre Pigalle. He also collaborated with Goncharova on the designs for Alfred Savoir's *La Petite Catherine*, given at the Théâtre Antoine, while Goncharova made designs for Komisarzhevsky's production of Mussorgsky's comic opera *Foire de Sorotchinsk* (*Sorochinsk Fair*). The artists continued to lend works to exhibitions both at

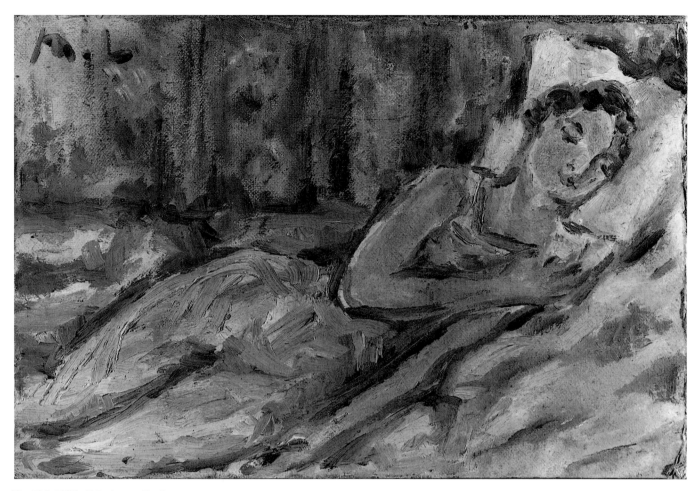

Fig. 205. Mikhail Larionov, *Reclining Woman*, 1933

home and abroad, the most important of which was their joint exhibition at the Galerie de l'Epoque in June 1931, their first since that at the Barbazanges twelve years before.

Diaghilev's death, paradoxically, seems to have released Larionov's painterly talents once again and the 1930s witnessed his return to easel painting. Larionov expressed his vivid and experimental ideas in dozens of nonobjective rayist gouaches and watercolors (pls. 27–28), which reveal the renewed fertility of Larionov's creative imagination. The rays themselves differ according to the needs of the composition. Some of the paintings are filled with rapid and jerky lines, others with interpenetrating planes and long thin rays slicing the picture space like sabres. From a technical viewpoint these works also exhibit a subtle handling of the medium, in which Larionov achieves a wide variety of effects. In particular, he

applies one transparent wash over another, so that the rays bleed into the picture plane, creating a sensation of the intangible or immaterial. The unusual coloring of these works—the unexpected combinations of oranges and reds against pale purple and blue grounds, and indigos against delicate washes of light browns—also evokes a mysterious quality. In fact, as Yuri Annenkov shrewdly noted, Larionov's works of the 1930s possess a musical quality, created by a precision which the artist only attained after years of experience. Of course Larionov had always associated rayism with music but, as Annenkov points out, these works are like "the post-script to a letter," the fulfillment of a prophecy made long ago.[3]

Larionov's figure paintings of the period, such as *Reclining Woman* (fig. 205), possess the same qualities. They are executed in monochromatic colors, usually greys or browns, and their figures seem to

Fig. 206. Mikhail Larionov, Maquette for the ballet *Sur le Borysthène*

belong to another world. Annenkov describes these figures as the rudiments of human forms which are "immaterial" and "deny their own substance." For Annenkov they are more "nonobjective" than rayism itself and their qualities are more akin to music than painting: ". . . stand before a painting by Larionov and you are turned into a listener. Perhaps, having worked so many years for the ballet, Larionov became imbued with music? It's difficult to say. Whatever it may be, therein lies the secret of Larionov's later years."[4] Annenkov's critique of these paintings characterizes them succinctly, and differentiates them in spirit, style, and execution from those of earlier periods. They are among Larionov's most profound and poignant paintings and it is unfortunate that, because they do not belong to the heroic period of Larionov's creativity, they are not better known and appreciated.

Whenever opportunities arose, Larionov and Goncharova, for financial reasons at least, worked on theatrical projects. Their fame as two leading *Ballets Russes* designers and their friendships with young dancers, who in turn became directors and choreographers of companies, ensured that they were frequently offered theatrical commissions.

In the autumn of 1932 Serge Lifar invited Larionov and Goncharova to collaborate with Prokofiev on the staging of his opera *Sur le Borysthène* to be shown at the Paris Opéra in December. The subject was a love story set in Soviet Russia and was the last theatrical work that Prokofiev wrote while abroad. Lifar designed the choreography, Goncharova the costumes, and Larionov the décors (fig. 206), which included a gigantic stylized oil well constructed on the stage alongside a peasant cottage. According to Lifar, Larionov made the most of his "modernism and abstract forms" but *Sur le Borysthène* was too advanced for the public who gave it a cool reception.[5] Frédéric Pottecher, however, explained the significance of the décors: "Larionov tries to synthesise both the human endeavor so curious of the U.S.S.R. and the legendary Russian earth, with its brooding, its immensity, its eternity. A canvas with a colored, shaded background, recalls the traditional Russia, and the constructions (the oil well, the home of a peasant), the Russia of Stalin."[6]

This synthesis represented Larionov's attempt to assess the historical and cultural implications of the Soviet evolution of his country since his departure in

1915. Larionov may still have entertained a deep desire to return someday to his native land although apparently he shrugged off any such suggestion. Lina Prokofiev, who shortly after the staging of *Sur le Boysthène* emigrated to the Soviet Union with her husband, recalled that Larionov could have easily returned home at this point, but preferred to stay in Paris.[7] The artistic atmosphere of Paris certainly inspired Larionov. In his diary for October 1934 Kliment Redko wrote, "In a gallery on the Rue de Seine we talked animatedly in front of paintings by Derain, Utrillo, Segonzac, Vlaminck, De Chirico, and others. Larionov is not exactly a recognized celebrity in Paris, despite his references to 'my friend Picasso.' However Larionov is a living, vivid personality and looks young."[8]

There were also social, cultural, and political factors that may account for Larionov's decision not to return to Russia. Since the mid-1920s life in the Soviet Union had been intolerably difficult and friends such as Le-Dantyu had warned him not to return:

> Since 1917 we have lived through very hard times from the material point of view; everyone has lost everything they had; most people can't earn a livelihood in their original line of business, and make ends meet by taking chance jobs which pay next to nothing. Everyone is at a loss, exhausted, many are ill, discouraged, full of gloom. . . . No one has the time or the energy to occupy himself with his own field of study in this persistent struggle for existence. . . . Art reviews do not exist. . . . There are very few illustrated magazines and their quality leaves a lot to be desired. Photographs of paintings are very rare and their choice depends on the propagandist function of the subject and never on artistic quality.[9]

In addition, the state exerted increasing control over artistic production. Realism was the order of the day and the experimental avant-garde were branded formalists and driven underground. In 1932 the Central Committee of the Communist Party further curtailed the artist's independence by dissolving all official art groups and two years later in 1934 the First All-Union Congress of Soviet Writers established Socialist Realism as the only viable style for Soviet art and literature. Larionov, a rebel against authority and a champion of personal creative freedom, could not have existed in this environment.

Moreover, Larionov heard reports of Stalin's purges, and books by writers such as Karl Kautsky, which discussed the subject of liquidation in the Soviet Union, did nothing to reassure him.[10] It seems that Larionov, uncertain of his ultimate fate in Russia, chose to remain in Paris and to make his creative responses to the Soviets from the Rue de Seine. In fact, his last contribution to the Soviets was made in 1933 when he made a series of cover designs for Mark Slonim's book *Portrety sovetskikh pisatelei* (*Portraits of Soviet Writers*). Larionov's drawings employ the neo-primitive motif of the pagan head with the flying bird (fig. 207), but they were rejected in favor of a cover and illustrations by Yuri Annenkov.[11]

During the summer of 1933 Larionov and Goncharova returned to Favière where they were joined by Oreste Rosenfeld, Stalinsky, Goncharova's pupil Tatiana Loguine, and Aleksandra Tomilina (1900–1987) who had become Larionov's mistress.[12] Tomilina, known to her friends as "Sandpaper" because of her unpleasant disposition, was the daughter of Klod Tomilin, a rich merchant who lived in Moscow. She had emigrated from Russia in the 1920s to become a student in Paris. There she began a thesis on the Romanesque churches of Saintonge and to support herself she became librarian of the Students' Union on the Boulevard Saint-Michel as well as an artists' model. It was as a model that Yuri Annenkov introduced her to Larionov.

On his return to Paris after his summer holiday at Favière, Larionov began work on a ballet version of Shakespeare's *Hamlet* to be produced by Rolf de Maré (1888–1964), director of the former *Ballets Suédois*. For this unusual performance there was to be no décor, and no costumes in the accepted sense, only the naked bodies of the dancers, made up and partially covered (fig. 208). A few accesories such as batons, spheres, and cords were to complement the expressions and gestures of the dancers, and as in *Renard*, the characters were identified by their names stencilled across their bodies. The corps de ballet were to be divided into two to play the chorus of ancient tragedy, one part narrating and the other commenting upon the events taking place on the stage. Larionov planned to use three stages, one below and one above the proscenium. Each role was played by three dancers, identically made up, one performing on each stage. The origin of this concept lay in Larionov's designs for the futurist play *Plyaska ulits* which he had executed in Moscow nearly twenty years before. But now, rather than locating the three scenes one behind the other on the stage, he arranged them one above the other. The ballet was to be accompanied by the music of Bach and Palestrina—sometimes the dancers were to dance to the music,

sometimes they were to stand immobile until the music had ended, whereupon they would interpret it. Larionov's plans for *Hamlet* created a great deal of interest in the theatrical world with the result that in June 1934 Rolf de Maré visited Larionov to discuss production details and publicize the ballet in *Archives Internationales de la Danse*. *Hamlet* represents Larionov's last piece of experimental theatre and it is unfortunate that it was never completed or staged as it would have been a remarkable *tour de force*.

During 1934 Larionov also became friendly with Colonel de Basil (pseudonym of Vasily Voskresensky, 1888–1951), a Russian impresario who had acquired the décors and costumes of Diaghilev's *Ballets Russes* and organized his own company. It was due to Larionov's influence that a number of his own and Goncharova's ballets were revived by de Basil's *Ballets Russes* in 1934. In April Goncharova's *Boléro* was performed in Monte Carlo, in August Larionov's *Contes Russes* in London, and in November Goncharova's *Mariage d'Aurore* in Philadelphia.

Both artists also received commissions to illustrate books although some fell through as, for example, Goncharova's charming drawings for Léon Osmin's book on the pioneers of Socialism.[13] Others were extremely successful, such as Arnold Haskell's *Balletomania* which went through sixteen impressions in

Fig. 207. Mikhail Larionov, Projected cover design for *Portrety sovetskikh pisatelei*, 1933

Fig. 208. Mikhail Larionov, Costume design for *Hamlet*, 1933

its first ten years alone. Haskell's book was a selective yet entertaining account of Diaghilev's *Ballets Russes* which was illustrated with drawings from Larionov and Goncharova's sketchbooks. The artists also provided Haskell with material for the penultimate chapter of the book on the artistic background of ballet, in which Haskell described Larionov's collection of theatrical archives:

> Today, in an historic building, rue de Seine, four cruel flights up a wooden stair case, in Larionov's studio, is one of the finest theatrical museums in the world, kept in such disorder, so constantly added to, that, after several long visits, I have only just skimmed the surface. It is my great ambition to work on a systematic arrangement of the hundreds of portfolios, that contain sketches, maquettes, letters, photographs and working notes of all the choreographers from Petipa to Lifar. This is not in any sense a sentimental collection; every item has its practical value that traces the journey from St. Petersburg and Moscow to Paris. The loss or disposal of these works would be a tragedy.[14]

Haskell was particularly close to Larionov and had rare access to his archives denied to others, which makes his insights all the more valuable. Haskell also left an interesting record of Larionov's working method, noting that entire folios were filled with drawings that treated themes realistically, in caricature, abstractly (studies in form and color), and finally theatrically. He also noted that these works were executed on a variety of papers from thick parchment and rare Japanese vellum to toilet paper. In the same chapter Haskell assessed Larionov's importance:

> . . . he makes little effort to make himself more generally known as an easel painter, in a city where it is necessary to help genius by an occasional shout.
>
> He is fully accepted by a small group of brother artists, and has been acclaimed by the two finest critical minds of his generation, Diaghileff and Apollinaire. His ultimate fame is certain, but probably he will never live to enjoy it. He does not complain, but I do. It is largely his own doing that he is not as universally recognised as Picasso, whom he has influenced, as he influenced the whole Diaghileff circle, and whose equal he is, at any rate as an artist-investigator.[15]

It was characteristic of Larionov never to "shout" about his work. Even as a Russian futurist Larionov had retained a modest streak. Lentulov recalled that in the first Jack of Diamonds exhibition Larionov

humbly took a poor position by the window which failed to show his works to their best advantage.[16] Many of Larionov's friends have testified to his diffidence and reluctance to talk about his work, and during the 1930s there are several accounts of Larionov's obstinacy when selling works to American collectors, despite his own and Goncharova's poverty, at the time. Haskell tells how the rich collector Albert Barnes visited with Paul Guillaume one day to buy some paintings, but, having chosen the ones he liked, was informed by Larionov that he could not buy them since he was going to give them to Goncharova as a present.

In February 1935 de Basil's *Ballets Russes* was once again in Philadelphia, and here, *Soleil de Nuit* was revived. During the following two years it was taken to New York, London, and Melbourne. Meanwhile the Polish dancer Léon Woizikovsky (1897–1975), formerly a leading member of Diaghilev's *Ballets Russes*, who had since formed his own company, aware of Larionov and Goncharova's formative influence within the Diaghilev enterprise, sought their expertise and support. He commissioned Goncharova to prepare designs for the ballet *L'Amour Sorcier* to the music of Manuel de Falla and Larionov to design the sets and costumes of the ballet *Port Saïd*, both of which were staged during his September season at the London Coliseum.

Port Saïd is a humorous ballet in one scene written by Anatole Shaikevitch and set to the music of Konstantinov with choreography by Woizikovsky. Larionov's designs for the cast of sailors, chorus girls, and Arabs are almost banal and gently caricature the characters that wear them (fig. 209). The matelots are dressed in striped T-shirts, the sea-dog captain, smoking a pipe, sports a spotted cravat and the chorus girls of the bar wear pretty frilled and star-spangled dresses. In particular his designs for the coquette cleverly caricature a familiar image of the popular imagination. The poses and choreography (fig. 210) reinforced Larionov's iconography, and much of the humor of the ballet must have been derived from this subversion of popular types. However, by the time of the première, on September 27, the choreography was still incomplete and so the cast improvised their own finale. The ballet was a success nonetheless and was performed regularly for two years.

Although Goncharova continued working for the theatre for twenty years more, earning just enough for them both to live on, Larionov ended his career as a stage designer with *Port Saïd*. Increasingly he devoted himself to the study of dance, to the development of his impressive theatrical archives, and to the ex-

Fig. 209. Mikhail Larionov, Costume designs for *Port Saïd*, 1935

pansion of his library, which was so extensive that it threatened to entomb the artists in their own apartment.

Larionov's library comprised an important collection of publications relating to modern art and choreography. Marcel Mihalovici recognized it as "one of the most important libraries on the art of choreography in Paris."[17] The sculptor Zadkine remembered huge stacks of books around which figures mysteriously appeared and disappeared.[18] Mary Chamot recalled that there were piles of books everywhere, magazines, catalogues, papers of all sorts and piled so high against the walls that one had to squeeze sideways through the narrow corridors.[19] And Kyrle Fletcher describes heaps of books on the floor, on the furniture, and piled up to the ceiling—so many that he and Larionov sat literally knee to knee, surrounded by a "sea" of books waist high.[20]

During 1936 Larionov and Goncharova contributed to three important exhibitions. The International Exhibition of Theatrical Art in Vienna resulted in the purchase of Larionov's exhibits by the Nationalbibliothek. Then in the Sixth Triennale in Milan both artists exhibited in the French section of the exhibition, as opposed to the Russian section, and were awarded the Silver Medal. In winning the medal for France, Larionov and Goncharova clearly expressed their desire to be considered French artists. Larionov also sent rayist paintings to the exhibition Cubism and Abstract Art organized by Alfred Barr at the Museum of Modern Art in New York. On this occasion Larionov wrote a letter to Barr explaining the nature of rayism, his first commentary on rayism for over two decades.[21] Some of the themes Larionov discusses are based upon those in the rayist manifestos of 1913 and 1914, such as the emphasis on the

Fig. 210. The cast of *Port Saïd*, 1935

emotive effects of structure and the varying density of the colors. He also states again his interest in radiation, infrared and ultraviolet rays, but now adds radio rays to the list. In response to Barr's questions about Einstein's theory of the materiality of light and Leonardo's writings about light-rays, Larionov denies any influence whatsoever. Beyond this the letter is complicated and couched in philosophical terms, which Larionov fails to define or elaborate. He refers, for example, to the intriguing but unexplained "radiation of thought" (*rayonnement de la pensée*):

Rayism attempts to define everything which pertains to the world of human and animal sensations in relation to the inorganic world. The visible radiation of light is material and measurable; invisible radiation (radioactivity etc.), in the majority of cases, is also quantifiable; the radiation of a human being or animal (what we could call intuitive or sympathetic) would also be measurable if one could establish the correlation between radiation already quantified and radiation as yet unmeasured, that's to say the radiation of thought.

Thus, if one places the radiation of thought in the same category as all other radiation, that is perceptible and imperceptible radiation, one has only to find a correlation between them in order to be able to define its qualities. It is evident that these qualities are only measurable by means of movement more rapid than the speed of light.[22]

Parts of the letter imply a mystical content in rayism but again Larionov is not specific. The document, however, indicates his continued commitment to the rayist style and the fact that he continually revised his theory in the light of contemporary developments in science and technology.

The exhibition at the Museum of Modern Art marked a turning point for Larionov and rayism. For the first time rayist paintings were viewed as having sufficient status to be bought by galleries and museums for their collections. The Museum of Modern Art, in fact, acquired all Larionov's exhibits as well as several rayist works by Goncharova. The opening of the exhibition was celebrated by the publication of Alfred Barr's *Cubism and Abstract Art* in which rayism was accepted as having played an important role in the history of modern art.

Throughout 1936 Colonel de Basil revived more Larionov and Goncharova ballets. In April *Les Noces* was staged at the Metropolitan Opera House in New York. Soon afterwards de Basil obtained the performance rights of *L'Amour Sorcier* and *Port Saïd* from Woizikovsky and these were produced in Melbourne in November and December respectively. During 1937 Larionov and Goncharova received a commission from de Basil for a new version of *Le Coq d'Or*. Fokine was employed to recreate the choreography in three scenes, Goncharova to make new designs, and Larionov to supervise their execution and the production of the ballet as a whole. Goncharova's designs were completed by the summer, and between July and September, the month of the première, Larionov made two visits to London to fulfill his contract.

Le Coq d'Or proved so successful that Larionov acquired two new commissions for Goncharova, for ballets to be produced by de Basil during 1938. In the spring of that year Goncharova made designs for *Cinderella*, set to the music of d'Erlanger and with choreography by Fokine. Larionov, again appointed to supervise the execution of the costumes and scenery, visited London while the ballet was being rehearsed at the Royal Opera House for its première in July. The second commission was for *Bogatyri*, about the legendary heros of Russia, set to the music of Borodin and with choreography by Massine. Goncharova created her designs during the summer and the ballet had its première in September at the Metropolitan Opera House in New York. The ballet, however, had little success, although Goncharova's designs received some praise.

Following Hitler's invasion of Austria in March 1938 and the threat to Czechoslovakia, to which both France and Russia were united in treaty, war seemed increasingly imminent. Larionov and Goncharova realized that their position as foreign nationals in an alien land was now precarious. As the two artists found it impossible to return to Stalinist Russia, they applied to the Minister of Justice on April 14 for French naturalization and received full citizenship on September 8.[23] This decision secured both their lives and possessions from almost certain destruction.

When France and Britain declared war against Germany in September 1939 Larionov and Goncharova were on holiday at *Le Gai Logis* at Thomery in Seine et Marne.[24] At the end of the month they returned to Paris and remained there for the duration of the war. During these lean years Larionov obtained an extraordinary commission for Goncharova from Boris Kniaseff (1900–1975), a Russian ballet dancer, teacher, and choreographer, who had assembled his own company. Kniaseff ordered designs for a suite of ten ballets which he produced at the Marigny Theatre from 1940

to 1942. The ballets were choreographed by Kniaseff himself and, despite the German occupation of Paris, each was eventually staged with Goncharova's costumes and décors.[25]

The German occupation of Paris on 14 June 1940 curtailed artistic life in the city. Many artists fled and their archives and possessions were destroyed. The apartment of the Rumanian composer Marcel Mihalovici, for example, was raided several times and his manuscripts and scores burned. Larionov and Goncharova survived this period, perhaps in part by virtue of their French nationality. Larionov devoted himself to writing a history of dance, based upon his vast archive and library, the manuscript of which remains unpublished. Nonetheless it was surprising how many artistic events continued under the German occupation. In 1941 Larionov contributed to the *Salon des Tuilleries*. In 1942 Goncharova made designs for *La Princesse des Ursins* which Larionov helped to produce at the Théâtre de la Cité. A year later in 1943 Goncharova, Lifar, and the Georgian composer Djabadari collaborated on the ballet *Goulnar*. That same year Larionov was involved in a large celebration to commemorate Kniaseff's twenty-fifth anniversary on the stage. Then in 1944 Goncharova made designs for a second version of *Sorochinsk Fair* which was performed at the Salle Pleyel.

After the liberation of Paris in August 1944 and the end of the war in Europe in May 1945, Larionov and Goncharova spent a holiday in Monte Carlo. In the postwar period commissions were few and from 1946 onwards Larionov made regular visits to London with folios of work which he sold *en bloc* to collectors. During September 1947 Larionov supervised the production of the ballet *Piccoli* for Colonel de Basil in London and advised the young choreographer David Lichine on his production of the ballet *The Graduation Ball*. In fact Larionov visited London many times during the late 1940s and 1950s and worked in an advisory capacity for several English companies including the London Festival Ballet.[26]

In June 1948 Michel Seuphor returned to Paris after fourteen years in religious and philosophical retreat at Anduze in the south of France. On his return Aimé Maeght, the director of the influential Galerie Maeght, invited Seuphor to organize an exhibition entitled *Les Premiers Maîtres de l'Art Abstrait*. Moreover, as Seuphor knew these "first masters of abstract art" personally, Maeght suggested he write a book on the subject to be published in conjunction with the exhibition. For this reason Seuphor visited the artists of Montparnasse whom he had known during the 1920s.

During the autumn of 1948 Seuphor became extremely friendly with Larionov and Goncharova and also renewed his friendship with Sonya Delaunay and Nina Kandinsky who were hostile to the artistic achievements of Larionov and Goncharova. In fact the Maeght exhibition, which sought to establish the historical reputation of its contributors as the founders and initiators of abstract art, while of crucial significance, only intensified a spirit of bitterness and conflict within the Parisian artistic community. The artists of the old avant-garde began to disparage each other's achievements so as to bolster their own claim as the first and foremost abstract artist of the century. The hostility of Sonya Delaunay and Nina Kandinsky was motivated by the unfounded but real fear that Larionov and Goncharova might displace their respective husbands from the *cursus honorum* of modern art. Seuphor recalled the tense atmosphere at the time because Sonya Delaunay did not believe that rayism had ever existed. She told Seuphor that Larionov and Goncharova spoke of rayism as though it had existed but that they had in fact done nothing. Nina Kandinsky, on the other hand, admitted that there was such a thing as rayism but considered it of no importance. When Seuphor told Larionov of his conversations with Sonya Delaunay he cried "moi prouver! moi prouver!" and from underneath a table piled with books he took a copy of Eganbyuri's monograph and showed Seuphor reproductions of rayist works dated 1912.[27] Astounded by the evidence of a nonobjective movement in Russia before the First World War, Seuphor decided to rehabilitate Larionov's and Goncharova's reputations and organized an exhibition devoted to the rediscovery of rayism. Everyday during the winter of 1948 Seuphor visited Larionov and Goncharova to talk about the theory and practice of rayism and to select the exhibits.

The exhibition Le Rayonnisme 1909–1914 was held at the Galerie des Deux Iles during December 1948 and played a crucial role in establishing Larionov and Goncharova as two of the first nonobjective painters of the century. In addition Seuphor published a short article "against the enemies of rayism" which effectively addressed contemporary criticism and disbelief.[28] Following the exhibition Sonya Delaunay was furious with Seuphor and there was "a big discussion" between them. In the end Seuphor's viewpoint prevailed and Sonya Delaunay retracted her allegations. Seuphor was a powerful force in the art world of postwar Paris, and afterwards Larionov and Goncharova told Seuphor that they owed their lives to him.[29] In recognition Larionov gave him the

Portrait of Vladimir Tatlin (fig. 128) and inscribed on the reverse in large letters *A Mon Ami Michel Seuphor.*

The deserved recognition of Larionov and Goncharova was made at the cost of historical accuracy. The title of the exhibition suggested that rayism originated in 1909. Moreover, Larionov's *Study of a Woman* (fig. 37) and *Head of a Bull* (fig. 41) were both dated 1906. In defending themselves against the criticism from Sonya Delaunay and Nina Kandinsky, Larionov and Goncharova pre-dated their early works. The artists consciously and consistently followed this practice in future exhibitions and art historians, following their lead, assigned the birth of rayism to 1909.

The publication of Seuphor's book on abstract art coincided with the opening of the exhibition *Les Premiers Maîtres de l'Art Abstrait* at the Galerie Maeght in April 1949. Here the works by Larionov and Goncharova were again pre-dated.[30] *Glass* (fig. 44) was dated 1909 and Goncharova's *Cats* 1910. At this stage Larionov and Goncharova pre-dated their paintings by a mere three or four years but later they pre-dated them by more than a decade, thereby hoping to establish firmly their own claim to be the first "masters of abstract art."[31]

Although their heroic days were over, Larionov, hoping to attract new commissions for Goncharova, continued to associate with the leading figures of the ballet world in these years. Few showed any interest, but in 1948 Larionov's discussions with the rich and flamboyant impresario the Marquis de Cuevas (1886–1961) led to two unexpected commissions for ballets, *La Péri* and *Un Coeur de Diamant*, to be staged by his *Grand Ballet de Monte Carlo* in the following year. By February 1949 Goncharova's designs were nearing completion and the two artists left Paris for the Hôtel de Berne in Monte Carlo, where they stayed until April, supervising the production and premières of the two ballets.

Despite recurrent illness Larionov pursued his commitment to the theatre as best he could, even writing an article at this time for the international English press on the art of stage decoration.[32] During 1950, however, when he was working for one of the British ballet companies in London, Larionov suffered a stroke which virtually terminated his career. He was taken to the French hospital in Shaftesbury Avenue. Goncharova came to London to be with him and stayed several weeks, stopping with the dancer Catherine de Villiers and with Princesse Carlos de Rohan. When Larionov was well enough to travel she returned home and arranged for him to recuperate in a rest home at Châtanay-Malabry on the southern outskirts of Paris. Larionov stayed here throughout 1950 and most of 1951. Slowly he regained his health and the use of his right arm but the stroke left the right-hand side of his face paralyzed with a wide-open and staring eye (fig. 215).

The expenses incurred because of Larionov's illness were partially offset by donations from friends and colleagues as well as fees from the publication of Goncharova's charming illustrations to the fairy stories of Natalya Kodryanskaya.[33] However, the effects of the rigid economy that Goncharova practiced now began to tell. Tatiana Loguine remembered:

> The rest home cost a lot. She walked miles on foot to go and see him and each day ate only a little soup donated by a restaurant. She wasted away and became transparent. Only her eyes retained their brilliance.
>
> Larionov returned to the rue Jacques-Callot walking with difficulty but still with his extreme lucidity for everything concerning art. His morale was often very low. "In such destitution, this is how the artists of the avant-garde are made to live," he used to say to me. Goncharova never complained.[34]

During 1952 Larionov and Goncharova did little but exhibit their works—anything else taxed their strength beyond endurance. From May to June they held a double exhibition at the Galerie de l'Institut in the Rue de Seine. Both artists were also represented in the large historical exhibition *Chefs d'Oeuvre du XX siècle* at the Musée d'Art Moderne in Paris, and again at the exhibition Modern French and Russian Drawings at the Victoria & Albert Museum in London. They now began to sell their paintings to international museums and galleries to supplement their meagre income. In this year Larionov sold *Glass* (fig. 44) to the Guggenheim Museum in New York and a year later he met John Rothenstine, director of the Tate Gallery in London, who purchased the rayist painting *Nocturne*, Goncharova's cubo-futurist *Linen* and her painting *Autumn*, from the early 1920s, on behalf of the Gallery.

In 1954 Mary Chamot, the assistant director of the Tate Gallery and a Russian by birth, visited Larionov and Goncharova, became friendly with the artists and subsequently corresponded with them at length. Another visitor from England in 1954 was Richard Buckle who was organizing an exhibition of *Ballets Russes* stage designs at the Edinburgh Festival to commemorate the twenty-fifth anniversary of Diaghilev's death. In connection with this exhibition

Fig. 211. Mikhail Larionov, *Lettered Composition*, c. 1956

Serge Grigoriev, the *régisseur* of Diaghilev's *Ballets Russes*, and his wife, the dancer Tchernicheva, revived the 1926 version of the ballet *L'Oiseau de Feu*, and Goncharova was asked to redraw some of her designs. The ballet was produced at the Empire Theatre in Edinburgh in August and then toured to Covent Garden in London and La Scala in Milan. From this commission Goncharova earned sufficient money to hire domestic and secretarial help for both herself and Larionov.

At this time Larionov and Goncharova were visited by Pierre Vorms, who had given up the Galerie Billiet in Paris to become an art publisher at Belvès in the Dordogne. Vorms suggested the publication of a new appraisal of Diaghilev's *Ballets Russes*, and during 1954 and 1955 Larionov and Goncharova wrote an essay for the book on the evolution of *Ballets Russes* stage designs and illustrated the text with several drawings from the 1920s. In addition to their essay and one by Vorms, the book contained a list of ballets designed by each artist Diaghilev had employed, with illustrations of their work. *Les Ballets Russes: Serge de Diaghilew* was published by Pierre Vorms in November 1955 and was the last book on which Larionov collaborated. Just before this, in June of 1955 Larionov and Goncharova surprised all their friends when, having lived with each other for fifty-five years, they decided to marry. The quiet ceremony took place in the town hall of the 6th arrondissement on the morning of June 2, with Oreste Rosenfeld as witness.[35]

A year later Vitali Fokine commissioned Goncharova to design costumes and décors for a suite of seven ballets for a festival at Monte Carlo, which took place in February 1957, celebrating his father's choreographic work.[36] This commission, which was Goncharova's last design work for the theatre, provided sufficient income to help her and Larionov through their last lean and difficult years. In 1956 the two artists once again held a double exhibition at the Galerie de l'Institut—the *Exposition Nathalie Gontcharova: Oeuvres Anciennes et Récentes* in May followed by *Michel Larionov: Oeuvres Anciennes et Récentes* which ended in June. Their early paintings were again pre-dated but Goncharova, who kept up the practice of easel painting in her late years as best she could, also showed some recent rayist works.

The title of Larionov's exhibition at the Galerie de l'Institut proved a misnomer, for the most "recent" work he showed there was his collage *The Smoker* (fig. 199) dated 1915! None of his more contemporary works were exhibited. Larionov, preferring perhaps a more immediate and less complex form of expression, in these years resorted to pencil and colored inks and gave his works liberally to friends who happened to visit. An innovator to the end of his days, Larionov continued to experiment and among his last works is a series of colored ink drawings executed on absorbent papers, which feature either intriguing combinations of Cyrillic and Latin letters (fig. 211) or imaginary landscapes made up of simple dots and squiggles (fig. 212).

Fig. 212. Mikhail Larionov, *Imaginary Landscape*, 1963

By this time Larionov's early works were invariably included in the large historical exhibitions of modern art, such as *L'Art Abstrait: Les Premières Générations* at Saint Etienne in 1957, *50 Ans d'Art Moderne* at Brussels in 1958, the *Beitrag der Russen zur Modernen Kunst* at Frankfurt in 1959, and the impressive exhibition *Les Sources du XXᵉ Siècle* at the Musée d'Art Moderne in Paris during 1960–1961 at which the French government purchased two of Larionov's paintings. Increasingly Larionov and Goncharova were visited by art and theatre historians. In the summer of 1959 Frank Jotterand interviewed them for *L'Illustré*, and in 1960 they were visited by Camilla Gray who was gathering material for the first major history of modern Russian art. Gray developed a close relationship with the couple and Larionov

generously opened his extensive archives for her research. A year later in 1961 she and Brian Reade engineered a spectacular purchase on behalf of the Victoria & Albert Museum—a portion of Larionov's library which, after six years of cataloguing, was seen to amount to over four hundred books, periodicals, catalogues, posters, programs, photographs, and other printed material. In addition to this the Museum bought important drawings, sketchbooks, and watercolor designs for the stage from both artists. The £2,000 paid by the Museum for this remarkable consignment helped to meet the financial needs of the two artists.[37]

On 4 June 1961 Larionov celebrated his eightieth birthday in the company of Goncharova and Mary Chamot who had brought her camera and took sev-

Fig. 213. Larionov on his eightieth birthday in June 1961 holding his painting *Spring 1912.* Photographed by Mary Chamot

eral photographs of both artists.[38] One of these depicts a relaxed Larionov contemplating his painting *Spring 1912* (fig. 213). Camilla Gray also paid several visits to the artists during the year in order to select paintings and designs for an exhibition of their work in England, which she and Mary Chamot had planned together. This Arts Council exhibition opened in September 1961 at Leeds (fig. 214), then travelled to Bristol in October, and finally moved to London where it was shown from November to December. The exhibition, a fitting and timely tribute to two great artists nearing the end of their lives, brought together well-chosen and representative examples of Larionov and Goncharova's entire oeuvre and attempted to view the various phases of their career as an integrated whole. Unfortunately Larionov and Goncha-

rova were in no position to enjoy the recognition that the exhibition brought or the publication of Camilla Gray's book which hailed them as "two personalities of fundamental importance in the history of the modern movement in Russia."[39]

At the end of the summer Larionov again became ill and was taken to hospital. Goncharova remained in the apartment alone, except for Anne-Marie Mayer and Marita Herlitzius, another German friend, who regularly came to help her. During October Goncharova's health declined and it became clear that she was suffering from terminal cancer. She was transferred to a private clinic in Paris where on 17 October 1962 she died. On October 22 her body was buried according to the rites of the Russian Orthodox Church in the cemetery of Ivry on the southern out-

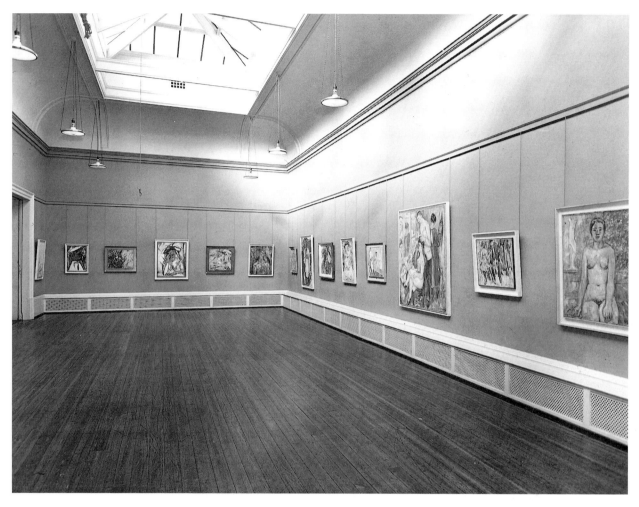

Fig. 214. Installation shot of the retrospective exhibition of Larionov's and Goncharova's work, Leeds, 1961

skirts of Paris. When Larionov returned to the apartment at the Rue Jacques-Callot he found life so difficult that Alexandra Tomilina moved in to help him. She became his secretary, his guardian, and finally his wife.[40] During 1963 Larionov, with Tomilina's help, continued to exhibit his works. That spring he showed paintings at *La Grande Aventure du XX Siècle* in Strasbourg. Then during the summer he helped to prepare the important *Rétrospective Gontcharova – Larionov* at the Musée d'Art Moderne de la Ville de Paris. His presence at the opening in September (fig. 215) was his last public appearance, for he was already extremely ill.

Since 8 April 1963 Larionov had been living in a quiet rest home called *La Provençale* at Fontenay aux Roses. It was an historic building, dating from the eighteenth century, and had once been the property of Chauveau Lagarde. In recent times it was owned by the Blanc family, who had established a rest home for elderly intellectuals including the philosophers Julien Benda and Jean Grenier.[41] Larionov was charmed by the dilapidated yet romantic appearance of the old villa, by its mysterious grotto and unkempt grounds, as well as by its historical associations. Larionov even now spent as much time as possible with his friends, among them Mary Chamot, whom he entertained at *La Provençale,* and Waldemar George and André Shaikevitch who visited to check on his progress and pass on the latest artistic and theatrical news. In the spring of 1964 Marcel Mihalovici also visited the artist at Fontenay aux Roses and recalled:

With his faltering pronunciation, entirely his own, slightly exaggerated by illness, and in his picturesque French he asked me: "For how long have we known each other?" "For no less than forty-two

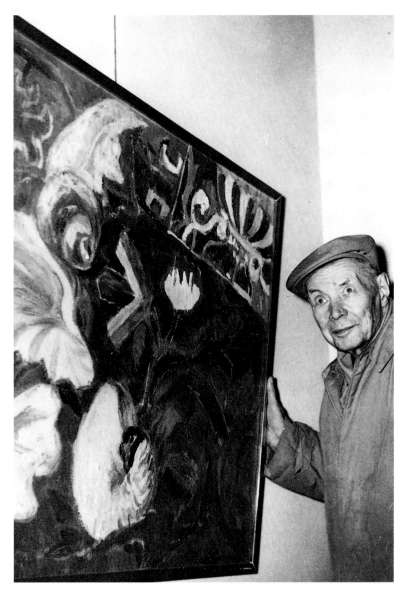

Fig. 215. Larionov with his painting *Seashells*, early 1960s

years," was my reply. "Well then," he continued, "we are able to *tutoyer.*" Thus, after forty-two years of friendship, we called each other *tu* for almost an hour.[42]

Marcel Mihalovici was one of the last people to see Larionov alive for he died on 10 May 1964 in his bed at *La Provençale* (fig. 216). On May 14 he was buried according to the rites of the Russian Orthodox Church, next to his companion in life, Goncharova, in Ivry Cemetery, division 7, line 1, tomb 14, which bears the words:

NATHALIE GONTCHAROVA
(ARTISTE, PEINTRE)
1881–1962

MICHEL LARIONOV
(ARTISTE, PEINTRE)
1881–1964

Despite his futurist gasconade—and to the end of his life he remained a staunch protagonist of modernism in the artistic and theatrical world—Larionov was basically a self-effacing man. He was nonetheless a complex personality who exhibited a self-indulgent temperament and a lazy streak in his character. The fact that he over-painted and pre-dated his works has not encouraged recognition of his contribution to

Fig. 216. Larionov on his death bed, 1964

twentieth-century art by art historians. Larionov was, however, an outstanding artist and theatrical designer and in the years before the war was a vital and important force in the Russian art world. A decline in painterly vitality after 1915 may be explained in terms of his medical condition which impaired his concentration and creative vision. His graphics and theatre designs, however, still reflected the scintillating magic of his former talent.

As to Larionov's importance for twentieth-century art, the most significant contribution was his development of neo-primitivism. His personal collection of *lubki* and icons, his writings on art, and various books that still exist in his library reveal him to be an artist with wide-ranging interests—not only in an-

cient, tribal, naive, and folk art outside the Fine Art tradition, but also in archaeology, mythology, and ethnography, and these interests frequently informed his artistic research and practice. He was an intellectual, literary, and erudite artist, despite the coarseness of his style and subject matter. Neo-primitivism was a remarkably emotive, powerful, and primal style of painting, an equal of German expressionism, and Larionov's enthusiasm for rediscovering and reevaluating in painterly terms the visual traditions of the Russian nation influenced an entire generation of Russian painters. Soviet artists today still admire Larionov for his work in this field, and the stylistic approach of some has evolved by reference to Larionov's contribution.

In the development of rayism, contemporary science was particularly important, as was the close aesthetic and theoretical relationship between Larionov and the Italian futurists. However, the influence of futurist thought never led Larionov to abdicate his individuality or originality in his painting, and he frequently anticipated the Italians in both theory and practice. Rayism is of historical importance in that it was the first nonobjective style of painting in Russia and as such it had a profound effect. Goncharova executed a gorgeous series of rayist works, Shevchenko and Vera Shekhtel are known to have adopted the style, while the graphic work of Rozanova in the years before the First World War shows rayist influence. In particular, Larionov's emphasis on the formal aspects of painting—his conviction that a picture could be constructed according to a specific method—was to have important repercussions on the later evolution of constructivism, which have yet to be fully investigated. Heralded by Apollinaire, rayism was a distinctive aesthetic and spiritual expression of modernism and, in the history of art, occupies an important place alongside the kindred and analogous movements of its day.

Larionov's work for the *Ballets Russes* and the theatre was no less innovatory. Applying an original flare and talent in this field, he was one of the most successful artists of the Diaghilev troupe. His daring designs for ballets such as *Soleil de Nuit, Contes Russes, Chout,* and *Le Renard,* succeeded in communicating to western audiences the riches, depth, and grandeur of Russian culture. His more avantguard researches in this field captured the imagination of leading composers, artists, and impresarios, from Lord Berners and Casella, to Diaghilev and Rolf de Maré, all of whom sought his collaboration. Moreover, he was internationally respected as an historian of the ballet, an authority on all aspects of drama, dance, and choreography, whose theatrical library and archives were, and still are, unique.

Larionov made another crucial contribution to twentieth-century art. His years at the Moscow School were distinguished by a remarkable ability for organizing exhibitions and mobilizing artists. Without his efforts Russian futurism would have been principally a literary and poetical school, not blossoming into the rich cultural movement that it became. Diaghilev recognized these talents in Larionov when he invited the artist to join him in Switzerland in 1915 to reorganize the *Ballets Russes.* In Paris during the 1920s Larionov continued to organize, not only exhibitions, but important artistic events such as the *Grand Bal* for the *Union des Artistes Russes.* Ultimately in the late 1920s he coordinated cultural events between France and the Soviet Union. It was through his initiative, his connections, and his determination that, for example, the Exhibition of Contemporary French Art was shown in Moscow, and that works by Soviet artists were shown in Paris.

Finally, a sense of humor pervades Larionov's work. The *raison d'être* of many of his creations is simply to make one laugh. His humor is not the intellectual and punning verbal wit of cubism nor the dubious and menacing humor of Dada and surrealism; rather it is a simple, good-natured, earthy humor, "straight from the pages of Russian proverbs," as Joan Osiakovski observed.[43] It is the humor of the ridiculous *Blue Pig,* the transparent clothes of the lewd *Boulevard Venus,* and the wicked caricatures of the *Ballets Russes* troupe as repulsive dogs. In this, Larionov's art is like that of Rabelais, and in modern times, of James Joyce, whose contemporary Larionov was. With Joyce, Larionov shares the ability to make a significant and important statement and then to set it against a bawdy joke or comic scene. In a century where the trend of art has been principally sophisticated and intellectual, Larionov's use of humor is humanizing and, as in Joyce, a mark of genius.

NOTES

(The Larionov Collection in the National Art Library of the Victoria & Albert Museum, London, is abbreviated to NAL. References to Larionov's writings are given with short titles in addition to the date to facilitate their location in the Bibliography.)

PREFACE

1. The term *rayism* is the literal translation of the Russian *luchizm, luch* (ray), and is used throughout. The term *rayonism*, derived from the French translation of *luch* (*le rayon*), is preserved only in quotations.

2. In the exhibition *Hommage à Gontcharova et Larionov* (Paris, 1981) a folio of theatre designs entitled *Art Théâtral*, published in 1919, had been pre-dated to 1911 to accord with an inscription in Larionov's hand.

3. Vergo 1972, p. 479. The revised copies of *Luchizm, Poluzhivoi*, and Eganbyuri's monograph *Goncharova Larionov* are located in NAL.

CHAPTER ONE

1. Russian dates before 1918 are given according to the Old Style Julian Calendar.

2. "Certificat No. 96," Dossier No. 37203x38: "Naturalisation Française concernant Michel Larionoff," Ministère des Affaires Sociales et de la Solidarité Nationale, Paris.

3. Larionov, letter to Mary Chamot, 29 September 1954. Collection of the author.

4. D. Mitrokhin, "Avtobiograficheskie zametki" (1936), and "Pis'mo F. L. Ernstu" (14 February 1932), in Mitrokhin 1986, pp. 14, 164.

5. Jotterand 1959, p. 65.

6. George 1966, pp. 25–26; Chamot 1955, p. 173; Loguine 1971, p. 13; and Gray 1962, p. 102.

7. A. S. Trofimov, Pro-Rector of the Surikov Institute, letter to the author, 9 February 1983.

8. Larionov, "Moya pervaya vstrecha s Dyagilevym," 1967.

9. Eli Eganbyuri, pseudonym of Ilya Zdanevich, wrote an illustrated monograph on Larionov and Goncharova in 1913, which includes a chronological catalogue of their paintings. The author admitted its shortcomings in a letter to Le-Dantyu (see Dyakonitsyn 1966, p. 197).

10. Grabar 1937, p. 267.

11. Purchasers of paintings are taken from Eganbyuri's list principally but also from exhibition catalogues.

12. Skif, "Vystavka moskovskago tovarishchestva khudozhnikov," *Zolotoe runo*, February 1906, p. 118.

13. N. Tarovaty, "Na akvarel'noi vystavke v Moskve," *Zolotoe runo*, January 1906, pp. 123–24.

14. Mitrokhin 1986, p. 14, and Punin 1928.

15. Impressionist works by Sisley, Manet, Monet, and Pissarro were illustrated in *Mir iskusstva*, February–March 1901 and July 1901. Works by Renoir and Degas were published in 1903, no. 10, pp. 52–55 and pp. 248–54, respectively.

16. Grabar 1937, p. 187.

17. N. Tarovaty, "Na vystavke 'Mir iskusstva' – vpechatleniya," *Zolotoe runo*, March 1906, p. 125.

18. A. Shervashidze, "Vystavka russkago khudozhestva v Parizhe," *Zolotoe runo*, November–December 1906, pp. 130–33.

19. P. Muratov, "Vystavka soyuza i peredvizhnaya v Moskve," *Vesy*, 1907, no. 2, pp. 109–11.

20. *Zolotoe runo*, March 1907, p. 82.

21. *Vystavochny vestnik*, 10 April 1907, no. 10, p. 19, and P. Muratov, "XIV Vystavka kartin moskovskago tovarishchestva khudozhnikov," *Russkoe slovo*, 5 April 1907, no. 78, p. 5.

22. Larionov, "Malevitch," 1957, pp. 6–8, states that he met Malevich after the exhibition of the Moscow Association of Artists in 1906. However Malevich did not exhibit with the Moscow Association of Artists until 1907.

23. Marcadé 1971, p. 203.

24. P. Muratov, "Staroe i molodoe na poslednikh vystavkakh," *Zolotoe runo*, January 1908, p. 89, and I. Grabar, "Soyuz i venok," *Vesy*, January 1908, no. 1, pp. 137–42.

25. These were *The Water Seller, Evening after the Rain, Through the Nets, Restaurant on the Sea-Shore*, and *Bathing Women*.

26. Toporkov purchased Larionov's *Landscape, Flowers, Still Life*; Poznyakov, *Acacia at Noon*; and René Ghil, *Lilac in Front of the Setting Sun*.

27. I. I., "Vystavki," *Zolotoe runo*, February 1908, p. 70.

28. Mercereau was a member of the Abbaye de Créteil and was coeditor of the magazine *Verse et Prose*. He lived in Russia in 1906 and contributed to *Vesy* and *Zolotoe runo* under the pseudonym Eshmer Valdor.

29. P. Ettinger, "Salon 'Zolotogo runa,'" *Russkie vedomosti*, 18 April 1908, no. 90, p. 4.

30. Aleksandr Kuprin, in Kravchenko 1973, p. 58.

31. The exhibition was extended by a month. *Zolotoe runo*, 1908, no. 6, p. 78.

32. M. Voloshin, "Novyya ustremleniya frantsuzskoi zhivopisi"; Ch. Morice, "Novyya tendentsii frantsuzskago iskusstva"; Van-Gogh, "Iz perepiski s druz'yami"; G. Tasteven, "Impressionizm i novyya iskaniya." These were published as a special section in *Zolotoe runo*, 1908, nos. 7–9, pp. i–xii. Further translations of Van Gogh's letters were published in 1909, nos. 2–3, pp. 80–86.

33. Bowlt cites David Burlyuk as author and its title as "Golos impressionista v zashchitu zhivopisi." Quotations here were reprinted in Chuzhanov (note 34 below).

34. Ivan Chuzhanov, "Vystavki I: 'Zveno,'" *V mire iskusstv* (Kiev), 1908, nos. 14–15, pp. 19–21.

35. "Khudozhestvennaya khronika," *Iskusstvo i pechatnoe delo* (Kiev), January–February 1909, nos. 1–2, pp. 17–18. The fable referred to is "Lisitsa i osel," in Krylov's *Fables*, book 7, no. 9. Republished in I. A. Krylov, *Sochineniya*, vol. III, Moscow, 1946, p. 158.

CHAPTER TWO

1. *Zolotoe runo*, 1909, no. 1, p. 11.

2. M. Denis, "Definition of Neotraditionism" (1890), in Chipp 1968, p. 94.

3. A. Shervashidze, "Zhorzh Sera (George Seurat): 1859–1891," *Apollon*, 1911, no. 7, pp. 26–29. Seurat's work was first exhibited in Russia in the *Exposition Centennale* organized by the *Institut Français* in early 1912.

4. *Zolotoe runo*, 1909, nos. 2–3, p. 116.

5. I. Grabar, "Moskovskie vystavki II: 'Zolotoe runo,' 'tovarishchestvo,' 'peredvizhniki,'" *Vesy* 1909, no. 2, pp. 103–10.

6. Maurice Denis, *Journal: Tome II (1905–1920)*, Paris, 1957, pp. 98–115.

7. Moris Deni (Maurice Denis), "Ot Gogena i Van-Goga k klassitsizmu," *Zolotoe runo*, 1909, no. 5, pp. 63–68, and 1909, no. 6, pp. 64–67.

8. Daulte 1979, p. 48.

9. "Beseda s N. S. Goncharovoi," *Stolichnaya molva*, 5 April 1910, no. 115, p. 3.

10. Letter from Van Gogh to his brother Theo, September 1888, *The Complete Letters of Vincent Van-Gogh*, New York Graphic Society, 1958, vol. III, p. 39.

11. Anri Matiss (Henri Matisse), "Zametki khudozhnika," *Zolotoe runo*, 1909, no. 6, pp. iii–x.

12. If it is the same painting as *Landscape after the Rain*, exhibited in the Golden Fleece exhibition of February 1909, it may date from late 1908.

13. It is worth noting that a painting of a hairdresser by Matisse was reproduced in the June 1909 edition of *Zolotoe runo*. This was not the painting exhibited under the same title in the first Golden Fleece exhibition, which was of a woman at her dressing table, reproduced in *Zolotoe runo*, July–September 1908.

14. A. Toporkov, "O tvorcheskom i sozertsatel'nom estetisme," *Zolotoe runo*, 1909, nos. 11–12, p. 72.

15. S. Glagol, "Moi dnevnik," *Stolichnaya molva*, 3 February 1909, no. 42, p. 1.

16. Gauguin's carvings and ceramics of phallic-shaped idols were reproduced in *Zolotoe runo*, 1909, no. 1, pp. 9, 12. The essay by Charles Morice, "Gogen kak skul'ptor," was published in *Zolotoe runo*, 1909, nos. 7–9, pp. 132–35, and no. 10, pp. 47–51.

17. "Vystavka 'Soyuza molodezhi' II," *Rizhskaya mysl'* (Riga), 28 June 1910, no. 871, p. 3.

18. Aleksandr Kuprin, in Kravchenko 1973, p. 58.

19. Vladimir Markov, letter, January/February 1910, Russian Museum, St. Petersburg, fond 121, no. 44, p. 1.

20. N. Breshko-Breshkovsky, "Soyuz molodezhi," *Birzhevyya vedomosti*, 13 March 1910, no. 11612, p. 6.

21. "Khronika: Soyuz molodezhi," *Zolotoe runo*, 1909, nos. 11–12, p. 101.

22. Larionov, "Gazetnye kritiki v roli politsii nravov," 1909.

23. Mikhail Khodasevich, father of the artist Valentina Khodasevicha (1894–1970) and elder brother of the poet Vladislav Khodasevich (1886–1939). For a review of the proceedings, see "Bubnovaya dama na sudom," *Protiv techeniya*, 4 January 1911, p. 4.

24. Livshits records: "In the summer of 1910 the painter of *The Soldier's Venus* [i.e., Larionov] had stayed at Chernyanka together with Khlebnikov, enjoying the grand hospitality of the Burlyuk family" (Livshits [1933] 1977, p. 90). A letter from Larionov to his brother, 2 June 1910, states that he has been with the Burlyuks at Chernyanka for three days (Khardzhiev 1976, p. 77, n. 85).

25. D. and N. Burlyuk, E. Guro, V. Kamensky, and V. Khlebnikov, *Sadok sudei*, St. Petersburg, 1910.

26. Matisse, "Notes of a Painter" (1908), in Chipp 1968, p. 135.

27. A. Kuprin, "Preobrazovanie moskovskago uchilishcha zh. v. i. z. v akademiyu," *Zolotoe runo*, 1909, nos. 11–12, pp. 93–95.

28. I am grateful to Mr. A. S. Trofimov of the Surikov Institute for this information. The date Larionov received his diploma is based on Loguine 1971, p. 13, n. 9.

CHAPTER THREE

1. For responses to Vergo's analysis in *Burlington Magazine* see Vergo, September 1972, no. 834, p. 634; Bowlt, October 1972, no. 835, pp. 719–20; Hutton Galleries, October 1972, no. 835, p. 720; and Rudenstine, December 1972, no. 837, p. 874. And see Isarlov 1923, p. 3, and Eganbyuri 1913, p. 32.

2. *Larionov Dessins et Peintures*, exhibition catalogue, 1973, pl. 104.

3. I am grateful to Susan Compton for this information.

4. Dossier No. 37203x38: "Naturalisation Française concernant Michel Larionoff," Ministère des Affaires Sociales et de la Solidarité Nationale, Paris.

5. Pospelov 1985, p. 218, n. 45.

6. Livshits (1933) 1977, p. 97, and Kirill Zdanevich's logbook in the Iliazd-Zdanevich archive.

7. Conversation with Mary Chamot, 13 January 1983, who heard this from Eugene Mollo.

8. *Soldiers* was reproduced in *Bubnovy valet*, 1910, but then repainted and illustrated in Eganbyuri's monograph. Afterwards it was repainted again. The second (Eganbyuri) version is reproduced here because of the poor quality of the original reproduction.

9. Illustrated advertisements for corsets frequently appeared in the Russian press; see *Birzhevyya vedomosti* (St. Petersburg), March–May 1910.

10. Lentulov, in *Sieben Moskauer Künstler*, 1984, pp. 155–56.

11. Sergei Glagol, "Bubnovy valet," *Stolichnaya molva*, 13 December 1910, no. 156, p. 5; I. Ignatov, "Otkliki zhizni: Bubnovy valet i veliky inkvizitor," *Russkie vedomosti*, 6 January 1911, no. 4, p. 3; "Musca," "Bubnovy valet," *Rannee utro*, 11 December 1910, no. 286, p. 2.

12. Konchalovsky, in *Sieben Moskauer Künstler*, 1984, p. 74.

13. Rusakov 1975, p. 290, quotes from *Vechernaya gazeta* 30 October 1911.

14. "Matiss o Moskve," *Utro Rossii*, 27 October 1911, no. 247, p. 5.

15. "The Society of Free Aesthetics has included a new enterprise in its activities—the organization of one-day exhibitions of its painter members," *Apollon*, January 1912, no. 1, p. 10.

16. "M. F. Larionov," *Protiv techeniya*, 17 December 1911, no. 48, p. 3.

17. Cherri, "Ssora 'khvostov' s 'valetami,'" *Golos Moskvy*, 11 December 1911, no. 285, p. 5.

18. *Obozrenie teatrov*, 30 April 1911, no. 1385, p. 11.

19. A. fon Vizen, "Pis'mo v redaktsiyu," *Utro Rossii*, 22 March 1912, no. 68, p. 5.

20. Livshits (1933) 1977, pp. 82–84.

21. N. Goncharova, "Pis'mo v redaktsiyu," *Stolichnaya molva*, 20 February 1912, no. 230, p. 5.

22. Loguine 1971, pp. 19–20, cites Shklovsky, who gives 1910. Nigel Gosling, in *The Adventurous World of Paris 1900–1914*, New York, 1978, p. 83, gives 1905.

23. Ilya Repin, "Iskusstvo i khudozhniki," *Birzhevyya vedomosti*, 20 May 1910, no. 11728, pp. 5–6.

24. *Rannee utro*, 8 January 1911, no. 5, p. 2.

25. Chamot 1973, p. 496.

26. For an account of the fire, see "Pozhar 'Oslinogo khvosta,'" *Stolichnaya molva*, 12 March 1912, no. 233, p. 4.

27. "Kopcheny khvosty," *Utro Rossii*, 14 March 1912, no. 61, p. 5.

28. M. Voloshin, "Khudozhestvennaya zhizn': Osliny khvost," *Apollon – Russkaya khudozhestvennaya letopis'*, April 1912, no. 7, pp. 105–6.

29. See "Zakrytie vystavka," *Stolichnaya molva*, 9 April 1912, no. 237, p. 4.

30. *Obshchestvo khudozhnikov 'Soyuz molodezhi'*, St. Petersburg, April 1912, and *Obshchestvo khudozhnikov 'Soyuz molodezhi'* 2, June 1912.

31. Letter from Van Gogh to his brother Theo, August 1888, *The Complete Letters of Vincent Van-Gogh*, New York Graphic Society, 1958, vol. III, p. 6.

32. Larionov's designs include *Aleksei Kruchenykh* (fig. 38), *Sonya the Whore* (fig. 39), *The City* (fig. 40), *The Street, Changing the Guard, Self-Portrait, Portrait of Nataliya Goncharova, The Waitress* or *The Café, The Hairdresser, Resting Soldier, Bread, Mistress and Maid Servant* from *An Imaginary Voyage to Turkey*, and *Katsap Venus*.

33. Larionov, *Luchizm*, 1913, pp. 17–19.

34. Larionov, letter to Alfred Barr, 1936 (NAL Box 36.F), comments: "The relationship with the ideas of Leonardo would have only been conceived. It would have smoothed out certain difficulties arising during the course of the acceptance of Rayism. Leonardo would have been a wonderful grandfather, in that each new artistic theory, by tradition, has got to have an ancestor. But so what? Rayism doesn't need him . . ."

35. Paul Valéry, "Introduction à la Méthode de Léonard da Vinci," *Nouvelle Revue* (Paris), 15 August 1895.

36. Compton 1978, pp. 70–71, and 121, n. 10.

37. Vrubel, in Prakhov, *Stranitsy proshlogo*, Kiev, 1958, pp. 159–60.

38. Essem (Sergei Makovsky), "Vystavki i khudozhestvennyya dela: Mir iskusstva," *Apollon*, February 1913, no. 2, pp. 55–58.

39. Benois 1912. This review dates the exhibition, and hence the genesis of rayism, to December 1912 rather than December 1911 which was based on a misprint on the cover of the catalogue.

40. Larionov, letter to Mary Chamot, 29 September 1959. Collection of the author.

41. George 1966, p. 116, and Loguine 1971, pp. 18–19, n. 24.

42. Chamot 1979, p. 12.

43. Khardzhiev 1940, p. 358, n. 1, quotes a letter of 1 March 1911 from Kandinsky to Goncharova. See also chap. 4, n. 14, below.

44. Benois 1912, in Vanslova 1977, p. 597.

45. *Stolichnaya molva*, "Venery Mikhaila Larionova," 1912.

46. A. Rostislavov, "Doklady i disputy," *Rech'*, 17 February 1913, p. 6. For Larionov's vacillation about taking part in the debate, see Howard 1992, pp. 157–58.

47. *Moskovskaya gazeta*, 8 July 1913, no. 261, p. 2.

48. Fokine 1961, p. 227. Khardzhiev, "Mitrokhin v obratnoi perspective," in Mitrokhin 1986, p. 394.

CHAPTER FOUR

1. N. V. Bogoyavlensky, ethnographer and author of *Zapadny zastenny Kitai*, St. Petersburg, 1906.

2. Ya. Tugendkhold, "Moskovskaya vystavki," *Apollon*, March 1913, no. 3, p. 58.

3. F. Mukhortov, "Luchisty," 1913.

4. Second Corporation of Signboard Artists, letter to *Rannee utro*, 29 March 1913, no. 73, p. 5.

5. N., "Khudozhestvennye vesti: Disput 'Mishena,'" *Utro Rossii*, 24 March 1913, no. 70, p. 5.

6. "Moskovskaya khronika: Skandal na sobranie," *Rech'*, 25 March 1913, no. 82, p. 1.

7. Ya. Tugendkhold, "Moskovskiya pis'ma: Vystavki," *Apollon*, April 1913, no. 4, pp. 57–59.

8. Annenkov, in Loguine 1971, p. 74.

9. Larionov, *Luchizm*, 1913, p. 13.

10. Ibid., pp. 20–21.

11. *Russkaya molva*, 21 May 1913, no. 157, p. 5.

12. "Khudozhestvennye novosti," *Moskovskaya gazeta*, 8 April 1913, no. 246, p. 6.

13. Larionov, "Luchisty i budushchniki," 1913, pp. 9–10.

14. Kandinsky, letter of 5 June 1913: "Up till now I have received offers from Busse, Reuber (Berlin), Larionov. I asked them all to send manuscripts but did not promise anything" (in Kandinsky and Marc 1974, p. 31).

15. Larionov, "Luchisty i budushchniki," 1913, pp. 12–13.

16. A. Bely, *Simvolizm*, Moscow, 1910, p. 143.

17. A. Grishchenko, *O svyazyakh russkoi zhivopisi s Vizantei i Zapadom XIII–XX vv*, Moscow, 1913, p. 89.

18. Le-Dantyu, "Zhivopis' vsekov," Central State Archive of Literature and Art, Moscow (f. 792, op. 1, ed. khr. 1, ll.17–34, 35–56). This is probably the text of his lecture in St. Petersburg, 10 December 1913. Zdanevich lectured on the subject in Moscow, November 1913, and Shevchenko refers to the concept in the title of his book *Printsipy kubizma i drugikh sovremennykh techeny v zhivopisi vsekh vremen i narodov*, Moscow, 1913.

19. Khudakov cites an edition of forty copies though none are extant. Khardzhiev (1940, p. 375) believed Lotov was a pseudonym for Ilya Zdanevich but has since admitted his source was erroneous. He suggests the pseudonym was Bolshakov's (1976, p. 80, n. 114). Markov (1969, p. 403, n. 4) concludes that *Rekord* did not exist and that Lotov was a pseudonym for Larionov, but Larionov referred to Lotov in his letter to *Nov'* (n. 48 below). Lotov's name occurs in newspaper reports of the period, as author of plays for the "Futurist Theatre" and as a participant in the film *Drama v kabare futuristov No. 13*. Goncharova referred to Lotov and *Rekord* in sketchbook notes now in the Victoria & Albert Museum, London (Salmina-Haskell 1972, p. 51). In addition, Eganbyuri (1913, p. xxi) cites a book by S. Lotov entitled *Stikhi* and illustrated by Larionov. Lotov may thus be the pseudonym of either Sergei Bobrov or Konstantin Bolshakov.

20. The date of publication is printed in the back of the book.

21. *Stolichnaya molva*, 24 March 1914, no. 359, p. 4.

22. Rosstsii, "Khudozhestvennye vesti: Vystavka kartin N. S. Goncharovoi," *Russkie vedomosti*, 1 October 1913, no. 225, p. 6.

23. A. Benois, "Dnevnik khudozhnika," *Rech'*, 21 October 1913, no. 288, p. 4.

24. *Russkoe slovo*, 6 November 1913, no. 256.

25. "Futuristicheskaya drama," *Stolichnaya molva*, 7 October 1913, no. 331, p. 5.

26. *Vladimir Mayakovsky: Tragediya* was performed at the Luna-Park Theatre in St. Petersburg on 2 and 4 December 1913. *Pobeda nad solntsem* (*Victory over the Sun*) was performed there on 3 and 5 December 1913.

27. Khardzhiev 1939, p. 83.

28. "K proektu futuristicheskogo teatra v Moskve," *Teatr v karrikaturakh*, 8 September 1913, no. 1, p. 14.

29. "Teatr 'Futu,'" *Moskovskaya gazeta*, 9 September 1913, no. 272, p. 5.

30. Ibid.

31. "Vcherashnyaya progulka futuristov," *Stolichnaya molva*, 15 September 1913, no. 327, p. 4; "Raskrashenny Larionov," *Moskovskaya gazeta*, 9 September 1913, no. 272, p. 3; and "Raskrashennye moskvichi," *Moskovskaya gazeta*, 15 September 1913, no. 273, p. 5, and 16 September 1913, no. 274, p. 5.

32. A. D. Privalova was "the first follower of futurist novelties"; *Teatr v karrikaturakh*, 21 September 1913, no. 3, p. 14.

33. Michel Georges-Michel, *L'Epoque Tango*, Paris, 1920, pp. 68–69.

34. "Russkaya moda (pis'mo iz Parizha)," *Moskovskaya gazeta*, 27 January 1914, no. 297, p. 2.

35. P. K., "Rozovy fonar," *Teatr v karrikaturakh*, 13 October 1913, no. 6, p. 15.

36. "V 'Rozovom fonare,'" *Obozrenie teatrov*, 22 October 1913, no. 2240, p. 17.

37. See *Moskovskaya gazeta*, 21 October 1913; *Rul'*, 21 October 1913; *Russkie vedomosti*, 22 October 1913; *Stolichnaya molva*, 21 October 1913.

38. "'Manifest k muzhine' i 'Manifest k zhenshchine,'" *Stolichnaya molva*, 15 September 1913, no. 327, p. 4.

39. Reports of the subsequent court proceedings are to be found in "Protsess futuristov," *Peterburgskaya kur'er*, 17 May 1914, no. 114, p. 7; "Ne ot mira sego: Futuristy na sude," *Zhizn' i sud* (St. Petersburg), 19 May 1914, p. 10; and "Opravdannye futuristy," *Stolichnaya molva*, 19 May 1914, no. 370, p. 3.

40. Mayakovsky's articles included "Teatr, kinematograf, futurizm," "Unichtozhenie kinematografom 'teatra' kak priznak vozrozhdeniya teatral'nogo iskusstva," and "Otnoshenie segodnyashnego teatra i kinematografa k iskusstvu," *Kinezhurnal*, (Moscow), 27 July 1913, no. 14; 24 August 1913, no. 16; and 18 September 1913, no. 17. Reprinted in Mayakovsky 1955.

41. Kasyanov's memoirs are in Gosfil'mfond in Moscow.

42. "Futuristy v kinematografe," *Nov'*, 26 January 1914, no. 11, p. 6; "Futuristicheskaya film,'" *Nov'*, 30 January 1914, no. 14, p. 10; and "Futurizm na ekrane," *Teatr i iskusstvo*, 23 August 1915, no. 34, p. 626. These reviews support Kasyanov's recollections.

43. Leyda 1960, p. 61, and Ginzburg 1963, pp. 233–34.

44. Larionov, "Pochemu my raskrashivaemsya," 1913, p. 115.

45. *Birzhevyya vedomosti*, 29 November 1913, no. 13881, p. 4, advertised the reading of a manifesto, a slide show of works by Larionov and Goncharova, and Negro and Chinese art, as well as lectures by Le-Dantyu on "Everythingism and Painting," and Ilya Zdanevich on "Everythingism and Retrograde Futurism" and "Everythingism and Nataliya Goncharova."

46. "K priezdu Marinetti: Ugroza tukhlymi yaitsami i kislym molokom," *Vechernie izvestiya* (Moscow), 24 January 1914, no. 381, p. 2.

47. V. Shershenevich, "Futurist o Marinetti: pis'mo v redaktsiyu," *Nov'*, 26 January 1914, no. 11, p. 8, and K. Malevich, "Otmezhevavshiesya ot Larionova," *Nov'*, 28 January 1914, no. 12, p. 5.

48. Larionov, "K raspre futuristov (pis'mo v redaktsiyu)," *Nov'*, 29 January 1914, no. 13, p. 8.

49. V. Shershenevich, "Pis'mo v redaktsiyu," *Nov'*, 30 January 1914, no. 14, p. 9.

50. Larionov, "Pis'mo v redaktsiyu," *Nov'*, 31 January 1914, no. 15, p. 3.

51. *Nov'*, 5 February 1914, no. 19, p. 6. The final letter of the debate by Shershenevich, Mayakovsky, and Bolshakov was published in *Nov'* on 15 February 1914, p. 9.

52. Kovtun 1989, p. 90.

53. "Gonenie na futuristov," *Russkoe slovo*, 21 February 1914, no. 43, p. 6.

54. "Nashe prazdnichnoe interv'yu s futuristami," *Teatr v karrikaturakh*, 1 January 1914, nos. 1–2, p. 19.

55. "Prodelka futurista," *Peterburgskaya gazeta*, 11 February 1914, no. 41, p. 5.

56. N. Breshko-Breshkovsky reported the commission in "Futuristy i sal'nye svechi," *Peterburgskaya gazeta*, 5 December 1913, no. 334, p. 4.

57. Michel Fokine 1961, pp. 227–28.

58. *Den'* (Moscow), 7 October 1913, no. 271, p. 5.

59. "'Vystavka kartin No. 4, futuristy, luchisty, primitiv 1914 goda' v Moskve," *Ogonek*, 13 February 1914, no. 15.

60. Milner 1983, p. 191.

61. "Original'naya vystavka," *Vechernee vremya*, 1 April 1914, no. 727, p. 4. Also see "Vystavka 'Luchistov,'" *Peterburgsky kur'er*, 2 April 1914, no. 72, p. 4.

62. "Futurism i koshchunstvo," *Peterburgsky listok*, 16 March 1914, no. 73, p. 9.

CHAPTER FIVE

1. Shevchenko, *Neo-Primitivizm*, 1913, in Bowlt 1976, p. 46.

2. N. Goncharova, "Predislovie," *Vystavka Natalii Sergeevny Goncharovoi 1900–1913*, Khudozhestvenny Salon, Moscow, 1913, in Bowlt 1976, pp. 54–60.

3. Shevchenko, *Neo-Primitivizm* (1913), in Bowlt 1976, p. 53.

4. Ibid., p. 49.

5. Ibid., p. 45.

6. Isarlov 1923, p. 2.

7. Dobuzhinsky 1987, p. 344, n. 37.

8. Dobuzhinsky's painting was reproduced in *Zolotoe runo*, 1906, no. 6, p. 16.

9. *Zolotoe runo* published the following: Pavel Kuznetsov, "Broderie Moderne," and Aleksandr Sredin, "Broderies Anciennes," in 1906, no. 3, pp. 23–30, and 88–93, respectively. A. I. Ouspensky, "L'Iconographie en Russie jusqu'à la Seconde Moitié du XVII Siècle," and idem, "Fresques de Parvis de la Cathédrale de l'"Annonciation à Moscou," in 1906, nos. 7–9, pp. 5–32 and 33–48 respectively. E. O., "Les Manuscrits pomoriens leurs miniatures et leurs ornements," in 1907, no. 10, pp. 19–23. In addition forty-six reproductions of Persian art works were published in 1908, nos. 3–4, pp. 5–38.

10. Sergei Makovsky, "Golubaya roza," *Zolotoe runo*, 1907, no. 5, p. 25.

11. Markov 1969, p. 35.

12. Larionov, "Luchisty i budushchniki" (1913), in Bowlt 1976, p. 90.

13. A. Koiransky, *Protiv techeniya*, 17 December 1911, no. 14, p. 3.

14. Alexandre Benois, "La valeur artistique de Venetzianov," *Zolotoe runo*, 1907, nos. 7–9, pp. 29–32. This issue also contained reproductions of Venetsianov's paintings (pp. 5–28), works by his pupils (pp. 43–60), an article by A. I. Ouspensky, "A. Venetzianov" (pp. 33–40), and one by Baron N. Vrangel, "Venetzianov et son école" (pp. 61–64).

15. The Old Believers (*Raskol'niki*) originated in the seven-

teenth century when the patriarch Nikon reformed the antiquated religious traditions of Russia. Those who did not support the revisions were declared Old Believers and excommunicated.

16. D. A. Rovinsky, *Russkiya narodnyya kartinki*, St. Petersburg, 1881.

17. Z. Ashkinazi, "Pis'mo iz Moskvy: Na vystavkakh," *Apollon*, February 1915, no. 2, pp. 70–72.

18. "Russkoe oslokhvostie zagranitsei," *Obozrenie teatrov*, 5 June 1912, p. 14.

19. Kruchenykh 1928, p. 24. Compton (1978) and Janecek (1984) both discuss the printing techniques employed in the production of futurist books.

20. Larionov, "Les Icônes" (c. 1920s), in Larionov, *Une Avant-Garde Explosive*, 1978, pp. 132–33.

21. Icons were traditionally hung in the "Red Corner" of a Russian home.

22. Tatlin, quoted by B. Lubetkin in his lecture, "The Origins of Constructivism" (1969), in Lodder 1983, p. 12.

23. N. P. Likhachev, *Tsarsky 'izograf' Iosif i ego ikony*, St. Petersburg, 1897, and *Stroganovsky ikonopisny litsevoi podlinnik, konstsa xvi i nachala xvii stoletii*, Moscow, 1869. Larionov's copies are located in NAL.

24. John House, in his paper "Manet: *Naïveté* Reinvented," Xth Conference of the Association of Art Historians, Edinburgh 1984, argued that the "naivety" of Manet's paintings was conditioned by his subversion of French academic conventions and culture, and that each society cultivates its own naivety based upon the subversion of traditions within its knowledge and experience.

25. Larionov, "Les Icônes," pp. 132–33.

26. Ibid.

27. K. A. Inostrantsev, *Iz istorii starinnykh tkanei*. Reprint from *Zapiski vostochnago otdeleniya Imperatorskogo Russkago Arkheologicheskago Obshchestva*, vol. XIII, St. Petersburg, 1901. The pamphlet was in NAL but is now lost.

28. Gray, in *Larionov and Goncharova*, exhibition catalogue (London, 1961), no. 40.

29. Mayakovsky 1955, p. 41.

30. N. Breshko-Breshkovsky, "Soyuz molodezhi," *Birzhevyya vedomosti*, 13 March 1910, no. 11612, p. 6.

31. Yu. B., "Mir iskusstva," *Rannee utro*, 4 December 1911, no. 279, p. 6. The painting was caricatured in *Rannee utro*, 18 December 1911, no. 291, p. 3.

32. A. Mertvago, "Mir iskusstva," *Utro Rossii*, 7 February 1912, no. 30, p. 2.

33. Bowlt 1974, p. 138.

34. A proposed book by Larionov and Khudakov entitled *Russkoe iskusstvo* on the subjects of stone *babas*, fretwork, dough, moulding, the lubok, icon, frescoes, signboards, and old and new artists was advertised in the almanac *Osliny khvost i mishen'*, 1913, p. 153.

35. Livshits (1933) 1977, p. 53.

36. Zdanevich (1965) describes the discovery of Pirosmanashvili.

37. Larionov, in F. M., "Luchisty (v masterskoi Larionova i Goncharova)," *Moskovskaya gazeta*, 1913.

38. Larionov, in Zdanevich 1965, p. 30.

39. Parnack 1919, p. 17.

40. *Soldat tudyt tvoyu . . . pod mramor* (the soldier fucks your . . . first class).

41. Andreenko, in Loguine 1971, p. 140.

42. F. Marc, "Masks," in Kandinsky and Marc, *The Blaue Reiter Almanach*, 1974.

43. Raynal, "Conception and Vision" (1912), in Fry 1966, p. 94.

44. Kulbin, "Svobodnoe iskusstvo kak osnova zhizni," in Markov 1969, p. 35. The biogenetic law equated the development of the child with the development of the human race: ontogenesis repeated philogenesis. The fields of study were thus related. After the discovery of the naturalistic cave paintings at Lascaux the biogenetic law was discredited.

45. L. Bakst, "Puti klassitsizma v iskusstve," *Apollon*, November 1909, no. 2, pp. 63–78.

46. Aleksei Kruchenykh, *Sobstvennye razskazy i risunki detei*, St. Petersburg, 1914.

47. David Burlyuk, "Kubizm," in *Poshchechina obshchestvennomu vkusu*, 1912, in Bowlt 1976, p. 77.

48. Fig. 118 in the exhibition catalogue *Larionov Dessins et Peintures* (Saint Etienne, 1973).

49. I wish to thank Scott Campbell for his observation on the use of children's art by Larionov.

CHAPTER SIX

1. Count I. I. Tolstoy and N. Kondakov, *Russkiya drevnosti v pamyatnikakh i iskusstva*, St. Petersburg, 1889–1899. Larionov's copies of Vols. II–VI are in NAL.

2. Balmont's findings were published in *Iskusstvo*, 1905, and *Zolotoe runo*, 1906, no. 1, pp. 78–89, and no. 2, pp. 45–57.

3. V. Kandinsky, "Iz materialov po etnografii simbol'skikh i vychegodskikh zyrian," *Etnograficheskoe obozrenie* (Moscow), 1889, no. 3, pp. 102–10. For Kandinsky's use of ethnography, see Weiss 1986.

4. Larionov's copies of *Starye gody* (St. Petersburg, 1909–1916) as well as his complete set of *Apollon* are in NAL.

5. Michael Jan de Goeje, *Mémoires d'Histoire et de Géographie Orientales . . . No. 3: Mémoir sur Les Migrations des Tsiganes à Travers l'Asie*, Leide, 1903. Located in NAL.

6. M. Kuzmin, "Puteshestvie Sera Dzhona Firfaksa po Turtsii i drugim zamechatel'nym stranam," *Apollon*, February 1910, no. 5, pp. 11–64.

7. Jacob Spon, *Voyage d'Italie, de Dalmatie, de Grèce et du Levant fait aux Années 1675 et 1676*, R. Alberts, La Haye, 1724. Larionov's copies are in NAL.

8. *Stolichnaya molva*, "Venery M. Larionova," 1912.

9. Larionov shared his interest in archaeology with other members of his family. In May 1912 his brother, the soldier and painter Ivan Larionov, went on an expedition to the Polynesian Islands in search of lost antiquities. "V mire iskusstva: Sredi khudozhnikov," *Stolichnaya molva*, 28 May 1912, no. 246, p. 4. Larionov's own interest in archaeology can be verified by the archaeological books which he still possessed in his library at his death.

10. In 1908 Nikolai Kulbin referred to the art of prehistoric peoples, and the artist Vladimir Markov in 1912 wrote of "monuments of the Stone Age, of hunting peoples, preserved in caves." Markov, "Printsipy novogo iskusstva," in Bowlt 1976, p. 32. The symbolist poets Balmont and Blok used prehistoric subjects in their poems as did Khlebnikov, who evokes prehistoric Slavic settings and events in several of his major works.

11. Gimbutas 1974, p. 33.

12. Archaeologists erroneously used the term "steatopygous" for figurines thought to represent a naturalistic portrayal of women with abnormally large buttocks. Gimbutas argues rather that these statuettes represent the bird-goddess and that the buttocks of the figurines were modelled around an egg.

13. Fig. 121 in the catalogue *Larionov Dessins et Peintures* (Saint Etienne, 1973).

14. They included nos 348–49 (Glinyannyya figurki), no. 360 (Glinyannaya statuetka, Indiya), nos. 376–77 (Glinyannyya figurki, Tulk.), nos. 372–73 (Nubyskiya statuetki), no. 374 (Egipetskaya figurka, derevo), no. 419 (Kukla, Nubiya).

15. John Bowlt suggests the importance of petroglyphs in Filonov's work (in Proffer 1980, p. 386).

16. Shklovsky 1974, p. 21.

17. "Beseda s N. S. Goncharovoi," *Stolichnaya molva*, 5 April 1910, no. 115, p. 3.

18. "Vystavka 'Soyuz molodezhi II.'" *Rizhskaya mysl'*, 28 June 1910, no. 871, p. 3.

19. See chap. 5, note 34, above.

20. Isarlov 1923, p. 2.

21. The photograph, dated 1927, is in NAL.

22. Livshits (1933) 1977, p. 45.

23. Herodotus, *The Histories*, Book IV, 71–76.

24. René Dussaud, *Les Civilisations Préhelléniques dans le bassin de la Mer Égée*, 1914. Located in NAL.

25. Larionov, "Predislovie," 1913, p. 6.

26. Shamans may be male or female and are distinguished by the spirits they serve. "Black" shamans serve evil spirits and are feared by the tribe while "white" shamans serve good spirits and are honored after death.

27. Eliade states: "Shamanism always remains an ecstatic technique at the disposal of a particular élite and represents as it were the mysticism of the particular religion." Eliade 1964, p. 8.

28. S. Shashkov, *Shamanstvo v Sibiri*, Zapiski Imperatorskago Russkago Geograficheskago Obshchestva, 1864. See the bibliographies in Czaplicka (1914) and Eliade (1964).

29. V. Anuchin, "Spiritizm i shamanizm," *Birzhevyya vedomosti* (St. Petersburg), 19 March 1910, no. 11622, p. 3 and 20 March 1910, no. 11623, p. 6.

30. "Khoromnyya deistviya" was advertised in *Birzhevyya vedomosti*, 20 January 1911, no. 12132, p. 1, and was reviewed in *Sovremennoe slovo*, 29 January 1911, no. 1102, p. 4.

31. Shklvosky 1971, pp. 33–34.

32. M. N. Khangalov, *Zapiski po etnografii: Novye materialy o shamanstve u Buryat*, Zapiski Vostochno-Sibirskago Otdela Imp. Russkago Geograficheskago Obshchestva po Etnografii, vol. 20, pt. II, Irkutsk, 1890. Larionov's copy is in NAL.

33. No. 614: "Buryatsky lubok iz kollektsii M. F. Larionova" ("Buryat *Lubok* from the Collection of M. F. Larionov").

34. Castagné, in Eliade, p. 97.

35. Eliade 1964, p. 94.

36. Ibid., p. 205. In Ovid, *Metamorphoses*, Book VII, 174–211, Medea claims the ability to make rivers run backward to their sources.

37. Quoted in Khudakov 1913, p. 140.

38. Kruchenykh discusses glossolalia in *Vzorval* (1913) and quotes meaningless words uttered by a Khlyst.

39. Kruchenykh, "Novye puti slova," *Troe*, 1913. Kruchenykh means that these Russian mystics had intuitively discovered the principles upon which *zaum* was later based. Markov (1969, pp. 202 and 398, n. 22) states that Kruchenykh was inspired by D. G. Konovalov's article, "Religiozny ekstaz v russkom misticheskom sektantstve," serialized in *Bogoslovsky vestnik* during 1907 and 1908.

40. Varlaam Shishkov (Livshits 1977, p. 164) was an authority on Shamanism and a practicing Khlyst. Bely's novel *Serebryany golub'* was serialized in *Vesy* during 1909 and published in Moscow in 1910. In Larionov's library (NAL) there is

an article on the Khlysts by P. I. Melnikov, "Tainyya sekty," in *Russky vestnik* (May 1868, vol. 75, pp. 5–70).

41. Khlebnikov's poem *Utro v lesu* was published in *Futuristy: Rikayushchy parnas*, St. Petersburg, 1914.

42. Livshits (1933) 1977, pp. 134, 236.

43. See Eliade on the relationship between the ecstatic language of shamanism and the development of lyric poetry (1964, pp. 510–11).

44. Kamensky 1940, p. 38.

45. Czaplicka 1914, p. 235.

46. See Larionov's greeting card executed in 1943 to mark Boris Kniaseff's 25th anniversary on the stage, in *Sergei Diaghilev, Boris Kniaseff, Max Reinhardt*, Sotheby & Co., London, 15–16 December 1969, lot 163.

47. For a full account of the complex role played by birds in shamanism, see Czaplicka (1914) and Eliade (1964).

48. Ovid, *Metamorphoses*, Book XI, 710–48. The Alcyone myth is one of many human/bird transformations that Ovid records. Ovid was exiled to the Black Sea Coast in A.D. 9 and died in a town near Odessa now called Ovidopol. Delacroix commemorated the event in his painting *Ovid among the Scythians*.

49. *Vystavka ikonopisnykh podlinnikov i lubkov*, 1913, nos. 149, 190, 238. The birds Alcyone and Sirin are familiar motifs in the iconography of Russian folk art. For a contemporary discussion of their significance, see M. N. Ditrikh, "Proiskhozhdenie ptitsy Sirina v russkom ornamente," *Trudy vserossyskago s'ezda khudozhnikov*, 1914, vol. 2, pp. 102–6.

50. In 1905 Khlebnikov went on an expedition with his brother to study birds in the Urals and in 1911 published a paper entitled "Ornithological Observations at the Pavdinsky Foundry" (Khlebnikov 1976, pp. 267–68). Khlebnikov's interests in ornithological symbolism were well known among the Russian avant-garde. Livshits wrote, "In the pictorial and poetical iconography of the 'King of Time' there exists a noticeable tendency to depict him as a bird [and] . . . his spiritual profile tended to take the shape of a Hawk-Horus" (Livshits [1933] 1977, p. 125).

51. Eganbyuri 1913, p. 33.

52. Eliade 1964, pp. 155–57.

53. Ibid., pp. 98–99, 219.

54. See Czaplicka 1914, pp. 58, 230, 234; Mikhailovskii 1895, p. 93; Eliade 1964, pp. 399–401.

55. Ibid., pp. 219, 417.

56. The function of Hermes Psychopompus was similar to that of the shaman. The interrelationship between Greek mythology and shamanism is discussed by Eliade 1964, pp. 387–94.

57. Isarlov 1923, p. 3.

58. Eliade 1964, p. 391.

59. Grigoriev 1953, p. 102.

60. L. G. Orshansky illustrated Eskimo and Ostyak dolls in his lecture "Igrushki i prikladnoe iskusstvo," All Russian Congress of Artists 1911–12. See *Trudy vserossyskago s'ezda khudozhnikov*, 1914, vol. 2, pp. 248–53.

61. Spence 1910, pp. 123–124.

62. Czaplicka 1914, p. 359.

63. Brown, in Khlebnikov 1976, p. 13.

64. Ibid.

65. Gray 1962, pp. 108–9.

66. Drawings on shamanic drums described in Czaplicka 1914, pp. 220–22, and Eliade 1964, p. 172, also utilize these devices.

67. J. Frazer, *The Golden Bough: A Study in Magic and Reli-*

gion, Part V: Spirits of the Corn and of the Wild, London, 1913. Also see Kandinsky's discussion (n. 3 above).

68. Boccioni et al., "Manifesto of Futurist Painters" (1912), in Apollonio 1973, p. 29.

CHAPTER SEVEN

1. Larionov, "Luchisty i budushchniki: Manifest" (1913), in Bowlt 1976, p. 87.

2. Léger's lectures included "Les origines de la peinture et sa valeur représentative," 15 May 1913, and "Les réalisations picturales actuelles," *Les Soirées de Paris*, 15 June 1914, pp. 349–54.

3. E. Glebova refers to Filonov's visit to Paris in "Vospominaniya o brate," *Neva*, 1986, no. 10, pp. 149–71.

4. Livshits (1933) 1977, p. 98.

5. "Vystavka rabot frantsuzskikh khudozhnikov v Moskve," *Utro Rossii*, 3 December 1910, no. 316, p. 4, reports an exhibition of French painting which showed the work of Cézanne, Gauguin, Van Gogh, Signac, Van Dongen, and Marquet.

6. "Frantsuzskaya vystavka kartin 'Sovremennoe iskusstvo,'" Khudozhestvenny salon, Moscow, January 1913. The opening was advertised in *Stolichnaya molva* (31 December 1912, no. 283, p. 5).

7. "Nemzetközi Postimpresszionista Kiállitásahoz," Budapest, April–May 1913.

8. Larionov subscribed to *Lacerba* (Firenze). His copies for 1914, nos. 1–10, 13, are in NAL.

9. E. Sem-v, "Futurizm (literaturny manifest)," in *Nasha gazeta*, 6 March 1909, no. 54, p. 4.

10. P. Buzzi, "Pis'ma iz Italii: Zhivopis,'" in *Apollon* ("Khronika"), July–August 1910, no. 9, pp. 16–18. Other articles in this issue included V. Sh., "Futuristicheskiya dramy na Florentyskoi stsene," pp. 18–20, and M. Kuzmin, "Futuristy," pp. 20–21.

11. "Manifest futuristov," "Eksponenty k publike," and Le Fauconnier, "Proizvedenie iskusstva," in *Soyuz molodezhi 2*, St. Petersburg, 1912, pp. 23–28, 29–35, and 36–37, respectively.

12. M. Matyushin, "O knige Metzanzhe-Gleza: *Du Cubisme*," in *Soyuz molodezhi 3*, March 1913, pp. 25–34.

13. Gleizes and Metzinger, *O kubizme* (translated by Max Voloshin), Moscow, July 1913, and *O kubizme* (translated by Ekaterina Nizen), St. Petersburg, November 1913.

14. Le Fauconnier, "Sovremennaya vospriimchivost' i kartina," and Apollinaire, "Fernan Lezhe," in *Sbornik statei po iskusstvu: Obshchestvo khudozhnikov 'Bubnovy valet,'* Moscow, February 1913, pp. 41–51 and 53–61, respectively.

15. For example, *Rech'*, 11 March 1913, included an article on "Orphism" (no. 68, p. 3).

16. In December 1913 *La Prose du Transsibérien* by Sonya Delaunay and Blaise Cendrars was exhibited at the Stray Dog (*Apollon*, January–February 1914, nos. 1–2, p. 134). David Burlyuk lectured on cubism at the Jack of Diamonds on 12 and 24 February 1912 (Moscow), the Union of Youth on 23 November 1912 (St. Petersburg), and the Artists' Association on 3 December 1912 (St. Petersburg). Grischenko lectured on "Picasso's Violin" in Autumn 1913 (Grishchenko, *Roki buri i natisku*, New York, 1967, p. 63).

17. A. Rostislavov, "Khudozhestvennyya vesti: Doklad o futurizme," in *Rech'*, 9 April 1913, no. 97, p. 4.

18. Larionov, *Luchizm*, 1913, pp. 11–12.

19. Boccioni et al., "The Exhibitors to the Public" (1912), in Apollonio 1973, p. 47.

20. Boccioni et al., *Futurist Painting: Technical Manifesto* (1910), in Apollonio 1973, p. 28.

21. Boccioni et al., "The Exhibitors to the Public," in Apollonio 1973, p. 48.

22. Larionov, "Le Rayonnisme Pictural," 1914, p. 15.

23. Boccioni et al., "The Exhibitors to the Public," in Apollonio 1973, pp. 48, 50.

24. Larionov, *Luchizm*, 1913, p. 15.

25. In Apollonio 1973, p. 28.

26. The futurist exhibition toured through Europe but not Russia. Its principal venues were: Bernheim-Jeune, Paris, 5–24 February 1912; Sackville Gallery, London, March 1912, and *Der Sturm*, Berlin, 12 April – 15 May 1912.

27. In Apollonio 1973, p. 48.

28. Boccioni et al., "The Exhibitors to the Public," in Apollonio 1973, p. 50.

29. Larionov, "Le Rayonnisme Pictural," 1914, p. 15.

30. Severini, in a letter of 27 September 1913 to Ardengo Soffici, discussed the significance of noises while working on the *Dynamic Hieroglyphic of the Bal Tabarin* (Museum of Modern Art, New York) See Gambillo and Fiori 1962, p. 292.

31. Boccioni et al., "The Exhibitors to the Public," in Apollonio 1973, p. 47.

32. Compton 1981, p. 344.

33. Larionov fails to elaborate his concept of a "synthesis image." It may relate either to futurism or the multiple viewpoints adopted by cubism. Roger Allard discussed the work of Metzinger in these terms ("Au Salon d'Automne de Paris," *L'Art Libre*, November 1910, in Edward Fry 1966, pp. 62–63). The concept may be related to the fourth dimension. Metzinger talked of "the total image" in the context of Maurice Princet, mathematician and friend of the cubists, who was fascinated by the fourth dimension ("Note sur la Peinture," *Pan*, October–November 1910, in Edward Fry 1966, p. 59–61).

34. Eganbyuri 1913, pp. 38–39.

35. Luigi Russolo, *L'Arte dei Rumori (Manifesto Futurista)*, Milan, 1916, is in NAL.

36. Boccioni et al., "The Exhibitors to the Public," in Apollonio 1973, p. 49.

37. Boccioni et al., *Futurist Painting: Technical Manifesto*, in Apollonio 1973, pp. 27–28.

38. Ibid., p. 30.

39. Ibid., p. 28.

40. In his notebook Balla wrote "Raggi de Röntgen e loro applicazioni . . . Manuali Hoepli"; in M. Fagiolo, *Omaggio a Balla*, Rome, 1967, p. 54.

41. Larionov's copy of Italo Tonta, *Raggi di Röntgen e loro Practiche Applicazioni*, Manuali Hoepli, Milan, 1898, is in NAL.

42. Balla, "Futurist Manifesto of Men's Clothing" (Manuscript, 1913), in Apollonio 1973, p. 132.

43. Larionov, "Pochemu my raskrashivaemsya," 1913, p. 118.

44. Larionov, "Luchistskaya zhivopis'" (1913), in Bowlt 1976, p. 97.

45. For a discussion of futurist cinema see Edward Aiken, "The Cinema and Italian Futurist Painting," *Art Journal*, Winter 1981, pp. 353–57.

46. Larionov, "Luchisty i budushchniki," 1913, p. 9.

47. Boccioni et al., *Futurist Painting: Technical Manifesto*, in Apollonio 1973, p. 28.

48. Several exhibition catalogues belonging to Ilya Zdanevich, now in a private collection in Paris, are signed on the

cover: "Ilya Zdanevich Futurist." As a mature poet Zdanevich addressed Marinetti as "Cher Maître" and sent him his publications (*Iliazd*, exhibition catalogue, Paris, 1978, pp. 182–83).

49. Marinetti 1972, p. 347.

50. Larionov, "Luchistskaya zhivopis'" (1913), in Bowlt 1976, pp. 95–96.

51. Ibid., p. 97.

52. Braque's *Grand Nu* was reproduced in *Zolotoe runo*, February–March 1909, nos. 2–3, p. 20.

53. Larionov, "Luchistskaya zhivopis'" (1913), in Bowlt 1976, p. 95.

54. K. Malevich, *Essays on Art 1915–1933* (ed. T. Anderson), London, 1967–1969, vol. 4, p. 203.

55. Livshits (1933) 1977, p. 200.

56. Apollinaire, *Soirées de Paris*, 1914, p. 371.

CHAPTER EIGHT

1. P. Laporte, "Cubism and Science," *Journal of Aesthetics and Art Criticism*, March 1949, vol. 7, no. 3, pp. 243–56.

2. Henderson 1971, p. 417.

3. The development of the concept of the fourth dimension is discussed in Henderson 1983.

4. Ouspensky 1931, pp. 1–10.

5. Dr. Richard Maurice Bucke, author of *Cosmic Consciousness*, cared for the American poet Walt Whitman after his stroke in 1873. Bucke's biography *Walt Whitman* (1883) presents the poet as a mystical superman. It is interesting that Bucke inspired Ouspensky while Whitman inspired Larionov, who introduced "Luchistskaya zhivopis'" with quotations from *Leaves of Grass*, translated into Russian by Balmont as *Pobegi travy* (Moscow, 1911).

6. Ouspensky (1911), 1922, p. 244.

7. Ibid. p. 262. Bragdon explained that "The Organon of Aristotle formulated the laws under which the subject thinks; the Novum Organum of Bacon, the laws under which the object may be known; but the third canon of thought existed before these two, and ignorance of its laws does not justify their violation. Tertium Organum shall guide and govern human thought henceforth" (Ibid., p. 1). The English translation of *Tertium Organum* was made from the second Russian edition and includes chapters 11 and 15 which are not in the first edition of 1911.

8. Ouspensky notes that Hinton's *The Fourth Dimension* and Bragdon's *Man the Square* had reached Russia at the latest by 1908–1909 and 1914–1915, respectively. Ouspensky translated Hinton's work into Russian as *Vospitanie voobrazheniya i chetvertoe izmerenie* (St. Petersburg, 1915). Anna Butkovsky-Hewitt (1978) discovered *Tertium Organum* shortly after its publication, in a public library in St. Petersburg. For a listing of Russian works on the subject of the fourth dimension, see Duncan M. Y. Sommerville, *Bibliography of Non-Euclidean Geometry, Including the Theory of Parallels, Foundations of Geometry and Space of 'N' Dimensions*, University of St. Andrews, 1911.

9. Larionov, "Pochemu my raskrashivaemsya," 1913, p. 118.

10. Ouspensky (1911), 1922, p. 83.

11. See Henderson 1971 and 1983; T. H. Gibbons, "Cubism and 'The Fourth Dimension,' in the Context of the Late Nineteenth Century and the Early Twentieth Century Revival of Occult Idealism," *Journal of the Warburg and Courtauld Insti-*

tutes, 1981, vol. 44; and Linda D. Henderson, "Italian Futurism and the Fourth Dimension," *Art Journal*, Winter 1981, vol. 41, no. 4, pp. 317–23. Max Weber wrote an essay entitled "The Fourth Dimension from a Plastic Point of View," *Camerawork*, 1910.

12. See Henderson 1975/1976; Susan Compton, "Malevich and the Fourth Dimension," *Studio International*, April 1974, vol. 187, no. 965, pp. 190–95; and Compton, "Malevich's Suprematism – The Higher Intuition," *Burlington Magazine*, August 1976, vol. 118, no. 881, pp. 576–85.

13. Nakov 1974, p. 283, and Nakov, *Studio International*, July 1974, vol. 188, no. 968, p. 8. Also see A. Povellikhina, "Matyushin's Spatial System," in *The Isms of Art in Russia 1907–1930*, Galeria Gmurzynska, Cologne 1977, pp. 27–41.

14. M. V. Lodyzhensky, *Sverkhsoznanie i puti k ego dostizheniyu*, St. Petersburg, 1912. The undated letter from Matyushin to Spandikov is in the Russian Museum, St. Petersburg, fond 121.48.2.

15. Livshits (1933) 1977, p. 50.

16. Larionov, *Luchizm*, 1913, p. 20.

17. Larionov, "Le Rayonnisme Pictural," 1914, p. 15.

18. Hinton 1904, p. 10.

19. Larionov, "Le Rayonnisme Pictural," 1914, p. 15.

20. In "Luchisty i budushchniki" (1913) and "Luchistskaya zhivopis'" (1913), the sensation described is spatial since it concerns higher dimensions while in "Le Rayonnisme Pictural" (1914) it is beyond space, i.e., beyond our experience of three-dimensional space.

21. Ouspensky (1911) 1922, p. 268.

22. Livshits (1933) 1977, p. 165.

23. Larionov, "Le Rayonnisme Pictural," 1914, p. 15.

24. Ouspensky (1911), 1922, pp. 207–8.

25. Ibid., p. 162.

26. Larionov and Goncharova met Ivan Firsov before July 1913 when Eganbyuri records that a painting by Goncharova was based upon his theory. In August 1913 the three artists collaborated on the book *Le Futur*, which was handwritten by Firsov. Firsov exhibited several works based upon his theory of transparency at the No. 4 Exhibition in March 1914.

27. Ouspensky (1910) 1931, p. 78, makes the same point.

28. Larionov, "Le Rayonnisme Pictural," 1914, p. 5.

29. Larionov, "Luchisty i budushchniki" (1913), in Bowlt 1976, p. 90.

30. It is interesting that the daily newspaper *Nov'*, which Ouspensky himself edited, published an illustrated article on Larionov's face-painting (23 January 1914, no. 8, p. 11).

31. Larionov, "Pochemu my raskrashivaemsya," 1913, p. 118.

32. Ibid.

33. Propert 1921, pp. 43–45.

34. Boccioni et al., *Futurist Painting: Technical Manifesto*, in Apollonio 1973, pp. 28–29. Kamensky (1914), in Marcadé 1971, p. 211.

35. M. Kyuri, *Radioaktivnost'* (Radioactivity), St. Petersburg, 1912, and M. Kyuri, *Otkrytie radiya* (The Discovery of Radium), St. Petersburg, January 1913.

36. Larionov, "Le Rayonnisme Pictural," 1914, p. 15.

37. Larionov, *Luchizm*, 1913, p. 17.

38. See *Lectures Pour Tous: Revue Universelle Illustrée*, Paris, Janvier 1903, pp. 303–12 and 356–64; in NAL.

39. Kulbin, in Milner 1983, p. 34.

40. Parnack 1919, p. 7.

41. Larionov, "Luchisty i budushchniki" (1913), in Bowlt 1976, p. 89.

42. Boccioni et al., "Manifesto of Futurist Painters" (1912), in Apollonio 1973, p. 29.

43. Larionov, "Pochemu my raskrashivaemsya," 1913, p. 118.

CHAPTER NINE

1. "V masterskoi Goncharovoi," *Moskovskaya gazeta,* 26 March 1914, no. 306, p. 5.

2. What Larionov exhibited here is unknown, as neither he, Goncharova, Kandinsky, nor Vladimir Burlyuk featured in the catalogue. They may, however, have included works to be shown in Paris later in the year.

3. Larionov and Goncharova corresponded with Olga Resnevich-Signorelli between 1918 and 1962. Their letters (Fondazione Giorgio Cini, Venice) are in *Minuvshee* 1986–1987.

4. Giuseppe Sprovieri, letter to the author, 1 April 1983. Translated from the Italian by Pamela Gregg.

5. Larionov's and Goncharova's visits abroad are detailed in their statements of 1938 to the Minister of Justice in support of their application for French naturalization. These are in the Ministère des Affaires Sociales et de la Solidarité Nationale, Paris.

6. Fokine 1961, p. 228. His reference to "flying pitchers" is an allusion to Larionov's and Goncharova's futurist cabaret evenings.

7. The première of *Le Coq d'Or* was postponed from May 21 to May 24 because the costumes failed to arrive from Moscow on time. Fokine (1961, p. 233) and Kochno (1973, p. 99) cite the advertised date as that of the première.

8. Apollinaire, "L'Exposition Nathalie de Gontcharowa et Michel Larionow," 1914.

9. George, in Loguine 1971, pp. 79–80.

10. George erroneously cites Nijinsky, Diaghilev, Fokine, and Karsavina as present. Nijinsky was in Vienna (Buckle, *Nijinsky,* London, 1971, p. 414), and Diaghilev, Fokine, and Karsavina were at the Theatre Royal, Drury Lane.

11. See the inscription in Carrieri 1963, p. 134.

12. The July 1914 number of the magazine carried an announcement that Larionov and Goncharova were shortly to become contributors. *Lacerba,* 1 July 1914, Anno II, no. 13, p. 207.

13. Serge Fotinsky and Pierre Vorms, "Entretiens avec Serge Fotinsky à propos de Michel Larionov," recorded interview, 1960s. Pierre Vorms Archive, France.

14. Ibid.

15. N. Goncharova, *Voina: Misticheskie obrazy voiny, 14 litografy,* Izd. V. N. Kashin, Moscow, 1914.

16. Tikhon Churilin, *Vesna posle smerti: Stikhi,* Moscow, 1915.

17. Katanyan 1961, p. 67, and Mayakovsky 1955, pp. 355, 451–52. For plates of these *lubki* see Rudenstine 1981, pls. 946–64.

18. *Boulevard Venus* and other works on exhibition at Der Sturm Gallery in Berlin in 1914 were stored by Herwarth Walden during the war. He sold some to cover his expenses and after the war returned them to Larionov and Goncharova in Paris (Chamot 1979, p. 17).

19. Ya. Tugendkhold, "V zheleznom tupike," *Severnye zapiski,* July–August 1915, pp. 102–11. The portrait is now in a private collection.

20. Ibid.

21. Lentulov, in Bowlt 1976, p. xxxi.

22. Shklovsky 1974, p. 21.

23. See George 1966, pp. 24, 74. Other reviews include *Russkoe slovo,* 25 March 1915, no. 68, p. 6; *Kievskaya mysl',* 6 May 1915, no. 125, p. 2; and *Russkie vedomosti,* 28 March 1915, no. 70, p. 5.

24. Balla and Depero, *The Futurist Reconstruction of the Universe* (1915), in Apollonio 1973, pp. 197–200.

25. Ibid., p. 198.

26. Ibid., p. 197.

27. *Lacerba,* 10 April 1915, Anno III, no. 15, p. 125. Sprovieri records that it was Soffici who retitled the drawing (letter to the author, 1 April 1983).

28. Reproduced in Loguine 1971, p. 200.

29. Stravinsky 1936, p. 99.

30. Eurythmics is a system of rhythmical bodily movements expressing the time values of the accompanying music. It was developed by Jacques Emile Dalcroze (1865–1950) who founded an institute at Hellerau where he researched and taught eurythmics. In 1913 Nijinsky introduced eurythmics into the ballets *Jeux* and *Le Sacre du Printemps.* Larionov and Massine studied eurythmics in preparation for *Liturgie* and while at Ouchy may have visited Dalcroze, who had moved to Geneva. Larionov's illustrated manual *Der Rhythmus: Ein Jahrbuch* (Hellerau Bildungsanstaldt Jacques Dalcroze, Jena, 1911) is in NAL.

31. N. Goncharova, "Les Metamorphoses de *Noces* à propos des Costumes et des Décors," in Chamot 1972, pp. 117–19, and translated as "The Metamorphosis of the Ballet 'Les Noces,'" *Leonardo* (Oxford), Spring 1979, vol. xii, no. 2, pp. 137–43.

32. George 1966, p. 89.

33. Parnack 1919, pp. 10, 16; George 1966, p. 90; Schaikevitch, in Loguine 1971, pp. 165, 171; Chamot 1979, p. 15.

34. Massine 1968, p. 74.

35. Ibid.

36. For the ideology of the *Ballets Russes,* see Bazarov 1975, and Grigoriev 1953, p. 107.

37. Stravinsky 1936, p. 100.

38. George recalled, "I saw Goncharova and Larionov again during leave in December 1915. . . . A firm and fervent friendship was established between us" (in Loguine 1971, p. 80). A letter from Fernand Léger to Larionov of 13 January 1916 is in George 1966, p. 120.

39. Apollinaire 1916, pp. 373–74.

40. Nathalie Gontcharova, *Liturgie: 16 Maquettes Reproduites au Pochoir,* Lausanne, 1915, and *Portraits Théâtraux,* La Cible, Paris, 1916.

41. N. Goncharova, *Vtoroi sbornik tsentrifugi,* Moscow, 1916. Goncharova's copy is in NAL.

42. Massine 1968, pp. 98–99.

43. Ibid.

44. Grigoriev recalls, "After the departure of the main body of the troupe, we left Spain to take up our winter quarters in Italy. Larionov and Goncharova went up with us" (1953, p. 109). This agrees with the details in Larionov's and Goncharova's naturalization applications.

45. Giuseppe Sprovieri, letter to the author, 1 April 1983.

46. *Ornement d'Architecture/Coulisse,* in *Der Sturm* (Berlin), April 1922, p. 53.

47. Catalogues of the Boccioni exhibition are in NAL.

48. Reproduced in George 1966, p. 122.

49. Ibid.

50. Marinetti, "The Variety Theatre" (1913), in Apollonio 1973, pp. 126–31.

51. The first published date for designs to *Histoires Naturelles* is 1917 (*First Russian Exhibition of Arts and Crafts*, exhibition catalogue, London, 1921). Shortly after the designs were dated Paris 1917 (*The Goncharova – Larionov Exhibition*, exhibition catalogue, New York, 1922). Later they were redated to Lausanne 1916 in Georges-Michel, George, and Gontcharova 1930. Lifar used this as his source in 1940. Later still the designs were redated to Lausanne 1915 (Gontcharova, Larionov, and Vorms 1955). Neither Grigoriev nor Massine mention the ballet. The experimental nature of the designs are compatible with those executed for Berners and Casella during 1917–1919, and had the designs been completed by 1918, Larionov would have exhibited them at the Galerie Sauvage. They were probably completed after this as they were constantly exhibited from February 1919 onwards.

52. Lifar 1940, p. 212.

53. Balla and Depero, in Apollonio 1973, p. 200.

54. Massine 1968, pp. 147–48.

55. Balla and Depero, in Apollonio 1973, p. 200.

56. Ravel, in Myers 1960, p. 28.

57. Depero, *Il Canto dell'Usignuolo*, Depero Museum, Rovereto, Italy. I am grateful to John Bowlt for this information.

58. Larionov's volumes of *The Mask* 1908–1915, 1918–1919, and 1923–1929 are in NAL.

59. As a child Berners made a toy theatre in which a prominent role was played by colored lights: "I placed the theatre in a bow window and, covering the window panes with coloured gelatine and tissue paper, arranged blinds and shutters so that the light could be directed on to any part of the stage required" (Berners, *A Distant Prospect*, London, 1945, p. 90). During his service in Constantinople, he probably would have seen the popular Karagöz shadow plays, in which lights illuminate colored paper puppets, throwing colored shadows on to a screen.

60. The *Théâtre des Ombres Colorées* (Pollock's Toy Museum, London) was a popular toy theatre at the turn of the century.

61. Louis Lemercier de Neuville, *Les Pupazzi Noirs, Ombres Animées*, Paris, 1896. Larionov also owned the book *Ombromanie*, Paris, 1860, comprising eighteen plates showing how to cast shadows on a wall. Both are in NAL.

62. Fry 1919, p. 117.

63. Recorded in Larionov and Goncharova's naturalization applications. Chamot (1972, p. 131) states that Goncharova spent the summer in Florence, Venice, and Turin before returning to Paris in October but there is no evidence to support this view (Mary Chamot, letter to the author, 1 February 1982).

CHAPTER TEN

1. Valerian Svetlov was the pseudonym of Valery Ivchenko (1860–1934). His essay "Goncharova i Larionov: Etyud V. Svetlova" was published in a currently unlocated source. My copy was given to me by Tatiana Loguine.

2. Ibid.

3. Ibid.

4. Ibid.

5. Larionov subscribed to Joseph Rivière's *Soi-Même*, Picabia's *391*, Reverdy's *Nord-Sud*, and Pierre Albert-Birot's *Sons, Idées, Couleurs*. Larionov's copies are in NAL.

6. Zadkine, in Loguine 1971, p. 143. Portraits of Larionov and Goncharova by Chana Orlova are reproduced in Loguine 1971, p. 55.

7. "Goncharova i Larionov: Pantum" (July 1917) was published in *Spolokhi* (Berlin), 1922, no. 4, and later in Gumilev 1964, pp. 167–68.

8. For an analysis of the poem see Parton, "Fabulous Paths Converge," 1987.

9. *Gondla* (1916) was published in *Russkaya mysl'*, 1917, no. 1, pp. 66–97.

10. "Muzhik" (1917), in Gumilev 1964, p. 14.

11. Shortly afterwards Diaghilev suspended the ballet. It was finally staged in 1919 but with designs by Derain.

12. Larionov's copies of Carlo Gozzi, *Théâtre Fiabesque de Carlo Gozzi*, Paris, 1865, and *Le Fiabe. Con un Discorso di R. Guastalla*, Milan, 1914, are in NAL.

13. Parnack 1919, p. 17.

14. Apollinaire, letter to Larionov, 16 July 1918, in George 1966, p. 124. Larionov's "telegramme" to Apollinaire, imitating the latter's "calligrammes" poems, is reproduced in George 1966, p. 116.

15. In George 1966, p. 124.

16. Larionov, letter to Lord Berners, Coll. Gavin Bryars.

17. Larionov, draft of an article on Malevich; in sketchbook, Print Room, Victoria & Albert Museum, E. 964-1961. Salmina-Haskell (1972, pp. 48–49) cites Goncharova as the author but the unsigned manuscript is in Larionov's hand.

18. A design by Larionov in the collection of Gavin Bryars is inscribed: "Marche Funèbre sur le Mort d'une tant à heritage. Personnage. Dedié à Tyrwitt. Novembre 918 [sic] Paris."

19. *The Musical Times* (London), 1 January 1920, p. 46.

20. See Polunin 1927.

21. Diaghilev's telegram reads: "We wish to add to Liadov's ballet a small dance between Bova and the Swan Princess. May I receive from you a poetic sketch for a curtain featuring the magic lake and moonlight, possibly framed with silver folk ornamentation? Serge Diaghilev" (*Diaghilev et Les Ballets Russes*, exhibition catalogue, Paris, 1979, no. 204.

22. Larionov, letters to Diaghilev, 5 December 1918, in Kochno 1973, pp. 112–13, and 6 December 1918, in *Ballet Material and Manuscripts from the Serge Lifar Collection*, Sotheby & Co., London, 9 May 1984, item 173.

23. Polunin 1927, p. 27.

24. Fry 1972, letter 441.

25. "Children's Tales: Bright Ballet at the Coliseum," *The Times*, 14 December 1918, p. 9.

26. A. E. Johnson, "The Russian Dancers," *Illustrated London News*, 22 November 1919, vol. 155, p. 822.

27. Fry 1972, letter 446.

28. Larionov's design for the *La Reine d'Ethiope* was auctioned at Sotheby's, New York, 15 December 1977, item 85. His designs were in line with other activities at the Omega. Fry made a toy theatre there during 1913–1914, and Winifred Gill had made paper puppets with pivoted joints for a *Castanet Dance*, a *Shawl Dance*, and a *Blue Butterfly Dance* (Courtauld Institute Galleries, London).

29. Roger Fry 1972, letters 394, 396, 399, 447, and 472, and *Burlington Magazine*, June 1917.

30. *Athene* 1947, p. 9. In the Marion Richardson Archive there is a letter from Mary Hart, an old pupil, which recalls how she and other children used to gather round Richardson's feet and listen to her descriptions of the Russian Ballet. Marion Richardson Archive, School of Art Education, City of Birmingham Polytechnic, item 3071.

31. Richardson 1948, p. 33.

32. Marion Richardson Archive, items 4429–4474. Those based on descriptions of *Soleil de Nuit* are 4431, 4433, 4436, 4438, 4440, 4441, 4444, 4446–4448, 4453, 4454, 4461, 4466, 4468, 4469, and 4473.

33. Shortly after meeting Larionov and Goncharova for the first time in Paris in April 1920, Roger Fry wrote, "Gontcha is a brown round-faced Tartar, very sympathetic. She teaches children and showed me marvellous results working on Marion Richardson's lines." Fry 1972, letter 472.

34. Fry 1919, p. 118.

CHAPTER ELEVEN

1. *Art Théâtral* was published by Jacques Povolotzky, under the imprint *La Cible*, in three editions: 15 folios lettered A to O, with original covers on special paper; 100 folios, comprising 8 prints and 8 pochoirs, and 400 bound copies comprising 8 prints and 6 pochoirs.

Larionov's works included a costume design for *Le Bouffon*, a makeup design for Kikimora, *The Peacock, The Cricket, The Kingfisher, The Swan* from *Histoires Naturelles*, as well as a makeup design for the ballet and a puppet design for Berners' *Marche Funèbre pour une Tante à Héritage* (*Funeral March for a Great Aunt*). The more expensive folios included two extra pochoirs entitled *Theatrical Mask* and *Dance Balance*.

2. Parnack 1919, pp. 14–15.

3. The curtain design for *La Conférence de la Paix* was sold at Sotheby's, London, 25 May 1977, no. 105.

4. The invitation card for two evening concerts and a literary afternoon at the Galerie Barbazanges on 18, 20 and 24 June 1919, is reproduced in Loguine 1971, p. 86.

5. A copy of the program in NAL refers to the cancelation of Larionov's two ballets.

6. Popova, in Loguine 1971, p. 157.

7. C. E. Bechhofer was a foreign correspondent in Petrograd during 1914 and 1915 who had written "Letters from Russia" for *The New Age* magazine.

8. Propert 1921, p. 38. The book proved a failure and was remaindered by Chatto in May 1922.

9. The Tiflis publications in NAL include A. Kruchenykh, *Malokholiya v karote* 1918 (illus. Kirill Zdanevich); A. Kruchenykh, *Milliork* 1919 (cover Ilya Zdanevich); I. Zdanevich, *Ostraf paskhi* 1919; and Terentiev, *Fakt: Stikhi* 1919, and *Traktat o sploshnom neprilichii* 1919. For cultural life in Tiflis, see T. Nikolskaya, "Russian Writers in Georgia 1917–1921," in Proffer 1980, pp. 295–326.

10. Haskell 1933, p. 319.

11. The contract is quoted in Kochno 1973, p. 159.

12. Marcel Mihalovici recalled that *Chout* was a masterpiece and Larionov's costumes "highly original" (conversation with the author, 9 July 1982). In addition see E. Eganbyuri, "Le Cubisme au Théâtre," *Comoedia* (Paris), 23 March 1922, and "A propos du Ballet *Chout*," *Le Petit Journal* (Paris), June 1922. Extracts of these are reprinted in George 1966, pp. 108–9.

13. *Vogue*, early December 1921, p. 61.

14. H. G., "The Russian Ballet: *Chout* (*The Buffoon*)," *The Observer*, London, June 1921.

15. Larionov, letter to Mary Chamot, 11 February 1956. Collection of the author.

16. Contemporary letters in the Ilya Zdanevich archive give his address as c/o Larionov, 43 Rue de Seine, Paris. Also, M.

Guyon, the concierge, gave Zdanevich a reference on 16 January 1922, stating, "I certify that Mr. Zdanevich is living at 43 Rue de Seine with Mr. Larionov" (Hélène Zdanevich 1982, pp. 181–82).

17. Rogovin, letter to Larionov, 1921, in Larionov, *Une Avant-Garde Explosive*, 1978, p. 21.

18. Chekrygin (1921) 1982, p. 40.

19. Two masks for *Le Renard* are reproduced in Haskell 1934, p. 93.

20. Stravinsky 1936, pp. 168–69.

21. Propert 1931, p. 18.

22. The New York exhibition was organized by Dr. Christian Brinton (1870–1942) who became an authority on Russian and Soviet art during the 1920s and 1930s. He was friendly with Larionov and Goncharova, visited them when in Paris, and remained a supporter of their art until his death. The Japanese exhibition is discussed in *Chuo Bijutsu* (Tokyo), April 1923, no. 91, pp. 106–7.

23. "Shut," *Teatr* (Berlin), July–August 1922, no. 12/13, pp. 3–4.

24. See Eganbyuri 1922, and *Der Sturm* (Berlin): April 1922, vol. 13, no. 4, pp. 53, 55, 57; May 1922, vol. 13, no. 5, p. 75; June 1922, vol. 13, no. 6, p. 89; September, 1922, vol. 13, no. 9, p. 133.

25. A. Avdeev, "Pokryvalo P'eretty," *Teatr* (Berlin), September 1922, no. 14, pp. 11–15.

26. Nina Berberova, *The Italics are Mine*, London, 1969, p. 168.

27. The cover design of *Art Théâtral* 1919, an illustration from *Slovodvig/Motdinamo* 1920, and the cover design of *Pupazzetti* 1921 were all reworked for *Solntse*.

28. Earlier Larionov had organized and designed the annual *Press Ball* in Moscow. Eganbyuri 1913, p. xxi.

29. Larionov (1923), in Loguine 1971, pp. 135–36.

30. Gerald Murphy (1888–1964) studied under Goncharova in Paris during 1921–1922. In late 1922 Larionov helped organize the famous party on his barge in the Seine (Loguine 1971, pp. 133–37).

31. Zdanevich published a poster: "Why is this ball called Transmental? Because Iliazd, Kruchenykh, Terentiev are the creators of Transmental poetry. Without images, without descriptions, without usual words." Ilya-Zdanevich Archive, Paris.

32. Michel Seuphor, conversation with the author, 12 May 1983.

33. Marcel Mihalovici, letter to the author, 23 October 1982.

34. Mihalovici, in Loguine 1971, p. 160.

35. "Teatr marionetok," *Teatr, iskusstvo, ekran* (Paris), January 1925, pp. 12–13.

36. See T. Nikolskaya, n. 9 above.

37. The puppet show was staged on 29 April 1923 at La Galerie La Licorne (*Iliazd*, exhibition catalogue, 1978, pp. 55, 59).

38. For Exter's puppets see *Alexandra Exter: Marionettes*, Hutton Galleries, New York, 1975.

39. The Chicago Allied Arts Co. was formed in 1924 and directed by Adolph Bolm, in charge of ballet, and Eric DeLamarter, in charge of music. Ruth Page was *première danseuse* though guest stars such as Karsavina also performed. Costumes and sets were principally designed by Nicolas Remisoff and Konstantin Somov. The Chicago Allied Arts Co. existed for three years and performances were given in the Eighth Street Theatre, the Studebaker Theatre, and the Goodman Theatre. I am grateful to Ann Barzel for these details.

40. The date of 1923 in George 1966, p. 122, is inaccurate. The Savoy Hotel archives show Larionov as only resident there in November 1926.

41. Vinicio Paladini, *Arte Nella Russia dei Soviets; il Padiglione dell'U.R.S.S. a Venezia*, Rome, 1925.

42. Rodchenko almost certainly participated as he arrived in Paris in March and stayed until June. Aleksandr Rodchenko, "Rodchenko v Parizhe," *Novy lef* (Moscow), 1927, no. 2, pp. 9–21.

43. Le-Dantyu, letter to Larionov, 1925, discussing the artistic conditions in the Soviet Union, and Malevich, letter to Larionov, 1926, requesting help in obtaining a French visa for a visit to Paris are translated into French in Larionov, *Une Avant-Garde Explosive*, 1978, pp. 21–22. Punin, letter to Goncharova, 7 June 1927, is in the collection of the Institute of Modern Russian Culture.

44. B. Ternovets, "Vystavka sovremennogo frantsuzskogo iskusstva v Moskve," *Pechat' i revolyutsiya*, October–November 1928, pp. 117–41, and "Levoe iskusstva i khudozhestvenny rynok Parizha," *Iskusstvo*, nos. 1 and 2. Also see his articles in *Pravda*, 14 September 1928, and *Vechernaya Moskva*, 5 October 1928.

45. Abram Efros, "Russkaya gruppa," *Vystavka sovremennogo frantsuzskogo iskusstva*, exhibition catalogue, 1928, pp. 27–28.

46. Robert Falk, letter to V. Midler, Paris 1929. Reprinted in Falk 1981, p. 87.

47. Recounted by Oleg Prokofiev. A similar encounter is described in Falk 1981, pp. 68–69.

48. Joan Osiakovski, conversation with the author, 14 July 1983.

49. Two folios are in the Print Room, Victoria and Albert Museum, London, and Musée d'Art Moderne, Centre Georges Pompidou, Paris.

50. K. Somov, letter to A. Mikhailova, 27 May 1929, in *Sergei Diaghilev 1982*, vol. 2, p. 209.

51. See Redko 1974, p. 90 (diary entry for 29 May 1929).

52. Falk, letter to R. V. Idelson, 17 January 1930, p. 98.

53. *Les Montparnos* was the name of a café popular with the artists of Montparnasse.

CHAPTER TWELVE

1. Joan Osiakovski, conversation with the author, 14 July 1983.

2. Serge Fotinsky and Pierre Vorms, "Entretiens avec Serge Fotinsky à propos de Michel Larionov," recorded interview, 1960s, Vorms Archive, France.

3. Annenkov, in Loguine 1971, p. 75.

4. Ibid.

5. Lifar, in Loguine 1971, p. 126.

6. Pottecher, in George 1966, p. 110.

7. According to Lina Prokofiev, Larionov on this occasion claimed he was "un enfant du quartier latin" (conversation with the author, 23 May 1985).

8. Redko 1974, p. 111.

9. Le-Dantyu, letter to Larionov, 5 November 1925, in Larionov, *Une Avant-Garde Explosive*, 1978, p. 21.

10. Karl Kautsky, *Bolshevizm v tupike*, Berlin, 1930. Larionov's copy is located in NAL.

11. Mark Slonim, *Portretykh sovetskikh pisatelei*, Paris, 1933.

12. Two holiday photographs are in Loguine 1971, p. 60.

13. Léon Osmin, *Figures de Jadis: Les Pionniers Obscurs du Socialisme*, Paris, 1934. Goncharova's illustrations are in the *Musée d'Art Moderne*, Centre Georges Pompidou, Paris.

14. Haskell 1933, p. 322.

15. Ibid., pp. 322–23.

16. Lentulov, in *Sieben Moskauer Künstler*, exhibition catalogue, Cologne, 1984, p. 155.

17. Mihalovici, letter to the author, 29 October 1981.

18. Zadkine, in Loguine 1971, pp. 143–44.

19. Chamot, conversations with the author.

20. Fletcher, in Loguine 1971, pp. 183–84.

21. Larionov, "A Propos du Rayonnisme," letter to Alfred Barr, 5 pp. 1936 (in NAL). A Russian draft of this letter is reproduced with an English translation in *Michail Larionov*, exhibition catalogue, Stockholm, 1987, pp. 7–10.

22. Ibid.

23. Dossier no. 37203x38, "Naturalisation Française concernant Michel Larionoff," Ministère des Affaires Sociales et de la Solidarité Nationale, Paris.

24. Tomilina and Daulte, in George 1966, p. 126.

25. The ballets included *Carnaval de Venise*, Goldoni; *Temple Egyptien*, Arenski; *Vision Antique*, Gagotsky; *Coup de Bambou*, Satie; *La Veillée*, Skriabin; *L'Obsession* and *Le Lac des Cygnes*, Tchaikovsky; *Marchande des Poupées*, Alexandre Tcherepnine; *L'Offrande Pathétique*, Konstantinov; and *Piccoli*, Rossini.

26. Braunsweg 1973 cites Larionov as one of the scene-painters for the London Festival Ballet in its early years.

27. Seuphor, conversation with the author, 22 August 1981. The works were Larionov's *Rayist Construction of a Street* and Goncharova's *Cats*.

28. The text took the form of an introductory essay on the preview card. It is reproduced in Loguine 1971, p. 99.

29. Seuphor, conversation with the author, 12 May 1983.

30. The exhibition catalogue is in *Derrière le Miroir*, Paris, May 1949, nos. 20–21.

31. Other members of the avant-garde also deliberately predated their work. In 1936 Alfred Barr challenged the date of 1909 for Balla's *Street Lamp*. Balla insisted it was correct. It is now known that the painting was executed between 1911 and 1912.

32. Larionov, "The Art of Stage Decoration," 1949, p. 4.

33. Natalya Kodryanskaya, *Skazki*, Paris, 1950.

34. Loguine 1971, p. 65.

35. I am grateful to the Mairie du 6ème Arrondissement de Paris for this information.

36. The ballets were *Les Sylphides, Les Elphes, Eros ou l'Ange de Fiesole, Les Aventures d'Arlequin, Islamey, Igroushki,* and *Le Carnaval*.

37. A copy of the bill is in the author's collection.

38. At the turn of the century the difference between the Julian and Gregorian calendars increased by one day. Thereafter Larionov celebrated his birthday on June 4.

39. Gray 1962, p. 96.

40. The wedding took place at *La Provençale* on 28 May 1963. I am grateful to the Mairie du Fontenay aux Roses for this information.

41. I am grateful to Christine Gauthier for information regarding *La Provençale* and Larionov's admission.

42. Mihalovici, in Loguine 1971, p. 159.

43. Joan Osiakovski, conversation with the author, 14 July 1983.

BIBLIOGRAPHY

Amberg, George, *Art in Modern Ballet*, Routledge and Sons, London, 1946.

Apollinaire, Guillaume, "Nathalie de Gontcharowa et Michel Larionow," *Paris-Journal*, 18 June 1914. Reprinted as preface to *Exposition Nathalie de Gontcharowa et Michel Larionow*, exhibition catalogue, Paris, 1914.

Apollinaire, Guillaume, "L'Exposition Nathalie de Gontcharowa et Michel Larionow," *Les Soirées de Paris*, July 1914, p. 305.

Apollinaire, Guillaume, "La Vie Anecdotique: Mme. de Gontcharova et M. Larionov," *Mercure de France*, no. 422, 16 January 1916, pp. 373–74.

Apollinaire, Guillaume, *Apollinaire on Art: Essays and Reviews 1902–1918*, ed. L. C. Breunig, trans. S. Suleiman, London, 1972.

Apollon (St. Petersburg), October 1909 – October/December 1917.

Apollonio, Umbro (ed.), *Futurist Manifestos*, London, 1973.

Aranowitsch, D., "Larionoff, Michail Fjodorowitsch," in U. Thieme and F. Becker, *Allgemeines Lexicon der Bildenden Künstler*, bd. XXII, Leipzig, 1928, p. 385.

Athene: The Official Organ of the Society for Education in Art (London), A Special Number Commemorating the Work of Marion Richardson, Summer 1947, vol. 4, no. 1.

Baer, Nancy Van Norman, *Theatre in Revolution: Russian Avant-Garde Stage Design 1913–1935*, London, 1991.

Bablet, Denis, *Edward Gordon Craig*, New York, 1966.

Bal de la Grande Ourse, program, Paris, 8 May 1925.

Bauhaus Drucke Neue Euopaeische Graphik. 4te Mappe: Italienische v Russische Kuenstler, folio of prints, Potsdam, 1923.

Bazarov, Konstantin, "Diaghilev and the Radical Years of Modern Art," *Art and Artists*, July 1975, vol. 10, no. 4, pp. 6–15.

Bénézit, E., "Larionoff (Jean)" and "Larionoff (Michel)," *Dictionnaire Critique et Documentaire des Peintres, Sculpteurs, Dessinateurs, et Graveurs, de tous les Temps et de tous les Pays*, Librairie Gründ, 1976, vol. 6, pp. 453–54.

Benois, Alexandre, "Vystavka 'soyuza molodezhi,'" *Rech'* (St. Petersburg), 21 December 1912, no. 257, p. 3. Reprinted in Vanslova, pp. 591–97 (see below).

Berlewi, Henryk, "Michael Larionoff, Natalie Gontcharowa und der Rayonnismus," *Werk* (Zurich), October 1961, pp. 364–68.

Berners, Lord (Gerald Hugh Tyrwhitt-Wilson), *Trois Morceaux pour Piano à Quatre Mains: Chinoiserie, Valse Sentimentale, Kasatchok, Couverture, Illustrations et Ornément de Michel Larionov*, London, January 1919.

Betz, Margaret, "The Icon and Russian Modernism," *Artforum*, Summer 1977, vol. 15, no. 10, pp. 38–45.

Blok, Alexandre, *Les Douze. Traduit du Russe par Serge Romoff, avec sept illustration d'après les Dessins de Michel Larionow*, Paris, April 1920.

Blok, Aleksandr, *Dvenadtsat'. Skify. S devyat'yu illyustratsiyami N. Goncharovoi i M. Larionova*, Paris, June 1920.

Blok, Alexander, *The Twelve. Translated from the Russian with an Introduction and Notes by C. E. Bechhofer. With Illustrations and Cover Designs by Michael Larionov*, London, November 1920.

Bolshakov, Konstantin, *Le Futur: Stikhi K. Bol'shakova, ris.*

Nat. Goncharovoi, Mikhaila Larionova, Moscow, August 1913.

Bowlt, John E., "Neo-Primitivism and Russian Painting," *The Burlington Magazine* (London), March 1974, vol. CXVI, no. 852, pp. 132–40.

Bowlt, John E. (ed. and trans.), *Russian Art of the Avant-Garde: Theory and Criticism 1902–1934*, New York, 1976.

Bowlt, John, "Stage Design and the Ballets Russes," *The Journal of Decorative and Propaganda Arts*, Summer 1987, no. 5, pp. 28–45.

Bowlt, John, "Mikhail Larionov; A Conjuror of Coloured Dust," *Michail Larionov*, exhibition catalogue, Stockholm, 1987, pp. 57–88.

Bowlt, John, "Natalia Goncharova and Futurist Theatre," *Art Journal*, Spring 1990, vol. 49, no. 1, pp. 44–51.

Bragdon, Claude, *A Primer of Higher Space, The Fourth Dimension, to Which is Added 'Man the Square', a Higher Space Parable*, New York, 1913.

Braunsweg, Julian, *Braunsweg's Ballet Scandals*, London, 1973.

Buckle, Richard, *Diaghilev*, London, 1979.

Butkovsky-Hewitt, Anna, *With Gurdjieff in St. Petersburg and Paris*, London, 1978.

Carrieri, Raffaele, *Futurism*, Milan, 1963.

Casella, Alfredo, *Pupazzetti: Five Pieces for Marionettes for Piano Four Hands*, London and Geneva, 1921.

Chamot, Mary, "The Early Work of Goncharova and Larionov," *Burlington Magazine* (London), June 1955, vol. XCVII, pp. 170–74.

Chamot, Mary, *Gontcharova*, Paris, 1972.

Chamot, Mary, "Russian Avant-Garde Graphics," *Apollo* (London), December 1973, vol. 98, no. 142, pp. 494–501.

Chamot, Mary, *Goncharova: Stage Designs and Paintings*, London, 1979.

Chauby-Rousseau, Serge, "Larionoff (Jean)" & "Larionow (Michel)," in Edouard Joseph, *Dictionnaire Biographique des Artistes Contemporains*, Paris, 1931, vol. II, pp. 316–20.

Chekrygin, Vasily, "The Letters of V. Chekrygin to M. Larionov," *A-Ja* (Paris), 1982, no. 4, pp. 40–43.

Chipp, Herschel B. (ed.), *Theories of Modern Art: A Source Book by Artists and Critics*, Berkeley, Los Angeles, London, 1968.

Compton, Susan, *The World Backwards: Russian Futurist Books 1912–1916*, London, 1978.

Compton, Susan, "Italian Futurism and Russia," *Art Journal*, Winter 1981, vol. 41, no. 4, pp. 343–48.

Czaplicka, M. A., *Aboriginal Siberia: A Study in Social Anthropology*, Oxford, 1914.

Dabrowski, Magdalena, "The Formation and Development of Rayonism," *Art Journal*, Spring 1975, vol. 34, no. 3, pp. 200–207.

Daulte, François, "Est-Il le 'Peintre Maudit' du XXe. Siècle? Larionov le Rayonniste," *Connaissance des Arts* (Paris), January 1967, no. 179, pp. 46–53.

Daulte, Marianne, "Larionov et L'Art Néo-Primitif Russe," *L'Oeil* (Paris), June 1979, no. 287, pp. 44–51.

Davies, Ivor, "Primitivism in the First Wave of the Twentieth Century Avant-Garde in Russia," *Studio International*, September 1973, vol. 186, no. 958, pp. 80–84.

Degand, Léon, "Le Rayonnisme: Larionov-Gontcharova," *Art*

d'Aujourd'hui (Paris), November 1950, serie 2, no. 2, pp. 26–29.

Descargues, Pierre, "Il y a un An Je l'Interviewais," *Les Lettres Françaises* (Paris), 1 November 1962, p. 10.

Dobuzhinsky, M. V., *Vospominaniya*, Moscow, 1987.

Douglas, Charlotte, "The New Russian Art and Italian Futurism," *Art Journal*, Spring 1975, vol. 34, no. 3, pp. 224–39.

Draguet, Michel, "Mikhail Larionov et l'Abstraction: Le Pneumo-Rayonnisme dans la Peinture Euopéenne des Années 1910," *Annales d'Histoire de l'Art & d'Archéologie* (Brussels), vol. X, 1988, pp. 67–86.

Dyakonitsyn, Lef Fedorovich, *Ideinye protivorechiya v estetike russkoi zhivopisi kontsa 19-nachala 20 vv.*, Perm, 1966.

Eganbyuri, Eli (Ilya Zdanevich), *Nataliya Goncharova Mikhail Larionov*, Moscow, July 1913.

Eganbyuri, E. (Ilya Zdanevich), "Goncharova i Larionov," *Zharptitsa* (Berlin), 1922, no. 7, pp. 39–40.

Eliade, Mircea, *Shamanism: Archaic Techniques of Ecstasy*, New York, 1964.

Ex Libris 6: Constructivism and Futurism: Russian and Other, sale catalogue, Ex Libris, New York, 1977.

Falk, Robert R., *Besedy ob iskusstve, pis'ma, vospominaniya o khudozhnike*, Moscow, 1981.

Fokine, Michel, *Memoirs of a Ballet Master*, London, 1961.

Fry, Edward, F., *Cubism*, New York, 1966.

Fry, Roger, "M. Larionow and the Russian Ballet," *The Burlington Magazine* (London), March 1919, vol. XXXIV, pp. 112–18.

Fry, Roger, *Letters of Roger Fry*, 2 Vols., London, 1972.

Fülop-Miller, Réné & Gregor, Joseph, *The Russian Theatre: Its Character and History with Especial Reference to the Revolutionary Period*, London, 1930.

Gambillo, Maria, and Teresa Fiori, *Archivi del Futurismo*, 2 Vols., Rome, 1958 and 1962.

George, Waldemar, "Le Costume Théâtral: Gontcharowa, Larionow, Leurs Costumes Rigides et l'Avenir du Costume Théâtral," *Le Crapouillot* (Paris), April 1921, pp. 9–11.

George, Waldemar, "Nathalie Gontscharowa und Michel Larionow," *Das Kunstblatt* (Berlin), 1924, vol. VIII, pp. 185–88.

George, Waldemar, "Les Anticipations de Gontcharova et de Michel Larionov," *Les Lettres Françaises*, 1963, vol. 997, p. 135.

George, Waldemar, *Larionov*, Paris, 1966.

Georges-Michel, Michel, *La Vie Mondaine Avant La Guerre: L'Epoque Tango. Pall Mall-Deauville-Paris-Riviera*, Paris, 1920.

Georges-Michel, Michel, *Les Montparnos, Roman Illustré par les Montparnos*, Paris, October 1929.

Georges-Michel, Michel; Waldemar George, and Nathalie Gontcharova, *Les Ballets Russes de Serge de Diaghilew: Décors et Costumes*, Paris, 1930.

Gimbutas, Marija, *The Gods and Goddesses of Old Europe: 7,000 to 3,500 B.C., Myths, Legends and Cult Images*, London, 1974.

Ginzburg, S., *Kinematografiya dorevolyutsionnoi rossii*, Moscow, 1963.

Gontcharowa. Larionow: L'Art Décoratif Théâtral Moderne, folio of prints, Paris, 1919.

Gontcharova, Nathalie, Michel Larionov, and Pierre Vorms, *Les Ballets Russes: Serge de Diaghilew et la Décoration Théâtrale. Nouvelle Edition Revue et Augmentée*, Belvès, Dordogne, 1955.

Gordon, Donald, *Modern Art Exhibitions 1900–1916. Vols. I and II. Selected Catalogue Documentation*, Munich, 1974.

Grabar, Igor Emmanylovich, *Igor Emmanylovich Grabar': Moya zhizn', avtomonografiya*, Moscow/Leningrad, 1937.

Grand Bal des Artistes Travesti-Transmental, program booklet, Paris, 23 February 1923.

Gray, Camilla, *The Great Experiment: Russian Art 1863–1922*, London, 1962.

Grigoriev, S. L., *The Diaghilev Ballet 1909–1929*, London, 1953.

Gumilev, Nikolai, *Sobranie sochineny v chetyrekh tomakh*, Washington, vol. I, 1962; II, 1964; III, 1966; IV, 1968.

Haskell, Arnold A., *Balletomania: The Story of an Obsession*, London, 1934.

Henderson, Linda D., "A New Facet of Cubism: 'The Fourth Dimension' and 'Non-Euclidean Geometry' Re-Interpreted," *Art Quarterly*, Winter 1971, pp. 410–33.

Henderson, Linda D., "The Merging of Time and Space, The Fourth Dimension in Russia from Ouspensky to Malevich," *The Structurist* (Saskatoon), 1975/1976, no. 15/16, pp. 97–108.

Henderson, Linda D., *The Fourth Dimension and Non-Euclidean Geometry in Modern Art*, Princeton, 1983.

Herodotus, *The Histories*, Translated by Aubrey de Sélincourt, Harmondsworth, Middlesex, Revised Edition, 1972.

Hinton, Charles Howard, *A New Era of Thought*, London and New York, 1888.

Hinton, Charles Howard, *The Fourth Dimension*, London and New York, 1904.

Hoog, Michel, "A Propos de l'Automne de Michel Larionov," *La Revue de Louvre* (Paris), 1972, no. 1, pp. 25–30.

Howard, Jeremy, *The Union of Youth: An artists' society of the Russian avant-garde*, Manchester and New York, 1992.

Ingold, Felix P., "Zwischen Primitivismus und Rayonismus," *Neue Zurcher Zeitung* (Zurich), 23–24 February 1980, p. 65.

Ingold, Felix P., "Rayonism: Its History and Theory," *Michail Larionow*, exhibition catalogue, Zurich, 1987, pp. 5–8, 19–22.

Isarlov, G. I., "M. F. Larionov," *Zhar-ptitsa* (Berlin), 1923, no. 12, pp. 2–4, 26–30.

Janecek, Gerald, *The Look of Russian Literature: Avant-Garde Visual Experiments 1900–1930*, Princeton, 1984.

Ivanov, S. V., *Materialy po izobrazitel'nomu iskusstvu narodov Sibiri XIX-nachala XX v.*, Moscow/Leningrad, 1954.

Jotterand, Franck, "Des Ballets Russes aux Voyages dans l'Espace: Larionov et Nathalie Gontcharova," *L'Illustré* (Lausanne), 24 September 1959, no. 39, pp. 65–67.

Kamensky, Vasily, *Zhizn's Mayakovskim*, Moscow, 1940.

Kandinsky, Wassily and Marc, Franz (eds.), *The Blaue Reiter Almanach*, London and New York, 1974.

Katanyan, V., *Mayakovsky: Literaturnaya khronika*, Moscow, 1961.

Khangalov, M. N., *Novye materialy o shamanstve u Buryat*, Irkutsk, 1890.

Khardzhiev, Nikolai, "Iz Materialov o Mayakovskom," *30 Dnei: Novella sovetskaya i inostrannaya, stikhi, publitsistika, literaturny felleton* (Moscow), 1939, no. 7, pp. 82–85.

Khardzhiev, Nikolai, *Mayakovsky: Materialy i issledovaniya*, Moscow, 1940.

Khardzhiev, Nikolai, "Pamyati Natalii Goncharovoi (1881–1962) i Mikhaila Larionova (1881–1964)," *Iskusstvo knigi* (Moscow), 1968, vol. V for 1963–1964, pp. 306–18.

Khardzhiev, Nikolai, *K istorii russkogo avangarda*, Stockholm, 1976.

Khlebnikov, V. V., *Sobranie sochineny*, vol. I, Munich, 1968.

Khlebnikov, V. V., *Snake Train: Poetry and Prose*, Michigan, 1976.

Khudakov, S., "Literatura, khudozhestvennaya kritika disputi i doklady," *Osliny khvost i mishen'*, Moscow, 1913, pp. 125–53.

Knizhnaya letopis' glavnogo upravleniya po delam pechati (St. Petersburg), July 1907–1920. Reprint, Vaduz, 1964.

Kobiakov, D., "Sovremennaya zhivopis': Larionov," *Zemlya* (Paris), 1949, no. 2, p. 16.

Kochno, Boris, *Diaghilev et Les Ballets Russes*, Paris, 1973.

Korzukhin, A., "Dar novatora: Zametki o tvorchestve M. Larionova," *Moskovsky komsomolets* (Moscow), 2 October 1980.

Kovtun, E., "Experiments in Book Design by Russian Artists," *The Journal of Decorative and Progpaganda Arts*, Summer 1987, no. 5, pp. 46–59.

Kovtun, E., *Russkaya futuristicheskaya kniga*, Moscow, 1989.

Kravchenko, K. S., *A. V. Kuprin*, Moscow, 1973.

Kruchenykh, Aleksei, *Starinnaya lyubov'*, Moscow, October 1912.

Kruchenykh, Aleksei & Khlebnikov, Velimir, *Mir s kontsa*, Moscow, December 1912.

Kruchenykh, Aleksei, *Poluzhivoi: Soch. A. Kruchenykh. Ris. Mikh. Larionova*, February 1913.

Kruchenykh, Aleksei, *Pomada: Stikhotvoreniya. Risunki Larionova*, Moscow, February 1913.

Kruchenykh, Aleksei, *15 Let russkago futurizma 1912–1917: Materialy i kommentarii*, Moscow, 1928.

Kuznetsov, Erast, *Niko Pirosmanashvili*, Leningrad, 1985.

Lapshin, V. P., *Soyuz russkikh khudozhnikov*, Leningrad, 1974.

M. L. (Mikhail Larionov): "Gazetnye kritiki v roli politsii nravov," *Zolotoe runo*, November–December 1909, nos. 11–12, pp. 97–98.

Larionov, Mikhail, "Predislovie," *Vystavka ikonopisnykh podlinnikov i lubkov*, exhibition catalogue, Moscow, 1913, pp. 5–10.

Larionov, Mikhail, "Predislovie," *Vystavka kartin gruppy khudozhnkov "Mishen',"* exhibition catalogue, Moscow, 1913, pp. 5–7.

Larionov, Mikhail, *Luchizm*, Moscow, April 1913.

Larionov, Mikhail & Goncharova, Nataliya et al., "Luchisty i budushchniki: Manifest," *Osliny khvost i mishen'*, Moscow, 1913, pp. 9–48. Translated in Bowlt 1976, pp. 87–91.

Larionov, Mikhail, "Luchistskaya zhivopis'," *Osliny khvost i mishen'*, Moscow, 1913, pp. 83–124. Translated in Bowlt 1976, pp. 91–100.

Larionov, Mikhail, and Ilya Zdanevich, "Pochemu my raskrashivaemsya: Manifest futuristov," *Argus* (St. Petersburg), Christmas number 1913, pp. 114–18. Translated in Bowlt 1976, pp. 79–83.

Larionov, Mikhail, and Nataliya Goncharova, *16 Risunkov. 16 Dessins: N. Goncharovoi i M. Larionov, M-e. N. Gontcharoff et Michel Larionoff*, Moscow, 1913–1914.

Larionov, Mikhail, "Predislovie," *Vystavka kartin No. 4* (futuristy, luchisty, primitiv), exhibition catalogue, Moscow, 1914.

Larionov, Michel, "Le Rayonnisme Pictural," *Montjoie!* (Paris), April/May/June 1914, nos. 4/5/6, p. 15.

Larionow, Michele, and Nataliya Gonciarova, *Radiantismo: Giudizi, Raccolti e Tradotti dal Francese e dal Russo da N. A.*, Rome, 1917.

Larionov, Michel, *Voyage en Turquie: 32 Pochoirs*, folio of prints, Paris, c. 1928.

Larionow, Michel, "Souvenirs sur Diaghilev," *La Revue Musicale* (Paris), December 1930, pp. 48–56.

Larionow, Michel, and Marcel Mihalovici, *Karagueuz: Ballet Plastique: Livret de M. Larionow, Musique de Marcel Mihalovici*, Paris, 1930.

Larionov, Michel, "The Art of Stage Decoration," *The Continental Daily Mail*, 13 December 1949, p. 4.

Larionov, Michel, and Nathalie Gontcharova, "Serge de Diaghilev et l'Evolution de Décor et du Costume de Ballet," Gontcharova, Larionov and Vorms, 1955, pp. 27–39.

Larionov, Michel, "Malevitch: Souvenirs de Michel Larionov," *Aujourd'hui: Art et Architecture* (Paris), December 1957, pp. 6–8.

Larionov, Michel, "Michel Larionov: Première Rencontre avec Diaghilev," *Art et Danse: Les Informations Chorégraphiques* (Paris), June–July 1959, no. 4, pp. 2, 6.

Larionov, Mikhail, "Moya pervaya vstrecha s Dyagilevym," *Russkie novosti* (Paris), 1967, no. 1142, p. 5.

Larionov, Michel, *Diaghilev et les Ballet Russes: Dessins et Textes de Michel Larionov*, Paris, 1970.

Larionov, Michel, *Une Avant-Garde Explosive. Textes Traduits, Réunis, et Annotés par Michel Hoog et Solina de Vigneral*, Lausanne, 1978.

Larionov, Michel, and Nataliya Goncharova, *Larionov i Goncharova: Stikhi*, Paris, 1987.

Levinson, André, "Les Hommes des 'Ballets Russes': Larionov," *Comoedia* (Paris), 2 July 1923. Reprinted in George 1966, p. 109.

Leyda, Jay, *Kino: A History of the Russian and Soviet Film*, London, 1960.

Lifar, Serge, *Serge Diaghilev: His Life, His Work, His Legend. An Intimate Biography*, New York, 1940.

Livshits, Benedikt, *Polutoraglazy strelets*, Leningrad, 1933. Translated by J. E. Bowlt as *The One and a Half-Eyed Archer*, Newtonville, Masachusetts, 1977.

Lobanov, V. M., *Khudozhestvennye gruppirovki za poslednie 25 let*, Moscow, 1930.

Lodder, Christina, *Russian Constructivism*, New Haven and London, 1983.

Loguine, Tatiana, *Gontcharova et Larionov: Cinquante Ans à Saint Germain-des-Près. Témoinages et Documents Recueillis et Présentés par Tatiana Loguine*, Paris, 1971.

Loguine, Tatyana, "Larionov i Goncharova — osnovateli luchizma i russkago avangarda," *Russkaya mysl'* (Paris), 16 November 1978, no. 3230, p. 11.

Loguine, Tatyana, "Larionov i Goncharova v sovremennom iskusstve," *Russkaya mysl'* (Paris), 2 August 1979, p. 10, and 9 August 1979, p. 8.

Loguine, Tatyana, "K stoletiyu Mikhaila Fedorovicha Larionova," *Russkaya mysl'* (Paris), 2 July 1981, no. 3**7, p. 12.

Loguine, Tatyana, "Natalya Goncharova i Mikhail Larionov," *Russky al'manakh*, Paris, 1981, pp. 178–83.

Mak, V., (Pavel Ivanov) "Luchizm," *Golos Moskvy* (Moscow), 14 October 1912, no. 237, p. 5.

Makovsky, Sergei, " 'Novoe' iskusstvo i 'chetvertoe izmerenie' (po povodu sbornika 'Soyuza molodezhi')," *Apollon* (St. Petersburg), September 1913, no. 7, pp. 53–60.

Manning, Henry Parker, *The Fourth Dimension Simply Explained: A Collection of Essays from Those Submitted in the Scientific American's Prize Competition*, New York, 1910.

Marcadé, Valentine, *Le Renouveau de l'Art Pictural Russe 1863–1914*, Lausanne, 1971.

Maré, Rolf de, "La Tragédie Chorégraphique 'Hamlet,'" *Archives Internationales de la Danse*, 15 July 1934, no. 3, p. 107.

Marinetti, *Marinetti: Selected Writings*, London, 1972.

Markov, Vladimir, *Russian Futurism a History*, London, 1969.

Massine, Leonide, *My Life in Ballet*, London, 1968.

Mayakovsky, Vladimir, *Solntse: Poema*, Moscow and Petrograd, June 1923.

Mayakovsky, Vladimir, *Polnoe sobranie sochineny v trinadtsati tomakh: Tom pervy 1912–1917*, Moscow, 1955.

Milner, John, *Vladimir Tatlin and the Russian Avant-Garde*, New Haven and London, 1983.

Mikhailovskii, Professor V. M., "Shamanism in Siberia and European Russia, Being the Second Part of *Shamanstvo*," *Journal of the Anthropological Institute of Great Britain and Ireland* (London), 1895, vol. XXIV, pp. 62–100, 126–58.

Minuvshee, "The Letters of Natalya Goncharova and Mikhail Larionov to Olga Resnevich Signorelli," vol. 5, Paris, 1986–1987.

Mitrokhin, Dmitry, *Kniga o Mitrokhine: Stat'i, pis'ma, vospominaniya*, Leningrad, 1986.

Moskovskaya gazeta, "Raskrashenny Larionov," 9 September 1913, no. 272, p. 3.

Moskovskaya gazeta, "Raskrashenye moskvichi", 15 September 1913, no. 273, p. 5, and 16 September 1913, no. 274, p. 5.

Mukhortov, F., "Luchisty (v masterskoi Larionova i Goncharovoi)," *Moskovskaya gazeta*, 7 January 1913, no. 231, p. 2.

Mukhortov, F., "Lider 'Oslinogo khvosta,'" *Moskovskaya gazeta*, 28 November 1913, no. 162, p. 2.

Myers, Rollo H., *Ravel: Life and Works*, London, 1960.

Nakov, Andrei B., "The Iconoclastic Fury," *Studio* (London), June 1974, vol. 187, no. 967, pp. 281–88.

Nakov, A. B., "Matériau et être pictural: au-delà des limites de la mimesis," *Mikhail Larionov: La Voie vers l'Abstraction*, exhibition catalogue, Frankfurt and Geneva, 1987–1988, pp. 22–73.

Osliny khvost i mishen', almanac by M. Larionov, N. Goncharova, S. Khudakov, V. Parkin, Moscow, July 1913.

Otsup, Nikolai, "O Larionove," *Chisla* (Paris), 1931, vol. 5, pp. 183–86.

Ouspensky, P. D., *Chetvertoe izmerenie: opyt' izsledovaniya oblasti neizmerimago*, St. Petersburg, 1910.

Ouspensky, P. D., *Tertium Organum: Klyuch k zagadkam mira*, St. Petersburg, 1911. Second edition translated as *Tertium Organum, The Third Cannon of Thought: A Key to The Enigmas of the World*, London, 1922.

Ouspensky, P. D., *Vnutrenny krug: 'O poslednei cherte' i o sverkhcheloveke: (dve lektsii)*, St. Petersburg, 1912.

Ouspensky, P. D., *A New Model of the Universe: Principles of the Psychological Method and Its Application to Problems of Science, Religion and Art*, London, 1931.

Ovid, *The Metamorphoses*, Harmondsworth, Middlesex, 1955.

Ovsyannikov, Yuri, and Arthur Shkarovsky-Raffé, *Lubok: Russkie narodnye kartinki XVII–XVIII vv.*, *The Lubok: 17th–18th Century Russian Broadsides*, Moscow, 1968.

Parkin, Varsanofy, "Osliny khvost i mishen'," *Osliny khvost i mishen'*, Moscow, 1913, pp. 49–82.

Parnack, Valentin, "Gontcharova et Larionow," *l'Art Décoratif Théâtral Moderne*, Paris, 1919, pp. 7–18.

Parnack, Valentin, *Motdinamo/Slovodvig. Huit illustrations d'après les dessins de N. Gontcharova. Couverture et sept illustrations d'après les dessins de Larionow*, Paris, 1920.

Parton, Anthony, "Russian Rayism, The Work and Theory of Mikhail Larionov and Natalya Goncharova 1912–1914: Ouspensky's Four Dimensional Super Race?" *Leonardo: Journal of the International Society for the Arts, Sciences and Technology* (Oxford), Autumn 1983, vol. 16, no. 4, pp. 298–305.

Parton, Anthony, *Mikhail Fedorovich Larionov 1881–1964: A Study of the Chronology and Sources of His Art*, Ph.D. Thesis, University of Newcastle on Tyne, 1985.

Parton, Anthony, "Fabulous Paths Converge: Gumilev, Goncharova and Larionov in Paris, 1917," *Journal of Russian Studies*, 1987, no. 52, pp. 17–35.

Parton, Anthony, "The Rayist Revolution in Russian Art," *Michail Larionov*, exhibition catalogue, Stockholm, 1987, pp. 13–54.

Parton, Anthony, "'Goncharova and Larionov': Gumilev's Pantum to Art," *Nikolai Gumilev 1886–1986*, Oakland, California, 1987, pp. 225–42.

Petropavlovskaya, N. A., "Russkie khudozhniki v Parizhe (pis'ma i vospominaniya o N.S. Goncharovoi i M.F. Larionove)," *Vstrechi s proshlym* (Moscow), 1984, no. 5, pp. 170–84.

Polunin, Vladimir, *The Continental Method of Scene Painting*, London, 1927.

Pospelov, Gleb, "O 'valetakh' bubnovykh i valetakh chernovykh," *Panorama iskusstv '77* (Moscow), 1978, pp. 127–42.

Pospelov, Gleb, "M. F. Larionov," *Sovetskoe iskusstvoznanie '79*, 1980, no. 2, pp. 238–66.

Pospelov, Gleb, *Larionov i Pirosmanashvili. K voprosu o sud'bakh primitiva v iskusstve noveishego vremeni tezisy*, IV Mezhdunarodny Simpozium po Gruzinskomu Iskusstvu, Tbilisi, 1983.

Pospelov, Gleb, *Karo-Bübe: Aus der Geschichte der Moskauer Malerei zu Beginn des 20 Jahrhunderts*, Dresden, 1985.

Pospelov, Gleb, "Nasledstvo Goncharovoi Larionova," *Nashe Nasledie*, 1990, no. 1, pp. 152–58.

Pottecher, Frédéric H., "Dans un Restaurant de la Rive Gauche avec Larionov, Fougeux Décorateur . . . ," *Comoedia* (Paris), 17 December 1932. Extract reprinted in George 1966, pp. 109–10.

Proffer, E., and C. R. Proffer, *The Ardis Anthology of Russian Futurism*, Ann Arbor, 1980.

Propert, W. A., *The Russian Ballet in Western Europe 1909–1920*, London, 1921.

Propert, W. A., *The Russian Ballet 1921–1929*, London, 1931.

Punin, Nikolai, "Impressionistichesky period v tvorchestve M. F. Larionova," *Materialy po russkomu iskusstvu*, Leningrad, 1928, vol. 1, pp. 287–91. Reprinted in N. Punin, *Russkoe i sovetskoe iskusstvo*, Moscow, 1976.

Redko, Kliment, *Kliment Redko: Dnevniki, vospominaniya, stat'i*, Moscow, 1974.

Richardson, Marion, *Art and The Child*, London, 1948.

Rischbieter, Henning, and Wolfgang Storch, "Larionow und Gontscharowa," *Bühne und Bildende Kunst im XX Jahrhundert: Maler und Bildhauer Arbeiten für Das Theater*, Hannover, 1968.

Rosenthal, T. G., "Larionov and Goncharova," *The Arts Review*, 2–16 December 1961, vol. XIII, no. 23, p. 5.

Rudenstine, Angelica Z., "Larionov: *Glass*," *Guggenheim Museum Collection, Paintings 1880–1945*, New York, 1976, vol. II, pp. 446–51.

Rudenstine, Angelica Z. (ed.), *Russian Avant-Garde Art: The George Costakis Collection*, London, 1981.

Rusakov, Yu. R., "Matisse in Russia in the Autumn of 1911," *The Burlington Magazine* (London), May 1975, vol. CXVII, no. 886, pp. 284–91.

Russian Futurism 1910–1916 Poetry and Manifestos: 54 Titles on Colour and Monochrome Microfiche, (ed. S. Compton), Chadwyck-Healey, Cambridge, England.

Russkaya khudozhestvennaya kul'tura kontsa XIX-nachala XX veka (1908–1917): kniga chetvertaya: izobrazitel'noe iskusstvo arkhitektura dekorativno prikladnoe iskusstvo, Moscow, 1980.

Sadok sudei II, almanac by D. and N. Burlyuk, E. Guro, V. Khlebnikov, A. Kruchenykh, B. Livshits, V. Mayakovsky, E. Nizen, St. Petersburg, February–March 1913.

Salmina-Haskell, Larissa, *Russian Drawings in The Victoria and Albert Museum*, London, 1972.

Sampson, Earl D., *Nikolay Gumilev*, Boston, 1979.

Sarabyanov, Dmitry, "Primitivistsky period v tvorchestve Mikhaila Larionova," *Russkaya zhivopis' kontsa 1900-x nachala 1910-x godov: Ocherki*, Moscow, 1971, pp. 99–116.

Sarabyanov, Dmitrii, "Vystavka Larionova," *Sovetskaya zhivopis'* (Moscow), no. 5, 1982, pp. 189–200.

Sarabyanov, Dmitry, *Niko Pirosmanashvili sredi russkikh khudozhnikov na vystavke "Mishen',"* IV Mezhdunarodny Simpozium po Gruzinskomu Iskusstvu, Tbilisi, 1983.

Schafran, Lynn, "Larionov and The Russian Vanguard," *Art News* (New York), May 1969, vol. 68, no. 3, pp. 36, 66–67.

Sergei Diaghilev i russkoe iskusstvo: Stat'i, otkrytye pis'ma, interv'yu, perepiska. Sovremenniki o Diaghileve, 2 vols., Moscow, 1982.

Seuphor, Michel, *L'Art Abstrait: Ses Origines, Ses Premiers Maîtres*, Paris, 1950.

Shaikevich, André A., "Vospominaniya M. F. Larionova," *Russkie novosti* (Paris), 1967, no. 1142, p. 5.

Shevchenko, Aleksandr, *Neo-Primitivizm: Ego teoriya, ego vozmozhnosti, ego dostizheniya*, Moscow, 1913. Translated in Bowlt 1976, pp. 41–54.

Shevchenko, Aleksandr, *Printsipy kubizma i drugikh sovremennykh techenii v zhivopisi vsekh vremen i narodov*, Moscow, 1913.

Shklovsky, Viktor, *Zoo or Letters Not About Love*, Ithaca/London, 1971.

Shklovsky, Viktor, *Mayakovsky and His Circle*, London, 1974.

Slonim, Mark, "Goncharova i Larionov," *Novoe russkoe slovo Russian Daily* (New York), 15 April 1973.

Spence, Lewis, *A Dictionary of Mythology: Being a Concise Guide to The Myths of Greece and Rome, Babylonia, Egypt, America, Scandinavia and Great Britain*, London and New York, 1910.

Steneberg, Eberhard, "Larionow, Gontscharowa und der Rayonismus," *Das Kunstwerk* (Baden-Baden), February 1963, vol. 16, no. 8, pp. 11–22.

Stolichnaya molva, "Khudozhestvennaya zhizn': Venery M. Larionova," 29 October 1912, no. 272, p. 5.

Stravinsky, Igor, *Chronicle of My Life*, London, 1936.

Struve, Gleb, "Pis'ma M. F. Larionova o N.S. Gumileve," *Mosty*, 1970, no. 15, pp. 403–10.

Sytova, Alla, *The Lubok: Russian Folk Pictures 17th–19th Century*, Leningrad, 1984.

Théâtre des Petits Comédiens de Bois de Julie Sazonowa, theatre program for December 1924 – January 1925, Paris, 1924.

Treizes Dances: Conrad Beck, Marcel Delannoy, Pierre Ferroud, Tibur Harsanyi, Jacques Larmanjat, Nikolai Lopatnikoff, Bohuslav Martinu, Georges Migot, Marcel Mihalovici, Manuel Rosenthal, Erwin Schulhoff, Alexandre Tansman, Jean Wiener, Couverture d'après les dessins originaux de M. Larionov, Paris, 1929.

Trudy vserossyskago s'ezda khudozhnikov . . . dekabr' 1911 – yanvar' 1912, 3 vols., Petrograd, 1914.

Tsvetaeva, Marina, "Natal'ya Goncharova (zhizn' i tvorchestvo)," *Prometei* (Moscow), 1969, pp. 144–201.

Vanslova, V. V., *Russkaya progressivnaya khudozhestvennaya kritika vtoroi poloviny XIX – nachala XX veka: Khrestomatiya*, Moscow, 1977.

Vergo, Peter, "A Note on the Chronology of Larionov's Early Work," *The Burlington Magazine* (London), July–December 1972, vol. CXIV, pp. 476–79, with replies pp. 634, 719–20, 874.

Vesy: Ezhemesyachnikh iskusstv i literatury (Moscow), January 1904 – December 1909.

Vystavki sovetskogo izobrazitel'nogo iskusstva. Spravochnik 3 vols., Moscow, 1965–1975.

Weiss, Peg, "Kandinsky and 'Old Russia': An Ethnographic Exploration," *Syracuse Scholar*, Spring 1986, pp. 43–62.

Woroszylski, Wiktor, *The Life of Mayakovsky*, London, 1972.

Yakovleva-Liberman, Tatyana, "S brov'yu brovi: Fragment iz knigi vospominany" and "Larionov i Goncharova v pis'makh i risunkakh," *Chast' rechi: Al'manakh literatury i iskusstva* (New York), 1980, no. 1, pp. 239–42, 243–50.

Zdanevich, Hélène, "Il'ja Zdanevic a Paris: 1921–1923," *L'Avanguardia a Tiflis*, Venice, 1982, pp. 181–88.

Zdanevich, Kirill, *Niko Pirosmanishvili*, Tbilisi, 1965.

Zhar ptitsa, Berlin, 1921–1926.

Zolotoe runo (Moscow), January 1906 – December 1910.

Znosko-Borovsky, Eugène, "A Propos de Quatre Artistes: Larionov, Léon Zak, Modzalevsky, Bilinsky," *La Revue de l'Oeuvre* (Paris), November 1927, pp. 24–26.

Vystavka kartin. 27-aya po shchetu. Ucheniki Uchilishcha zhivopisi, vayaniya i zodchestva, Katalog, Moscow, 1904.

Vystavka akvarely, pastely, tempera, risunkov, Katalog, Zaly Literaturno-khudozhestvennogo kruzhka, Moscow, 15 January– , 1906.

XXV-aya periodicheskaya vystavka obshchestva lyubitelei khudozhestv, Katalog, Istorichesky muzei, Moscow, January 1906.

XIII-aya vystavka kartin "Moskovskago t-va khudozhnikov," Katalog, Istorichesky muzei, Moscow, January–February 1906.

Mir iskusstva, Katalog, Ekaterininsky zal, St. Petersburg, February 1906.

III-aya vystavka kartin "Soyuza russkikh khudozhnikov," Katalog, Pomeshchenie Stroganovskogo uchilishcha, Moscow, 3–30 April 1906.

Exposition de l'Art Russe / Russkaya khudozhestvennaya vystavka v Parizhe, Catalogue, Société du Salon d'Automne, Grand Palais, Paris, 6 October – 15 November 1906. Travelled to Germany as *Russische Kunst Austellung*, Kunsthandlung Eduard Schulte, Berlin, November 1906, and shown in Italy as part of the *VII Esposizione Internationale*, Venice, 22 April – 31 October 1907.

IV-aya vystavka kartin "Soyuza russkikh khudozhnikov," Katalog, Pomeshchenie Akademii khudozhestv, St. Petersburg, 27 December 1906 – 23 January 1907, and Moscow, Pomeshchenie Stroganovskogo uchilishcha, Moscow, 11 February – 11 March 1907.

XIV-aya vystavka kartin "Moskovskago t-va khudozhnikov," Katalog, Istorichesky muzei, Moscow, April 1907.

V-aya vystavka kartin "Soyuza russkikh khudozhnikov," Katalog, Novoe pomeshchenie Stroganovskogo uchilishcha Moscow, 26 December 1907 – 3 February 1908.

Stefanos, Katalog, Dom Stroganovskogo uchilishcha, Moscow, 27 December 1907 – 15 January 1908.

Vystavka kartin "Venok," Katalog, St. Petersburg, 24 March – ?, 1908.

Vystavka kartin "Salon zolotogo runa," Katalog, Moscow, 5 April – 11 May 1908.

Zveno, Katalog, Kiev, 2–30 November 1908. Travelled to St. Petersburg and Ekaterinoslav.

Zolotoe runo, Katalog, Moscow, 11 January – 15 February 1909.

VI-aya vystavka kartin "Soyuz russkikh khudozhnikov," Katalog, Pomeshchenie doma, gde zhil i umer A. S. Pushkin, Moika 12, St. Petersburg, 28 February – 8 April 1909.

Zolotoe runo, Katalog, Moscow, 27 December 1909 – 31 January 1910.

Salon. Internatsional'naya vystavka kartin, skul'pturny gravyury i risunkov, Katalogi: Odessa, 4 December 1909 – 24 January 1910, Kiev, 12 February – 14 March 1910, St. Petersburg, 19 April – 25 May 1910, and Riga 12 June – 7 July 1910.

VII-aya vystavka kartin "Soyuza russkikh khudozhnikov," Katalog, Pomeshchenie Doma Armyanskoi Tserkvy, St. Petersburg, 20 February – 20 March 1910.

Vystavka kartin o-va khudozhnikov "Soyuz molodezhi," Katalog, St. Petersburg, 7/8 March – 11 April 1910.

Vystavka kartin "Russky setsession," Katalog, Riga, 13 June – 8 August 1910.

Bubnovy valet, Katalog, Moscow, 10 December 1910 – January 1911. An album of reproductions was also published to accompany the exhibition.

Salon 2: Mezhdunarodnaya khudozhestvennaya vystavka, Katalog, Odessa, December 1910 – January 1911. Org. V. A. Izdebskim.

O-vo khudozhnikov Moskovsky salon: Vystavka zhivopisi, skul'ptury i arkhitektury, Katalog, Moscow, 1911.

Vystavka kartin o-va khudozhnikov "Soyuz molodezhi," Katalog, St. Petersburg, 11 April – 10 May 1911.

Mir iskusstva, Katalog, Moscow, 15 November – December 1911, and St. Petersburg, January–February 1912.

Odnodnevnaya vystavka proizveden M. F. Larionova, Katalog, Obshchestvo svobodnoi estetiki, Moscow, 8 December 1911.

Zweite Ausstellung der Redaktion: Der Blaue Reiter, Katalog, Hans Goltz Kunsthandlung, Munich, February 1912.

Vystavka kartin o-va khudozhnikov "Soyuz molodezhi," Katalog, St. Petersburg, 4 January – 12 February 1912.

Osliny khvost, Katalog, dom Stroganovskogo uchilishcha, Moscow, 11 March – 8 April 1912.

Second Post-Impressionist Exhibition, British, French and Russian Artists, Catalogue, Grafton Galleries, London, 5 October – 31 December 1912.

Vystavka kartin o-va khudozhnikov "Soyuz molodezhi," Katalog, Nevsky 73, St. Petersburg, 4 December 1912 – 10 January 1913. The cover of this catalogue is ambiguously dated, suggesting that the exhibition was held 4 December 1911 to 10 January 1912. However Benois (1912) firmly gives the date of this exhibition as 1912–1913.

Mir iskusstva, Katalog, Moscow, December 1912; Pomeshchenie Doma Shvedskoi Tserkvy, St. Petersburg, January–February 1913, and Kiev, February 1913.

Vystavka ikonopisnykh podlinnikov i lubkov, Katalog, Khudozhestvenny salon, 11 Bol'shaya Dmitrovka, Moscow, 24 March – 7 April 1913. Org. M. F. Larionovym.

Vystavka kartin gruppy khudozhnikov "Mishen'," Katalog, Khudozhestvenny salon, 11 Bol'shaya Dmitrovka, Moscow, 24 March – 7 April 1913.

Erster Deutscher Herbstsalon "Der Sturm" Internationale Gemäldeausstellung, Katalog, 75 Eckhaus Potsdamer und Pallasstrasse, Berlin, 20 September – 1 December 1913.

Vystavka kartin Natalii Sergeevny Goncharovoi 1900–1913, Katalog, Khudozhestvenny salon, 11 Bol'shaya Dmitrovka, Moscow, 30 September – October 1913.

Mir iskusstva, Katalog, Moscow, December 1913.

Vystavka kartin No. 4 (futuristy, luchisty, primitiv), Katalog, Khudozhestvenny salon, no. 11 Bol'shaya Dmitrovka, Moscow, March–April 1914.

Vystavka kartin Natalii Sergeevny Goncharovoi 1900–1913, Katalog, Khudozhestvennoe Byuro N. E. Dobychinoi, St. Petersburg, ?–20 April 1914.

Esposizione Libera Futurista Internazionale Pittori e Scultori: Italiani, Russi, Inglesi, Belgi, Nordamericani, Catalogo, Galleria Futurista, Direttore G. Sprovieri, 125 via del Tritone, Rome, 13 April – 25 May 1914.

Exposition Natalie de Gontcharova et Michel Larionow, Catalogue, Galerie Paul Guillaume, 6 Rue de Miromesnil, Paris, 17–30 June 1914. Travelled to Berlin as *Ausstellung Der*

Sturm: Larionov und Gontcharova, Katalog, Der Sturm, Berlin, 1914.

Vystavka zhivopisi "1915 god," Katalog, Moscow, 23 March – ?, 1915.

Exposition des Oeuvres de Gontcharova et de Larionow: l'Art Décoratif Théâtral Moderne, Catalogue, Galerie Sauvage, 370 Rue St. Honoré, Paris, 16 April – 7 May 1918.

Exhibition of Sketches by M. Larionow and Drawings by the Girls of the Dudley High School, Catalogue, Omega Workshops Ltd., 33 Fitzroy Square, London, February 1919.

Exposition des Oeuvres de Gontcharova et de Larionow: l'Art Décoratif Théâtral Moderne, Catalogue, Galerie Barbazanges, 109 Rue Fbg. St. Honoré, Paris, 11–28 June 1919.

La Section d'Or: Internationale Tentoonstelling: Kubisten – Neo-Kubisten, Catalogue, Rotterdam, 20 June – 4 July 1920; The Hague, 11 July – 1 August; Arnhem, August–September; and Stedelijk Museum, Amsterdam, 23 October – 27 November 1920.

First Russian Exhibition of Arts and Crafts, Catalogue, Whitechapel Art Gallery, London, June–July 1921.

Exposition des Artistes Russes à Paris en 1921, Catalogue, Galerie La Boëtie, Paris, 1921.

The Goncharova – Larionov Exhibition, Catalogue, Kingore Galleries, New York, 1922. Org. Christian Brinton.

Internationale Theater Tentoonstelling te Amsterdam, Catalogue, Stedelijk Museum, Amsterdam, January–February 1922. Travelled to London as *International Exhibition of Theatre*, Catalogue, Victoria and Albert Museum, London, 3 June – 16 July 1922.

Exhibition of Goncharova and Larionov: Esquisses for Stage Sets, Costume Designs etc., No catalogue (?), Gallery Shiseido, Tokyo, 4–11 March 1923.

Vystavka proizvedeny khudozhnikov gruppy "Bubnovy valet," Katalog, Gos. Tret'yakovskaya gallereya, Moscow, 1 March – ?, 1927.

Exposition International des Beaux Arts de Bordeaux, Catalogue, Bordeaux, 1927.

Vystavka sovremennogo frantsuzskogo iskusstva, Katalog, Gos. Muzei novogo zapadnogo iskusstva i Gos. Tret'yakovksaya gallereya, 1 May – 31 June 1928.

Exposition du Groupe de Moscou "La Voie de la Peinture," Catalogue, Galerie Billiet – Pierre Vorms, 30 Rue la Boëtie, Paris, 24 May – 6 June 1928.

Voyage en Turquie (Pochoirs), Catalogue, The Literary Book Co. Ltd., Coptic Street, London, 12–19 February 1929.

Exposition Rétrospective de Maquettes, Décors et Costumes Exécutés pour la Compagnie des Ballets Russes de Serge de Diaghilew, Catalogue, Galerie Billiet – Pierre Vorms, 30 Rue La Boëtie, Paris, 14–28 October 1930.

Michel Larionov Peintures et Dessins, Catalogue, Galerie de "l'Epoque," Paris, 11–25 April 1931.

Výstavy Slovanského Umění 1: Retrospektivní Výstavy Ruského Malířství XVIII–XX Stol., Katalog, Slovanský Ústav v Praze, Prague, 1935. Pořádané pod Protektorátem Hlavního Města Prahy.

Cubism and Abstract Art, Catalogue by Alfred Barr, Museum of Modern Art, New York, 1936.

Internationale Ausstellung für Theaterkunst, Katalog, Vienna, 1936.

Exhibition of Russian Art, Catalogue, Philadelphia Museum of Art, November 1941 – February 1942. Travelled extensively throughout the U.S.A. until 1946.

Le Rayonnisme 1909 – 1914: Peintures de Michel Larionov et de Nathalie Gontcharova, Catalogue, Galerie des Deux Iles, 1 Quai aux Fleurs, Paris, 6 – 18 December 1948.

Les Premiers Maîtres de l'Art Abstrait, Catalogue, Galerie Maeght, Paris, May 1949. Catalogue published in *Derrière le Miroir* (Galerie Maeght, Paris), May 1949, nos. 20–21.

Exposition Michel Larionov et Nathalie Gontcharova (Peintures), Catalogue, Galerie de l'Institut, Paris, 11–21 June 1952.

Chefs d'Oeuvre du XXe Siècle, Catalogue, Musée d'Art Moderne, Paris, May–June 1952. Travelled to London as *Twentieth Century Masterpieces*, Catalogue, Tate Gallery, London, July–August 1952.

Diaghilev, Catalogue, Edinburgh and London, 1954. Org. Richard Buckle.

Michel Larionov: Oeuvres Anciennes et Récentes, Catalogue, Galerie de l'Institut, Paris, 25 May – 13 June 1956.

L'Art Abstrait: Les Premières Générations 1910–1939, Catalogue, Musée d'Art et d'Industrie, Saint-Etienne, 10 April – June 1957.

Les Sources du XXe Siècle / The Sources of the XXth Century: The Arts in Europe from 1884–1914, Catalogue, Musée d'Art Moderne, Paris, 4 November 1960 – 23 January 1961.

Larionov – Gontcharova, Catalogue, Galerie Beyeler, Bâle, Switzerland, July–September 1961.

Larionov and Goncharova: A Retrospective Exhibition of Paintings and Designs for the Theatre, Catalogue, Leeds City Art Gallery, 9–30 September 1961; Bristol City Art Gallery, 14 October – 4 November, and Arts Council Gallery, London, 16 November – 16 December 1961.

Larionow – Gontcharowa, Catalogo, Galerie Schwarz, Milan, 1961.

Designs for the Theatre by Goncharova and Larionov, Victoria & Albert Museum, 15 March – 15 September 1962. No catalogue.

Rétrospective Gontcharova – Larionov, Catalogue, Musée d'Art Moderne de la Ville de Paris, 27 September – December 1963.

M. F. Larionov: Tegninger, Catalogue, Galerie Hybler, Bredgade 53, Copenhagen, 1–15 December 1963.

Larionov i Goncharova, Katalog, Biblioteka-muzei V. Mayakovskogo, Moscow, 1965.

Goncjarowa – Larjonov – Mansurov, Catalogo, Galleria Lorenzelli, S. Michele 1a., Bergamo, December 1966.

4 Pittori dell'Avanguardia Russa: Goncjarowa – Larjonov – Mansurov – Sarsun, Catalogo, Sala Comunale delle Esposizioni, Comune di Reggio Emilia, 12 February – 4 March 1967. In collaborazione con la Galleria Lorenzelli.

Michel Larionov, Catalogue, Musée des Beaux Arts de Lyon, Lyon, 17 March – May 1967.

Natalia Goncjarowa – Mikhail Larjonov, Catalogo, Gallerie d'Arte Martano, Turin, February 1968.

Larionov, Catalogue, Acquavella Galleries Inc., New York, 22 April – 24 May 1969.

Les Ballets Russes de Serge de Diaghilev 1909–1929, Catalogue, l'Ancienne Douane, Strasbourg, 15 May – 15 September 1969.

Rétrospective Larionov, Catalogue, Galerie de Paris, 14 Place François ler, Paris, 17 June – 27 September 1969.

The Cubist Epoch, Catalogue, Los Angeles County Museum of Art, 15 December 1970 – 21 February 1971, and Museum of Modern Art, New York, 9 April – 8 June 1971.

Russian Avant-Garde 1908–1922, Catalogue, Leonard Hutton Galleries, New York, 16 October 1971 – 29 February 1972.

Rétrospective Larionov, Catalogue, Maison de la Culture de Nevers et la Niévre, 3 June – 29 July 1972.

Larionov Dessins et Peintures, Catalogue, Maison de la Culture et des Loisirs, Saint-Etienne, 7 June – 30 September 1973.

Michel Larionov et Son Temps, Catalogue, Musée Toulouse-Lautrec, Albi, June–September 1973.

Larionov Gontcharova Rétrospective, Catalogue, Musée d'Ixelles, Brussels, 29 April – 6 June 1976.

Iliazd, Catalogue, Centre National d'Art et de Culture Georges Pompidou, Paris, 10 May – 25 June 1978.

Paris–Moscou, Parizh–Moskva 1900–1930, Catalogue, Centre National d'Art et de Culture Georges Pompidou, Paris, 31 May – 5 November 1979. Travelled to Russia as *Moskva–Parizh 1900–1930*, Katalog, Gos. Muzei izobrazitel'nykh iskusstv imeni A. S. Pushkina, Moscow, 3 June – 4 October 1981.

Diaghilev: Les Ballets Russes, Catalogue, La Bibliothèque Nationale, Paris, 1979.

Abstraction: Towards a New Art, Painting 1910–1920, Catalogue, Tate Gallery, London, 6 February – 13 April 1980.

The Avant-Garde in Russia 1910–1930: New Perspectives, Catalogue, Los Angeles County Museum, 8 July – 28 September 1980.

Mikhail Fedorovich Larionov 1881–1964, no catalogue. Gos. Tret'yakovskaya gallereya, October – ? 1980.

Hommage à Gontcharova et Larionov 1881–1981, no catalogue. Galerie Darial, 22 Rue de Beaune, Paris, 17–27 June 1981.

Russian Stage Design: Scenic Innovation 1900–1930, From the Collection of Mr. and Mrs. Nikita D. Lobanov-Rostovsky, Catalogue, Mississippi Museum of Art, 18 June – 29 August 1982.

Michel Larionov et Nathalie Gontcharova, Catalogo, Galleria Martini and Ronchetti, Genova, March 1983.

Meisterwerke Russischer Malerei vom Ende des 19 Jahr. bis zum Beginn des 20 Jahr., Katalog, Josef-Haubrich-Kunsthalle, Köln, 7 February – 25 March 1984.

Sieben Moskauer Künstler / Seven Moscow Artists 1910–1930, Catalogue, Galerie Gmurzynska, Cologne, 12 April – 15 July 1984.

Nathalie Gontcharova, Michel Larionov, Catalogo, Arte Centro, Milan, 1984.

Russisk Avantgarde 1910–1930 fra Museum Ludwig, Köln og Andre Museer, Louisiana Museum, Denmark, 28 September – 8 December 1985. Katalog published in *Louisiana Revy* (Denmark), 26 Argang Nr. 1, September 1985, pp. 62–66.

Futurismo & Futurismi, Catalogue, Palazzo Grassi, Milan, 1986.

Michail Larionow, Catalogue, Galerie & Edition Schlégl, Zurich, 14 March – 16 May 1987.

Mikhail Larionov: La Voie vers l'Abstraction / Der Weg in die Abstraktion, Catalogue, Schirn Kunsthalle, Frankfurt, 9 April – 24 May 1987, and Musée Rath (Musée d'Art et d'Histoire), Geneva, 10 March – 24 April 1988.

Kirill Zdanevich and Cubo-Futurism Tiflis 1918–1920, Catalogue, Rachel Adler Gallery, New York, 6 June – 31 July 1987.

Iliazd and the Illustrated Book, Catalogue, Museum of Modern Art, New York, 18 June – 18 August 1987.

Gontcharova / Larionov, Catalogue, Marion Koogler McNay Art Museum, San Antonio, 1987.

Michail Larionov 1881–1964: Pasteller, Gouacher, Akvareller 1912–1914, Catalogue, Galerie Aronowitsch, Stockholm, Sweden, 1987.

Mikhail Larionov Nataliya Goncharova: Zhivopis' i grafika iz fondov muzeya, Catalogue, Historical-Artistic Museum, Serpukhov, 1987.

Kunst und Revolution: Russische und Sowjetische Kunst 1910–1932 / Art and Revolution: Russian and Soviet Art 1910–1932, Catalogue, Austrian Museum of Applied Arts, Vienna, 11 March – 15 May 1988.

Russkaya sovetskaya zhivopis' 1900–1930 / Russian and Soviet Paintings 1900–1930, Catalogue, Hirshhorn Museum and Sculpture Garden, Smithsonian Institution, Washington, 12 July – 25 September 1988.

100 Years of Russian Art 1889–1989. From Private Collections in the U.S.S.R., Catalogue, Barbican Art Gallery, London, 27 April – 9 July 1989.

Arte Russa e Sovietica 1870–1930, Catalogo, Lingotto, Turin, 1989.

L'Avant-Garde Russe 1905–1925: Chefs d'Oeuvre des Musées de Russie, Catalogue, Musée des Beaux-Arts de Nantes, 30 January – 18 April 1993.